STUDIES IN IMPERIALISM

General editors: Andrew S. Thompson and Alan Lester
Founding editor: John M. MacKenzie

When the 'Studies in Imperialism' series was founded by Professor John M. MacKenzie more than thirty years ago, emphasis was laid upon the conviction that 'imperialism as a cultural phenomenon had as significant an effect on the dominant as on the subordinate societies'. With well over a hundred titles now published, this remains the prime concern of the series. Cross-disciplinary work has indeed appeared covering the full spectrum of cultural phenomena, as well as examining aspects of gender and sex, frontiers and law, science and the environment, language and literature, migration and patriotic societies, and much else. Moreover, the series has always wished to present comparative work on European and American imperialism, and particularly welcomes the submission of books in these areas. The fascination with imperialism, in all its aspects, shows no sign of abating, and this series will continue to lead the way in encouraging the widest possible range of studies in the field. 'Studies in Imperialism' is fully organic in its development, always seeking to be at the cutting edge, responding to the latest interests of scholars and the needs of this ever-expanding area of scholarship.

Dividing the spoils

MANCHESTER
1824

Manchester University Press

Dividing the spoils

Perspectives on military collections
and the British empire

Edited by Henrietta Lidchi and Stuart Allan

MANCHESTER UNIVERSITY PRESS

Published by MANCHESTER UNIVERSITY PRESS
ALTRINCHAM STREET, MANCHESTER M1 7JA
www.manchesteruniversitypress.co.uk

British Library Cataloguing-in-Publication Data
A catalogue record for this book is available from the British Library

ISBN 978 1 5261 3920 7 hardback

First published 2020

Typeset
by Sunrise Setting Ltd, Brixham

CONTENTS

CONTENTS

LIST OF FIGURES

CONTRIBUTORS

Stuart Allan is Keeper of Scottish History & Archaeology at National Museums Scotland. His specialism is the material and organisational culture of the British Army, and his research focuses on the Scottish military tradition in its wider cultural contexts. He is author of *Commando Country* (2007), and co-author of *Common Cause: Commonwealth Scots and the Great War* (2014) and *The Thin Red Line: War, Empire and Visions of Scotland* (2004). He is currently co-investigator for the Arts and Humanities Research Council project *Baggage and Belonging: Military Collections and the British Empire, 1750–1900* (AH/P006752/1).

Christopher Evans is Executive Director of the Cambridge Archaeological Unit, University of Cambridge. Having worked in British archaeology for over forty years, Evans co-founded the Unit, together with Ian Hodder, in 1990. He has directed a wide variety of major fieldwork projects, both abroad (Nepal, China & Cape Verde) and in the United Kingdom. He is a Fellow of the Society of Antiquaries of London, and in 2018 he was elected a Fellow of the British Academy. He has published widely, both monographs arising from his own landscape projects and those of earlier-era practitioners in the Unit's *Historiography and Fieldwork* series. Also contributing many papers on the history and social context of the subject, he is a member of editorial board of *The Bulletin of the History of Archaeology* and, together with Tim Murray, edited *Histories of Archaeology: A Reader in the History of Archaeology* (2008).

Nicole M. Hartwell is Postdoctoral Researcher at National Museums Scotland working on the Arts and Humanities Research Council project *Baggage and Belonging: Military Collections and the British Empire, 1750–1900* (AH/P006752/1). She completed her doctorate at the University of Oxford which examined how non-European military cultures were perceived in Britain during the nineteenth century through an analysis of visual and textual sources, a work that is currently being prepared for publication. Her research interests include the material culture of conflict; the collecting practices of the British armed forces; the development of military museums; and the military, cultural and intellectual history of the British Empire, c. 1750–1900.

Charles Kirke is a soldier and military anthropologist specialising in the organisational culture of the British armed forces. His principal research area is British Army culture at unit level from 1700 to date. This research, based on cultural analysis of military first-hand accounts from the past and contemporary interviews and observations, began informally in 1974, after he had graduated in Archaeology and Anthropology at Cambridge. More formal research began with a MOD Defence Fellowship at Cambridge in 1993–94. He completed his doctorate with Cranfield University in 2003, the year before he left the Army, and worked until 2015 at the Defence Academy of the UK as lecturer/senior lecturer.

Henrietta Lidchi is Chief Curator at the National Museum of World Cultures, the Netherlands, which she joined in 2017. From 2005–17 she was Keeper of the Department of World Cultures, National Museums Scotland, where she is currently a Research Fellow. Prior to that she held posts at the British Museum. Lidchi has conducted research primarily in the arts and material culture of indigenous North America, but has also published in the field of the history of collections, issues of representational practice in museums and visual anthropology. She is editor of *Imagining the Arctic* (with J. C. H. King), *Visual Currencies* (with Hulleah Tsinhnahjinnie) and author of *Surviving Desires: Native Jewellery of the American Southwest*. She is Principal Investigator of *Baggage and Belonging: Military Collections and the British Empire, 1750–1900* funded by the Arts and Humanities Research Council (AH/P006752/1).

John Mack is Professor of World Art Studies at the University of East Anglia, which he joined in 2004. Before that, he was Keeper of Ethnography in the British Museum specialising in the cultures of sub-Saharan Africa and for six years also its Senior Keeper. He was elected a Fellow of the British Academy in 2009. Mack has conducted anthropological fieldwork in what is now the Republic of South Sudan, northern Kenya and the islands of the western Indian Ocean. He has published extensively, his latest book being *The Artfulness of Death in Africa* (2019).

John M. MacKenzie is Professor Emeritus of Imperial History at Lancaster University and has close connections with several Scottish universities as honorary or visiting professor. He is the author of *The Empire of Nature: Hunting, Conservation and British Imperialism* (1988) and of many other works in imperial cultural and environmental history. His book on the built environment of the British Empire, *The British Empire through Buildings: Structure, Function and Meaning*, was published in March 2020, and he is currently writing a cultural history of empire. He is a Fellow of the Royal Society of Edinburgh.

Alastair Massie worked at the National Army Museum, London between 1991 and 2018 and was latterly its head of research. Since his retirement he has continued to be involved, as curator emeritus, in various aspects of the Museum's work, including its liaison with National Museums Scotland in the Arts and Humanities Research Council project *Baggage and Belonging: Military Collections and the British Empire, 1750–1900* (AH/P006752/1).

Rosanna Nicolson is an Assistant Curator in the Department of World Cultures at National Museums Scotland with particular responsibility for the Southeast Asian collections. Her research interests are in visual and material culture, collectors and collecting, colonial and military encounters. She is currently an associate member of Edinburgh Buddhist Studies, an interdisciplinary research network, focusing on the material culture and everyday practice of Buddhism. Nicolson is also interested in the histories of cultural exchange and trade with, and between, Southeast Asian nations, and contemporary expressions of, and responses to, historic museum collections.

Edward M. Spiers is an emeritus professor at the University of Leeds. His nineteen books include *Haldane: An Army Reformer* (1980), *The Army and Society, 1815–1914* (1980), *Radical General: Sir George de Lacy Evans, 1787–1870* (1983), *The Late Victorian Army, 1868–1902* (1992), *The Victorian Soldier in Africa* (2004) and *The Scottish Soldier and Empire, 1854–1902* (2006). He edited *Sudan: The Reconquest Reappraised* (1998) and co-edited *A Military History of Scotland* (2012), which received the Saltire Prize and Templer Medal. He has also edited *Letters from Ladysmith: Eyewitness Accounts from the South African War* (2010) and *Letters from Kimberley: Eyewitness Accounts from the South African War* (2013), and written *Letters from Mafeking: Eyewitness Accounts from the Longest Siege of the South African War* (2019).

Desmond Thomas is Curator of the Museum of The Royal Regiment of Scotland at Edinburgh Castle. His research interests include regimental collecting practices, irregular warfare during the Second World War and the service of Irish men and women in the British armed forces.

Louise Tythacott is Woon Tai Jee Professor of Asian Art at Northumbria University and was previously Pratapaditya Pal Professor in Curating and Museology of Asian Art at the School of Oriental and African Studies (SOAS), University of London. Her research focuses on the collecting and display of Buddhist and Chinese art in museums. Her books include: *The Lives of Chinese Objects: Buddhism, Imperialism and Display* (2011), *Museums and Restitution: New Practices, New Approaches* (2014), *Collecting and Displaying China's 'Summer Palace'*

in the West: The Yuanmingyuan in Britain and France (2017), and *Returning Southeast Asia's Past: Objects, Museums, and Restitution* (2020).

Friederike Voigt is Principal Curator of the Middle Eastern and South Asian collections at National Museums Scotland. Her research focuses on Iranian material culture and museum practices of collecting. Among her recent publications are 'Orientalist collecting of Indian sculpture', in R. Jeffery (ed.) *India in Edinburgh: 1750s to the Present* (2019) and 'For Close Observation: Imagery in the Architecture of Qajar Iran', in S. Salgirli (ed.) *Inside/Outside Islamic Art and Architecture: A Cartography of Boundaries in and of the Field* (forthcoming).

PREFACE

Henrietta Lidchi and Stuart Allan

Dividing the Spoils sets out critical issues that pertain to British military collecting of the non-European world. The genesis of this book lies in two exploratory research projects based at National Museums Scotland (NMS) undertaken between 2013 and 2015 with support from the Royal Society of Edinburgh (RSE) and the British Academy (BA)/Leverhulme, and additional partnership funding from the National Army Museum (NAM). These adopted a two-pronged approach to address what the editors believe was the undervaluing of the histories, meanings and relevance of collections acquired by military organisations and personnel during active and garrison service in the British overseas empire, collections which continue to be housed in regimental, corps and service museums throughout the United Kingdom. The projects originated in a casual conversation between the editors, both at the time curators at NMS, about museum objects of mutual interest, but developed with the realisation that their respective roles and disciplinary specialisms within the same institution – one as an anthropologist and one as a military historian – led them to a range of objects with similar histories rooted in colonial warfare, which from each of their perspectives were only partially understood. From Allan's point of view, the academic anthropological community's disregard for the function of British organisational military culture in the acquisition of these artefacts has left them overlooked and misunderstood, coupled with the observation that in a post-colonial setting they have tended to become a source of unease for their military museum custodians. From Lidchi's point of view, there have been unanswered questions about the interpretations and intercultural relationships which underpinned the production and acquisition of the objects, questions which could be fruitfully explored with new museological and material culture theories. From both sides of the disciplinary divide, the analysis of material culture currently residing in regimental museums seemed to be disadvantageously stripped of cultural associations, which included most particularly those of military collecting culture itself. Conversely, however, military collections offer insight into military colonial encounters mediated through a different lens. Their role in bolstering *esprit de corps*, handed down through generations of military organisations, reveals practices of according values. This is a system which does not nullify other perceptions of value but one which is particular to itself and which is barely understood beyond the military world.

Preliminary research indicated that several national surveys of non-European or ethnological collections in the UK had largely omitted those belonging to military museums. The workshops and collections research which followed, led by the editors, had as a key goal the fostering of an interdisciplinary and multi-perspectival dialogue between material anthropologists and military historians. *Dividing the Spoils* draws inspiration from the methodologies that emerged and employs source material from surveys of source collections that were undertaken during the two research projects.

Over the course of two years, a series of interdisciplinary workshops held under the project *Hidden in Plain Sight: Non-European Collections in Military Culture* (RSE) brought together senior academics, curators and early career researchers from the fields of military history and anthropology, including many of the contributors to his volume. The workshops discussed current research, the distinct character of military collecting, the question of looting and contemporary collecting practice in the present-day armed forces, as well as the distinctions, nuances and inconsistencies in definitions around terms such as trophies, souvenirs, plunder and loot. Preliminary research was undertaken in military museums with project researchers Desmond Thomas and Inbal Livne surveying several regimental museum collections, primarily those of the Scottish regiments and those now subsumed within the collections of the NAM.

Concurrently, the project *Material Encounters: Reassessing Military Collecting in North America and Tibet* (BA/Leverhulme) employed researcher Rosanna Nicolson to survey the collections of nine regimental museums with the aim of documenting links to two campaigns which bookended the period of rapid British imperial expansion: the Seven Years' War in North America (1754–63) and the Younghusband Mission to Tibet (1903–04).[1] The aim was to test a campaign-based research methodology which could draw out connections between objects distributed across the British Army's 130+ museums scattered around the UK. In addition, through the NAM's network of regimental and corps museum staff, several knowledge exchange workshops were organised to review the findings of the research projects with curators and public engagement staff working in regimental museums, allowing all those involved to better understand the potential for widening access to these collections.

Further research into the material culture of colonial conflict is currently being undertaken through a major research project, *Baggage and Belonging*, funded by the Arts and Humanities Research Council (AH/P006752/1). This ongoing project seeks to develop further the insights illuminated in this volume by considering in greater detail a range of

colonial military campaigns from 1750 to 1900 in Africa and South Asia, based on a deeper engagement with the collecting cultures of the British Army and the Royal Navy and a fuller appreciation of the historical specificity of each encounter.

Dividing the Spoils deploys a historical and material culture-based methodology to place military collections in the context of military organisational culture, and to elucidate their meaning as material witnesses of encounters between non-European peoples and British imperial forces. This book argues for an understanding of these collections within a range of intercultural relationships which embrace diplomacy, alliance, curiosity and enquiry, as well as violence, appropriation and cultural hegemony. As a consequence of the different disciplines that inform the text, the vocabulary and terms vary across the chapters, with some contributions more indebted to historic terminology deriving from primary sources and the norms of military history. The Afterword charts the more recent and apparently seismic forces in the current debate about colonially derived collections and issues of restitution, claim and response. As a contribution to the continuing debate, this volume argues that military colonial collecting needs to be better understood. This avoids the essentialising of collecting down to a single action as the cumulative display of asymmetries of power between colonists and those being colonised, entirely relevant and uncomfortable though that imbalance may be, but rather also through analysing questions of military culture and material culture. Such approaches, we suggest, can be applied more widely, across the histories of former colonising powers, as an element of the ongoing reappraisal of colonial collecting among European museums.

Note

1 Material Encounters catalogue: https://www.nms.ac.uk/collections-research/our-research/highlights-of-previous-projects/material-encounters/

ACKNOWLEDGEMENTS

The editors wish to acknowledge the support of the principal funders of the research projects which formed the basis of ideas and content for this book: the RSE, the British Academy/Leverhulme Trust, and the NAM. Our research into military collections and the British Empire continues with the generous support of the Arts and Humanities Research Council (Standard Research Grant AH/P006752/1). We are indebted to our colleagues at National Museums Scotland (NMS) and at the National Museum of World Cultures (NMVW), Netherlands for supporting our time on these projects. Maggie Briggs and Nicole Hartwell in particular have provided indispensable editorial and research support. We are grateful for financial support from NMS and especially for an NMVW publications grant towards the production of this volume.

We would like to thank all of the contributors to this book, many of whom are members of the Project Advisory Board for our ongoing research, and all of our project participants including Clare Harris, Sharon MacDonald, and J.D. Hill. We are indebted to Inbal Livne, Desmond Thomas, and Rosanna Nicolson for their initial research into the collections which form the subject of many of the chapters that follow. We are grateful to all of those who participated in the workshops held between 2013 and 2015 for their contribution to our understanding of the topic.

The work of the editors and contributors has relied heavily upon the interest and time of staff, trustees and volunteers at the many regimental, corps and services museums which have made their collections and collections information available, including: Fusilier Museum, Tower of London; Royal Green Jackets (Rifles) Museum, Winchester; Gurkha Museum, Winchester; Black Watch Castle and Museum, Perth; Royal Engineers Museum, Library and Archive, Gillingham; Royal Norfolk Regiment Collection, Norwich Castle; Royal Ulster Rifles Museum, Belfast; Royal Artillery Museum, Woolwich; Redoubt Fortress Military Museum, Eastbourne and Royal Sussex Regimental Archives, West Sussex County Records Office, Chichester; Royal Scots Museum, Edinburgh Castle; Highlanders Museum, Fort George; York Army Museum; Gordon Highlanders Museum, Aberdeen. Our wider contacts with the UK's military museums have been facilitated by our colleagues at the NAM, by the Army Museums Ogilby Trust and the Association of Scottish Military Museums.

The editors' thanks are also offered to the team at Manchester University Press for their consistent and professional support throughout the publication process.

ABBREVIATIONS

ASH Museum	Argyll and Sutherland Highlanders Museum
HLF	Heritage Lottery Fund
IED	Improvised Explosives Device
ILN	*Illustrated London News*
IOR	British Library, India Office Records and Private Papers
JHC	*Journal of the History of Collections*
JRUSI	*Journal of the Royal United Services Institution*
JSAHR	*Journal of the Society for Army Historical Research*
NADFAS	National Association of Decorative and Fine Arts
NAM	National Army Museum
NMS	National Museums Scotland
QVJ	*Queen Victoria's Journals*
r.	reign
RPG	rocket-propelled grenade
RUSI	Royal United Service Institution
SAD	University of Durham, Sudan Archive
UK	United Kingdom
UKPHA	United Kingdom Punjab Heritage Association
USJ	*The United Service Journal and Naval and Military Magazine*
USM	*Colburn's United Service Magazine, and Naval and Military Journal*
UNESCO	United Nations Educational, Scientific and Cultural Organization
V&A	Victoria & Albert Museum

Introduction: dividing the spoils

Henrietta Lidchi and Stuart Allan

In a century that has already widely witnessed the destruction and appropriation of cultural property in war zones across the Middle East, and in the midst of renewed calls to reckon with the colonial antecedents of collections in European museums (see Afterword), it is timely to consider that the appropriation of objects in time of conflict has been part of the culture of war for as long as wars have been fought and recorded.

In the United Kingdom (UK), material culture brought back from foreign wars is to be found in some of the large national museum collections but equally, and importantly for this volume, in the collections of the many military museums which represent the distinctive and decentralised character of the British armed forces. This book takes as its base for investigation the collections derived from British military service beyond European theatres of war, objects whose acquisition reflected the practices and cultural attitudes arising from the asymmetrical nature of much colonial warfare. These collections held by regimental, corps and service museums, embedded in military culture, have been and remain comparatively neglected by material culture specialists.

Among the many publications that address colonial collections in European museums,[1] few specifically address military collections, or military culture as an aspect of collecting. Conversely, while the material turn and biographical approach in anthropological research is now several decades old, it is only beginning to be applied to military history and its material legacies,[2] and the scant military historical literature on the object-collecting aspects of the culture of war has been principally concerned with conflicts among Western powers.[3] Reviewing this literature in order to better understand the nature and meaning of collections in regimental, corps and service museums,

[1]

across the UK, it is clear that the omissions and assumptions regarding military collecting require further interrogation.

Divided destinies of military objects: Maqdala

Transcultural artefacts that are the product of the colonial military context take complex paths to reach their museum destinations. Seemingly similar collecting aims can lead to quite different destinies, as the museums of which they become part control the afterlives of these objects, bestowing meanings on them which define them quite differently over time.

It is no accident that the origins of the multidisciplinary analysis of this book, drawing from military history on the one hand and material anthropology on the other, lie within National Museums Scotland (NMS), a multidisciplinary museum of singular breadth. By several turns of convoluted institutional history, NMS is unique in the UK in encompassing collections of the art and material culture of the non-European world on the one hand and collections representing a national tradition of military service on the other. Two related and yet disconnected artefacts in the collections serve here to introduce the themes and methodologies of this book.

In 1893, the Edinburgh Museum of Science and Art (now National Museum of Scotland)[4] received a donation of twenty-eight artefacts documented as 'Ethnographic objects from Abyssinia, India, etc.', of which seven are said to have been 'obtained at the storming of Magdala, Abyssinia, in 1868'.[5] Maqdala, Ethiopia (Magdala, Abyssinia in British accounts) was the fortress capital of Emperor Tewodros II (anglicised in British accounts as 'Theodore'), which fell to a British imperial force on 13 April 1868, the culmination of the Anglo-Abyssinian campaign commanded by Sir Robert Napier, who was later ennobled as Lord Napier of Magdala in recognition of his victory. The captured city contained what amounted to a huge haul of cultural property inherited and amassed by Tewodros II, who had taken his own life in preference to being captured. As was considered customary upon capturing an enemy fortress, the property was set aside for auction, in order to furnish a prize money fund for proportionate distribution among officers and other ranks, a spectacle described by Edward Spiers in his contribution to this volume. Spiers (Chapter 1) records how the *in situ* auction afforded an opportunity for officers and other ranks, as well as collecting institutions to acquire fine pieces of Ethiopian art and material culture on the spot.[6]

Of the seven Ethiopian objects donated to the museum, one is a horn drinking cup[7] said to have belonged to 'King Theodore', a

conspicuous presence in the context of the present volume given that such items are typically found within the collections of those regiments present during the Anglo-Abyssinian war.[8] The collection was donated by Sir William Mackenzie (1811–95), former Inspector General of the Madras Medical Service (1861–71), who had retired from his long career as a senior physician in the British Indian Army. On the underside of the cup is a printed label that states 'given by' Mackenzie and, hand-written, 'taken at Magdala'. However Mackenzie's record of military service gives no indication that he was present at Maqdala or ever served in Ethiopia, apparently remaining in India throughout the 1868 campaign. Mackenzie's wider collecting interests suggest that he was able to use his position in India, from which the Anglo-Abyssinian campaign was launched and returned, to add to his personal collection, probably through the active assistance of fellow officers who had been on the expedition. We might therefore consider Sir William Mackenzie to be a soldier ethnographer, someone with connoisseurial interests whose international imperial networks allowed the building of collections as a sideline to their professional duties.[9] From the moment of donation, the cup has been accepted as an example of Ethiopian material culture[10] and has enjoyed an afterlife in the museum as an ethnographic object in what is now the world cultures collection, although seemingly very rarely on display.

Within the military collections of NMS is another Ethiopian horn cup of similar dimensions and origins, with a notable difference. This artefact has been modified, enhanced with a silver base and an inscribed rim on which the former ownership of 'King Theodore' is plainly asserted in English script (Figure 0.1). Accompanying provenance documentation reveals that 'The cup was bought at the sale of Colonel Grant . . . He got the cup from a nephew I believe. Colonel Grant's sister married a Major Thomson, who was Paymaster in the 33rd Regiment. Lord Napier says in his despatches that the 33rd was the regiment that first reached the gates of Magdala.'[11]

On its donation to the Scottish United Services Museum in Edinburgh Castle (now the National War Museum) in 1949, having previously been on loan there, the information accompanying the cup recounted (as noted above) that it had been bought by the owner at a sale of the estate of a friend, Colonel Grant, of Carrbridge, Inverness. That the regiment was present at the taking of Maqdala is recorded by the regimental historian of the 33rd writing in 1922:

When Napier entered Magdala the 33rd and 45th were appointed to garrison the place, and an end was put to the plundering which had begun. The intention of the Commander-in-Chief in preventing looting was

to collect all that the town contained, so that it might be sold and the money equitably divided among the troops . . . Magdala had fallen on the 13th of April. On the 16th the released captives began their homeward march; on the 18th the army abandoned the place and crossed the Bashilo. A review was held on the 20th, after which the loot taken in Magdala was sold by auction, and distributed among the non-commissioned officers and men.[12]

Examination of the War Office's periodically published *Army List* confirms that Captain (Honorary) John Thomson was Paymaster in the 33rd (Duke of Wellington's) Regiment from 1855 to 1870. After 1870, Thomson moved on to positions in the Control Department and

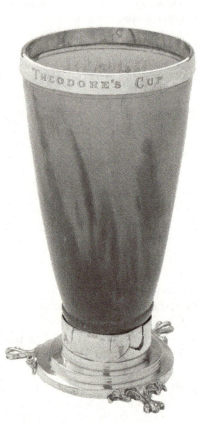

Figure 0.1 Horn cup with silver rim and silver mounts, acquired by Paymaster Thomson of the 33rd Regiment, and taken at the Storming of Maqdala, 1868.

Commissariat at the Cape of Good Hope and in London, retiring in 1879. A paymaster was the appointed officer responsible for managing a regiment's financial affairs. In that capacity, Thomson would have been present with his regiment on overseas service, and may safely be assumed to have been in the vicinity of Maqdala in 1868. The auctioned riches acquired by more senior officers, or secured thereby for national collections might have been beyond Thomson's budget, but he seems to have acquired this cup as his own trophy of the victory and whatever part he played in it.

The added silver mount attributes trophy status. The personal connection to Tewodros II can be reasonably taken as a soldier's assertion of the value of his acquisition rather than a statement of fact, since there is no other evidence that this unremarkable cup was a personal possession of Emperor Tewodros II. The silver mount and added inscription, 'MAGDALA 1868' and 'THEODORE'S CUP' were probably undertaken in India[13] (as there is no hallmark), and appear aspirational, intended to permanently record and transform the item into a symbol of victory of the highest possible order. In this Thomson ultimately succeeded. On entering the museum it was accessioned into the collection as 'Theodore's Cup' in deference to its inscription confirming its association and origins, and with no pretension to being a curiosity or located in a wider project of connoisseurship. The National War Museum was interested in this object fully on Thomson's terms: as a trophy of British colonial warfare of the 1860s, in particular the fall of Maqdala, and therefore as a part of its collections reflecting individual experience in colonial military service and, by extension, the Scottish contribution to British imperial and military power.

The British Army and empire

In their origins, display and interpretation, military museum collections can arguably tell us at least as much, or indeed more, about military organisational culture as they can about military history understood in straightforward terms of a narrative and analysis of events. One of the collective strengths of the chapters which follow is that they do not fall into the trap of treating the British Army as a monolithic entity, or of representing its activities in simplistic terms as the official actor of a notionally monolithic British imperial state. Recent historiography in imperial studies supports the understanding that the British Empire was never one thing alone, or the outcome of a single imperial policy, and that it was not a phenomenon that can fully be understood merely as a set of relationships between a metropolitan centre and colonial peripheries.[14] The contributors to this volume deal with a range of

different locations and sets of historical circumstances. Addressing objects and events in North America, India, Africa (Ethiopia, Ghana, Sudan, Nigeria, South Africa), China and Tibet, the chapters extend across the period of rapid British colonial expansion, from the Seven Years' War of the mid-eighteenth century to the Younghusband Mission to Tibet of 1903–4. During the period covered, British regiments were also engaged in major European wars, and it is worth remembering that while British military culture was heavily influenced by its colonial experiences, the Army's history and traditions, and its collecting practices, were part of a wider, older and pan-European story.[15] The volume's principal focus on the British Army is also intended to complement and advance understanding of collecting, preservation and display practices among its two counterparts in British imperial military activity: the Royal Navy and the armies of the East India Company, each of which has enjoyed greater attention from historians and museum anthropologists.[16] Sailors, Company soldiers and British soldiers often crossed paths, and while the impetus behind the acquisition of objects was similar, the trajectories of their acquisitions followed their own routes through the distinctive administrative structures and organisational cultures of these services.

Just as the British Empire was an accumulation of interactions which differed by place and through time, in this volume so too will the British Army emerge in its true complexity. The Army was simultaneously a structured organisation and a variegated evolving enterprise. It was both bound together and internally differentiated by a culture of regiment and tradition, and by sets of rules and customs, formal and informal, among which temporal contingencies and a degree of collective and individual agency among the officer class were always in play.[17] There exists an obstacle to the fuller incorporation of military culture into the historiography of empire, which is that within the vast bibliography of British Army history, questions of culture have been little written about in analytical terms. For an organisation with norms and idiosyncrasies so heavily based in tradition, there have been few serious published expositions of what the customs and practices of this essentially enclosed world actually were. Kirke and Hartwell (Chapter 5) propose a way of thinking through the dual influences of the official governance structure and the informal culture of army life[18] as expressed in their study through codes of conduct and communal living, with particular reference to the officers' mess. By focusing on the lived experience of soldiers and the domestic mess environment, formerly and still the location of some of a regiment's most precious possessions, they provide a sense of the way in which objects have a role in military life, be they trophies of war, regimental

standards, objects from colonial service or the regimental silver. Highlighting the use and conventions surrounding objects within this communal space also affords a better appreciation of military conventions and value systems inherent in traditional military museum display (see Chapter 7), which might appear random or incongruous to an anthropologist or lay visitor.

In the knowledge that the Army did not necessarily, nor even typically, move from home service to war service as, for example, in the 1868 Anglo-Abyssinian campaign in Ethiopia, which was undertaken by the British Indian Army from its base in Mumbai (the Bombay Army), or the Younghusband Mission also launched from India, and recognising that the service of individual officers took them through different colonies and different military structures, it might be helpful to think of the British Army, with its multiple and lengthy experience of colonial campaign service across the globe, as an imperial network. In this view, it is possible to characterise military officers as imperial careerists, in the terms described by David Lambert and Alan Lester, and John MacKenzie, among others, demonstrating that 'in an empire without a controlling government philosophy, it was through the career paths of such individuals that a heterogeneous collection of colonies was connected by experiences and techniques forged in the events and conditions of specific geographical settings.'[19] It was the ultimate purpose of soldiers to fight and deter, but their presence was often lasting. In Chapter 3, 'Collecting and the trophy', MacKenzie explains how connections between military campaigning and much longer periods of garrison service created recreational opportunities for hunting. MacKenzie shows that the values of soldiering created an equivalence between recreational hunting and war, such that both were valued in the terms of the time as honourable and manly activities. This expressed itself in the collection of hunting trophies which constituted 'at the same time souvenirs of service and of travels, markers of heroic expeditions and of dominance of the natural world'.

Military collecting practices

By focusing on military collections and military culture, this book seeks to occupy a particular place within the theorisation of colonial collecting. In their influential volume *Colonialism and the Object* published in the 1990s, Tim Barringer and Tom Flynn advance the need for questions of colonialism, objects and museums to be more widely tackled within the domain of academic, as well as museological, concern. Citing Homi Bhabha and Edward Said, the editors argued for the

importance of contextual analysis and representational awareness, noting the 'ambivalence and hybridity of colonial culture and the paradoxical dependency of the coloniser and colonised'.[20] This clarion call to address the national role of museums, their representational practices and collecting histories within, in this case, primarily national museums, was an acknowledgement that museums as institutions have historically created displays 'symbolic of a corresponding ordering of the colonial subject'[21] while trying, at the same time, to engender a disciplinary set of behaviours from their viewing public. Writing in the early 2000s, Chris Gosden and Chantal Knowles in their influential volume *Collecting Colonialism* argued for a generative quality of colonialism in material terms. 'Colonial relations always involved material culture',[22] they state, with Gosden arguing slightly differently that '[c]olonial culture was a profoundly material culture'.[23] This signals that colonial collecting has to address the multiple flows of materials in all directions, which include material extraction by Europeans as well as material transactions between Europeans and the people they encountered and colonised. Both volumes emphasise the need for a historiography of museums formerly described as ethnographic, now as world cultures, to explore how material and visual cultures arising out of colonial and imperial relations were created and circulated through representations of other cultures and thus entered national imaginations. This has recently been explored through another category of collectors, extensive in their influence but somewhat neglected, namely missionaries.[24] As many historians of museums or imperial collecting have noted, showing the non-European world to European audiences involved a correspondence between objects, images and persons or 'living exhibits' shown at world's fairs, international, colonial and missionary expositions and circulating through popular culture.[25] John McAleer and John MacKenzie argue that while the historiography of the British Empire is well established, British imperial history has yet to be fully material, or to understand the reciprocal influences of 'extra-European' activities of empire on British society through material objects and visual imagery.[26] By closely analysing the culture of the military and the particular characteristics of military collecting, we seek to contribute to this discussion.

A downside of the colonial collecting model is that it can too easily focus on collectors and thus produce histories that are more about the culture of collecting 'than about the cultures in which the objects were made or used'.[27] This critique could be levelled at this volume; however, the editors contend that military culture is too frequently invoked as a monolithic form of governance and needs first to be better

understood. Our focus on military collecting as a particular kind of activity allows a number of presumptions to be questioned. British soldiers were part of imperial networks, mobile and translocated, and were linked to traders, missionaries, political agents, administrators and professional networks at home. Considering the microhistories of times, places and relationships allows new insights to come into view, insights concerning different types of agency, be that of soldiers under military governance (see Spiers, Chapter 1, and Lidchi with Nicolson, Chapter 6), or of civil administrators with regard to the wards of the British government (see Voigt, Chapter 11) or of soldiers contributing to emerging fields of knowledge (see MacKenzie Chapter 3 and Evans Chapter 4). By looking at interconnected biographies of people and things, this volume is in keeping with developments that have arisen in the fields of colonial collecting and material anthropology which emphasise actor network theory, and which promote the value of object biographies.[28] The complex motivations, movements and relations that these objects represent and subsequently create – historically and into the present – are precisely the types of 'entanglement' that Nicholas Thomas has long invited us to consider.[29] The macrohistories and microhistories of these transactions have lasting effects worldwide, both in the imperial 'centres' and 'peripheries', not least because their legacies are museums, variously located, whose future they continue to influence.[30]

Indeed, questions of military culture, the distinction between forms of governance and customary practice have rarely been systematically addressed by those writing about or documenting colonial objects.[31] As shown with the introductory example of the two Ethiopian horn cups, similar objects with analogous provenance do not perform the same function once they have been inserted into differing museological settings. The 'ethnographic' object is un-modified and all museological practices would keep it so, because its role is that of exemplifying an authentic Ethiopian form. The military object which has been modified as part of the desire to enhance its trophy value consequently becomes embedded as a military item. Kirke and Hartwell (Chapter 5) note the role of regimental silver, fostering identity and loyalty with the acquisition and use of silver an evolving part of regimental history. The silver cup in the National War Museum, if entered into a mess collection, could conceivably serve communal, convivial and display functions. It could simultaneously serve as a commemorative piece, not only of the action, but of the experience of drinking *tej* (see Spiers, Chapter 1) – a possible reason why modified Ethiopian cups are found with such regularity in regimental museums as an inheritance of officers' mess collections. This volume uses overviews, case studies

centred around types of objects, and campaign studies to highlight the moments of extraction and the ways in which individual agents within the British Army were guided by custom and practice and formal governance structures in their manner of collecting.

Curios, loot, trophies

Looking at military colonial collections more biographically provides insight into the categories that can be applied to various objects, for example the 'curio'. As shown in the discussion of powder horns (Allan and Lidchi, Chapter 9), 'curios' or 'curiosities' have a wider museological applicability, arising from antiquarian collecting in the early modern and 'Enlightenment' periods.[32] The term suggests interest without a specific form of judgement, inferring wonder and interest, the 'exotic', as well as something akin to a souvenir. Highlighting North American powder horns from the French and Indian War (1754–63) as transcultural objects, Allan and Lidchi (Chapter 9) describe their role in a specific campaign context and their transitory afterlife as 'Indian curiosities' before they assumed more conventional regimental museum roles as campaign souvenirs. These objects survive in military museums as composite pieces (folk art and indigenous art) tacitly indicating the histories of political alliances, exchange and, one might even suggest, possible guarded respect for indigenous allies. Here military collections and national museum collections cross over, and Evans (Chapter 4) writes about the influence of military men in professional and learned societies from the eighteenth century onwards. Evans traces the connections forward from antiquarianism on into the height of Victorian imperial ambition, noting the lasting influence of military officers within the fabric of intellectual and museological culture in the UK. Evans shows how the gentleman officer, with his slightly self-regarding connoisseurship and intellectual pursuits, undertook activities complementary to his formal military duties (as also observed by MacKenzie in Chapter 3). Looking at regimental museum collections, we find the aspirational qualities of connoisseurship to have been subsidiary to collecting and display practices that fostered a sense of identity and belonging. A curio may or may not have been a testament of connoisseurship or opportunity, a means of recollecting a moment or place, or a gift. Such objects appear in many regimental collections, but the curio as a category of objects is not reliable, especially when the circumstances of its acquisition are tainted by appropriation in the midst of military conflict and conquest.

To observers outside the embrace of military culture, the phenomenon of collecting in theatres of war is primarily associated with

looting. Being attendant to questions arising from colonial collecting, material anthropology and military history creates a very specific obligation centred around language. In the writing of this volume, and the discussion of its content, it was necessary to be aware that there are a number of terms habitually used, sometimes indiscriminately, to describe the objects collected by men on military service overseas. 'Curio', 'souvenir', 'loot', 'trophy', 'plunder', 'booty', 'prize' and 'spoil' are some terms used in this volume, and their shifting definitions and the full implications of their meaning are currently the subject of further research.

Spiers (Chapter 1) argues that 'loot', 'booty' and 'plunder' were commonly applied terms for military appropriation, processes which the British Army repeatedly sought to regulate.[33] This desire for discipline and control was expressed in particular though the prize system, which repurposed 'loot' into prize money, a practice which came into play when a city or fortress fell to siege or storming rather than in the more general circumstances of land warfare. The military prize system echoed the wartime practice of prize law in the Royal Navy, where the capture of enemy vessels made the distribution of prize a more systematic issue.[34] Its operation in relation to the capture of fortresses and cities on land was also an echo of the European siege warfare of the early modern period. In the British imperial context, the prize system was established through service regulations, custom and practice which allowed for auctions to be undertaken *in situ*, to raise prize money for distribution through the conquering army or to be sent home for auction with the same purpose, keeping aside certain items reserved for the Crown, pointedly noted by Voigt (Chapter 11) in relation to the Koh-i-Noor diamond (see also Mack, Chapter 2, for the 'great war drum of the Khalifa').[35] Although there is much invocation of the noun 'loot' both in military histories and anthropological analyses, one purpose of this book is to expose the subtle distinctions operating at the time, and to illustrate how the term itself has become overly generic when used with regard to military collections. The lack of appreciation of the subtleties of military codes and practices offers one partial explanation for why military collections of this kind have been poorly analysed, misunderstood or ignored. For example, the Maqdala cup currently in the National War Museum is linked, counter-intuitively in this military context, to plunder but also to the prevention of plunder. At Maqdala, Napier, the expedition commander, intervened to stop uncontrolled plunder through the agency of placing Thomson's regiment in garrison inside the captured fortress city to restore order. That this was a concern for military officers on the spot underlines that in British military understanding there was a difference

between plunder and prize. For military commanders, such distinctions were not as moot as they might now appear to be. As an unsanctioned and unregulated action on the part of individual soldiers, plunder was taken to be indicative of a breakdown of military discipline and was therefore viewed as unacceptable by the military hierarchy.[36] In this instance the preferred solution to the opportunity for spoliation was the systematic sanctioned appropriation and ordered redistribution of the spoils according to the rules of war as they were understood by the British at the time, and indeed more widely. Mack (Chapter 2) comes to the same conclusion, creating a distinction between what he describes as 'official booty', 'unofficial booty' and 'trophies'. The sale of prize property, as Voigt (Chapter 11) extensively shows, was a bureaucratic endeavour, and its removal was viewed as legitimate, in many instances, as justifiable retribution for a perceived wrong against British interests or prestige (see also Mack, Chapter 2).

From the perspective of twenty-first-century military collecting, much more proscribed now than in the colonial period, Thomas (Chapter 7) addresses the distinctions understood through military regulations and within military museums for categories of objects that non-military curators might generically think of as loot. He argues that some 'non-private property or, more specifically, property with a clear military application or association taken from an enemy in war' should not be described as loot, but should be understood as 'a legitimate war trophy' which is not entirely at odds with the value system of colonial military officers, even as they honoured it in the breach as well as in the observance. He illustrates this with captured and recaptured weapons taken from the Taliban in Afghanistan, now in the collection of the museum of the Museum of The Royal Regiment of Scotland. As a contemporary regimental museum curator, operating in an undertheorised, under-researched field, he adopts a deliberately subjective, first-person approach where his observations and inferences add nuance to this controversial topic, as questions of historical legality continue to be debated both inside and outside the military museum community internationally (see Lidchi, Afterword).

Throughout this volume trophies of victory appear as objects of value in individual, military-communal and national terms depending on the conditions under which they were taken.[37] Mack shows that items removed from Benin City, Nigeria, following the 1897 Punitive Expedition lastingly influenced European perceptions of African art and entered national museums, whereas the more plentiful items that emerged from the Battle of Omdurman, Sudan 1898, associated with the almost mythical figure of General Gordon, assumed high status in military museum collections. Their appropriation and later display

were driven by ideas of retribution and redemption for the earlier British military defeat at Khartoum.

Because of the desire to connect objects to place, time, experience and heroes (or villains) such military objects tend to be inscribed and modified in the manner shown by the Paymaster Thomson's Maqdala cup, aspirational though Thomson's inscribed association with Emperor Tewodros might have been. From a present-day museum perspective these inscription practices work counter to the idea of the preservation of the integrity of objects, and certainly to our modern understanding of conservation. But from the military perspective, at the time of acquisition and later preservation, inscriptions were perhaps the defining elements of the originality, integrity and value of these trophies as commemorative objects, serving to memorialise the circumstances of acquisition.

Without fear or favour

With some notable exceptions[38] military collections are frequently overlooked by museum anthropologists. Tythacott (Chapter 8) addresses some of the dissonances between regimental museum displays and more canonical representations of such objects as Chinese art. She considers the manner in which the objects from Yuanmingyuan were dispersed and subsequently displayed in military collections, offering an anthropological perspective on the significance of these collections and the apparent incongruity of regimental display practices given their international cultural value. Conversely, in the hierarchy of value systems which the Army ascribed to collections, objects with colonial origins which did not answer the salient functions of visible memorialisation and communal use were rarely highly placed.

Such considerations may have determined the relative obscurity of the regimental museum afterlives of individual and communal photographs. Although photography as a technology was quickly adopted by the military for formal survey and recording purposes, Lidchi with Nicolson (Chapter 6) explores how photographs and albums arising out of the Tibet or Younghusband Mission (1903–4) have a greater affinity to the mnemonic and memorial culture of the British Army than to objective documentation. These albums, when considered alongside the diaries, newspaper cutting scrapbooks, letters and objects, record both the formal and informal culture of the military, revealing their tacit practices of appropriation. They show, as in other chapters, that the abundance of material and archival evidence which exists in military museums is as yet untapped.

Considering military collecting not solely as a representation of asymmetries of force but as an integral function of communal, individual,

[13]

formal and informal military life gives us better tools to address its material legacies. Massie (Chapter 10) shows how the creation of new displays at the National Army Museum (NAM) aimed to reappraise and reinterpret colonially derived collections with the aid of community consultation as part of a wider effort to reach new audiences. This represented one approach to addressing the sense of unease proceeding from active post-colonial critique, which can serve to undermine military curators' confidence when dealing with the entangled stories these objects can tell (see Afterword). Massie and Voigt (Chapters 10 and 11) address the potential future lives of such collections, and how, by curatorial engagement with audiences and artists, new understandings can be generated in response to fraught histories.

In putting military colonial collections at the heart of this publication, we offer an argument for the value of the collections in historical and anthropological terms. It is our intention that they be framed as intercultural legacies formed through conflict and as having an identity in their own terms. This means, on the one hand, not expunging them of those colonial and imperial relationships which provide powerful layers of meaning. On the other hand, it means that their return to their countries of origin, in the spirit of post-colonial restitution, is not the inevitable, or in many circumstances the only, response to the variation and complexity they represent. Understanding the characteristics of British military collecting in the context of colonial and imperial warfare of the past offers us deeper insight into the challenges that face us today. As the Afterword of this volume considers, debates about the post-colonial legacies of colonial collecting, including issues of restitution, reparation and redress, have come to the fore in the cultural politics of international relations in recent years. Meantime the collecting impetus among soldiers in in contemporary military contexts remains with us, albeit subject to close scrutiny (see Thomas, Chapter 7). Souvenir and curio hunting, trophy taking and looting are continuous elements of human behaviour in war zones, and we have seen them in the near past. These practices remain matters of international concern in relation to the loss of cultural heritage, and are live issues for defence establishments in their management and media management of military deployments overseas. This book is about facing up to the nature of these aspects of our shared past without fear or favour.

Notes

1 A. Coombes, *Reinventing Africa* (New Haven and London: Yale University Press, 1994); C. Harris, *The Museum on the Roof of the World* (Chicago: University of Chicago Press, 2012); C. Gosden and C. Knowles, *Collecting Colonialism: Material*

Culture and Colonial Change (Oxford: Berg, 2001); A. Henare, *Museums, Anthropology and Imperial Exchange* (Cambridge: Cambridge University Press, 2005); P. J. ter Keurs (ed.), *Colonial Collections Revisited* (Leiden: CNWS Publications, 2007); M. O'Hanlon and R. L. Welsh (eds), *Hunting the Gatherers: Ethnographic Collectors, Agents and Agency in Melanesia, 1870s–1930s* (Oxford: Berghahn Books, 2000); N. Thomas, *Possessions: Indigenous Art/Colonial Culture* (London: Thames and Hudson, 1999); L. Tythacott, *Collecting and Displaying China's 'Summer Palace' in the West, The Yuanmingyuan in Britain and France* (London: Routledge, 2018); R. B. Phillips, *Museum Pieces: Exhibiting Native Art in Canadian Museums* (Montreal: McGill, 2011).

2 K. Jones, J. Macola and D. Welch (eds), *A Cultural History of Firearms in the Age of Empire* (Ashgate: Farnham, 2013); B. Finn and B. C. Hacker (eds) *Materialising the Military* (NMSI: London 2005); N. Saunders (ed.), *Matters of Conflict* (New York and London: Routledge, 2004); N. Saunders and P. Cornish (eds), *Contested Objects* (New York and London: Routledge, 2009); J. Schofield, W. Gray Johnson and C. M. Beck (eds), *Matériel Culture* (Routledge: London, 2002).

3 S. Nestor (ed.), *War-Booty: A Common European Heritage* (Stockholm: Royal Armoury Livrustkammaren, 2009).

4 See H. Lidchi, 'The World to Edinburgh', in *Scotland to the World: Treasures from the National Museums of Scotland* (Edinburgh: NMS, 2016), pp. ix–xv.

5 National Museums Scotland (NMS), Royal Museum Register of Specimens, Vol. 8, 1892–1989.

6 Then the British Museum, which now encompasses the British Museum and the British Library.

7 NMS, A.1903.209.

8 Current research has located a number of these cups in regimental museums.

9 Evidenced because the sandals he also donated (NMS, A.1893.216) have a price attached and appear to have been new at the time of purchase. See also E. Talbot Rice and M. Harding, *Butterflies and Bayonets: The Soldier as Collector* (London: NAM, 1989).

10 The gift is recognised in the annual report of activities in 1893, but the collection is not cited in guidebooks of the early twentieth century, though other military collections are credited in light of their military provenance.

11 NMS, object file M.1949.215, donation correspondence.

12 A. Lee, *History of the Thirty-Third Foot, Duke of Wellington's (West Riding) Regiment* (Norwich: Jarrold, 1922), p. 364.

13 There is no hallmark, and had it been undertaken in the United Kingdom, there would have been.

14 For one summary of recent imperial historiography see S. Howe (ed.), *The New Imperial Histories Reader* (London: Routledge, 2009).

15 Nestor (ed.), *War-Booty: A Common European Heritage*.

16 J. McAleer and N. Rigby, *Captain Cook and the Pacific: Art, Exploration and Empire* (Newhaven and London: Yale University Press, National Maritime Museum, 2017); J. Owen, 'Collecting Artefacts, Acquiring Empire: a Maritime Endeavour', *Journal of Museum Ethnography*, 18 (May 2006), 141–8; M. Finn and K. Smith (eds), *The East India Company at Home* (London: UCL Press, 2018).

17 J. MacKenzie, *Popular Imperialism and the Military* (Manchester: Manchester University Press, 1992).

18 See also C. Kirke, *Red Coat, Green Machine* (Birmingham: Birmingham War Studies Series, 2009).

19 J. M. Mackenzie, Editorial introduction, 'Imperial networks', *Britain and the World*, 11:2 (2018), p. 150; D. Lambert and A. Lester, *Colonial Lives across the British Empire: Imperial Careering in the Long Nineteenth Century* (Cambridge: Cambridge University Press), pp. 21–4.

20 T. Barringer and T. Flynn, *Colonialism and the Object: Empire, Material Culture and the Museum* (London: Routledge, 1998), p. 2.

21 C. Wintle, 'Career development: domestic display as imperial, anthropology and social trophy', *Victorian Studies*, 50:2 (Winter 2008), 279–88 (p. 282).

22 Gosden and Knowles, *Collecting Colonialism*, p. 6.
23 C. Gosden, 'On His Todd: Material Culture and Colonialism', in O'Hanlon and Welsh (eds), *Hunting the Gatherers*, p. 232.
24 K. Jacobs, C. Knowles and C. Wingfield, *Trophies, Relics and Curios: Missionary Heritage from African and the Pacific* (Leiden: Sidestone Press, 2015).
25 Coombes, *Reinventing Africa*; A. Jackson and D. Tomkins (eds), *Illustrating Empire: A Visual History of British Imperialism* (Oxford: Bodleian Library, 2011); J. MacAleer and J. M. MacKenzie (eds), *Exhibiting the Empire* (Manchester: Manchester University Press, 2012); J. M. MacKenzie, *Museums and Empire* (Manchester: Manchester University Press, 2009).
26 MacAleer and MacKenzie (eds), *Exhibiting The Empire*, pp. 2–3.
27 P. J. ter Keurs, 'Introduction: Theory and Practice of Colonial Collecting', in ter Keurs (ed.), *Colonial Collections Revisited*, p. 3.
28 A. Appadurai, *The Social Life of Things* (Cambridge: Cambridge University Press, 2001); S. Byrne, A. Clarke, R. Harrison and R. Torrence (eds), *Unpacking the Collection* (New York: Springer, 2011); R. Harrison, S. Byrne and A. Clarke, *Reassembling the Collection Ethnographic Museums and Indigenous Agency* (Santa Fe: School of American Research Press, 2013).
29 N. Thomas, *Entangled Objects: Exchange, Material Culture and Colonialism in the Pacific* (Cambridge, Mass.: Harvard University Press, 1991).
30 MacKenzie, *Museums and Empire*; S. Longair and J. McAleer (eds), *Curating Empire: Museums and the British Imperial Experience* (Manchester: Manchester University Press, 2012).
31 Coombes, *Reinventing Africa*; Harris, *The Museum on the Roof of the World*.
32 See for object categories and histories H. Lidchi, 'The Poetics and Politics of Representing Other Cultures', in S. Hall, J. Evans and S. Nixon (eds), *Representation: Cultural Representations and Signifying Practices* (London: Sage/Open University Press, 2013), pp. 120–211.
33 Hevia notes that the connotations of loot are many, J. Hevia, 'Loot's fate', *History and Anthropology*, 6:4 (1994), 319–45.
34 J. Hill, *The Prizes of War: The Naval Prize System in the Napoleonic Wars, 1793-1815* (Stroud: Sutton in association with the Royal Naval Museum, 1998).
35 See also Hevia, 'Loot's fate', pp. 321–2.
36 R. Davis, 'Three styles in looting India', *History and Anthropology*, 6:4 (1994), 293–317.
37 Jacobs and Wingfield writing about missionaries note that the classical definition of trophy is *tropaion*, meaning a place where a turning point occurred, usually in battle; however, their definition is relatively short, and does not really take into account military ideas such as *spolia opima*. K. Jacobs and C. Wingfield, 'Introduction', in Jacobs, Knowles, and Wingfield (eds), *Trophies, Relics and Curios*, p. 11.
38 See L. Tythacott, *The Lives of Chinese Objects* (Oxford: Berghahn Books, 2011) and C. Harris, *The Museum on the Roof of the World*.

Part I

Ideologies of empire and governance

CHAPTER ONE

Spoils of war: custom and practice

Edward M. Spiers

A plentiful by-product of the British wars of empire in the mid- to late nineteenth century was plunder or booty, or as it became commonly known from the mid-nineteenth century term, 'loot' (allegedly from the Hindi word *lut*, to plunder). By these means artefacts from outside the UK would come to adorn, by turn, the Royal Collection, national museums, regimental museums and some stately homes across the country. With the passage of time, items of symbolic or national value have been claimed by their countries of origin (as the Afterword identifies) for restitution, repatriation or 'return'.[1] Although aware of these debates,[2] this chapter will focus instead on the history and process of military looting. It will use contemporary accounts, records, and the literature linked to military campaigns to place the acquisitions in context and so indicate how practices changed over the course of the nineteenth century. This overview will address the varied nature of the loot seized, the challenges of bringing booty back from the theatre of operations, and the diverse attempts by the British Army to regulate looting during the many wars and campaigns waged in Africa during the mid- to late nineteenth century. In this chapter reference will be made to 'plunder', 'booty', 'loot' and 'prize', demonstrating how the vernacular terms and their technical meaning changed over time, and so created circumstances in which they were used interchangeably. As a starting point it is important to understand the military meaning of 'prize'.

Technically all plunder taken in war belonged to the Crown and while particular artefacts, often appropriated or acquired from foreign heads of state, were reserved for the monarch and members of the royal family, the Victorian army had the sovereign's sanction to regulate the division of the remainder as prize money.[3] Sir Garnet J. (later Field-Marshal Viscount) Wolseley, who became the Army's commander-in-chief

(1895–1900), explained and effectively sanctioned this system in his *Soldier's Pocket Book for Field Service*, which was issued to all soldiers. He did so because the system, though endorsed by the Treasury and War Office, was not described in army regulations. When capture was made or about to be made on active service, stated Wolseley, the general officer commanding (GOC) should call upon his officers to elect or appoint two or three of their number to represent him as prize agents (with another prize agent appointed from any naval unit involved). Whenever a capture was made, the prize should be collected and the GOC should determine which troops would participate in the sharing of the prize (although the final decision rested with the secretary of state for war). The prize agents would then advise whether the prize should be converted into money through an auction on the spot, or be sent home in the charge of a prize agent to be sold there. Any legal or other expenses incurred by the prize agents would be charged to the prize fund, and remuneration at the rate of 1.5 per cent upon the net amount paid to the prize agents. Money raised at auction had to be divided by shares, allocated by rank from a general with 400 shares down to a private with one share. 'The practical effect of this principle', wrote Wolseley, 'will be to divide the available fund in the proportion of about 1/3 to the offrs., and 2/3 to the NCOs and privates, after deducting the share of the G.O.C.'[4]

Accordingly, soldiers' letters, like those of Lieutenant Herbert Charles Borrett (4th Foot or King's Own Regiment) from the Anglo-Abyssinian campaign (1867–68), sometimes recorded that 'No looting, except of eatables, was permitted, and every thing found in the place was collected together. Theodore's crown (made of red velvet, gold and precious stones), his seal, and other articles of value are now being exhibited in front of our Guards.'[5] Serving in the same campaign, Ensign Walter A. Wynter (33rd Foot, Duke of Wellington's Regiment) agreed that the looting orders had been very strict, and that he had had to hand over the head of a processional cross, which is 'now in the R[oyal] A[rtillery] mess'.[6] Yet Borrett retained 'two Abyssinian swords picked up on the battlefield. A ring I cut off a dead enemy, part of a native bible, and a bullet that fell at my feet during the fight.'[7]

This apparent anomaly between a ban on looting and the acquisition of battlefield trophies reflected the endurance of another military custom, namely the right of a soldier to retain anything seized at the point of the bayonet. After sieges this was a fairly expansive concept, and, as Wynter conceded, it led to the trading of mementoes or the purchasing of items by private bargains outside of the prize system.[8] Conversely, as plundering on the line of march could threaten military discipline, it contravened military law and the penalties could be

severe. During the Peninsular War, Sergeant D. Robertson (92nd Gordon Highlanders) recalled that a sergeant major of his regiment was caught in the act of 'plundering a house on the highway' and was sentenced to death, only for the sentence to be commuted to 800 lashes 'on account of his wife and family'. Several Guardsmen, added Robertson, were punished for similar offences.[9]

Historical context

Plundering precedents were almost certainly known to the Victorian soldiery, whether through folklore passed down the ranks or trophies displayed by regiments. One of the more famous of these events occurred after the rout of the French forces at the battle of Vitoria, Spain (21 June 1813), when soldiers, camp followers and non-combatants acquired the 'loot of a kingdom'. On roads blocked by abandoned guns and transport, and in accompanying fields stuck fast in the mud, were the carriages, baggage waggons and all the impedimenta of Joseph Bonaparte's court and army, including 'vast numbers of carriages with ladies belonging to the French Army, nuns, wives of generals and officers, actresses'.[10] These possessions were raided for 'laces and velvets, silks and satins, valuable pictures, jewels, gold and silver plate, cases of claret and champagne', and, among the goods seized, were the king's carriage and sword of state, Marshal Jourdon's baton, 5 million dollars from the military chest, and vast amounts of private wealth, with coins scattered over the fields, so 'depriving others of their fair share of prize money'.[11]

Service in India had also yielded fabulous returns, especially after the storming of fortresses such as Seringapatam (Srirangapatna, 5 May 1799), where a colonel received prize money of £297 sterling, a subaltern £52 and a British private, £3 15s 9d, above all the private plunder.[12] The confiscation of the Koh-i-Noor diamond under the terms of the Treaty of Lahore (1849), which ended the Second Anglo-Sikh War, enabled the East India Company to present Queen Victoria with this lavish gift in the following year (see also Voigt, Chapter 11). During the Indian Mutiny, or Uprising (1857–58) many incidents of looting occurred, particularly in the assault on the Kaiserbagh (Qaisar Bagh) complex, Lucknow (15 March 1858). Captured in a steel engraving of the later 1850s, this event prompted William Howard Russell of *The Times* to describe how British soldiers and their sepoy allies emerged from broken portals, 'laden with loot or plunder':

The men are wild with fury and lust of gold – literally drunk with plunder. Some come out with china vases or mirrors, dash them to pieces on the

ground, and return to seek more valuable booty. Others are busy gouging out the precious stones from the stems of pipes, from saddlecloths, or the hilts of swords, or butts of pistols and fire-arms.[13]

The culmination of the Second Anglo-China War in 1860 produced even more notorious scenes of pillage and plunder (see also Tythacott, Chapter 8). After a series of victories, in which the British troops found 'nothing worth having . . . in the way of loot',[14] the Anglo-French expeditionary force occupied the imperial palaces outside Peking (Beijing). When Wolseley, then a brevet lieutenant-colonel, entered the Old Summer Palace (Yuanmingyuan) on 7 October, he found the 'French allies' already engaged in 'indiscriminate plunder and wanton destruction of all articles too heavy for removal'. At these moments, he observed, soldiers 'are nothing more than grown-up schoolboys. The wild moments of enjoyment passed in the pillage of a place live long in a soldier's memory.'[15] While the French indulged themselves over a two-day period, British soldiers were kept in camp, with their officers mindful of the riot and insubordination wrought 'after the capture of Delhi',[16] but a few officers entered the palace. They faced huge temptations, as Frederick Stephenson informed his brother:

Fancy having the run of Buckingham Palace and being allowed to take away anything and everything you liked, and armed moreover with a thick stick and a deep-rooted feeling of animosity to the owner, being able to indulge in the pleasure of smashing looking-glasses and porcelain, and knocking holes through pictures. Such a scene I witnessed yesterday [. . .].[17]

As officers brought a large collection of valuables back to camp on carts, Lieutenant-General Sir James Hope Grant, the commander-in-chief, ordered them to donate their loot to the prize agents for immediate auction. Not all complied, including Wolseley, who kept a valuable French miniature in his pocket,[18] but a two-day auction followed, raising 123,000 dollars. As Hope Grant and the other generals renounced their claims, the proceeds were split one third to officers and two thirds to NCOs and men, with each soldier receiving nearly £4.[19]

Far less orderly looting occurred nine days later. Following Anglo-French demands for the surrender of Peking, the ensuing negotiations produced the return of the bodies of eighteen European and Indian prisoners. Seized under a flag of truce, these men had been imprisoned, hideously tortured, and executed. In retribution the Earl of Elgin, who was Britain's high commissioner to China, ordered the destruction of the Yuanmingyuan. Over 18–19 October, 3,500 troops looted and burned the vast complex of palaces. The French were once again to the fore, 'leaving us', as Wolseley reflected, with 'little more than the bare

shell of the buildings on which to wreak our vengeance for the cruelties practised therein on our ill-fated countrymen'.[20]

The looting, as ever, proved a hugely variable experience. While Gerald Graham arrived 'an hour too late for loot; the Sikhs had been before us, and all the palaces were in flames – a fine sight',[21] another officer recounted how 'two officers of the 15th P. I. [Punjab Infantry] found no less than £10,000 worth of pure gold', and he acquired 'a lot of silks' that will make 'eight or ten dresses . . . for all our sweethearts'.[22] Captain Charles George Gordon, who later died a Victorian hero in Khartoum, received 'upwards of £48 apiece prize money' but described the destruction as 'Vandal-like', destroying 'property which could not be replaced for 4 billions'. What vexed Gordon, as he informed his mother, was that

> You can scarcely conceive the beauty & magnificence of the place, which we burnt. These palaces were so large & we were so pressed for time that we could not plunder carefully. Quantities of gold ornaments were burned, evidenced as brass. It was wretchedly demoralizing work for an army, every one was wild for plunder. I have quantities of things of all sorts for you.[23]

African campaigns

In 1867, the first major British military expedition in Africa, outside of the frontier wars in southern Africa, occurred in Abyssinia (Ethiopia) – a vastly expensive undertaking, led by Sir Robert (later Lord) Napier, to release European prisoners seized by Emperor Theodore (Tewodros II). As the Victorian army had never campaigned in Abyssinia, the expedition attracted a substantial press contingent as well as Richard R. Holmes of the British Museum and Clements R. Markham of the Royal Geographical Society.[24] Those expecting to find fascinating artefacts in Theodore's stronghold of Magdala (Maqdala) were not disappointed; as Henry Stanley (*New York Herald*) reported, once inside the fortress, soldiers 'in two and threes . . . commenced an assiduous search for loot'.[25] Many were drunk on *tej*, finding scores of twenty-gallon jars of the traditional Ethiopian honey wine in the storehouse. They discovered 'innumerable articles of furniture' in the imperial palace, all manner of 'gilt' items in the 'treasure tents', and many royal and religious relics – the imperial standard and seal of Ethiopia, a chalice from the fifteenth century, a 300-year old mitre of pure gold, four royal crowns and numerous gold, silver and brass crosses.[26] Although Napier required that most of these trophies should be sold at auction on the return march, he reserved items for the Crown and allowed commanding officers to select mementoes for their regiments. 'Fifteen elephants and nearly 200 mules were loaded with these miscellaneous articles.'[27]

As Ensign Wynter recalled, private deals occurred outside of the auction,[28] but the two-day auction raised £5,000, which was divided among the NCOs and private soldiers, giving each man just over four Maria Theresa dollars. Bidders, as Stanley described, were not scarce, and Holmes, though armed with ample funds, found Colonel Charles C. Fraser, V. C., of the 11th Hussars, a fierce competitor. 'Every officer and civilian', wrote Stanley,

> desired some souvenir of Magdala. One bought a cross of silver or brass, another a censer, another chose a sword. Goblets and cups, pixes and chalices of silver, they were in plenty; silks, umbrellas, saddles resplendent with golden filigree, and starred with rare-coloured stones; tents, carpets, richly illuminated Bibles and manuscripts, trinkets, and jewellery, found ready purchasers.[29]

If the expedition possessed the means of transporting these artefacts, the immense and ponderous baggage train was highly vulnerable. When Oromo forces (known to British soldiers as Galla) tried to steal baggage animals, soldiers fired on them, 'caught ten prisoners and brought them into Camp and flogged them'.[30] Lieutenant Arthur Hartshorne (13th Bengal Infantry) recounted how a more calculated assault by sixty to eighty Oromo seized eight loaded camels and their drivers. He led the pursuit over hills and through ravines until they shot several looters, recovered 'a lot of silver dishes, candlesticks, etc.', and eventually secured 'all the camels and nearly all their loads'.[31] Napier had anticipated such attacks and 'had endeavoured by liberality and conciliation to engage the petty chiefs between the Antalo and Tascassie [sic Tacazze] rivers to maintain their friendly assistance in forwarding native convoys for supplies'.[32] This bribery did not always work but it reflected Napier's determination to minimise attacks on his supply chain and on the collections of loot during the return journey.

On 30 June 1871, the Abyssinian loot provoked a debate in the House of Commons, when Colonel John North, MP complained that Richard Holmes had acquired two items of loot at Magdala (Maqdala) but had not offered them for prize money. The items were a solid gold crown, which supposedly belonged to the head of the Ethiopian Church, and a gold chalice dating back to the reign of Emperor Iyasu I. North proposed that these items should be purchased for the nation, and that the House should award prize money of £2,000, so meeting the valuation of these items by the British Museum, which the Treasury had refused to pay on 22 January 1870.[33] In reply Robert Lowe, as Chancellor of the Exchequer, accepted the principle of prize money but objected to purchasing artefacts 'at a price higher than they would fetch on the open market'. He deplored the prospect of the museum becoming a

'temporary warehouse for the reception of the barbaric spoils of war', and recommended selling the items. Conversely, Sir Stafford Northcote insisted that the artefacts were 'of considerable historical value and antiquarian interest, like many of the articles possessed by the British Museum'.[34] William Ewart Gladstone, then prime minister, regretted 'that those articles were ever brought from Abyssinia, and could not conceive why they were brought. They were never at war with the people or the churches of Abyssinia. They were at war with Theodore [. . .]'. He agreed with Lord Napier that these articles 'ought to be held on deposit till they could be returned to Abyssinia', and made no commitment to reimburse the soldiery.[35]

Exclusivity in looting recurred, albeit in another form, during the Anglo-Asante War (1873–74). On this occasion Wolseley led a small British expeditionary force through the tropical rainforest of West Africa in a punitive mission against the Asante king, Kofi Karikari. Aided by a vast number of Fante men and women, acting as bearers on the line of march, Wolseley's forces entered a largely deserted enemy capital, Kumase (Kumasi), after victory at the battle of Amoafo (31 January 1874). Hopeful that the *Asantehene*, the Asante king, would return, capitulate, and pay the reparations requested of him, Wolseley banned looting, placed guards at the royal palace, and approved the flogging of any Fantes caught in the act. 'Our black fellows', wrote Private Ronald Ferguson (Black Watch), 'were always stealing, and we had to lash them for their lazy ways.'[36]

Wolseley, though, faced the onset of the rainy season, which would slow his retreat and increase his toll of sick soldiers. As King Kofi never appeared, Wolseley ordered royal treasures to be seized for auction and the burning of the capital. During the withdrawal, in which soldiers struggled through swollen rivers, Wolseley placed guards at the major crossing, at the River Pra, in the hope of preventing soldiers from carrying away private loot. To bypass these sentries, Melton Prior, a war correspondent for the *Illustrated London News*, placed all his booty, including specimens of Asante art and articles stolen from the royal palace, under a rug in his hammock, and then climbed in, affecting illness, and got safely across.[37] Even more remarkably, Private Sandy McPherson smuggled chickens past the guards, crossing swollen rivers in which the men had to strip and cross, holding hands, through the breast-high torrents.[38] The prize agents, headed by Captain (later General Sir) Redvers Buller, had found little of value in Kumase, but Wolseley sent back the state umbrella of King Kofi for Queen Victoria and a carved stool for the Prince of Wales.[39]

Despite attracting inflated prices, the prize auction held at Cape Coast from 23 February onwards raised little money, and even Wolseley

Figure 1.1 'Trophy head' in gold from the Asante kingdom which was likely of ceremonial importance and may depict decapitated high-status enemy.

only acquired an umbrella, an old coffee pot, and an orb that his daughter would use as a rattle. After the expedition's return to England, gold items were put on display and auctioned. Ultimately, a gold mask of the *Asantehene* found its way into the Wallace Collection (Figure 1.1), and a gold ram's mask into the Royal Artillery Mess at Woolwich; and Wolseley's mementoes moved via the Royal United Service Institution to become acquisitions of the National Army Museum (NAM).[40] As the prize money was considered too little to distribute, Disraeli's cabinet resolved on 25 April to provide thirty-days' pay in *lieu*, £12,000–£13,000. As Earl Derby observed, this sum was 'not objected to on its own account, but there is a doubt as to the precedent which it will create: however, the troops are to have it'.[41]

The cabinet need not have worried. Subsequent campaigns against the Zulus, Boers and Pedi mainly yielded battlefield trophies, as the belligerents fought battles either at British camp sites (Isandlwana, Rorke's Drift and Khambula, 1879) or in British territory (as in the Anglo-Transvaal War). In subsequent assaults upon the kraals of the Zulu king, Cetshwayo, and of the Pedi chief, Sekhukhune, soldiers found little of value in prize terms. Cetshwayo's walking stick and leopard's claw necklace, alongside numerous shields and assegais, were brought home,

and several relics were eventually deposited in the NAM.[42] So iconic were these battlefield weapons that Lichfield Cathedral commemorated the men lost by the 80th Regiment of Foot (later the 2nd Battalion, South Staffordshire Regiment) by displaying replica assegais and shields, with the names of the dead inscribed on the latter.[43]

Looting was more sporadic in the Egyptian and Sudanese campaigns of North Africa. After the principal battle of the intervention in Egypt, Tel-el-Kebir (13 September 1882), the special correspondent of the *Melbourne Age* found himself unable to follow the cavalry because 'the horses and baggage had been looted in the camp'.[44] As the British troops moved rapidly onto Cairo, where the Egyptian garrison surrendered immediately, the army had more immediate concerns than the sale of loot, but some items survived. These included a tripod of Arabi Pasha (Urābī Pasha) minus the seat cover, which Colonel H. F. N. Jourdain (Connaught Rangers) acquired and which is now in the NAM.[45] Similarly, the Black Watch Museum inherited Sudanese relics from the regiment's actions at El Teb (29 February 1884) and Tamai (13 March 1884), including knives, spears, belt daggers, guns, water bottles and the basket and shawl of Emir Osman Digna, commander of the Hadendowa (Hadendoa).[46]

Among the battlefield trophies were banners seized after battles with the Mahdists from the mid-1880s to 1899: about thirty-eight flags remain in British museums and collections (see also Mack, Chapter 2).[47] Looting Sudanese towns appeared more rewarding, albeit at greater risk, as in Dongola (23 September 1896), where defeated enemy soldiers found refuge in various dwellings. Major J. J. B. Farley (1st Battalion, North Staffordshire Regiment) recalled how 'The correspondents were well up with the firing line and reaped a rich harvest in the way of loot, and one of them, attended by his servant, was just entering a likely looking hut when out of it sprang a Dervish with a rifle and the bullet intended for the correspondent put "paid" to the servant's account.'[48] Farley relied on his servant to gather trophies, and the latter subsequently 'staggered into camp under a burden of four or five Baggara spears, a fine curved sword with crocodile scabbard, a despatch box, several minor objects and two extremely old Korans'.[49]

Officers also bought curios from the vanquished: 'Many of the Dervishes', wrote Farley, 'when they saw the "game was up", took off their jibbas [*jibbahs*] (collarless smocks worn by the Mahdists in battle) and hid them, and appeared before us as poor, ragged harmless villagers; later some of them brought their jibbas to us to sell, and I still have a Jaalin jibba and two "Dervish Dollars" which I got this way'.[50] Once again the formal 'sale of Dervish loot', as authorised by Major-General Horatio Herbert Kitchener, coincided with illicit deals. Farley, who

could not attend on the day of the sale (25 September 1896), told Lieutenant Osmond D. Blunt (Connaught Rangers), his 'good friend', who 'was in charge of a huge dump of miscellaneous trophies', that he 'would love to have one of the cartridge belts': Blunt looked away, as the major concealed 'one, as well as two or three other small objects'.[51]

Trophy hunting recurred after the battles of Atbara (8 April 1898) and Omdurman (2 September 1898). After the former battle, Lieutenant Ronald F. Meiklejohn (Royal Warwickshire Regiment) described how soldiers moved across the enemy's *zariba* (encampment protected by a thorn bush), where 'We all picked up some trophies'.[52] Officers and men acted similarly after Omdurman: Meiklejohn 'visited the Mahdi's tomb; Market place; etc and picked up some objects of interest . . . I got the Khalifa's State Banner, or what is said to be one of them'. When rumours of hidden treasure in the town arose, Meiklejohn described how his 'fatigue party really worked hard removing wood from floors, but we only found scorpions and other insect life!'[53]

Acquisition, as ever, was only part of the process; although British units travelled by river and railway back to Cairo, and so packed their loot in barges towed by steamers, the riverine journey proved hazardous. In crossing the Shabluka Cataract at full speed, several vessels ran aground and the odd one capsized, with the Guards losing much of their loot in one of these accidents. Nevertheless, the Marquess of Tullibardine (later the eighth Duke of Atholl) brought a remarkable collection home, including *jibbahs*, flags, chainmail, shields, daggers, *kaskaras* (Sudanic swords), guns, prayer boards, spears, war drums, banners, a padded saddle, horse head armour, padded helmets, a leather rifle bag, ammunition bandoliers, holsters, a padded hat, camel drums, powder horns and a replica of the finial from the Mahdi's tomb.[54]

Bringing these trophies back to Blair Castle, where they could be stored, preserved and later displayed, met the final requirement of Victorian collecting, namely the retention and display of artefacts. Many relics did not survive. Farley recalled how he passed a letter from the Mahdi's successor, Khalifa Abdullahi, in a Koran to another Staffordshire officer, Lieutenant John Wilson, but within a year, Wilson died from enteric (typhoid) fever and Farley never found the letter in his belongings.[55]

In the late 1890s, British forces mounted another three punitive expeditions in West Africa. In December 1895, Sir Francis C. Scott led an allied expeditionary force against the *Asantehene*, King Prempeh I, who had rejected the offer of British protection over his kingdom. Failing to encounter any opposition, this powerful force entered Kumase, where Prempeh surrendered to the incoming British governor, Sir William Maxwell. Having offered only 680

Figure 1.2 Illustration from *The Graphic* of 'The British Occupation of Benin: Loot from the King's Palace' by J. Nash from a photograph by Lieut. W. N. England, R. N.

ounces of gold towards the demand for 50,000 ounces unpaid since the Treaty of Fomena (1874), Prempeh and other Asante leaders were sent into exile, while two companies of West Yorkshiremen took possession of the royal palace. As Major Robert Baden-Powell observed,

There could be no more interesting, no more tempting work than this. To poke about in a barbarian king's palace, whose wealth has been reported very great, was enough to make it so. Perhaps one of the most striking features about it was that the work of collecting the treasures was entrusted to a company of British soldiers, and that it was done most honestly and well, without a single case of looting.[56]

Although the Asantes had removed the most valuable regalia, including the prestigious golden stool, the soldiers found gold-hilted swords, gold trinkets and rings, bottles of brandy, brass dishes, large metal ewers, and old arms, described by Baden-Powell as 'piles of the tawdriest and commonest stuff mixed indiscriminately with quaint, old, and valuable articles'.[57] As further searches in nearby fetish houses yielded nothing, the loot was sold at auction, apart from the golden valuables sent to the Colonial Office.

More controversial was the naval onshore expedition, under Rear-Admiral Harry Rawson, sent to capture the Benin king, or Oba, and destroy Benin City, in reprisal for 'The Benin Massacre' of a British-led expedition at Ugbine village (4 January 1897). Landing on 9 February 1897, the Royal Marines, sailors and Niger Coast Protectorate Forces advanced in three columns and, after nearly ten days of fierce fighting, two columns entered Benin City (see also Mack, Chapter 2). As the king and his principal generals, priests and family had fled, leaving the walled-in city a scene reportedly drenched in blood and heavy with the smell of human sacrifices,[58] the marines and sailors began pillaging the palaces, religious buildings, monuments and homes. Having gathered about 2,500 artefacts in three days, they preserved this plunder at the expense of some of their own baggage and provisions[59] when an accidental fire swept through the city, compelling most of them to retreat to the coast.

Contemporary accounts of the plunder paled by comparison with lurid reports of the 'city of blood', notably the descriptions of torture, crucifixions and human sacrifice, involving 176 newly decapitated and mutilated bodies.[60] Rawson, nonetheless, sent two tusks and two carved ivory leopards to Queen Victoria. Despite the lack of gold and silver, other than on swords and a small trinket, the booty included hundreds of superbly cast bronze plaques, a large array of ivory tusks and many bracelets and stools.[61] Naval officers received trophies in proportion to rank: Captain George le C. Egerton acquired a dozen major pieces, including ancient carved tusks; Lieutenant Walter Cowan, an executioner's sword, 'very heavy, with an ivory and silver handle, and very old';[62] and Midshipman L. E. H. Llewellyn, an armlet. At the Admiralty's auction Charles Hercules Read, Keeper of Antiquities at the British Museum, and General Augustus H. L-F. Pitt Rivers, a collector

of primitive art, acquired hundreds of the Benin antiquities despite strong bidding from German museums. Meanwhile British officials, such as Dr R. Allman and Lieutenant Herbert A. Child, who remained in Benin, and Cyril Punch, a trader, built up private collections, while the Hon. George William Neville of Lagos, who had accompanied the expedition, retained 'a remarkable private collection of Benin curiosities'.[63]

Such acquisitions were less feasible during the last of these punitive missions, which followed a revolt of the Asante, and the investment of a British fort near Kumase. As these events occurred in 1900, coinciding with the South African War, Colonel James Willcocks assembled a relief force largely of Nigerian levies. After suppressing the rebellious Asante, Willcocks' troops proved skilful looters, returning on one occasion to the loyalist village of Bekawi with articles of 'every conceivable description', including gold ornaments, bags of gold dust, £100 in cash, flags, chairs, state umbrellas, clothing, books, English-made trunks, ammunition, parts of a .303 Maxim gun, and some sheep and livestock. After distributing most of these items among his troops, Willcocks rewarded the Bekawi and Denkara chiefs with mementoes for their provision of levies or as compensation for those who had been captured and killed.[64] Since these troops spent far longer in the Asante territory than their British predecessors, they found treasure hidden in previous campaigns but not the golden stool. Willcocks rewarded loyal African leaders with items of loot, and sent 'a handsome palanquin chair to the Sultan of Zanzibar as a memento' for the 1,500 carriers sent from East Africa.[65]

Looting in the South African War

Looting occurred on an entirely different scale, and in different forms, during the last and greatest test of the late Victorian army, the South African War (1899–1902). The process was no longer associated primarily with the aftermath of battle, siege or campaign, nor one that principally benefited the British and allied forces. Almost as soon as the Boers invaded Natal and Cape Colony, they began plundering and ransacking the property of British settlers.[66] The burghers, who served in the citizen armies of the Transvaal and the Orange Free State, were neither professional soldiers nor subject to the discipline of their British counterparts. They ignored orders not to loot and escaped punishment for doing so. Deneys Reitz, despite his highly respectable background, joined the 1,500 men who pushed past their officers on entering the town of Dundee (23 October 1899), and the neighbouring military camp:

[31]

[W]e were not to be denied, and we plundered shops and dwelling houses, and did considerable damage before the Commandants and Field Cornets were able to restore some semblance of order. It was not for what we got out of it, for we knew that we could carry little or nothing away with us, but the joy of ransacking other people's property is hard to resist, and we gave way to the impulse.[67]

Although the ransacking of Dundee represented 'the nadir of Boer discipline',[68] Boer pillaging persisted across the northern regions of Natal and Cape Colony, and continued after the collapse of the sieges of Kimberley (15 February 1900) and Ladysmith (28 February 1900). It fuelled divisions of opinion about the war in Britain, as letters from Natalians disparaged their invaders for 'burning down defenceless villages and doing all the injury they can'.[69] British soldiers were equally appalled: Lieutenant-Colonel Sir Nevil Macready (2nd Battalion, Gordon Highlanders) reckoned that any 'unauthorised or unnecessary destruction' by British soldiers palled by comparison 'with the whole-sale destruction by the patriotic & God fearing Boer in Natal'.[70] Writing from the Kimberley front, Private G. Gregory described how it 'would make your heart burn to see the way the Boers have treated the English homes here. They have broken everything up.'[71]

None of these protestations inhibited the mutual plundering of enemy camps and kit. As camps were abandoned either by retreating adversaries or seized after battles and surrenders, both sides acquired arms, clothing, and food from the other. When British soldiers raided Boer camps, they found little of value but still appreciated the blankets, waterproofs and biscuit found at Elandslaagte, as they spent a rain-sodden night on the battlefield (21 October 1899).[72] Occasionally soldiers found currency, watches and even the contents of a safe blown up at Modder River,[73] but in the reliefs of Ladysmith, and later Mafeking (17 May 1900), they had to content themselves with tobacco, coffee, bread and other provisions; vast stocks of ammunition; and clothes, rugs, saddles and boots. A private in the 2nd Battalion, East Surrey Regiment, insisted that he did not rob the dead and wounded 'as most did' outside Ladysmith, but 'looted seven pairs trousers, four coats, four waistcoats, four shirts, a rug, and several pairs of socks . . . We are allowed to wear anything, for we were all in rags.'[74] After 4,000 Boers surrendered at Paardeberg (27 February 1900), Sergeant R. A. Cooke (2nd Battalion, Shropshire Light Infantry) shrewdly observed that the booty lacked value because so many burghers travelled as families. They had left 'the place strewn with bedding, camp chairs, blankets, rugs, cooking utensils, flour, coffee, tea, sugar, and even sewing machines. There were also thousands of rounds of ammunition and cartloads of shells.' Cooke later found several Bibles, hymnbooks, a violin and an auto-harp.[75]

Just as burghers on commando left few valuable battlefield trophies, so engaging two Boer republics, rooted in Calvinist theology, precluded the capture of exotic or jewel-encrusted regalia, ornate religious artefacts, or other forms of iconography. Nor were the gold mines a source of wartime contention. Most were closed at the outbreak of war, and were surrendered intact at the fall of Johannesburg (31 May 1900).[76] Looting intensified, nonetheless, throughout the guerrilla phase of the war, when burghers were dispersed to fight in local districts.[77] The Johannesburg Commando moved into the eastern Transvaal, where Roland Schikkerling described in his diary how burghers stole from their fellow combatants and from 'handsuppers', wrecking farmhouses and gardens (4–5 May 1901), stealing pumpkins and mealie cobs (24 July 1901) and, by 12 September 1901, robbed with a degree of authority that would frighten a thief.[78] The Boers recurrently ambushed British forces, compelling the vanquished 'to give over our rifles and straps and everything we had'.[79]

Meanwhile the British soldier and his imperial allies continued looting, a practice that soon became linked with the farm-burning policy. The burning of farms had occurred sporadically since January 1900 but, in March 1900, Lord Roberts authorised the destruction of all homesteads, flying a white flag, from which Boers had sniped at British forces. He extended this policy in the following June after a raid upon Roodewal station, led by Christiaan de Wet (7 June), which destroyed large stocks of supplies, mail and ammunition. Thereafter British and imperial soldiers responded to attacks on the railways – 250 breaks of the line over twelve months – and to guerrilla operations generally, by burning Boer homesteads, destroying crops and livestock, and looting extensively.[80]

Some of the plundering, as Captain Boyd A. Cunningham (4th Battalion, Argyll and Sutherland Highlanders) recorded, was utterly casual, notably at Lindley, on 15 January 1901, when we 'killed time as best we could. Our chief amusement was looting the Stores in the town. We now possess a "Grand Piano" and number of chairs and settees and crockery glasses etc.'[81] Rendered destitute by this policy, Boer families and many Africans made their way to refugee camps established by the British, later known as concentration camps. Within these confines, diseases spread rapidly and mortality rates soared, conditions revealed by Emily Hobhouse, which prompted the query of Sir Henry Campbell-Bannerman, then leader of the Liberal party: 'when is war not a war? When it is carried on by methods of barbarism in South Africa.'[82]

However contested this description, not least by soldiers who thought the Boers had brought 'farm burning on themselves and . . .

deserved all they got',[83] it still reflected the anomalous character of the conflict. Looting had flourished on both sides in a war where the boundaries between civil and military targets became blurred, and animosities deepened between belligerents and civilians. It derived from operations conducted over several years by widely dispersed, and sometimes isolated, units across a vast, inhospitable theatre. Amidst the ensuing ambushes, raids and reprisals, discipline suffered,[84] and looting, far from being a nominally regulated aspect of active service, became a means of obtaining supplies, depriving the enemy, passing idle moments, and amusing the perpetrators.

Conclusion

Looting had never been fully controlled during any of the African campaigns, and trophy hunting by individual soldiers had always accompanied the prize allocations. British soldiers and sailors were not the sole perpetrators, as allied soldiers, civilians, war correspondents, British Museum staff, local traders and camp followers also sought valuables and collected mementoes after battles. Looting appealed across every rank and socio-economic background; it was a customary feature of African campaigning, a process associated with the disarming of the vanquished, and exacting tribute or reparations. It was a practice, too, that had been honed over time, with soldiers adept in the gathering and trading of relics, and in improvising transport to bring them home.

The motivations of looters extended beyond opportunism and the incentives aroused by low rates of pay, lapses of discipline, idleness, and shortages of supplies on active service. They reflected the full range of emotions from natural curiosity and a desire for trophies, to outright avarice and wanton vandalism. In an inherently uncertain process individuals or small groups of men suddenly felt themselves freed from the constraints of military discipline, and were stimulated by post-battle relief or sometimes drink to seek or trade mementoes. Where they brought artefacts home, these items illustrated accounts of active service and the challenges posed by foreign armies: the trophies could be retained, sold, or distributed as presents.

Looting had enjoyed official sanction or at least acceptance throughout the nineteenth century. It provided gifts for the monarch, regimental trophies, compensation for unpaid reparations, rewards for allies, presents for family and friends, and artefacts for sale or retention at home. While all African belligerents engaged in looting, post-battle reports focused less upon looting than local atrocities – the 1,300 mutilated corpses on the slopes of Isandlwana, and the slaughter alongside Gordon of an entire garrison in Khartoum and nearly 4,000

inhabitants (1885), with many others carried off into slavery. It was only after the extensive pillaging of European property in South Africa that looting became an embarrassment. At the outbreak of the First World War Lord Kitchener, then secretary of state for war, issued written guidance for each British soldier about to embark upon active service 'for the most part' in a friendly country: 'Be invariably courteous, considerate and kind. Never do anything likely to injure or destroy property, and always look upon looting as a disgraceful act.'[85]

Notes

1 S. Jacob, 'Indian MPs demand Kohinoor's return', BBC News, 26 April 2000, http://news.bbc.co.uk/1/hi/world/south_asia/727231.stm and K. Opoku, 'When will Britain return looted golden Ghanaian artefacts? A history of British looting of more than 100 objects', http://www.modernghana.com/news/310930/1/when-will-britain-return-looted-golden-ghanian-ar.html, both accessed 13 December 2013.

2 J. Greenfield, *The Return of Cultural Treasures* (Cambridge: Cambridge University Press, 2007).

3 General Viscount G. J. Wolseley, *The Soldier's Pocket Book for Field Service* (London: Macmillan & Co., 5th edn, 1886), p. 165.

4 *Ibid*, pp. 165–6. Non-commissioned officers (NCOs) typically with the rank of sergeant obtained their position through promotion from the ranks.

5 H. Borrett, *My dear Annie: The letters of Lieutenant Herbert Charles Borrett, The King's Own Royal Regiment Written to his wife, Annie, during the Abyssinian Campaign of 1868* (Lancaster: King's Own Royal Regiment Museum, 2003), p. 40.

6 Brigadier B. W. Webb-Carter, 'A subaltern in Abyssinia', *Journal of the Society for Army Historical Research*, 38 (1960), 144–9 (p. 149).

7 Borrett, *My dear Annie*, p. 41. The ring and bullet are now in the Regimental Museum, Lancaster, *Ibid*., p. 42, n. 14.

8 Webb-Carter, 'A subaltern in Abyssinia', p. 149.

9 D. Robertson, *The Journal of Sergeant D. Robertson, late 92d Foot: comprising The Different Campaigns between the Years 1797 and 1818 in Egypt, Walcheren, Denmark, Sweden, Portugal, Spain, France, and Belgium* (Perth: J. Fisher, 1842), pp. 62–3.

10 Lieutenant-Colonel C. Greenhill Gardyne et al., *The Life of a Regiment: The History of the Gordon Highlanders from its Formation in 1794 to 1816*, 7 vols (London: The Medici Society, 1901–74), I (2nd edn, 1929), p. 284.

11 *Ibid*., pp. 284–5.

12 P. Mason, *A Matter of Honour: An Account of the Indian Army, Its Officers and Men* (London: Jonathan Cape, 1974), pp. 205–6.

13 W. H. Russell, *My Diary in India*, 2 vols (London: Routledge, Warne and Routledge, 1860), I, p. 330.

14 'The Battle of the Peiho Described by an Officer of Fane's Cavalry', *Glasgow Herald* (14 November 1860), p. 4.

15 Lieutenant-Colonel G. J. Wolseley, *Narrative of the War with China in 1860* (London: Longman, Green, Longman, and Roberts, 1862), pp. 224–5.

16 *Ibid*., p. 79.

17 F. Stephenson to W. Stephenson, 9 October 1870, in Sir F. C. A. Stephenson, *At Home and on the Battlefield* (London: John Murray, 1915), p. 272.

18 Field-Marshal Viscount Wolseley, *The Story of a Soldier's Life*, 2 vols (London: Constable & Co., 1903), II, p. 78.

19 *Ibid*.; Wolseley, *Narrative*, pp. 238–9.

20 Wolseley, *Narrative*, pp. 279–80.

21 G. Graham, diary, 19 October 1860, in Colonel R. H. Vetch, *Life, Letters and Diaries of Lieut.-General Sir Gerald Graham* (Edinburgh: William Blackwood and Sons, 1901), p. 192.
22 'Letter from China', *Scotsman* (31 December 1860), p. 2.
23 British Library, Add MSS., 52,389, ff. 195–6, Gordon Mss, Gordon to his mother, 25 October 1860.
24 D. Bates, *The Abyssinian Difficulty: The Emperor Theodorus and the Magdala Campaign 1867-68* (Oxford: Oxford University Press, 1979), p. 103.
25 H. M. Stanley, *Coomassie and Magdala: The Story of Two British Campaigns in Africa* (London: Sampson Low, Marston Low & Searle, 1874), p. 454.
26 *Ibid.*, pp. 455–8.
27 *Ibid.*, p. 467.
28 Webb-Carter, 'A subaltern in Abyssinia', p. 149.
29 Stanley, *Coomassie and Magdala*, p. 470.
30 Borrett to his wife, 6 May 1868, *My dear Annie*, p. 50.
31 'Skirmish with Abyssinian Plunderers', *Liverpool Mercury* (7 April 1868), p. 5.
32 'The Fall of Magdala: Sir R. Napier's Despatch', *Leeds Mercury* (18 June 1868), p. 4.
33 *Parliamentary Debates*, Third Series, vol. 207 (30 June 1871), cols. 939–40.
34 *Ibid.*, cols. 942–4.
35 *Ibid.*, cols. 948–52.
36 'A Stirlingshire soldier's account of the war', *Stirling Observer* (2 April 1874), p. 6; see also M. Prior, *Campaigns of a War Correspondent* (London: Edward Arnold, 1912), pp. 24–5.
37 Prior, *Campaigns*, p. 29.
38 'Arrival of the Black Watch', *Huntly Express* (28 March 1874), p. 7.
39 I. F. W. Beckett (ed.), *Wolseley and Ashanti: The Asante War Journal and Correspondence of Major General Sir Garnet Wolseley 1873-1874* (Stroud: History Press for the Army Records Society, 2009), pp. 306 and 407.
40 *Ibid.*, pp. 367–8, 392, 406–7; Royal Archives, VIC/ADD E/1/7336, Duke of Cambridge MSS., Wolseley to the Duke of Cambridge, 27 February 1874.
41 J. Vincent (ed.), *A Selection from the Diaries of Edward Henry Stanley, Fifteenth Earl of Derby (1826-93) between September1869 and March1878*, Camden Miscellany, 5th series, IV (London: Royal Historical Society, 1994), p. 172.
42 National Army Museum (NAM), 1963-10-166, 1963-10-308, 1963-10-284 and 1963-08-1.
43 R. Hope, *The Zulu War and the 80th Regiment of Foot* (Lichfield: Churnet Valley Books, 1997).
44 'The war in Egypt', *(Melbourne) Argus* (7 November 1882), p. 8.
45 NAM, 1950-10-13, Jourdain collection: Tripod stool, 1882 (c).
46 F. Nicoll, 'Material related to the Mahdia', www.sssuk.org/main/Mahdia materials.pdf, accessed 8 April 2015.
47 D. Johnson, 'A Note on Mahdist Flags', www.savageandsoldier.com/sudan/MahdistFlags.html, accessed 4 March 2014.
48 University of Durham, Sudan Archive (SAD). 304/2/26, Major J. J. B. Farley, 'Some recollections of the Dongola Expedition', p. 24.
49 *Ibid.*
50 *Ibid.*, p. 25.
51 *Ibid.*, p. 26.
52 NAM, 1974-04-36-3, Lieutenant R. F. Meiklejohn, 'The Nile campaign', pp. 29 and 32.
53 *Ibid.*, p. 54.
54 Nicoll, 'Material related to the Mahdia'.
55 SAD, 304/2/26, Farley, 'Some recollections', p. 24.
56 Major R. S. S. Baden-Powell, *Downfall of Prempeh: A life with the Native Levy in Ashanti, 1895-6* (London: Methuen, 1896), pp. 128–9.
57 *Ibid.*; see also W. W. Claridge, *A History of The Gold Coast and Ashanti from the Earliest Times to the Commencement of the Twentieth Century*, 2 vols (London: Frank Cass, 2nd edn, 1964), II, p. 415.

58 Royal Naval Museum, 1985/275.1, H. J. G. Hood, 'The Benin Disaster', pp. 11–13.
59 *Papers Relating to the Massacre of British Officials near Benin and the Consequent Punitive Expedition*, C. 8677 (1898), LIX, Consul-General R. Moor to the Marquis of Salisbury, 20 March 1897.
60 R. Allman, 'With the Punitive Expedition to Benin City', *Lancet*, 150 (3 July 1897), 43–4; 'The British occupation of Benin: loot from the King's Palace', *Graphic* (24 April 1897), p. 1; 'The March to Benin', *Exeter Flying Post* (27 March 1897), p. 2.
61 G. Rawson, *Life of Admiral Sir Harry Rawson* (Oxford: Thornton Books, 1914), pp. 140–1.
62 Captain L. Dawson, *Sound of the Guns: Being an account of the wars and service of Admiral Sir Walter Cowan* (Oxford: Pen-In-Hand, 1949), p. 36.
63 R. Home, *City of Blood Revisited: A New Look at the Benin Expedition of 1897* (London: Collins, 1982), p. 101; 'Mr G. W. Neville', Obituary, *The Times* (30 November 1929), p. 14.
64 Brigadier-General Sir J. Willcocks, *From Kabul to Kumassi: Twenty-Four Years of Soldiering and Sport* (London: John Murray, 1964), pp. 371–3.
65 *Ibid.*, p. 423.
66 Homes, abandoned by the Uitlanders as they fled from the Transvaal, were also looted: see D. Cammack, *The Rand at War 1899–1902: The Witwatersrand and the Anglo-Boer War* (London: James Currey, 1990), pp. 62–4.
67 D. Reitz, *Commando: A Boer Journal of the Boer War* (London: Faber & Faber, 1929), p. 32.
68 F. Pretorius, *Life on Commando during the Anglo-Boer War 1899-1902* (Cape Town Pretoria Johannesburg: Human & Rousseau, 1999), p. 219.
69 'Refugees in Natal', *Sussex Daily News* (13 December 1899), p. 6; see also 'Wigston's man's farm looted', *Leicester Chronicle and Leicestershire Mercury* (25 November 1899), p. 7.
70 Gordon Highlanders Museum, PB 174, Lt.-Col. Sir Nevil Macready, diary, p. 79.
71 'Leicestershire lad's experiences at Belmont, Graspan, and Modder River', *Leicester Chronicle and Leicestershire Mercury* (6 January 1900), p. 2.
72 'Teignmouth man at Elandslaagte', *Western Morning News* (24 November 1899), p. 8.
73 'More soldiers' letters', *(Gloucestershire) Echo* (4 January 1900), p. 3 and 'A Perth Sapper on the Battle of Belmont', *Strathearn Herald* (13 January 1900), p. 2.
74 'How they relieved Ladysmith', *Dover Express* (20 April 1900), p. 7; see also 'Boer spoils', *Morning Leader* (6 April 1900), p. 2; 'Soldiers' letters', *North Wales Guardian* (6 April 1900), p. 2; 'Sidelights on the war', *Northern Whig* (9 April 1900), p. 8.
75 'Letters from the front', *Isle of Wight Observer* (31 March 1900), p. 5.
76 T. Pakenham, *Boer War* (London: Weidenfeld & Nicolson, 1979), pp. 116, 384, 428, 432.
77 Pretorius, *Life on Commando*, pp. 211–22.
78 R. Schikkerling, *Commando Courageous (A Boer's Diary)* (Johannesburg: Hugh Keartland, 1964), pp. 153, 195, 265, 302.
79 'De Wet's long march', *Inverness Courier* (5 February 1901), p. 5; see also 'Experiences of an officer of The Black Watch', *Nairnshire Telegraph* (17 January 1900), p. 3.
80 F. Pretorius, *The Anglo-Boer War 1899–1900* (Cape Town: Struik Publishers, 1985), pp. 27–8; I. van der Waag, 'South Africa and the Boer Military System' in P. Dennis and J. Grey (eds), *The Boer War: Army, Nation and Empire, the 1999 Chief of Army/Australian War Memorial Military History Conference* (Canberra: Army History Unit, 2000), pp. 45–69 (p. 53).
81 Argyll and Sutherland Highlanders (ASH) Museum, N-D4, CUN.B, Capt. Boyd A. Cunningham, diary, 15 January 1901, p. 12.
82 'National Reform Union', *Scotsman* (15 June 1901), p. 10; see also S. E. Spies, *Methods of Barbarism? Roberts and Kitchener and Civilians in the Boer Republics: January 1900-May 1902* (Cape Town: Human & Rousseau, 1977); P. Warwick, *Black People and the South African War, 1899-1902* (Cambridge: Cambridge University Press, 1983), pp. 147–8; and R. L. Wallace, *The Australians at the Boer War* (Canberra: The Australian War Memorial and the Australian Government Publishing Service, 1976), pp. 135, 137 and 302–3.

83 ASH Museum, N-D1. MacD, Private John MacDonald, diary, 2 December 1900, p. 13; see also E. M. Spiers, *The Scottish Soldier and Empire, 1854–1902* (Edinburgh: Edinburgh University Press, 2006), pp. 193–4; and E. M. Spiers, *The Victorian Soldier in Africa* (Manchester; Manchester University Press, 2004), pp. 171–3.
84 A. Davey (ed.), *Breaker Morant and The Bushveldt Carbineers* (Cape Town: Van Riebeeck Society, second series No. 18, 1987).
85 First World War.com, Primary Documents, 'Lord Kitchener's guidance to British Troops, August 1914', available at www.firstworldwar.com/source/kitchener1914.htm, accessed 9 July 2015.

CHAPTER TWO

The agency of objects: a contrasting choreography of flags, military booty and skulls from late nineteenth-century Africa

John Mack

Recent decades have witnessed an escalating emphasis on the ways in which otherwise inanimate material culture can be regarded as invested with a form of agency within a nexus of human relationships. This has illuminated thinking in a wide variety of contexts, often supplanting a focus on semantic models of the material world derived from linguistic and semiotic interpretations. Alfred Gell's influential book *Art and Agency* is taken by many as a major point of departure for such thinking, particularly among the anthropologists to whom it is primarily addressed.[1] But, that said, it has antecedents in earlier essays by himself and others and in a range of disciplines (notably archaeology and historical studies, including art history).[2] In this context, the idea of objects as invested with a form of personhood has become a pervasive theme. Two areas stand out as among the most compelling in application: one is memory studies, where objects have long been analysed in terms of having 'biographies';[3] the second is in the area of exchange, where the movement of physical objects has been explored as an instance of human–object entanglement in which gift giving and reciprocity are re-examined as creating and distributing personhood.[4] A further application of this idea is in situations of human displacement. David Parkin has explored the role of objects that are taken in flight when their owners become refugees. He argues that among them are often things which have no immediate functional purpose but are carried for more sentimental reasons, partly as contributory to memory, but also with the prospect that they may ultimately help re-establish selfhood, however long the process of dislocation.[5]

This chapter takes a slightly different tack on such questions. It looks at one particular arena of object biography: situations in which people are separated from an object as *it* (rather than they) becomes the refugee – or, in this instance, an abductee. This theme is explored by

examining situations in which something is forcibly taken in the context of human conflict from an unwilling and defeated foe. Indeed, since the context is one in which the original owner may be dead, the object obtains a set of different significances, adding further to the number of those with an investment in its 'personhood'.[6] The objects in question may be weapons, items of clothing, instruments of power and authority and, in some striking cases, human remains.

The process by which an object becomes commodified is a central focus of Arjun Appadurai's influential edited volume on the biography of objects.[7] The list of objects interpreted as 'commodities' runs by way of ritual and magical objects to artworks, gifts and heirlooms. To explore how 'loot' might fit into this register is one of the aims of this chapter. As abducted objects, what sense of personhood do they retain when separated from an original owner; and what sense do they obtain in their new locations? They are conventionally described as 'trophies' – a term used also into the early twentieth century of, for instance, missionary collecting[8] and particularly in the context of big-game hunting. But does this adequately express their complex agency? The theme is opened up by contrasting two different forms of military engagement in Africa in the late Victorian period and the divergent biographies of objects associated with each conflict.

Benin and Omdurman

In Britain, 1897 was set up to be a year for celebrating empire. *The Times* newspaper promoted the events as early as New Year's Day. It was suggested that, following the success of Queen Victoria's golden jubilee in 1887, royal – indeed imperial – pageantry should also mark her sixtieth year on the throne. So, the idea was floated that a diamond jubilee celebration – otherwise a seventy-five-year event – should be brought forward. It was, after all, uncertain that even so long-lived a monarch as Queen Victoria would still be on the throne in 1912, when she would be ninety-three years of age. The recalibration of the jubilee cycle culminated in a spectacular display attended in June 1897 by, among many massed spectators and dignitaries, an estimated 50,000 troops brought in from all corners of the colonial dominions to witness a grand procession through the packed streets of London. It was a dramatised, costumed representation of the Empire itself which included colonial troops: Gold Coast, Royal Niger, Lagos 'Haussas' or 'Houssas' (troops usually assumed to be Muslim Hausa soldiers of northern Nigerian origin, though in fact most were Yoruba from the south)[9] and Sierra Leone Frontier Forces, all assembled to represent West Africa.

[40]

But, just as the suggestion of an early diamond jubilee was being mooted, other news emerged to puncture any premature sense of celebration. On 12 January came the first newspaper reports circulated by Reuters of the death of almost the whole of an ostensibly peaceful British-led expedition to Benin City in the south-east of what would become Nigeria, an event that happened on 4 January.[10] Those involved were the Acting Consul General, James Phillips, together with eight other British participants and around 240 'Kroomen and native carriers'. The Edo Kingdom centred on Benin was effectively surrounded by territories under British administration and its incorporation into the developing Protectorate was seen as a desirable act of consolidation.

Although the event was described as 'a massacre' and 'a terrible disaster', it was in effect an inept and unauthorised attempt by an ambitious colonial official to break the trade embargo while the argument as to whether this should be done by peaceful means or by force was still unresolved. An instruction from the Foreign Office not to proceed only arrived days after the murders had already taken place. Once the news reached London, *The Times* led the way in identifying the ruler (the Oba) as personally responsible, though he had in fact himself twice warned that the proposed visit should be postponed as it would take place during the important annual *Ague* (or yam) festival. And, in fact, the party was ambushed at a place which was over twenty miles from the city itself. Repeating an unremitting stream of degrading tropes, the paper proceeded in its comments' and letters' columns to print characterisations of the Oba as a 'juju king' overseeing 'a powerful theocracy of fetish priests' in his 'city of blood', addicted to human sacrifice as a means of counteracting even such natural conditions as adverse weather.[11] A so-called 'punitive expedition' was hastily put together and by 18 February Benin City had fallen to a British-led force. This led to the occupation of the capital of the Edo Kingdom, the torching of a number of important ritual sites including (probably by accident) the Oba's palace and ultimately the imprisonment of the Oba when he returned to the city, having initially fled; in due course, he was sent into exile. It was also the occasion for the seizure of a spectacular collection of loot, most seized from within the Oba's palace and consisting of carved ivory tusks, cast 'bronze' figures, heads and plaques and other works made from iron and wood.

Revenge was also a major motivation in the drawn-out preparations for another, and defining, conflict of the late nineteenth century. In the following year – on 2 September 1898 – a major battle took place near Omdurman to the west of the confluence of the White and Blue Nile on the opposite bank to Khartoum. It led to the defeat of a large army of Islamic militants who had taken power in Sudan under the Mahdiya, the

rule initiated by Mohammad Ahmad, the Mahdi (a title for the proph-
esied redeemer of Islam). It was the culmination of a two-year campaign
undertaken by an Anglo-Egyptian force under the command of the Sirdar
(his Egyptian title), Major-General Herbert Kitchener. This was widely
presented in the British press as retribution for an open wound that had
remained unsutured since the killing of General Gordon in Khartoum
thirteen years earlier, in 1885. Those events had been a major national
cause célèbre. After a prolonged siege, the British government had finally
decided to send a force to relieve Gordon and his small military and
administrative staff, not to mention the citizens who Gordon had not
succeeded in evacuating and who, like him and his staff, had suffered a
year-long blockade. Following the failure of an exchange during which
each sought to persuade the other of the righteousness of their respective
faiths, the Mahdi's forces had finally broken through. Very large numbers
of inhabitants were killed and Gordon, famously, had been beheaded.
The relief expedition arrived several days too late. The Queen was
dismayed – as she wrote to her prime minister, 'Mr Gladstone should
remember what she [Britain] suffers when the British name is humiliated.
He can go away and resign, but she must remain.'[12]

Gordon was to become a mythical – indeed, for many, a martyred –
figure, the circumstances of his death reconstructed in a number of
mediums – for instance, as paintings and as a diorama at Madame
Tussauds.[13] A statue of him was erected in central London. But,
beyond that, the beleaguered figure of Gordon and what the manner
of his ultimate demise represented had struck at the heart of the
Victorian ideals of crusading masculinity. With the retaking of the
Mahdi's former stronghold, the despoiling of his tomb and the flight
of his successor, the Khalifa, the imperial project had been restored in
the British public imagination. As one of those who participated in
the events, Winston Churchill wrote in a book published shortly
afterwards: 'And if the British people had cared to indulge in the more
indecent pleasures of triumph, they might reasonably have commanded
the stonemason to bring his hammer and chisel and cut on the ped-
estal of Gordon's statue in Trafalgar Square the sinister word
"Avenged!"'[14]

The contrast between the Benin encounter and the Sudan campaigns
is stark. Both were constructed in the British press as justified retali-
ation for actions not seen as of Britain's making. The first was a matter
of administering a short, sharp shock which took barely six weeks to
organise and seventeen days to execute and was carried out by a force
of 1,200 under the command of the Royal Navy and composed of the
Royal Marines and the African soldiers of the Protectorate – a classic
example of one of Europe's 'small wars' in Africa;[15] the second, by

comparison was a long, drawn-out affair which lasted for two years from 1896 to 1898 (or, arguably, the thirteen years since Gordon's death) with an army of Egyptian, Sudanese and British soldiers, some 25,000 strong. Attention to the events was constructed in different ways at home. Benin featured in the press and the public imagination for the first few months of 1897, and the expedition proceeded without an entourage of reporters, some arriving in West Africa only after the event, enabling a special supplement in the *Illustrated London News* (*ILN*) on 27 March 1897, a further six weeks after the fall of Benin City.[16] Omdurman had a much longer run-in, gathering pace through 1898 with reporters called back to Egypt from covering events in Cuba and the North-West Frontier and culminating in a storm of first-hand reporting and interviews with the soldiers involved, supported by cinematic, photographic and drawn images as soon after the battle as material could be got back to the metropole. The Queen sent a message of congratulations to the participants in the taking of Benin City, but it is not certain that any of the Africans involved with the expedition were included in the pageantry surrounding the diamond jubilee later that year; and otherwise there was no elaborate homecoming, and knighthoods were only granted to the two leading coordinators, Rear-Admiral Rawson and the Commissioner and Counsel-General of the Niger Coast Protectorate, Ralph Moor. Omdurman, by contrast, warranted a heroes' return, with the army brigades received at railway stations and marching through crowds of cheering onlookers. A range of medals, promotions and knighthoods were handed out and the Sirdar was ennobled with the title Lord Kitchener of Khartoum (widely shortened to 'K of K'). A significant part of the booty from Benin City was sold off to defray costs, finding its way, thereby, into museum collections worldwide; parts of the Sudan booty were put on public display as soon as it was brought back, not in an auction house, but in the Banqueting Hall in Westminster and these ended up in domestic trophy cabinets, officers' messes, regimental displays throughout Britain and what became the National Army Museum (NAM) and the Royal Collections. Yet, paradoxically, it is the objects from Benin City which are by far the more celebrated (and coincidentally, the subject of active repatriation debates); those from Omdurman are numerous, but largely predictable prizes of battle. The contrasting biography of one haul led to it coming to be regarded as 'art'; while the other remained as 'trophies'. The abiding image of the Benin Punitive Expedition is a photograph of the British participants relaxing among the quantities of objects (said to number around 4,000 in total) assembled in front of Oba's palace; the vast paintings of the battle scene are the most memorable representation of Omdurman.

War booty

Arguably, the basis of these contrasts lies in the essentially divergent character of each conflict: one was an expedition organised to a large extent locally within West Africa by the immediate colonial agents, albeit legitimised (in British eyes) by a proclamation from the Queen; the other was a full-scale campaign, a matter of explicit official government policy motivated by a long-standing sense of national grievance. The fact that one was conducted by sailors and marines with African soldiers and the other by an Anglo-Egyptian army is perhaps less important than the contrast in military styles and expectations of the opponents in Nigeria and Sudan. This in turn is reflected in the spoils of each and what their fate was to be.

The Benin expedition encountered a constant series of ambushes and skirmishes as it advanced through the bush from the point of landing in the rivers nearest to the city. But none of the accounts record any set-to battles and, unlike Omdurman, there was no single battlefield as such. Indeed, as the defending Benin forces attacked from the deep bush on an attack-and-run basis, usually firing on the head of the British military column before dispersing in the undergrowth, very few Edo dead were actually found. And on arrival the city itself was largely undefended, the Oba, his chiefs and a significant part of the population having fled. On arrival, there was no general looting in Benin and individual sailors, marines and soldiers did not, as far as is known, seize booty on their own account, though officers certainly did. In an odd article by an otherwise respected British Museum curator, William Fagg, it is argued that the city was not sacked.[17] This fails to acknowledge the burning of significant parts of the city deliberately and by accident.[18] It is certainly the case that there is a conspicuous absence of the quantities of trophies usually carried off as loot by the common soldiers (or in this case sailors and marines) of the victorious side. There was, of course, 'official' booty: the 900 to 1000 plaques which were subsequently sold off; and there was less official booty: the remainder of the objects – many pictured in the famous photograph – which were divided up between the officers. Nonetheless, the process of taking loot, which was usual at the time, appears more disciplined and less triumphalist than occurred a year later in Sudan. Military hardware, the stock-in-trade of most military campaigns of the period, was by comparison very limited, largely because of the nature of the encounter.

The terms of military engagement at Omdurman were known to both sides and the material culture of warfare was somewhat similar. The difference was in the devastating efficiency of firepower of the Anglo-Egyptian forces, particularly the availability of the new Maxim

guns, compared to the Mahdist reliance on sword and spears, with rifles captured in an earlier campaign kept in reserve as a back-up.[19] Earlier skirmishes and battles had already familiarised each side with the kinds of military tactics the other might be expected to adopt. Further, the very arrangement of buildings in Omdurman itself would have had a familiar ring. The two most famous former Austrian captives of the Mahdists, Father Joseph Ohrwalder and Rudolf Slatin (the autobiographical accounts of both having been translated by Kitchener's Head of Intelligence, Reginald Wingate, and published to popular acclaim before Omdurman),[20] each described the quarter of the town near the Khalifa's palace. There was an arsenal – the Beit el Amana – in which were kept guns, rifles, ammunition 'and other warlike material'.[21] Next door was the storehouse for the flags of all the Emirs residing in Omdurman, and next to that a semi-circular building for the Khalifa's war drums.[22] The complex was completed with a 'small-arms manufactory'.[23] From his time in captivity, Ohrwalder also describes a trophy house (or 'museum' in Wingate's translation) – Beit el Antikat – in the same part of the town containing the Mahdist loot, principally from their campaigns in Darfur, Egypt and Ethiopia.[24] Such Mahdist booty was held in a common hoard by the Treasury to be auctioned off or distributed as gifts; looting for individual gain was punishable by death.[25] The whole complex reads like a description of a British regimental headquarters. There was a general symmetry between the two opposing forces and their expectations which was largely lacking in the Benin expedition a year earlier.

There are a number of contemporaneous photographs and drawings in the various eyewitness accounts of the Sudan engagements the following year which are usually captioned 'Loot'[26] and a number of reports of what was acquired and how. Flags, drums, weapons and *jibbahs* (Mahdist tunics) are virtually the only objects that appear in these images and in the reports. Clearly these are the things that would be found on the battlefield. A similar cargo of 'trophies' was retrieved from Omdurman itself. On entering the city as the retreating troops there had been defeated, Kitchener indicated that the occupying forces would not engage in killing if the remnants of the Khalifa's army gave up their weapons. As Churchill reports, several hundred of the Ansar (the Mahdist troops referred to as 'Dervishes' in British sources), together with several Emirs, submitted to his cavalry unit alone, so overloading them with spears and swords that 'many interesting trophies had to be destroyed'.[27] Beyond that, Sudanese camp followers brought large numbers of objects from the battlefield for sale to the troops once established in Omdurman. Ernest Bennett, a special correspondent for the *Westminster Gazette*, lists the objects offered to

him: 'Huge shields of hippopotamus hide, spears, swords, old rifles, Mahdist coins and other trophies of battle or pillage'.[28] He was also offered chain mail armour which was priced at twenty-five shillings and quantities of *jibbahs* – after all, he remarks 'there were nearly eleven thousand of them available for selection on the sandy plain three miles away'.[29]

That leaves the question of what was taken from the city itself, and in particular from Omdurman's equivalent of the Oba's palace complex in Benin: the Khalifa's residence, the associated complex of buildings and, finally, from the Mahdi's tomb. Unlike Benin, the answer would appear to be very little. But this may not have been wholly a matter of restraint. Churchill visited the Khalifa's house and reported: 'What its contents may have been, it was impossible to say. The whole place was picked clean, and nothing had escaped the eye of the Sudanese plunderer.'[30] Whether this refers to the occupants of the city or the Sudanese troops within Kitchener's army is unclear, though it is known that the Sudanese troops, too, were very active in collecting booty from the battlefield itself. On the other hand, the top of the Mahdi's tomb, which had been blown off, was taken together with what is thought to be part of the surrounding railings, and both are now in the British Royal Collections.[31]

Finally, there is one mysterious object whose association with the Battle of Omdurman has until now seemed somewhat tenuous: it was always assumed that it came from the Khalifa's quarter of Omdurman, yet the circumstances and exact place of its acquisition had remained a mystery. It is also puzzling in other ways. The object is a large and heavy wood slit gong – that is, a drum with a slit along the top which is sounded by beating the sides. This is distinctively different from the kettle-style drums with a rounded bowl-like base, sounded by beating the skin stretched over the top – the kind otherwise used by the Mahdists. The large wooden example is, by contrast, in the form of a 'bushcow' and not far short of life-size. Clearly the aniconic traditions of Islam place its origins outside the realms of the Muslim world; this slit drum is in fact closest in style to those found in the Niger–Congo watershed area in the south-western margins of what is now the Republic of South Sudan. It has, however, carved Islamic motifs on the flanks: one side carved in high relief, the other inscribed, giving it a lopsided appearance and rendering it capable of giving two different tones when beaten.

There are discussions of war drums and, in particular, the 'great war drum' of the Khalifa found in the arsenal at Omdurman and mentioned though not described by, for instance, Churchill.[32] The bushcow drum is far too unwieldy to have been used on the battlefield itself. Its form

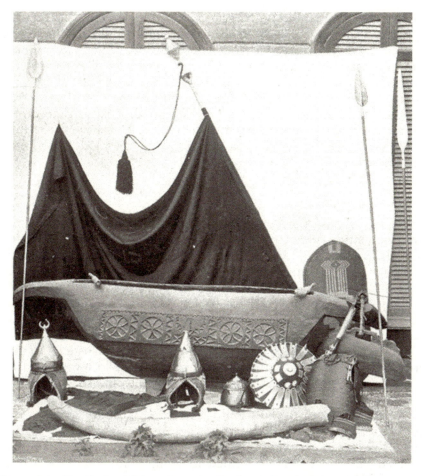

Figure 2.1 The 'high-end' loot from the Battle of Omdurman including the large black flag of the Mahdists, the bushcow drum and other iconic objects. The presence of a Japanese cuirass (in the Royal Collections) is puzzling. The photograph may have been taken in Egypt.

diverges radically from those otherwise being collected such that it might be expected to have occasioned comment – as, for instance, did the oddity of a much more mundane find in the Omdurman arsenal: a wooden provision box containing tins of sardines and potted meats wrapped in a Belgian newspaper (which leads Churchill to speculate it too had come from somewhere closer to the Congo).[33] However, a photograph in *The Navy and Army Illustrated* (5 November 1898, p. 165) and probably taken in Egypt shows what might be called high-end war trophies from Omdurman (Figure 2.1).

It includes the famous Mahdist black flag (described in the original caption as 'The Death Flag'), Persian-style helmets, shields (including one in the style of the Azande from the South Sudan), an ivory trumpet sounded in battle and the drum in the form of a bushcow together with two beaters resting on the top. Although not described by those who saw it *in situ*, it is identified unequivocally in the text that accompanies the photograph as 'the great war drum of the Khalifa'. The drum, like the black Mahdist standard and other pictured objects, was ultimately presented to Queen Victoria for the Royal Collections by the then Lord Kitchener.

Flags

Among looted objects there is only one item associated with the 1897 Benin expedition which apparently parallels those that were acquired on the battlefield in Sudan in the following year. This is a flag now in the National Maritime Museum, generally referred to as the 'Flag of the Benin Empire' and said to have been collected by Admiral F. W. Kennedy, a participant in the Punitive Expedition. The flag itself shows two upright figures in white against a red background, one decapitating the other with a sword (Figure 2.2).

The whiteness of the figures is suggestive of Europeans and, to that extent, would seem to represent an incongruous Edo reversal of the dominant narratives of Europeans about practices in the kingdom of Benin. However, it is a unique object which does not appear to be otherwise referenced in the often detailed first-hand accounts of the expedition by its members;[34] additionally, flags do not otherwise appear to have been used by the Edo. This has led to the suggestion that it was collected among one of the intermediate groups with whom the expedition would have come into contact en route to Benin City, notably the Itsekiri, who held a significant role as middle men in relations with Benin. There was a Lieutenant F. W. Kennedy on the Benin expedition, who was mentioned in despatches and subsequently received a Benin clasp on his existing Africa medal.[35] However, in the main account of the expedition it appears that he was stationed at Sapele in order to secure an important port town in the Niger Delta during the expedition rather than being a member of the force which proceeded to Benin City itself.[36] Sapele is a Urhobo town, though the Itsekiri had a controlling role over the rivers at the time. In terms of subject it also bears comparison with the flags of the Asafo companies, military organisations among the Fante, a coastal people in what is now Ghana. That said, flags are a standard battle trophy and might have been expected among the booty brought back from Benin. If it is not of Edo origin, it is arguable

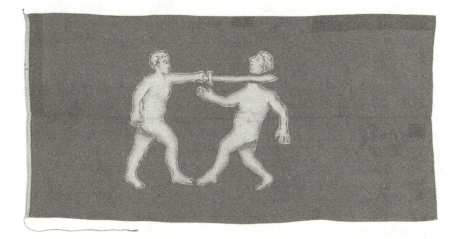

Figure 2.2 The so-called 'Flag of the Benin Empire', an ensign likely to have been used on local boats in river creeks distant from Benin City, reinterpreted as a battlefield prize consistent with European expectation of the trophies. Acquired in 1897.

that its ability to function as an icon of the Benin expedition – linked, albeit ironically, to European narratives about human brutality in Benin itself – made the association *appear* appropriate, and it has stuck.

By contrast, flags were among the most prized objects collected at Omdurman. The Ansar were divided into three major sections each under its own standard distinguished by their colours – black, green and white. But, within each, different units were also identified by their own flags.[37] As the Ansar numbered, it was estimated by Kitchener and Wingate, over 50,000 fighters, there were many hundreds of flags deployed in the battle. Descriptions of the manoeuvres of those who participated are as much in terms of the movements of flags as of warriors. As but one example, a letter home from a Lieutenant Hamilton Hodgson reads:

> 6.45. [am.] We opened fire with rifles just then, the Khalifa's black flag and a mass appeared round the cliff side just in front of us.
> One tribe of these bearing a yellow flag, got it down within 300 yards of our Zareeba . . . I was watching them occasionally with my glasses. I could never have imagined anything as cool and brave as those men were, especially one, the last but one to fall; he had been wounded in his arm and limped, yet his ambition was to get the flag, and he got it and carried it some 50 yards in a sort of slow trot, when he was shot, and as he fell his companion took it and came on a few yards only, when he fell, with the flag. I was sorry for these men, they were simply wiped out.[38]

Lieutenant Hodgson's admiration for the courage and sacrifice of the foe was based on a common understanding of the significance of the flag: it represented the soldiery; its fate was that of those who served under it; and its acquisition represented the opponents' acquiescence.

During the combat itself the Khalifa's Ansar army assembled in three sections, each under its own commander with its appropriate standard. Towards the end of the battle the black standard troops remained to be defeated, the flag indicating the presence of the Khalifa. It was eventually discovered fluttering above a mound of dead soldiers, the Khalifa having fled first to the relative security of his palace in Omdurman and, as the Anglo-Egyptian troops threatened to take the city, into the countryside where he rejoined the remnants of his army. When Kitchener entered Omdurman, it was with the captured Khalifa's large black flag unfurled behind him to which three former soldiers of the Khalifa surrendered pleading for the lives of the soldiers and people of Omdurman to be spared, their *jibbahs* turned inside out and bearing a white flag.[39] On their being reassured that clemency would be shown, the submission of the city was swiftly achieved, and Kitchener was given 'the keys of the gates' by an elderly Emir.[40]

There were in fact not only many flags captured in the battle but also a number which have been described as the black standard. Two are in the NAM, where they are catalogued as such though neither is of the size of the Khalifa's flag, and neither is actually black (though one has a black border). They are, however, likely to have been associated with the black standard troops as a division within the Khalifa's army rather than being *the* black flag itself. The division's significance is clearly greater because of its specific association with the Khalifa himself, just as the flag itself is considerably larger than any of the others. The Khalifa may have escaped for the time being, but possession of his black standard was as significant a token of his defeat as the taking of heads in other battles. Indeed, given the emphasis on revenge for Gordon's fate, the capture of flags bears a metonymic relationship to his demise. Taking the black flag can itself be interpreted as an equivalent to decapitation. An undated painting in the Royal Collections by the Scottish artist William Gibb[41] draws together the references, showing 'The Khalifa's Flag. The Jibbah Worn by his Son. An Ancient Helmet Worn by the Kings of Darfour'.

Skulls

Great play was made of the practice of human sacrifice in Benin City, replicating the macabre tropes widely spread about the kingdoms of Asante and Dahomey elsewhere in West Africa. Reports in the *ILN* and

other papers, or the accounts subsequently published by those who were there,[42] dwelt extensively on the gruesome details. Graphic reports of corpses by the wayside, of the resulting stench and of open pits where bodies had been deposited were all widely circulated. There probably was an increase in human sacrifice as the Benin expedition's approach to the city became known. The anthropologist Michael Rowlands has argued that this represented a traditional response to challenges to the stability of the kingdom. The retribution anticipated after the attack on Phillips's mission a few weeks before was expected to include a challenge to the power of the Oba himself. In that context, human sacrifice was more than a ritual formula to be carried out at moments of general uncertainty; it is seen as a response to specific historical circumstances which might include potential invasion by an external power.[43] The blood the invading force found on the so-called 'ju-ju' shrines – in fact ancestral shrines – was assumed to be human blood rather than that of sacrificed animals. The 'crucifixion trees' were blown up (and within a few months the space where one had been was, improbably, turned into the green of a golf course created in Benin City by British administrative officials).[44] And, although the remains of Phillips were not discovered, his possessions were found in the capital. It was assumed that he was likely to have been decapitated, as reported (to have happened to others who were killed) by one of the two members of the initial expedition who escaped.[45]

In Omdurman, the most vivid accounts of life in the Mahdist stronghold – those of Slatin and Ohrwalder – both record the practice of beheading the leaders of defeated enemies. Of these, the treatment of the corpses of two Christian celebrities is particularly significant in setting the scene for what was to follow the defeat of the Khalifa and his flight from his stronghold. Slatin records his horror at being shown Gordon's head, unwrapped from a bloodied cloth for him to see, as it was being taken to the Mahdi.[46] Later, in 1889, the body of 'King John of Abyssinia' (Emperor Yohannes IV of Ethiopia) was brought to Sudan. This followed what was a failed Mahdist campaign in military terms but which did lead to the death of the emperor and ultimately the capture of his corpse as it was being taken by his own troops for burial. On being brought back to the Mahdi, the head was separated from the body and displayed in Khartoum on a pike.

However, if, as with Benin, this sets up a distinction between civilised and uncivilised practices, converting an act of avowed revenge into something closer to a crusade, the fate of the Mahdi's skull subsequent to the Battle of Omdurman adds nuance to such a characterisation. The Mahdi had died within a few months of the murder of General Gordon and was buried in Omdurman. His successor, the Khalifa, set about

[51]

building a magnificent tomb over the gravesite, drafting in the most experienced architect and builders to construct a huge domed structure said to be visible from a distance equivalent to 'three day's journey'; 'rising high above the miserable mud hovels and straw huts', it was 'certainly the tallest of all the buildings in the Sudan'.[47] The Mahdi's tomb had become a place of pilgrimage: 'a visit to his tomb was said to confer even greater benefits than the pilgrimage to Mecca', even if the ceremonies occasioned by a visit to the Kaaba were not performed.[48]

With the fall of Omdurman, Kitchener moved quickly to have the tomb itself destroyed and the body of the Mahdi exhumed. In parallel, a form of memorial service was arranged in Khartoum near the steps of Gordon's former residence, scripted by Kitchener himself and witnessed by a large assembly of the troops. The Union Jack and, alongside it, the Egyptian flag were unfurled; 'God save the Queen' and Gordon's favourite hymn, 'Abide with me', were sung; and Handel's death march and a Scottish lament were played (the latter on the bagpipes); there were readings from Scripture and a benediction. In a carefully choreographed sequence of counterpart events the desecration of the Mahdi's tomb in Omdurman was combined with an honouring of Gordon at the place of his ultimate demise in nearby Khartoum. Queen Victoria wrote in her diary of 'a touching account' she had received from Kitchener 'of a memorial service held to the memory of poor Gordon on the spot where he was killed!'[49] This calculated scene-shifting has about it the symbolic structure of a Shakespearean drama. We might say that Kitchener's acts had sought to depersonalise the Mahdi at the same time as a ceremony was organised to re-personalise Gordon. The defiling of the Mahdi's remains was succeeded by the reinstatement of Gordon as a revered epitome of the imperial ideal.

But there is also a Yorick-like moment (albeit not so poignant) that concluded this calculated piece of theatre. Kitchener went further and arranged for the excavated torso of the Mahdi to be thrown in the Nile – again, replicating what had happened to Gordon. The question of what to do with the skull remained. Churchill recorded his version of what happened:

> The head was separated from the body, and, to quote the official explanation, 'preserved for future disposal' – a phrase which must in this case be understood to mean, that it was passed from hand to hand till it reached Cairo. Here it remained, an interesting trophy, until the affair came to the ears of Lord Cromer, who ordered it to be immediately reinterred at Wady Halfa [a Muslim cemetery] ... Such was the chivalry of the Conquerors![50]

As 'an interesting trophy', it is rumoured that Kitchener had it in mind to repurpose the skull for use as his personal ink-well. For

Churchill, not an uncritical admirer of Kitchener, this was clearly a step too far, as it was for Lord Cromer, the British Controller-General in Egypt and, no doubt, for the Queen also, who found the whole process of tampering with enemy graves distasteful, subsequently writing that they should be respected.[51] If Kitchener's intended scenario smacked of unwarranted triumphalism, it was arguably in part because it commodified the skull of a vanquished foe, thereby removing any semblance of personhood from the most personal of all potential booty. In a thorough study of late Victorian military practices, the anthropologist Simon Harrison has argued that a nineteenth-century scientific interest in phrenology combined with game-hunting practices extended to the battlefield and gave a sense of legitimacy to the appropriation of human body parts as trophies. Where the propaganda supporting the necessity of military intervention highlighted the primitive emotions of uncivilised opponents, such nobler purposes mitigated what might otherwise be interpreted as an equally primitive response in the taking of enemy skulls.[52]

While it may be little consolation to the defeated or their descendants, displaying war mementoes in a trophy cabinet does at least endow them with some, albeit dubious, honour. Converting body parts into a utilitarian object, on the other hand, eradicates any lingering sense of their original personhood or inalienability, denying even muted respect to a worthy opponent. Rather, it is a statement of total domination and complete disdain. Such acts led Churchill to a radical reassessment of the Mahdi himself. He went further than most on the Anglo-Egyptian side in describing the Mahdi as 'a man of considerable nobility of character, a priest, a soldier, and a patriot'.[53] His supporters deserved respect, which the killing of the wounded on the battlefield and the desecration of the Mahdi's tomb – let alone his physical remains – denied them.

Destinations

Such ambiguities underlie much of the response to the two campaigns. Both opponents were depicted as gruesome in the various reports circulated about Benin and Omdurman – imbued with brutality regarding Benin and blind fanaticism in the case of the Mahdists. These traits could be presented in the press at home as justification for intervention: humanitarian if possible; military when clearly it was not. In such characterisations, it is not immediately easy to detect the kind of emphasis on establishing equivalences of status rather than differences of race that, for instance, David Cannadine finds in the ideas of empire illustrated especially in the history of British India.[54] The Oba of Benin was far from being seen as having equivalence to the British aristocracy

and was quickly despatched into exile in Calabar, Nigeria – a fate meted out shortly before to Prempeh I, the *Asantehene* (the king of Asante in Ghana) and shortly after to the Kabaka Mwanga II of Buganda and his neighbour the Omukama Kabalega of Bunyoro, both from East Africa. All three were sequestered on the Seychelles in the Indian Ocean. The Khalifa, for his part, was hunted down and killed in battle the year following Omdurman. The story of empire-as-durbar (part of what Cannadine shrewdly styles 'Ornamentalism') gives a very different perspective from empire-as-battlefield. There are few obvious African versions of the kinds of potential relationships which gave Paul Scott the themes of his *Raj Quartet*.[55] But Cannadine's point is that there were many different versions of the British Empire, and this perspective should alert us to the ambiguities and inconsistencies in any single portrayal.

There were surprises in both Benin and Omdurman. The loot found in the Oba's palace was hard to associate with the kind of polity that indulged in widespread human sacrifice and crucifixion trees.[56] The very skill evident in their making suggested to Victorian observers a level of technical sophistication that could not easily be equated with the evidence in the British press suggesting the opposite: a lack of all appropriate indicators of cultural achievement. In analysing the agency of objects, Gell argues that their ability to produce an emotional effect is related to a degree of astonishment at how they could have been created in the first place.[57] In the case of the artworks from Benin, the captive object was at the same time indisputably captivating. If a late Victorian viewer could not imagine achieving the level of technical ability needed to create such things in an industrial age, how could someone from within the Edo Kingdom possess such virtuosity? Indeed, for a long time it was (wrongly) assumed that external influence must have been involved.

The objects from Omdurman were similarly provocative. The letter home penned by Lieutenant Hodgson already identifies what for many of the Anglo-Egyptian forces was a common reflection: that the followers of the Khalifa displayed the sort of courage that made the Mahdists worthy opponents. The objects assembled in the Banqueting Hall in November 1898 and acquired during all the campaigns that culminated at Omdurman included *jibbahs*, the chain mail and helmets reminiscent of Crusader-period armour, padded clothing for cavalry and their horses and the metal top of the Mahdi's tomb. But these were not anonymous objects. They were re-personified in a very specific context, the starting point for narratives about the Mahdists as brave, if misguided, opponents. There were, then, contradictions thrown up by the objects brought back from each military conflict:

barbarism, it seemed, begat elegant bronzes; fanaticism begat unsurpassed bravery in service to the Mahdist standard, represented literally by the many flags and banners brought back and distributed principally among the different army regiments.

Such ambiguity is also present in the ways the war booty was regarded. Two processes seem to be at work: one led to commodification in which the subjectivity of the object is transformed through its transposition into a different regime of value; the other retains reference to its original owners (or makers), whose personhood continues to be regarded as invested in objects associated directly with them. The most obvious expression of the first is the dispersal of the Benin loot through the market compared with the volume of Omdurman-provenanced objects that ended up in military museums throughout the UK. It was, of course, always intended that some of the booty from Benin would be dispersed in this way. But a significant proportion of the objects collected were also retained by those involved in the expedition as personal property, finding their way to the auction houses or by donation to museums separately, and often much later. Their 'value' in those cases was determined not by association with the Oba so much as by their provenance in the infamous events of January and February 1897 and their association with named officers of the British expedition. To the present day, auction catalogues highlight the captor of the object as the rationale for the valuation attached to it.

The looting at Omdurman led to many objects being retained by participants as personal trophies. Many of the objects displayed in 'the Dervish Trophies' exhibition in the Banqueting Hall were lent by officers in the Sudan campaigns. *The Times* advised its readers 'to avail themselves of this opportunity of seeing the *jibbahs*, barbaric weapons and quaint armour . . . before this collection is once more scattered'.[58] The display also included a particularly notable 'trophy': 'one great black standard, riddled with bullets', presumably the Khalifa's black flag subsequently presented to Queen Victoria. Each object possesses an explicit connection to the defeated Islamic forces and sometimes to known individuals; their capture and removal is a form of dispossession, an eradication of their original agency, just as their owners had been divested of military and political efficacy in their defeat. None the less, as 'trophies' they continue to objectify the absent person to whom they formerly belonged. Almost all the objects from Omdurman (and the earlier Sudan campaigns) which were incorporated into the Royal Collections are likewise identified with named Emirs, if not the Khalifa himself, including fragments of the Mahdi's tomb, a Qur'an formerly belonging to the Khalifa and the *jibbah* of the Khalifa's son, who died in the battle. The Queen was also shown objects when visited by members

of the expedition, notably the Khalifa's seal and 'very ink' used in issuing proclamations, both contained in an old watch, and in the possession of Sir Reginald Wingate.[59] By contrast with the objects from Omdurman, the Royal Collections received only a single donation from the Benin expedition – the extraordinary pair of ivory leopards which were presented to the Queen by Admiral Rawson and subsequently (in 1924) placed on long-term loan in the British Museum. Although readily identified directly with the Oba of whose power they are emblematic, this association was not a prominent part of its documentation.

But not all the Omdurman booty was so susceptible to the dominant narrative. One discordant object is the bushcow war drum.[60] It was – like other significant objects – presented to Queen Victoria by Kitchener, but the fact that it was the 'great war drum of the Khalifa' was not recorded. And, although the Queen was an assiduous diarist and gives a number of accounts in her journals of meetings with the Sirdar in late 1898, the slit drum is not specifically mentioned. A large sculpted bushcow seems to have escaped comment; yet she records making a special visit to the dairy farm at Windsor Castle to view another of Kitchener's gifts: a 'beautiful, very large Egyptian donkey'.[61] Having been overlooked for several decades after her (and Kitchener's) death, the slit drum was eventually given to the British Museum as a royal gift by King George VI in 1937. The object had not attracted comment because it did not fit the relevant narrative – the reverse of the scenario that led to the 'Flag of the Benin Kingdom' being presented as authentic when there are reasons to doubt its association with the Edo peoples. The slit drum resurfaced not because of its provenance within Islamic Sudan, but because it was a depersonalised example of artwork representative of the far distant equatorial forests.

Acknowledgements

A number of people have helped with aspects of the research on which this essay is based. I would like to thank, in particular, Rachel Peat at the Royal Collections, Robert Fleming at the NAM, Julie Hudson at the British Museum and Kathy Curnow for discussion of the probable origins of the 'Flag of the Benin Kingdom'.

Notes

1 A. Gell, *Art and Agency: An Anthropological Theory* (Oxford: Clarendon Press, 1998).

2 A. Gell, 'The Technology of Enchantment and the Enchantment of Technology', in J. Coote and A. Shelton (eds), *Anthropology, Art and Aesthetics* (Oxford: Clarendon Press, 1992), pp. 40–67. For an overview of the development and nuances of this

relationship between persons and things see J. Hoskins, 'Agency, Biography and Objects', in Tilley et al (eds), *Handbook of Material Culture* (London: SAGE, 2006), pp. 74–84.

3 A. Appadurai, *The Social Life of Things: Commodities in Cultural Perspective* (Cambridge: Cambridge University Press, 1986); I. Kopytoff, 'The Cultural Biography of Things: Commoditization as Process', in Appadurai (ed.), *The Social Life of Things*, pp. 64–91.

4 N. Thomas, *Entangled Objects: Exchange, Material Culture, and Colonialism in the Pacific* (Boston MA, London: Harvard University Press, 1991).

5 D. Parkin, 'Mementoes as Transitional Objects in Human Displacement', *Journal of Material Culture*, 4:3 (1999), 303–20.

6 In contemporary situations the repatriation of some such objects is increasingly sought in order to redress the historic abduction that has taken place.

7 Appadurai, *The Social Life of Things*.

8 K. Jacobs and C. Wingfield, 'Introduction', in K. Jacobs, C. Knowles and C. Wingfield (eds), *Trophies, Relics and Curios? Missionary Heritage from Africa and the Pacific* (Leiden: Sidestone, 2015), pp. 9–21 (pp. 9–14).

9 Commander R. H. Bacon, *Benin: The City of Blood* (London: Edward Arnold, 1897), p. 131.

10 Captain A. Boisragon, *The Benin Massacre* (London: Methuen and Co., 1897), p. 90.

11 'The Benin disaster', *The Times* (13 January 1897), p. 3, available at *The Times Digital Archive 1785–2013*, www.gale.com/intl/c/the-times-digital-archive, accessed 29 April 2019.

12 As quoted in D. Blair, 'Voice from the grave is Sudan's hope for the future', *The Daily Telegraph* (20 August 2004), www.telegraph.co.uk/archive/2004-8.html, accessed 29 April 2019.

13 D. Johnson, 'The death of Gordon: a Victorian myth', *The Journal of Imperial and Commonwealth History*, 10:3 (1982), 285–310.

14 W. S. Churchill, *The River War: An Historical Account of the Reconquest of the Soudan*, edited by Col. F. Rhodes, 2 vols (London: Longmans, Green and Co., 1899), II, p. 206. The statue of Gordon was taken down in 1943 and, after an intervention by Churchill as Leader of the Opposition, was re-erected in Victoria Embankment Gardens near Westminster Bridge and the Houses of Parliament in 1953.

15 Coincidentally, the commander of the Benin Punitive Expedition, Rear-Admiral Rawson, was also the person in charge of what has been described as the shortest war in history – the thirty-eight to forty-minute bombardment of the palace in Zanzibar's old town five months earlier which rapidly led to the Sultanate's surrender.

16 See 'The Benin Expedition', *Illustrated London News* (*ILN*) (27 March 1897), available at www.gale.com/intl/c/illustrated-london-news-historical-archive, accessed 29 April 2019.

17 W. Fagg, 'Benin: The Sack That Never Was', in F. Kaplan (ed.), *Images of Power: Art of the Royal Court of Benin* (New York: The University, 1981), pp. 20–1.

18 As documented in Bacon, *Benin*, Chapter 8, and as pointed out in E. Eyo, 'The dialectics of definitions: "massacre" and "sack" in the history of the Benin Expedition', *African Arts*, 30:3 (1997), 34–5.

19 I. H. Zulfo, *Karari: The Sudanese Account of the Battle of Omdurman*, trans. by P. Clark (London: Frederick Warne, 1980), Chapter 9.

20 Father J. Ohrwalder, *Ten Years' Captivity in the Mahdi's Camp, 1882–1892*, redacted from original manuscripts by Major F. R. Wingate (London: Samson Low, Marston and Co., 1892); Colonel Sir R. Slatin Pasha, *Fire and Sword in the Sudan: A Personal Narrative of Fighting and Serving the Dervishes, 1879–1895*, trans. by Sir F. R. Wingate (London: Edward Arnold, 1905).

21 Slatin, *Fire and Sword*, p. 350; see also E. N. Bennett, *The Downfall of the Dervishes, Being a Sketch of the Final Sudan Campaign of 1898* (London: Methuen and Co, 1898), p. 226.

22 Slatin, *Fire and Sword*, p. 351.

23 *Ibid*.

24 Ohrwalder, *Ten Years' Captivity*, p. 213.
25 M. Asher, *Khartoum: The Ultimate Imperial Adventure* (London: Penguin Books, 2007), p. xxix.
26 Churchill, *The River War*, II, p. 209.
27 Churchill, *The River War*, II, p. 180.
28 Bennett, *The Downfall of the Dervishes*, p. 232.
29 *Ibid.*, p. 233.
30 Churchill, *The River War*, II, p. 209.
31 There appears to be no mention, curiously, of any 'trophies' that may have been collected for presentation to the Khedive (or Viceroy) of Egypt, Abbas II.
32 Churchill, *The River War*, II, p. 216
33 *Ibid.*
34 Notably Bacon, *Benin*, and the correspondents whose accounts are summed up in the *ILN* supplement of March 1897, available at www.gale.com/intl/c/illustrated-london-news-historical-archive, accessed 29 April 2019.
35 'Admiral F. W. Kennedy', Obituary, *The Times* (12 July 1939), p. 16, available at *The Times Digital Archive 1785–2013*, www.gale.com/intl/c/the-times-digital-archive, accessed 29 April 2019.
36 Bacon, *Benin*, p. 130.
37 For a more detailed description of the organisation of the Madhist forces see Zulfo, *Karari*, pp. 32–4.
38 Letter reproduced in P. Harrington and F. A. Sharf (eds.), *Omdurman 1898: The Eye Witnesses Speak. The British Conquest of the Sudan as Described by Participants in Letters, Diaries, Photos and Drawings* (London: Greenhill Books, 1998), p. 81.
39 Churchill, *The River War*, II, p. 173.
40 *Ibid.*
41 Among the works by William Gibb (1839–1929) is a set of 36 chromolithographs depicting 'Naval and Military Trophies and Personal Relics of British Heroes'. This was dedicated by permission to 'HM Queen Victoria' and dates from 1896. The Royal Collections picture is a later addition.
42 Boisragon, *The Benin Massacre*, for the initial mission and Bacon, *Benin*, for the punitive expedition itself.
43 M. Rowlands, 'The good and bad death: ritual killing and historical transformation in a West African Kingdom', *Paideuma*, 39 (1993), 291–301.
44 A correspondent writing from Benin to the journal *Golf: A Weekly Record of Ye Royal and Ancient Game* (18 June 1897), p. 295, reported that a nine-hole course 'which would compare very favourably with many British courses' was fully operational. The best green was that under what was, a mere two months earlier, a 'crucifixion tree' (as cited in M. Husemann, 'Golf in "the City of Blood": the translation of the Benin Bronzes in 19th Century Britain and Germany', *Polyvocia, The SOAS Journal of Graduate Research*, 5 (2013), 1–24).
45 Boisragon, *The Benin Massacre*, p. 102.
46 In fact the Mahdi was reportedly annoyed at Gordon's death, as he had instructed that Gordon would be of more use to the Islamist cause if captured alive, Zulfo, *Karari*, pp. 21–2.
47 Ohrwalder, *Ten Years' Captivity*, p. 275.
48 *Ibid.*, p. 278.
49 *Queen Victoria's Journals (QVJ)*, 5 September 1898, available at www.queenvictoriasjournals.org, accessed 29 April 2019.
50 Churchill, *The River War*, II, p. 212.
51 J. Pollock, *Kitchener: Architect of Victory, Artisan of Peace* (New York: Carrol & Graff, 2001), p. 150.
52 S. J. Harrison, 'Skulls and scientific collecting in the Victorian Military: keeping the enemy dead in British frontier warfare', *Comparative Studies in Society and History*, 50:1 (2008), 285–303; see also S. J. Harrison, *Dark Trophies: Hunting and the Enemy Body in Modern War* (Oxford: Berghahn, 2012).
53 Churchill, *The River War*, II, p. 212.

54 D. Cannadine, *Ornamentalism: How the British Saw their Empire* (London: Penguin Books, 2001).

55 Arguably, an exception is the largely positive reception of the Zulu ruler, Cetshwayo kaMpande in 1882, when he arrived in the metropole to plead for the restoration of his kingdom. Speaking English, he was described in the *ILN* as 'a fine burly man, with a pleasant good-humoured face, though almost black; his manners are frank and jovial, but still dignified, and he wears a European dress', 'Cetewayo in England', *ILN* (12 August 1882), p. 178, available at www.gale.com/intl/c/illustrated-london-news-historical-archive, accessed 29 April 2019. His petitioning was successful.

56 This has been much commented upon. Perhaps the fullest consideration is that by A. Coombes, *Reinventing Africa: Museums, Material Culture and Popular Imagination in Late Victorian and Edwardian England* (London and New Haven: Yale University Press, 1994), pp. 9–28.

57 Gell, 'The Technology of Enchantment'; Gell, *Art and Agency*, pp. 68–72.

58 'The Dervish trophies', *The Times* (21 November 1898), p. 12, available at *The Times Digital Archive 1785–2013*, www.gale.com/intl/c/the-times-digital-archive, accessed 29 April 2019.

59 *QVJ*, 5 September 1899, available at www.queenvictoriasjournals.org, accessed 29 April 2019.

60 J. Mack, 'The 'Omdurman' Drum', in Z. Cormack and C. Leonardi (eds), *Recovering Cultures: The arts and heritage of South Sudan in museum collections* (Leiden: Sidestone, forthcoming).

61 *QVJ*, 13 November 1899, available at www.queenvictoriasjournals.org, accessed 29 April 2019.

CHAPTER THREE

Collecting and the trophy

John M. MacKenzie

Hunting and mastery of the environment

Imperial expansion and a lust for possession inevitably go together. Such yearning for acquisitions can extend beyond that of territory and subordinate peoples into the symbolic accumulation of items emblematic of the natural world as well as of artefacts and art associated with those who have been conquered. Such a phenomenon can be identified throughout the long history of empires, involving the transportation of such materials to the imperial centre as symbolic of conquest and rule. In many ways, this reaches a great and alarming climax in the era of modern dictators from Napoleon to Hitler. It was no less true of the British Empire, where it took complex forms. Among these are environmental ambitions that lie at the heart of the acquisition of territories: the identification and exploitation of resources, the 'planting' of European settlers upon the land and the creation of commercial cities and ports, as well as the domination of pre-colonial peoples and their conversion to serving the interests of the newly dominant rulers. But they also involved a fascination with the flora and fauna of exotic lands. For example, from the late seventeenth century, botanists fanned out into new zones of contact to identify previously unknown plants and examine them for their economic or aesthetic value.[1] This developed greatly in the eighteenth and nineteenth centuries, when botanic gardens became important instruments of imperial understanding, control and development. Plant collectors became key figures in the unveiling of the floral riches of, for example, the Cape Peninsula of southern Africa, the Himalayan regions and China. British domestic gardens, as well as the grander floral displays of country houses, became in effect botanical world tours, as they have remained. Economic plant transfers, often effected in apparently secretive ways, became significant in the

development of colonial economies. Rubber and cinchona were only two of the most significant of these.

Imperial military officers, with their opportunities for travel to exotic parts of the globe in the British Empire, developed a considerable range of interests, including botany, forestry, antiquities, archaeology and, perhaps above all, hunting. In all of these, there tended to be a considerable interaction between imperial territories and the metropolis, particularly if senior members of the military inherited or acquired estates in Britain. Among all of these, animals were perhaps the subject of particularly intense fascination. The rest of this chapter is devoted to the examination of the military's relationship with hunting and the manner in which the resulting trophies became a significant aspect of collecting activities. These constituted at the same time souvenirs of service and of travels, markers of heroic expeditions and of dominance of the natural world and evidence of a deeper understanding of exotic fauna in the supposed pursuit of zoological science and of the competitive search for both a range of quarries and quarries of, hopefully, record dimensions, as well as a celebration of marksmanship and ballistics.

Such a fascination with exotic animals was of long-standing. It is well known that animals from Africa have been sent to Europe from Roman times.[2] In the late medieval and early modern period, such transported creatures were generally used as offerings for monarchs, while artefacts pertaining to such animals entered the cabinets of curiosities of the age. The pursuit of fur-bearing animals became central to the development of European contact with North America and the lore surrounding such hunting, and the relationships with indigenous peoples which it engendered became a central characteristic of artistic representations of the landscape, its inhabitants and resources in Canadian art. In India, the hunting of tigers, often in highly dangerous encounters, went back to the eighteenth century.[3] In the nineteenth century, however, the hunting of exotic creatures in the British Empire began to take on new forms. Whereas in the past Europeans had often used native peoples to do their hunting for them, partly because of the limitations of firearms technology, access to the major fauna of the natural world later became a perquisite of the imperial hunter. In India, *shikar* (hunting) became one of the most emblematic activities of imperial power (Figure 3.1).[4] It could be pursued at a whole variety of levels, starting with the relatively small-scale activities of the common soldiery, often causing significant tensions with local Indian populations, particularly when it involved the pursuit and killing of what were regarded as sacred birds such as peacocks or other animals. For officers, hunting (and sports like pig-sticking) came to be seen as a vital preparation for war: developing an understanding of environments, encouraging (in some settings)

[61]

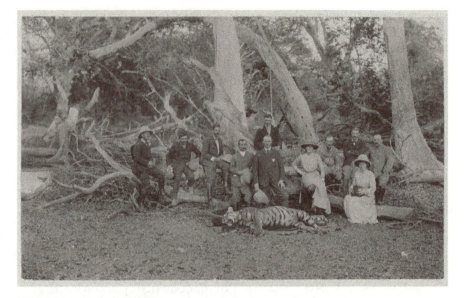

Figure 3.1 Tiger hunt, 1902. Photograph by Lala Deen Dayal, India, 1902.

courageous and expert horsemanship and of course developing marks-manship to a high degree.[5] These points were explicitly made in Robert Baden-Powell's book *Pig-Sticking or Hog-Hunting*, first published in 1889 and reissued in 1924, which has a section on 'Its value as a school for soldiers'.[6] Hunting was also pursued by civil officers, such as foresters, who had ready access to appropriate environments, and it additionally became a significant privilege of district administrators and, in major hunting expeditions, of senior imperial officials.

Army officers who were avid hunters often used their periods of leave to go on hunting expeditions, sometimes in the Himalayas or in other game-rich regions of India. Since the route to India lay round the Cape, many East India Company officers hunted on both sides of the Indian Ocean. Major Sir William Cornwallis-Harris (1807–48) was an East India Company military engineer who, after serving in India in 1823–36, went to the Cape to recover his health. There he encountered the distinguished military doctor, Andrew Smith (later Sir Andrew and regarded as a significant zoologist) and they went on a hunting exped-ition in the interior of southern Africa from 1837 to 1838. Roualeyn Gordon-Cumming (1820–66) served in the Madras Light Cavalry in 1838–43, after which he transferred into the Cape Mounted Rifles. He became one of the most celebrated, if not notorious, of hunters, known for his profligacy in killing. His extensive collection of trophies was

[62]

shown at the Great Exhibition in London in 1851, illustrated by a lecture on his exploits that he delivered in association with the display. Norman Magnus Macleod (1839–1929) served in the 74th Highlanders in India from 1848 to 1872. Moving on to southern Africa, he became a political agent on the Transvaal frontier and commanded a Swazi army against the Pedi people in 1879. An enthusiastic hunter, he made a large collection of trophies which he displayed at Dunvegan Castle on the Isle of Skye after he had become Chief of the Clan MacLeod.[7] Later in the century, another British Indian Army officer, Frederick Lugard (1858–1945), who served in India and Burma between 1878 and 1887, transferred to Africa and became a celebrated hunter as well as administrator (later Lord Lugard). Indeed, all the early governors in East and central Africa were notable hunters, sometimes masking their activities by insisting that they were naturalists.[8]

During this period hunting ceased to be a spontaneous and often opportunist activity and was transformed into a significant act of state authority. In the case of district officials, particularly in India, it was invariably portrayed as a means of protecting the people whom they administered (which generally meant a combination of the levying of taxation and the application of the law) from man-eating tigers or other big cats, alternatively in some areas from elephants who might devastate crops. When governors of specific provinces and governors general (from 1858 viceroys) went on hunting expeditions, shooting took on much the same aura as it had acquired under their Mughal predecessors. The latter were known to make major hunting progresses (leisurely expeditions) around their domains, and the British continued the tradition, often in the company of Indian princes. In the post-Indian Uprising period, the British were anxious to maintain good relations with the princely states and hunting became a major means by which they ingratiated themselves with these nominally independent rulers. Such hunting expeditions became a supremely public and visible imperial act, a means of dominating the environment, involving large numbers of followers, auxiliaries of the hunt, who were employed to track down the animals and beat them out for the guns. The progress was conducted with many animals, horses and elephants, to transport hunters, firearms and provisions (perhaps also tents) to facilitate reaching the areas where the hunt might be prosecuted. Many members of the gubernatorial and viceregal retinues were military officers, as guests or as aides-de-camp.

Hunting and trophies in British military culture

By the mid-nineteenth century, the results of such hunts, in tiger and other skins, in the antlers of deer and horns of antelopes or (to a lesser

extent) in elephant tusks, had become a central aspect, in effect, of a system of ceremonial exchange (particularly in relations with Indian princes), of trophy acquisition and of the appropriation of products of the environment for the purposes of interior decoration. This was true of colonies in Africa and Southeast Asia as well as in India. As imperial architecture embraced the institutions of the growing 'bourgeois public sphere', such as clubs, museums, hotels and the private homes of administrators and officials, such trophies became a ubiquitous feature of the imperial lifestyle. They were also often to be found in officers' messes in India, other colonies and in Britain, where they were often displayed in association with photographs of the officer-hunters who had shot the animals. Such photographs can still be found in officers' photograph albums in regimental collections (Figure 3.2). Thus, photography came to document the spread of such characteristic decoration, in the form of tiger-skin rugs, antlers and images of key moments in Indian *shikar* or African big-game hunting.

It is striking that by the 1860s hunting had become a central activity of royal tours, both in South Africa and in India. The tour of the youthful Prince Alfred in southern Africa (in 1860 when he was serving as a midshipman on HMS *Euryalus*) was punctuated by extraordinary hunting expeditions which resulted in the prolific slaughtering of African wildlife, sometimes of animals which were already becoming endangered through over-shooting. The tour of the Prince of Wales (the future Edward VII) in India in 1875–76 provided many opportunities for royal *shikar* on a grand scale and the appropriation (in effect) of the animals of the Indian environment became a perquisite of royal tourists. Such expeditions, in terms of the numbers of members of the retinue, the Indian hunters and large numbers of auxiliaries to beat out the prey, as well as the protecting escorts of soldiers and servants, began to take on the appearance of a military campaign. Hunting had indeed become the image of war. The visit of the Prince of Wales was punctuated by a great deal of military ceremonial in the various processions, as well as in visits to what the British regarded as key sites of the 1857 Uprising, as in Cawnpore (Kanpur). Such a phenomenon was to continue with all subsequent tours right down to the 1950s. When the Duke and Duchess of York (the future George V and Queen Mary) travelled round the Empire in 1901, to India in 1905 and again for the Delhi Durbar in 1911, a good deal of time was set aside for shooting and an interesting gendered distinction was introduced (earlier tours had been male-only affairs).[9] When the Duke went on his more or less lengthy hunting trips, the Duchess was taken on tours to cultural and historical centres, as well as to places of particular scenic interest. Similarly, royal tours in Africa, until well into the twentieth

[64]

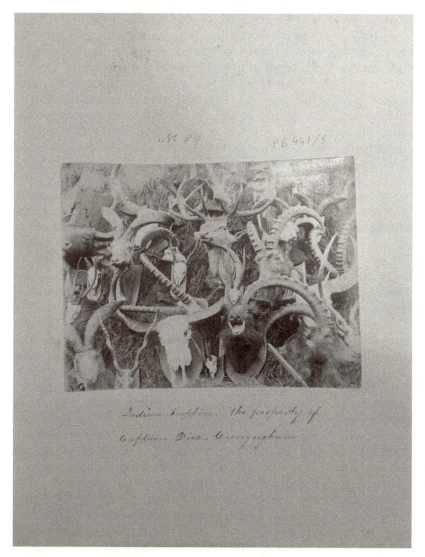

Figure 3.2 'Indian Trophies' of Captain Dick-Cunyngham VC, 2nd Battalion The Gordon Highlanders.

century, usually included big-game safaris, which linked the interests and tastes of the royal family to those of the aristocratic, gentlemanly officer class, members of which were always to be found in the accompanying suites of the royal tourists.

[65]

In these ways, the acquisition of the resulting natural trophies became almost a rite of passage for royal hunters, a source of ambitious trophy collecting which linked the royal family to the tastes of the imperial officer cadre. In all of this they were transferring to more distant and exotic locales an activity that symbolised the transformation of the Scottish Highlands (in deer-stalking and the collection of antlers or heads) into a hunting ground of royalty and other members of the British commercial and political elite, including off-duty military officers.[10] Antlers were removed from Scotland to grand English homes, as were not only skins, but also stuffed animals. Taxidermy became a classic commercial spin-off from the shooting exploits of the elites, with nineteenth-century directories indicating the wide distribution of the premises of taxidermists, particularly in hunting districts such as the Highlands of Scotland. Indeed, the cult of deer-stalking in Scotland became a vital aspect of upper-class life in the period, encouraged by the lifestyle of Victoria and Albert at Balmoral. This had both architectural and artistic dimensions, as indicated in the book *Deerstalking in the Highlands of Scotland* by Lieutenant-General Henry Hope Crealock (1831–91), who served in the 90th Light Infantry (the Cameronians) in the Crimea, China and India.[11] Crealock was himself a notable hunter, as well as an artist and naturalist, demonstrating the range of interests of many military officers. In the Highland hunting retreats of the elite, trophies (mainly of red deer stags, but sometimes of more exotic animals) became a significant aspect of interior decoration, often in hallways, banqueting halls or the halls in which tenant and servant balls were held.[12] Thus the owners of such lodges (often with military connections) indicated to their guests and tenants their expertise in the hunt and capacity to dominate the environment. All this was visually documented in the work of artists of the day, such as Landseer, as well as in such widely distributed images as railway posters.

The products of the dominant hunting passion in the British Empire and beyond also appeared in great Scottish houses and other buildings. In an age when elite travel by sea seemed to offer opportunities for the conveyance of large trunks and wooden cases of such products, the transfer of trophies and skins to the UK from India and elsewhere became both a practical and relatively common phenomenon. In some ways, such crates of trophies were the hunting equivalent of the booty of war being transported often at the same time. An excellent example is the Marquis of Tullibardine, heir to the Dukedom of Atholl, who brought back large quantities of military trophies from the Sudan campaign of 1896–98 to adorn Blair Castle in northern Perthshire, as well as the hunting trophies which were a key aspect of interior decoration of such great Highland retreats.

In Africa, such European hunting started out as the classic activity of the explorers of the continent in the period before the Partition, which started in the 1870s and accelerated in the 1880s. This shooting invariably had practical purposes in rather different ways than was the case in India. All travellers in Africa were required to be accompanied by large numbers of porters and other followers. In sub-Saharan Africa and in the region north of the more temperate zones of southern Africa, it was impossible to use horses because of the disease spread by the tsetse fly (*nagana*). Attempts at domestication of other animals for use in the continent, such as elephants or camels, failed. Human porterage was an essential aspect of transportation down to the physical appearance of railway lines, and indeed afterwards in respect of the more remote districts. Such a large number of people had to be fed and this necessitated the shooting of many animals to supply meat. Elephants, rhinoceros and hippos were an excellent source of large quantities of such protein, but they also provided 'trophies' which could help to finance the expeditions, particularly through sales of ivory. Indeed, in southern Africa many traders were active in operating as middlemen in passing skins, tusks, horns and other trophies into a wider market. There was thus an important commercial dimension. Meat hunting was also significant in the provision of a colonial infrastructure. The building of railway lines, roads and bridges required large numbers of workers, once again requiring to be fed.[13] These activities were invariably happening even as the era of African revolt and warfare, known to the propagandists of imperialism as the period of 'pacification', was still continuing. At that time, hunting and war could indeed operate in parallel. A good example is the Anglo-Ndebele war of 1893 and the revolt of the Shona and Ndebele people in what would become Zimbabwe in 1896–97.

Robert Baden-Powell, future founder of the Boy Scouts, published a book about the war in which he recounted operations in the suppression of the revolt as well as the intermittent hunting which occurred between violent encounters with humans.[14] Indeed he explicitly elided the hunting of animals with that of humans, an elision encapsulated in the title of one of his books, *Sport in War*. He wrote that 'The work involved in the military operations was sufficiently sporting in itself to fill a good measure of enjoyment coupled with the excitement incidental to contending with wild beasts of the human kind'.[15] Elsewhere he asserted that 'the longest march seems short when one is hunting', which he subsequently qualifies as being game hunting – whether of humans or animals.[16] Of all military hunters, Baden-Powell was one of the most influential, partly because he served and hunted in both India and Africa, publishing popular books on most of his experiences.

[67]

In 1908 he published *Scouting for Boys*, which launched the worldwide scouting movement. In the early editions, he emphasised the close relationship between hunting, understanding of the natural world and the importance of marksmanship in the training of young men for war. This was greatly toned down in later editions, particularly after the First World War when he began to emphasise nature study, conservation and the significance of 'shooting' with the camera.[17]

These descriptions of the hunting imperative within the imperial cultural, sporting and environmental complex give the impression that it was very much a male activity, part of the central masculine character of the extension of imperial power.[18] Some hunters indeed emphasised this, not only by describing the thrill of the chase in almost (or sometimes explicitly) sexual terms, but also stressing the fact that hunting etiquette generally placed a ban on killing the females or young of the species of prey that interested them at any given time. While there were some women hunters,[19] it was indeed the masculine values represented in the hunt and the close relationship with the military life that were invariably emphasised. It has, however, been demonstrated that indigenous peoples were more in control of the practices of the hunt than Europeans might have been prepared to recognise. African chiefs and hunting guides could direct white travellers where they wanted them to go and could sometimes set about furthering indigenous aims, in the freeing of certain areas of animals dangerous to humans or to crops, or in securing their own economic value from their participation as auxiliaries in the hunt. However, the opportunities for manipulation by Africans were much reduced once colonial power was fully established.

One of the prime hunting impulses was the search for the biggest and best trophies. The nineteenth century was not only an era in which taxonomy became a passion, it also became a highly competitive age. Just as sports were being extensively codified in this period and the statistics of sporting achievements assiduously noted and even published, so too did the measurements of animals (for example tigers in India) and of the trophies of antlers, horns and tusks come to be a source of careful recording. The principal leadership in this came from a London firm of taxidermists developed by Rowland Ward (1848–1912). Ward's family had already been involved in taxidermy and his father had opened the business in London in 1857, but it was Rowland who turned it into the most celebrated business in imperial hunting. It received the imprimatur of the royal family in 1870 when it secured the royal warrant, preparing specimens for the royal palaces. As a symbol of its prestige and elite connections, the business moved to Piccadilly.[20] Ward also turned it into a publishing house, issuing books

[68]

of hunting and travel. From 1892 he began to publish the *Records of Big Game*, which listed the biggest and best of all the animals in trophies to be encountered on a global scale. By this time, hunting had truly entered the contemporary fascination in the keeping of statistics, the maintenance of records and the stimulation of the search for the finest of specimens, encouraging the elite passion for emulating or surpassing the trophies of competitors. Trophy hunting had been transformed from a practical activity feeding a market for interior decoration into a major sport with its own lore and passion for size and numbers (Figure 3.1).

While for the British, India (particularly the mountainous regions to the north and west of the subcontinent), Sri Lanka (Ceylon), Africa and Canada (as well as the western United States) had become the main location for such hunting passions, they were also pursued in other regions, such as South America, the Arctic and East Asia. European immigrants in many colonies, some of them military, were also caught up in the hunting imperative, not least because they escaped the controls of landowners who restricted access in Britain. Shooting became a common activity in Canada, Australia and New Zealand, as well as in white settler territories in central and East Africa. In New Zealand, such a desire led to the introduction of game species (for example red deer) as well as grouse and the creation of a grouse moor and even trout for the territory's rivers.[21] Thus, hunting, shooting and fishing involved not only the pursuit of and taking of exotic species around the world, but also the attempt to recreate the conditions of 'home'. Many retired military officers became 'settlers' in other colonies, acquiring land and sometimes clearing it of indigenous game or introducing familiar hunting species from Britain.

Museum collecting of ethnographic materials and hunting trophies

The collecting of ethnographic materials and their relationship to the natural world and ultimately to hunting was given a considerable fillip by the voyages of Captain James Cook (1728–79) between 1768 and 1779. This brought the regions of the Pacific Islands and Australasia into such concerns even before they were fully extended to India, later elsewhere in Asia and Africa. The creation of collections of ethnographic materials as well as of trophies and specimens of the hunt became a central aspect of the creation of museums and can also be seen as part of the growing strategic understanding of the world and its peoples that fed into the expansion of empire. So far as Australasia is concerned, a considerable museum collecting mania was to develop around the products of New

Zealand Maoris.[22] Although Australia has never been seen as one of the prime imperial hunting lands, nevertheless Tom Griffiths has identified the presence there of a hunting culture that was closely related to archaeological, ethnographic, antiquarian and oral history interests.[23] This reflects the interconnectedness of the cultural complex embracing hunting, interests in the natural world and antiquarian and amateur collecting, particularly associated with the relationship between white settlers and peoples. All this came together in the development of museums and more 'professional' concerns of anthropologists and historians. Endemic violence against Australian Aboriginal peoples (and this is a theme that can be replicated in many imperial territories) together with social Darwinian ideas about the potential extinction of those allegedly incapable of coping with the technological and environmental developments in the modern world all stimulated a desire to collect and preserve, at least in recorded memory.

By the nineteenth century, the glorification of hunting as a military and elite (in some places even socially more widespread) sport, entwining the attributes necessary for the prosecution of colonial warfare, was to become a significant factor in this development of museums. Natural history museums became a characteristic type when such institutions spread widely throughout Britain and the Empire, particularly in the second half of the nineteenth century. Few such museums lacked dioramas of stuffed animals, often against painted backdrops of the environments in which they could be found. They were, in effect, taxidermy-inspired stuffed zoos intended to convey to museum visitors and children (both in Britain and elsewhere) the excitement of exotic fauna and the locations of their habitats. In these ways, practical imperial hunting as well as the elite passion for the domination of the environment and the collecting of natural trophies moved on from being a means of interior decoration to a relatively common content of museum displays. In the British world, the greatest institution was the Natural History Museum in South Kensington, which opened as a separate institution in 1881. In the development of its scientific and educational purposes, it became the main centre of the hunting and collecting of such specimens from across the globe.[24]

It is no surprise to find that one of the most notable hunters in Africa, Frederick Courtenay Selous, who began his hunting journeys in southern and central Africa in 1870, donated specimens (said to number as many as 5,000) of African flora and fauna to the Museum (including a significant assemblage of butterflies). He is commemorated in a bust and memorial on the staircase of its main hall. He was deeply implicated in the imperial advance on central Africa inaugurated by Cecil Rhodes, having been the guide to the 1890 so-called pioneer column which

seized the territory that became Southern Rhodesia, later Zimbabwe, for the British South Africa Company. He was also involved in the expedition of ex-President Theodore Roosevelt and his son to East Africa in 1909–10 which was known to have been immensely profligate in the killing of wildlife.[25] Selous became one of the most celebrated hunter-explorers of his generation and it is alleged that he was the model for the character Allan Quatermain in the novel *King Solomon's Mines* by Henry Rider Haggard. His hunting career developed into a military one, first of all on behalf of the British South Africa Company when he became an officer in the Bulawayo Field Force during the Ndebele Revolt of 1896.[26] At the outbreak of the First World War, he joined the Royal Fusiliers of the British Army and fought in the German East Africa campaign until he was killed in 1917, having won the Distinguished Service Order (DSO) in the previous year.

Some military hunters made large collections of the trophies of the hunt and came to regard these as sufficiently significant that they felt they should be transferred to the public sphere after their deaths.[27] There are several striking examples of this in Britain, including the collection of Colonel Harrison, which was donated in 1938 to the Kendal museum in Cumbria. Harrison had collected his trophies on a combination of military expeditions and hunting trips and he provided money for an extension to the museum to house his trophies. It also included a section on ballistics, including many examples of his bullets, flattened and distorted by contact with his prey. Two other military officers from the area, the brothers Cooper, also contributed their collections, all acquired on their military campaigns.[28]

The most celebrated such collection can be found in the Powell-Cotton museum in Birchington, Kent. P. H. G. Powell-Cotton hunted in Africa and Asia between 1887 and 1939, building up an enormous collection of trophies and of stuffed animals, remarkable examples of the taxidermist's art. He was wealthy enough to build a sizeable extension to his own home, Quex House, in which dioramas representative of African and Indian environments were created to illustrate the habitats of the animals. Along with these, he displayed the weaponry and products of the indigenous people among whom he had hunted. It therefore became a classic example of the combination of the ethnic and the natural historical. What is generally less clear is how Powell-Cotton acquired these ethnographic trophies, though he may well have purchased them from the people among whom he hunted.

Both of these collections and displays survive, the Kendal example now billing itself as a 'world wildlife gallery' illustrating issues of evolution and ecology, as well as highlighting conservation concerns.[29] The Powell-Cotton museum stresses the antique nature of the taxidermy

specimens, the fascinating nature of the ethnographic material and the fact that Percy Powell-Cotton was a pioneer in the use of magnificent dioramas, which now represent a unique display in Britain.[30] The museum also contains Asian weaponry, in addition to ceramics, jade and ivory from East Asia.[31] Such museums have therefore set about adapting the ideologies behind their collections to suit more modern sensibilities.

Expeditions of various kinds not only contributed to the collecting interests of the period but also played their part in the competitive understanding of regions of the globe and propaganda for imperial expansion. Good examples come from tensions over Central Asia. In many expeditions in this region, the ethos was clear. Cultural and historical materials supposedly hidden or lost to the Western conception of science were fair game for being discovered and removed. Among the competitive expeditions into Central Asia by Sven Hedin, Marc Aurel Stein and Lieutenant-Colonel Francis Younghusband the extraordinary activities of Stein as an individual collector stand out.[32] The Swede Hedin had removed artefacts and manuscripts from some sites, but his interest was primarily cartographic. It was the archaeologist Marc Aurel Stein, a Hungarian-born naturalised British citizen, who was the supreme exponent of plunder. He made four expeditions to Central Asia, in 1900–01, 1906–08, 1913–16 and in 1930. It is well known that his expeditions were regarded as being of value to the 'Great Game' of frontier tension between Britain and Russia, and there is also good evidence that his connections with imperial officials were close. James Dunlop Smith, the powerful secretary to the Viceroy, Lord Minto, seemed to develop a particular interest in Stein, conducted a considerable correspondence with him and arranged for him to meet the Viceroy at Peshawar in 1906.[33]

Stein's expedition was partially funded by the British Museum (two fifths of the total). In his letters, he indicated that he was in competition with people he called 'native treasure seekers', to a certain extent going over the same ground as Hedin. He collected vast numbers of manuscripts, silk scrolls and other early materials, even chipping fragments of frescoes from the walls of caves. He described himself as carrying off 'rich antiquarian spoil' from the cave of the thousand Buddhas. He was initially hindered from acquiring several hundred manuscripts by 'the ignorant priest in charge' who was oppressed by 'religious scruples and fear of popular resentment'.[34] But Stein's Chinese secretary succeeded in overcoming the reluctance of the priest and Stein made off with Chinese and Tibetan sacred works as well as early Indian and Central Asian material. It is some indication of the manpower he deployed that he was able to convey dozens of crates to

the coast for transfer to London, where to his rage they were to languish in the basement of the British Museum.[35] He implied that this was because of the lack of interest of the then director. Stein was however knighted in 1912, became a Fellow of the British Academy and was awarded honorary degrees by several British universities.[36]

The lack of conscience about this collecting activity lay in perhaps three justifications. Stein implied that it was morally wrong that such material should have lain ignored, unappreciated and unused for so many centuries. Second was the notion that it was in the process of being plundered in any case. If it was not saved by someone like himself for a great museum like the British Museum, then it would be seized by treasure seekers hoping to secure some income from its dispersal. Alternatively it might well fall into the hands of other Europeans whose level of appreciation might be less profound. And finally it was justified by the divine right and imperative of modern science. The acquisition of such cultural trophies, as with military booty, was deeply embedded in a whole complex of ideas of the time.[37]

By this time, the idea of the natural history museum had gone round the world, including the colonies of the British Empire.[38] Many such museums started out with ambitious objectives, often attempting to present examples from across the globe. Inevitably, this helped to stimulate an international trade, which commercial hunters were eager to supply, and exchanges of animal specimens and bones. Moreover, this entry of museums into the hunting culture (at least in terms of its resulting specimens, while some did employ hunters to add to their collections) also further encouraged the growth in the numbers of taxidermy establishments and the spread of diorama art. Hunting trophies (generally head and horns or antlers) had been transformed into museum specimens (usually the entire animal). Soon, certainly by the later nineteenth century, curators and their trustees recognised that the effort to present the entire natural world was hopelessly ambitious. They decided that the prime purpose of colonial museums should be to present the local flora and fauna to spread knowledge about the specific territory and, perhaps, create economic value as well as contribute to a sense of national identity. Thus displays were invariably transformed into the presentation of animals and associated ethnographic collections which would more closely reflect the character of the specific country in which the museum was located.[39] These were often combined with reconstructions or images of villages of indigenous peoples of the relevant colony (mainly in Africa or in Australasia) together with ethnographic materials including spears and arrows. These indigenous hunting techniques were being contrasted with modern firearms, particularly after the abandonment of the smooth-bore musket and the

development of the much more accurate high-velocity rifle in the last decades of the nineteenth century. The appearance of such modern firearms had made hunting a much less dangerous activity as well as often ensuring that an animal could be killed at longer range by a single shot. In these ways museum displays suggested that the hunting imperative was of very long standing in human history and that modern technology represented 'progress' and therefore the developing civilisation promoted by imperialism and the settler replenishing of the lands of the world. Thus hunting became linked in the minds of curators with the ethnographic ideas of the age, ideas which contrasted the 'primitive' with the 'civilised'.

While the ideological and educational objectives of collectors such as Harrison, the Cooper brothers, or Powell-Cotton, not to mention the curators of such displays around the world, are never entirely explicit, it may be surmised that their cherishing of, and desire to display, these collections was linked to the notion that hunting, travel (much of it imperial) and the acquisition of specimens constituted a sporting and cultural complex that could be seen as significantly building national (and colonial) character as well as contributing to the fund of scientific and ethnographic knowledge. These, together with Harrison's clear interest in ballistics and the characteristics of firearms and ammunition, were surely linked to the prosecution of warfare, which was after all his profession. Once again, the relationship between hunting and war was clearly asserted in the consideration of firearms technology. All this material would also have been regarded as having real scientific value, both for research and for the dissemination of ideas about nature. The collections would reveal the range of species and sub-species, together with evolutionary characteristics, to be found in the natural world. At another level, it was suggested that specimens would make the wildlife of Africa, India and elsewhere better known to the British public, also contributing perhaps to the objective of species conservation. If people became familiar with such animals through their stuffed manifestations, perhaps they would develop an interest in the preservation of such creatures for future generations, even although the scale of killing which helped to put the collections together actually reflected the astonishing profligacy of the era.

There can be little doubt that museum displays thus came to be closely linked to contemporary colonial warfare and the hunting and natural historical passions of military officers and imperial officials. But it is also the case that the development of ethnographic museums (including those reflecting worldwide archaeological exploration) alongside natural history displays equally reflected the same passions

for codification, taxonomies and the global archive. The Horniman Museum in London specifically organised its displays along evolutionary lines. The Pitt Rivers Museum in Oxford, containing the collection of General Augustus Pitt Rivers, also adopted a quasi-evolutionary approach, reflecting the utility of objects (see Evans, Chapter 4). It perfectly illustrates the relationship between an officer whose main interest was in the development of musketry and modern firearms and the studies of archaeology and ethnography.[40] This phenomenon spread more widely, invading country houses as well as the museums of Britain and the colonies.[41] Indeed, the close relationship between imperial warfare and the development of such collections has been emphasised by a number of authors. Holger Hoock identified the connection between war, collecting and the arts in his monumental *Empires of the Imagination*.[42]

Conquest and collecting went hand in hand in the invasion of India, as well as the spread of colonial rule into Ceylon (Sri Lanka), Burma (Myanmar) and elsewhere in South-East Asia.[43] What was little short of a passion for ethnographic and cultural collections continued into the twentieth century, so profoundly that in its pursuit moral values seemed to be put to one side. This is well illustrated by the major holdings of the Royal Ontario Museum in Toronto. This museum, perhaps more than any other in the British Empire, comes closer to the British Museum ideal which many museums initially aspired to, to display materials from almost all the continents. In this, it was greatly helped by its proximity to Europe, the North Atlantic crossing being shorter and easier to accomplish than journeys from India, the Far East and certainly Australasia.

Other media disseminating the hunting/collecting complex

If museums were expected to be sources of instruction to the young, as well as to a wider public, there was another means by which a new generation would be socialised into such norms in the course of the late nineteenth century. Both print and visual culture had become available to all with the extension of educational provision after the education acts of 1870 and 1872, the growth of literacy, the decline in printing costs and the reproduction of illustrations. This facilitated the manner in which the ideology and practice of hunting (as well as the alleged excitements of colonial warfare) penetrated the tradition of juvenile adventure literature which was such a publishing characteristic of the dissemination of imperial ideologies in the period. The indications are that such books were published (and reissued) in large numbers and were bought for the prize and present market, which was

a major phenomenon of the period. In these popular works, hunting became inseparably connected with heroic exploration, travel and also colonial warfare. It is possible to identify a number of the authors of such material, some of them household names during their heyday. R. M. Ballantyne was one of the most celebrated, writing about hunting in Canada, in its First Nations ethnographic setting, as well as in Africa. Among the latter were *The Settler and the Savage*, *The Gorilla Hunters* and *Black Ivory*. Captain Thomas Mayne Reid, a Presbyterian Irishman who migrated to the USA and whose alleged rank of 'captain' was entirely fictitious, set several hunting novels in South Africa, with titles like *The Bush Boys*, *The Young Yagers* and *The Giraffe Hunters*. W. H. G. Kingston contributed many more, as did the most celebrated producer of such material, G. A. Henty, a former newspaper war correspondent, who published well over 100 adventure novels, many of them with hunting content and even more celebrating colonial campaigns. A good example is *The Young Colonists: A Story of the Zulu and Boer Wars* (1885), in which hunting forms a significant part of the action. To these can be added the Scottish naval doctor W. Gordon Stables, who had served in the antislavery squadron on the East African coast.[44] Stables was himself a collector of natural history specimens. Such books went round the English-speaking world, contributing considerably to the hunting and collecting cultural complex of the period and influencing large numbers of young people (perhaps mainly boys, although there were some equivalents for girls) of the late nineteenth and early twentieth centuries.

By the early twentieth century, however, a considerable change in sensibilities in respect of wildlife was beginning to develop. The contraction in the frontiers of a number of game species, serious reductions in numbers and even extinctions, actual and feared, had become a major concern by the end of the nineteenth century. In 1900, the First Pan-African conference was organised by the British Foreign Office, to which representatives of every state with colonies in Africa were invited. The result was a Convention for the Preservation of Wild Animals, Birds and Fish in Africa, mainly the product of British and German anxieties (most of the other territories represented at the conference failed to ratify it). The results of this and further conventions included the further promulgation of game laws (some of which had the effect of prohibiting subsistence hunting on the part of Africans and others which had been a traditional part of their lifestyles and diets), as well as the foundation of game reserves and national parks. For British imperial officials in East Africa, these were anxieties which were particularly prompted by the massively destructive game safari of ex-President Theodore Roosevelt in 1909–10, which was partly

justified on scientific grounds through the sponsorship of the Smithsonian Institution in Washington, D.C. This was perhaps the last time that there would be a public glorification of indiscriminate slaughter, which Roosevelt and his followers seemed to imagine contributed to his heroic reputation (in reality Roosevelt had indifferent eyesight and was a very poor shot). The First World War helped to develop such sensitivities further. This can be charted in the works and attitudes of Baden-Powell, not least in the successive editions (1908–26) of his published manual *Scouting for Boys*. An enthusiastic hunter who had, as we have seen, connected the ideology of hunting to that of colonial warfare, he had clearly believed passionately in the efficacy of hunting in building character and acting as a training for war. But his view seemed to have changed by the 1920s. Originally he had extolled the virtues of hunting as training for his scouts, but he came to argue that it was as meritorious, and a great deal less destructive, to hunt and shoot with the camera rather than with the gun.[45]

All of this serves to demonstrate the wider context in which collections of ethnographic and other items were transferred both to Europe and to territories of white settlement around the world through the operations of colonial military campaigns and the consequent system of booty. It was a period of staggeringly energetic acquisitiveness in every conceivable area. Hunting was a means of unveiling, understanding and embracing the creatures of the globe, while trophies and taxidermy made them available to a wider circle of the public in museums and similar settings. It is indeed the case that such materials were often displayed in conjunction with the weaponry and other artefacts of war of the societies among whom such hunting was conducted. The two often went together and formed the bridge between the natural and human worlds, as well as connecting other cultural and historical materials emblematic of the territories in which the hunters operated, whether in their military service or in the hunting expeditions which often punctuated them.

Hunting produced considerable collections of trophies and specimens which were simply removed from the environment, almost without exception lacking the permission of indigenous peoples from whose lands such animals were taken or indeed of the colonial and imperial authorities which oversaw such territories. For many years there were no game laws and, even when they had been imposed, the supposition that they were always complied with is hard to sustain. Nevertheless, while there has been some controversy about plant hunting and the transfer of economic plants such as cinchona and rubber between one continent and another, there have been few instances of anxiety about the removal of animal materials until more modern times. In any case

[77]

the controversy about economic plants has occurred mainly in the historical literature and has no purchase in respect of continuing production.[46] That may have changed to a certain extent as fears of species extinctions developed in the twentieth century, and there has of course been major international legislation in respect of ivory and rhino horn. As a result, some museums have removed ivory items from their public displays. Yet it is an interesting fact that public interest in the displays of taxidermy specimens has declined to a certain extent, just as it seems to have done in respect of visits to zoos.[47] Popular enthusiasm for exotic animals has waned, partly because film and television natural history programmes have made them visually so accessible.

Conclusion

Collecting hunting trophies became one of the prime instigators of what we could now call the 'bucket list' of hunters' travel ambitions. In this world view, hunters were empire builders, who justified their activities in a whole variety of ways.[48] Hunting was certainly viewed as a preparation for war. It was a means of knowing both the environment and its indigenous human inhabitants. It was often justified on the grounds of the extension of scientific knowledge. Moreover, the urge to shoot only older males (bearing the finer and more coveted trophies) was seen as encouraging evolutionary processes, allowing younger and more vigorous males to dominate the gene pool. Hunting publications, including military ones, invariably proclaimed this scientific value of shooting, additionally providing knowledge of the lifespans and anatomy of the prey.

If the products of hunting have generally escaped modern problems with museum acquisitions, the manner in which extensive ethnographic and cultural collections were built up remains a grey area in the history of museums. Beneath the prominent and repeatedly recurring questions of restitution, e.g. of the so-called Elgin (or Parthenon) Marbles, the provenance of the collection of ethnographic materials, though acquired in questionable circumstances, is left out of historical accounts (see Lidchi, Afterword). While it is true that there have been successful demands for restitution in respect of human remains as well as of items of spiritual significance to the people from whom they originated, large quantities of other ethnographic material remain in museums although their acquisition, whether in warfare or by travellers, missionaries and others, can be regarded as dubious. Nevertheless, it is important to connect the acquisition of military booty from colonial campaigns to a wider cultural complex of the time.

Notes

1 For significant examples and the artistic dimensions of these activities, see H. J. Noltie, *Indian Forester, Scottish Laird* (Edinburgh: Royal Botanic Garden, 2016); H. J. Noltie, *The Dapuri Drawings: Alexander Gibson and the Bombay Botanic Gardens* (Edinburgh: Royal Botanic Garden, 2002); and H. J. Noltie, *The Cleghorn Collection: South Indian Botanical Drawings 1845–1860* (Edinburgh: Royal Botanic Gardens, 2016).

2 D. G. Kyle, *Spectacles of Death in Ancient Rome* (London: Routledge, 2000); K. E. Welch, *The Roman Amphitheatre* (Cambridge: Cambridge University Press, 2007). The Roman villa of Casale at Piazza Armerina, Sicily, contains the most complete mosaic representations of the capture of African and Asian animals intended for the sports of the Colosseum in Rome.

3 A. Mutch, *Tiger Duff: India, Madeira and Empire in Eighteenth-Century Scotland* (Aberdeen: Aberdeen University Press, 2017). Patrick Duff (1742–1803) was a high-ranking officer in the Bengal Artillery and an avid hunter. See also V. R. Mandala, *Shooting a Tiger: Big-Game Hunting and Conservation in Colonial India* (Oxford: Oxford University Press, 2019).

4 J. M. MacKenzie, *The Empire of Nature: Hunting, Conservation and British Imperialism* (Manchester: Manchester University Press, 1988), Chapter 7. The memoir literature of hunters in India is very extensive indeed. To a certain degree, the fascination with hunting was also linked to the medieval chivalric revival of the period. J. M. MacKenzie, 'Chivalry, Social Darwinism and Ritualised killing: The Hunting Ethos in Central Africa up to 1914', in D. Anderson and R. Grove (eds), *Conservation in Africa* (Cambridge: Cambridge University Press, 1987), pp. 41–61.

5 J. A. Mangan and C. C. McKenzie, *Militarism, Hunting, Imperialism: 'Blooding' the Martial Male* (Abingdon: Routledge, 2010).

6 Captain R. S. S. Baden-Powell, *Pig-Sticking or Hog-Hunting: A Complete Account for Sportsmen, and Others* (London: Harrison, 1889). See also Lieutenant-General A. E. Wardrop, *Modern Pig-Sticking* (London: Macmillan, 1914).

7 E. C. Tabler (ed.), *Trade and Travel in Early Barotseland, the Diaries of George Westbeech and Captain Norman MacLeod 1875–1876* (London: Chatto and Windus, 1963), pp. 105–12.

8 MacKenzie, *Empire of Nature*, p. 38.

9 For hunting on the 1901 royal tour, see D. M. Wallace, *The Web of Empire: A Diary of the Imperial Tour of the Their Royal Highnesses the Duke and Duchess of Cornwall and York in 1901* (London: Macmillan, 1902). The royal party considered that Australia was a poor place for 'sport' (shooting), p. 156.

10 The activities of Victoria and Albert at Balmoral are well-documented in the paintings of Landseer.

11 His book was published posthumously in 1892, edited by his brother, also a senior military officer.

12 M. Miers, *Highland Retreats: The Architecture and Interiors of Scotland's Romantic North* (New York: Rizzoli, 2017) contains many illustrations of such interior decoration.

13 All this is documented in detail in MacKenzie, *Empire of Nature*.

14 Colonel R. S. S. Baden-Powell, *The Matabele Campaign* (London: Methuen, 1897). Baden-Powell also published *Sport in War* (1900), *The Sport of Rajahs* (1900), *Marksmanship for Boys* (1915) and *Pig-Sticking or Hog-Hunting* (1889).

15 Major-General R. S. S. Baden-Powell, *Sport in War* (London: Heinemann, 1900), pp. 17–18.

16 Baden-Powell, *The Matabele Campaign*, p. 417.

17 This progression is noted in MacKenzie, *Empire of Nature*, pp. 48–51 and 307–08.

18 J. M. MacKenzie, 'The Imperial Pioneer and Hunter in the British Masculine Stereotype in Late Victorian and Edwardian Times', in J. A. Mangan and J. Walvin (eds), *Manliness and Morality: Middle-Class Masculinity in Britain and America,*

1800–1940 (Manchester: Manchester University Press, 1987), pp. 176–98; J. M. MacKenzie, 'Hunting in Eastern and Central Africa in the Late Nineteenth Century', in W. J. Baker and J. A. Mangan (eds), *Sport in Africa: Essays in Social History* (New York: Holmes and Meier, 1987), pp. 172–95.

19 A. Herbert, *Two Dianas in Somaliland: The Record of a Shooting Trip* (London: John Lane, 1908). A. Thompsell, *Hunting Africa: British Sport, African Knowledge and the Nature of Empire* (London: Palgrave Macmillan, 2015) demonstrates the extent of female hunting.

20 P. A. Morris, *Rowland Ward, Taxidermist to the World* (Ascot: MPM, 2003).

21 B. Patterson, T. Brooking and J. McAloon, *Unpacking the Kists: The Scots in New Zealand* (Dunedin: University of Otago Press, 2013), pp. 158–9. Settlers in New Zealand often emphasised the 'sporting' or shooting and fishing freedoms compared with the restrictions of the UK. *Ibid.*, pp. 235–6.

22 A. Henare, *Museums, Anthropology and Imperial Exchange* (Cambridge: Cambridge University Press, 2005).

23 T. Griffiths, *Hunters and Collectors: The Antiquarian Imagination in Australia* (Cambridge: Cambridge University Press, 1996).

24 Examples of the role of many natural history museums (including that in London) in biological conservation early in their institutional histories can be found in P. Davis, *Museums and the Natural Environment: The Role of Natural History Museums in Biological Conservation* (London: Leicester University Press, 1996).

25 J. G. Millais, *Life of Frederick Courtenay Selous* (London: Longmans, 1918). In 1974, I met an elderly man in Zimbabwe, almost certainly a centenarian, Headman Masunda, who had met Selous when Masunda had worked on road building for the pioneer column. When he was tested as to his memories of the appearance of Selous, I was convinced that it was a recollection of a genuine encounter. Selous' travels and hunting experiences were narrated in his *Travel and Adventure in South-East Africa: Being the Narrative of the Last Eleven Years Spent by the Author on the Zambesi* (London: Rowland Ward, 1893).

26 F. C. Selous, *Sunshine and Storm in Rhodesia* (London: Rowland Ward, 1896).

27 The celebrated African hunter, the Scot Roualeyn Gordon Cumming, brought back a large quantity of trophies and established a museum in Fort Augustus. It seems to have subsequently disappeared and all my efforts to track down what happened to his collection failed.

28 www.kendalmuseum.org.uk, accessed 25 August 2018. The given names of these donors do not seem to be known.

29 See www.kendalmuseum.org.uk/about-us/the-collections/world-wildlife-gallery/, accessed 25 August 2018.

30 I was brought up on similarly fine dioramas in the Kelvingrove Art Gallery and Museum in Glasgow, but they were removed during the renovation of that museum between 2003 and 2006. See also A. Scheersoi and S. D. Tunnicliffe (eds), *Natural History Dioramas – Traditional Exhibits for Current Educational Themes* (Cham, Switzerland: Springer, 2015).

31 www.quexpark.co.uk/museum/, accessed 25 August 2018.

32 For Younghusband's collecting activities, see C. E. Harris, *The Museum on the Roof of the World: Art, Politics and the Representation of Tibet* (Chicago: University of Chicago Press, 2014).

33 An account of Stein's activities, Dunlop Smith's relationship with him and copies of Stein's letters can be found in M. Gilbert, *Servant of India: James Dunlop Smith Private Secretary to the Viceroy* (London: Longmans, 1966), pp. 61–73. Stein had already met the Viceroy Curzon at the time of his first expedition.

34 Gilbert, *Servant of India*, p. 71.

35 Gilbert, *Servant of India*, pp. 71–2.

36 His knighthood was partly associated with the fact that he had held senior educational positions in British India and was also provided with the title of Superintendent of the Archaeology Department of the North-West Frontier Circle.

37　In popular culture, this competitive spirit bound up with archaeology can be found in the Indiana Jones books and films.

38　S. Sheets-Pyenson, *Cathedrals of Science: The Development of Colonial Natural History Museums in the Late Nineteenth century* (Kingston and Montreal: McGill-Queen's University Press, 1988).

39　J. M. MacKenzie, *Museums and Empire: Natural History, Human Cultures and Colonial Identities* (Manchester: Manchester University Press, 2009).

40　M. Bowden, *Pitt Rivers: The Life and Archaeological Work of Lieutenant-General Augustus Henry Lane Pitt Rivers* (Cambridge: Cambridge University Press, 1991). See also Christopher Evans, Chapter 4, in this volume.

41　S. Barczewski, *Country Houses and the British Empire, 1700–1930* (Manchester: Manchester University Press, 2014).

42　H. Hoock, *Empires of the Imagination: Politics, War and the Arts in the British World, 1750–1850* (London: Profile Books, 2010).

43　M. Jasanoff, *Edge of Empire: Conquest and Collecting in the East, 1750–1850* (London: Fourth Estate, 2005).

44　J. M. MacKenzie, 'Hunting and the Natural World in Juvenile Literature', in J. Richards (ed.), *Imperialism and Juvenile Literature* (Manchester: Manchester University Press, 1989), pp. 144–72. See also K. Castle, *Britannia's Children: Reading Colonialism through Children's Books* (Manchester: Manchester University Press, 1996) and M. D. Kutzer, *Empire's Children: Empire and Imperialism in Classic British Children's Books* (New York: Garland, 2000).

45　MacKenzie, *Empire of Nature*, p. 307.

46　L. H. Brockway, *Science and Colonial Expansion: The Role of the British Royal Botanic Gardens* (San Diego, California, 1979). See also R. Drayton, *Nature's Government: Science, Imperial Britain and the 'Improvement' of the World* (New Haven: Yale University Press, 2000). For a popular account, see T. Musgrave and W. Musgrave, *An Empire of Plants: People and Plants that Changed the World* (London: Cassell, 2000).

47　Nevertheless, the Natural World galleries at the National Museum of Scotland, opened in 2011, make extensive use of taxidermy specimens.

48　H. Gunn, 'The Sportsman as an Empire Builder', in J. Ross and H. Gunn (eds), *The Book of the Red Deer and Empire Big Game* (London: Simpkin, Marshall & Co, 1925), pp. 137–8.

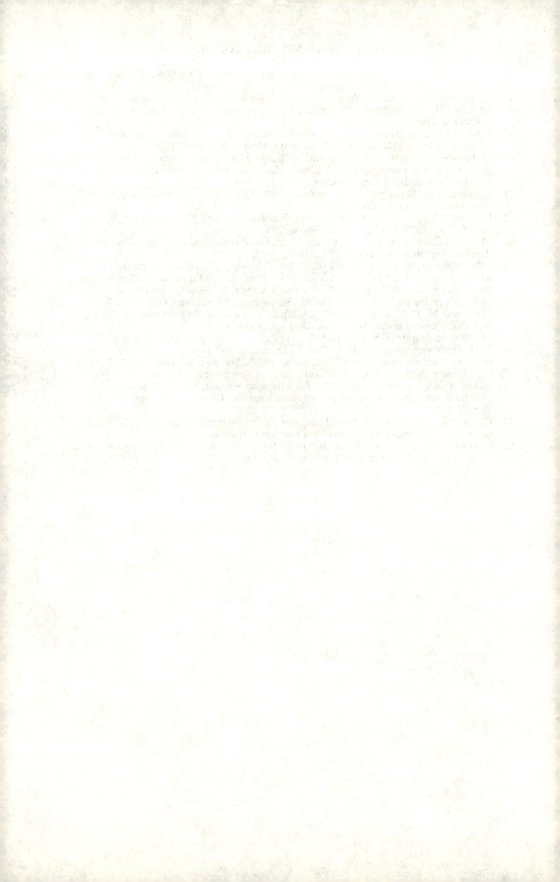

Part II
Military collecting cultures

CHAPTER FOUR

Soldiering archaeology: Pitt Rivers and collecting 'Primitive Warfare'

Christopher Evans

The British military contribution to the recording of the past during the nineteenth century has generally been overlooked and has really only been seriously appreciated by (Sir) Mortimer Wheeler. One of the twentieth century's leading archaeologists, a flamboyant public personality and, himself, a very successful soldier serving in both world wars (eventually holding the rank of brigadier), Wheeler championed a number of military archaeologists, particularly Lieutenant-General Augustus Pitt Rivers – 'the master' (Figure 4.1). Yet it should be recognised how singularly Wheeler construed archaeology's military legacy. In *Archaeology from the Earth* (1954), he heralded its organisation, precision and 'discipline' as a model for archaeological fieldwork:

> Meanwhile, it is scarcely necessary to observe that the [archaeological] director cannot be an expert in every branch of his work, any more than a general is an expert in every tank or gun under his command. But, just as a general must be exactly familiar with the performance – the range, firepower, mobility, and so forth – of every arm available to him or his enemy, so must the director of an archaeological excavation be acquainted with the exact potentiality of the various techniques appropriate to his craft and the nature of the problems which are likely to oppose him.[1]

With little subtlety, while this obviously presupposes Wheeler's own place in the pantheon of 'greats', his espousal overlooks the many pedestrian investigations done by serving officers and, moreover, homogenises the military. It was far from monolithic, with the experience and approaches acquired varying according to which branch of the forces service was in.

This chapter first appraises the breadth of the interrelationship of the British military and the study of the past, primarily during the 'long' nineteenth century (i.e. prior to First World War mass mobilisation). It

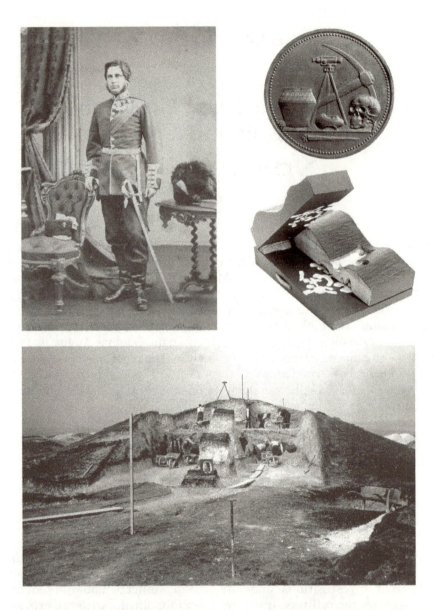

Figure 4.1 Pitt Rivers' Campaigns: Capt. Augustus Henry Lane Fox, Notman Studio portrait of 1862 (top left; McCord Museum 1–2063.1); upper right, a Pitt Rivers' excavation medallion and his Cissbury Hillfort excavation model (Salisbury and South Wiltshire Museum); bottom, Wor Barrow excavations of 1893 (notice the theodolite prominently perched on top of the mound and, at its front, one of his excavation models of the site).

touches upon the military's contribution to museum collections and, more extensively, archaeological recording, before focusing upon Pitt Rivers (1827–1900). He was arguably the leading British field archaeologist of that century. Variously serving in ordnance training, and as both a quartermaster and military legal prosecutor, Pitt Rivers' army background was crucial for the archaeologist he became, providing logistical, survey and adjudication/'proof' skills. His significance certainly does not just lie in those traits celebrated by Wheeler, but also in his intellectual perspective arising from the day's leading 'evolutionary circles', which he moved in.

Pitt Rivers' 'Primitive Warfare' paper is central to this appreciation.[2] Tracing the worldwide development of weaponry, and underpinned by principles of Darwinian evolution, this was the published version of lectures he delivered to the Royal United Services Institution and it appeared in their journal (*JRUSI*) over three successive years (1867–69). He drew upon material both from his own collection and that of the Royal United Service (Institution) Museum (hereafter referred to as the RUSI Museum or the RUSI collections), which was a major attraction within nineteenth-century London.[3] Though the *JRUSI* had previously carried contributions on ancient military themes, by virtue of its academic referencing and theoretical content there had been nothing comparable to 'Primitive Warfare' and it clearly marked Pitt Rivers' emergence as a scholar.[4] Packed to the rafters with an extraordinary array of objects, Oxford's Pitt Rivers Museum has come to be regarded by some as an 'attic of the mind'.[5] As we will see, while it can be compared with what were the RUSI Museum's overcrowded displays, its systematic evolutionary-typological basis was entirely different from the RUSI's geographically arranged collections.

Fieldwork and campaigning

The impact of military culture on Victorian Britain cannot be overestimated and, to a unique degree, it forged the nation's self-image. Its ties constituted a vast socio-economic network; few families would have been untouched by it, and it had, for example, an enormous influence upon the sciences and their affiliated industries (e.g. instrument makers).[6]

Following the Napoleonic Wars, far from being a matter of *Pax Britannica*, the expansion of the empire brought near incessant 'policing actions' and colonial wars.[7] With these came direct encounters with perceived 'warrior others': from the 'stick' warfare of the Andaman Islanders (1867) and Ethiopia/Abyssinia's medieval knight-equivalents (1868) to the highly organised Zulu armies capable of inflicting defeat

on British forces in open battle (1879). This fighting across what was seen at the time as the many branches of the evolutionary tree surely contributed to the era's comparative ethnography and it informed the racist content of much of the day's social studies.[8]

Through their respective campaigns, soldiers, sailors, explorers and archaeologists vied for pride of place in the pages of the *Illustrated London News*, with trophies brought back to both regimental collections and national museums. The 'archaeology of empires' was clearly a pre-rogative of latter-day empires,[9] and the navy was regularly called upon to ship 'prize antiquities' home.[10] Accompanying this, in a manner akin to ancient Rome, the nation's upper-class families were expected to supply intellectually well-rounded commanders. Officers were actively encouraged to pursue their own scientific interests. They were afforded enormous lengths of what was, in effect, study and/or travel leave, with some branches of the services promoting contributions to relevant journals, as well as encouraging collection for their museums.

The connection between the military and archaeology dates back to at least the later eighteenth century, their alignment both reflecting the personal pursuits of 'cultivated' military personnel and, more pro-fessionally, map-making and survey exercises. Eventually holding the rank of Major-General, as a military engineer and later founder of the Ordnance Survey, William Roy in 1793 published his *Military Antiquities of the Romans in North Britain*, which directly arose from his Military Survey of Scotland of 1747–55.[11] There were also Captain James Douglas' Chatham Lines investigations in Kent. When serving as an assistant engineer during work on its fortifications he was able to excavate some ninety Anglo-Saxon barrows and a Roman 'sepulchre'. He was elected to the Society of Antiquaries of London in 1783 and, on leaving the army that year, took up holy orders; he later published his findings in *Nenia Britannica* (1793).[12] Equally, in India, Colonel Colin Mackenzie's investigations could be cited.[13] Experience of 'campaigning' is something that the military and antiquarians/archaeologists clearly shared, and during Lysons' excavation of the Woodchester Roman Villa, through the patronage of Joseph Banks – the grandee and broker of later eighteenth-century British science, and a Fellow of the Society of Antiquaries of London – the army apparently provided both the labour and equipment.[14]

During the nineteenth century, overseas ruins and various 'old' fortifications were widely documented by the Regiment of Engineers/Sappers and Porter's *History of the Corps of Royal Engineers* of 1889 actually included a chapter on their 'Archaeological Exploration and Travel'.[15] Equally, among the exercises given to British officer cadets at the Royal Military College Sandhurst was surveying Roman roads,

with the resulting study, 'Roman Roads in Great Britain', published in three parts between 1836 and 1839 in *JRUSI* (see also Narrien's 1821 survey of a Roman encampment near East Hempstead; he was then later a lecturer at the college).[16]

While obviously reflecting personal interests, much of this military recording can be seen as broadly contributing to the 'project of empire' and 'imperial discourse'.[17] Examples were wide-ranging: from the Mediterranean fieldwork at Knidos and Cyrene of Captain Robert Murdoch Smith (later Major-General and, eventually, Director of the Edinburgh Museum of Science and Art),[18] and Rawlinson's recording at Behistun (leading to the decipherment of cuneiform) while an officer in the British East India Company Army[19] to Captain F. Brome's excavation of the cave system beneath Gibraltar's military prison (1862–8; he then being its governor), recovering its justly famous Neanderthal skull.[20] In India the first Director of the Indian Archaeology Survey was the army engineer-trained Sir Alexander Cunningham (1861–85).[21] Colonel Meadows Taylor, a singular polymath, whose many archaeological papers[22] were later collectively published as *Megalithic Tombs and other Ancient Remains in the Deccan* (1941), was also active there. In 1824 he accepted a military commission with the Nizam of Hyderabad. Transferring to the Nizam's civic administration, he undertook a series of excavations in Gulbarga, with the quality of his fieldwork – especially his detailed section recording – later being widely acknowledged, both in the subcontinent and, for example, by Wheeler.[23]

Later came Captain Charles Warren and, subsequently, the early career surveys in Palestine conducted by Lord Kitchener of Khartoum.[24] In 1874, then as an officer in the Royal Engineers, under the auspices of the Palestine Exploration Fund, Kitchener participated in the survey-mapping of the Holy Land. He eventually commanded the survey, only completed in 1877, and the results were published in eight volumes, of which Kitchener co-authored three, and wherein archaeology featured. This side of Kitchener's career (and personality) has been overshadowed by his later 'fame' (e.g. victor of the Battle of Omdurman, establishing concentration camps during the Boer War and as the face of the First World War recruitment poster), but he was himself an avid collector of antiquities and porcelain.[25] When subsequently appointed to survey Cyprus, he proposed to excavate sites there for the British Museum if funding could be forthcoming. This was later provided by the South Kensington Museum (now the Victoria and Albert Museum) and, with the site work undertaken by George Gordon Hake, Kitchener organised a number of investigations. He also participated in establishing the Cyprus Museum (1882) and, in recognition, was appointed its first honorary curator.[26]

The role of the Royal Navy in matters of the past was not just confined to the transportation of antiquities.[27] Captain W. H. Smyth, for example, surveyed the bath complex on Lipari and, donating a model of the same to the Society of Antiquaries, he eventually became one of the Society's directors.[28] Naval officers widely partook of site/monument recording during their coastal surveys and, in 'home waters', there were Lieutenant Thomas' Orkney studies while commanding the HM Surveying Vessel, *Woodlark*.[29]

Investigating a tumulus at Greenmount, County Louth (1870) – in truth, little more than a mound-tunnelling exercise – Major-General Lefroy was one of the fourteen British officers whose various researches, excavations and/or surveys were acknowledged in Fergusson's *Rude Stone Monuments* of 1872.[30] In the early decades of the last century the efforts of Lieutenant-Colonel Hawley of the Royal Engineers could be cited. After serving in South Africa and excavating with St John Hope at Old Sarum for the Society of Antiquaries, on behalf of the Office of Works between 1919 and 1926, he undertook fieldwork at Stonehenge. Among his interpretations of the latter was that its circuits related to a fortified settlement, which is obviously not now a widely held explanation of that great ritual monument; this likely reflected his military background.[31]

The role of archaeologist as spy, variously informing military operations, should not be overlooked. Most famously there were Sir Leonard Woolley and T. E. Lawrence's 'Wildness of Zin' surveys in the Negev Desert immediately prior to the First World War.[32] Sponsored by the army, while the archaeologists undertook genuine researches, this was essentially a pretext to its military mapping.[33] Earlier were Charles Masson's (alias James Lewis) activities in early to mid-nineteenth century Afghanistan. Masson was a sometime soldier (deserter) and agent of the British East India Company, excavating Buddhist monuments and the city of Begram;[34] this was a case of archaeology participating in the 'Great Game' of British strategic intelligence activity in Central Asia.

In the wake of the army and/or stationed with them abroad, military chaplains and doctors also undertook investigations. Within their ranks were Reverend Charles Swinnerton – chaplain to the Khyber forces – who 'excavated' at Adah, near Jellalabad (retrieving sculpture fragments)[35] and Edward Bawtree. Bawtree, when posted as Staff Assistant Surgeon to the Military Establishments at Penetanguishene, Ontario, dug a series of burial sites. Bawtree's publication, 'The Brief Description of some Sepulchral Pits of Indian Origin', appeared in the *Edinburgh New Philosophical Journal* of 1848 and was one of the first studies of Canadian archaeology.[36] On returning to England, he

apparently donated material, including four human skulls, to the Museum of the Army Medical Department, Chatham (now subsumed within the Museum of Military Medicine, Mytchett, Surrey).[37] Also, there is the now notorious Robert Knox, author of *The Races of Men*.[38] He served as an assistant surgeon with the army, first in the aftermath of Waterloo in Brussels and, then in southern Africa during the 6th Frontier War. While stationed at the latter, having plentiful access to human remains, he conducted wide-ranging researches which eventually underpinned his distinctly racial ethnology.[39]

By no means was such 'military archaeology' exclusive to Britain. The entourage that accompanied Napoleon's Egyptian campaign of 1798–1801 is an obvious case in point. But so too were French officers who, during the later nineteenth century, were encouraged to undertake investigations on sites – particularly Roman – in North Africa,[40] as did their Russian counterparts from the later eighteenth century, whose officers excavated, for example, tumuli in its eastern colonies.[41]

Any such appraisal as this must guard against exaggeration. While clearly such military investigations were far more frequent than is often credited, they pale in comparison to those of the nineteenth century's great 'leisured' practitioners: the clergy.[42] For example, taking almost any volume of the *Archaeological Journal* during the second half of the century, there are regularly three to five contributions by 'men of the cloth' (whose texts represent upwards of a fifth to a quarter of the journal's contents.). The past was, nonetheless, clearly an appropriate gentlemanly pursuit for the day's military officers. Aside from complementing an edification ethos generally, available time, ready labour and survey skills were what essentially promoted the military's involvement. Surveying, of course, was widely taught and practised throughout the forces (as was geology among the Royal Engineers).[43] This is further reflected in that, during the nineteenth century, the journal of the Royal Geographical Society saw many contributions from the services (whose members, at times, made up more than half of its council). Through various expeditions, the services survey-mapped enormous swathes of the world, helping to turn the map 'red', furthering British imperial ambitions. Yet it remains fundamentally difficult for us today to comprehend an intellectual–institutional milieu where, for instance, the membership of the Ethnological Society of London (originating from the Aboriginal Protection Society)[44] attracted such a high proportion of military officers. Its 1869 list of fellows included fifteen, among which were five generals and four lieutenant-colonels.[45] During the twentieth century, with the character of the military radically changing, and as archaeology became increasingly professional, this involvement largely came to an end.

Adjudication procedures and proofs – Pitt Rivers

Eventually appointed as the nation's first Inspector of Ancient Monuments, Pitt Rivers undertook excavations while still in service and, on coming into his inheritance (changing his name from Lane Fox), at his family estate at Cranborne Chase in Wiltshire he conducted a series of major investigations that were seminal to the development of fieldwork practice.

While the other members of the services who variously charted and facilitated 'the past' would have largely done so as a result of their immediate circumstances, Pitt Rivers differed. Publishing widely, and serving as Vice-President of the Society of Antiquaries (1871) and President of the Anthropological Institute (1880), he moved in London's leading intellectual circles.[46] Drawing directly upon his military experience, he formulated a distinctly evolutionary approach to the study of material culture.[47]

With Pitt Rivers' military career having been extensively summarised elsewhere, only its highlights need rehearsal.[48] Following family regimental tradition, after studying at the Royal Military College, Sandhurst, in 1845 he was commissioned into the Grenadier Guards. In the course of his thirty-two-year military career (albeit often interrupted by periods of leave) he only once saw a major front-line action, at Alma in 1854. Then decorated and promoted to major (on his retirement in 1882 he was accorded the honorary rank of lieutenant-general), he was evidently held to be an efficient and able staff officer.

Pitt Rivers' role in the development of, and instruction in, musketry was to be the mainstay of his military career. Probably beginning in 1851, he became a member of the committee to experiment and report upon the merits of the army's current smooth-bore muskets, as opposed to more accurate rifled designs. He was thereafter appointed to the Royal Artillery barracks at Woolwich to instruct in the use of the new Minié rifle. Subsequently, he was largely responsible for the founding of the Hythe School of Musketry and became its principal instructor, revising its *Instruction of Musketry* manual in 1855. When not otherwise serving in staff appointments as a quartermaster, the remainder of his service career revolved around musketry instruction and when, in 1858 he published his first paper, 'On the improvement of the rifle as a weapon for general use', it was in *JRUSI*, it being followed by his 'On a model illustrating the parabolic theory of projection' in the same journal and where, three years later, he published his 'Primitive Warfare'.[49]

The scientific branches of the artillery and engineers saw a high proportion of middle-class candidates. It was a path of more ability-based

advancement, as opposed to the commission by purchase/class-derived promotion of those of gentry-cum-nobility entitlement which gravitated towards cavalry, guards and infantry regiments. Ordnance was then certainly a leading scientific endeavour. To cast a state-of-the-art-standard cannon or a rifle barrel effectively amounted to a test of a nation's technical skills, requiring a high command of both chemistry and physics. Truly a matter of cutting-edge technology, it required the exact computation of projectiles, the adjudication of precisions and, in the case of army procurement, potentially involved vast expenditure.

There are other, more generic aspects of Pitt Rivers' military background that also shaped his archaeology. These range from his quartermaster duties (i.e. logistical organisation) to an appreciation of terrain mapping and survey. Well-versed in field survey techniques, it was surely not accidental that commanding pride of place upon his quasi-heraldic medallion (a device he employed to 'sign' and date his excavations by placing them in the trenches' backfill) was an engineer's level (Figure 4.1).[50] To this army influence could also be added an appreciation of modelling forms of topographic depiction, a technique he went on to render his major sites in and which had a long military pedigree (Figure 4.1 & 4.2).[51] Indeed, his fine-grained appreciation of landscape and its possibilities would surely have been informed by a 'gunner's countryside eye', and generally he stressed the value of seeing/recording with clarity and precision: 'Every detail should, therefore, be recorded in the manner most conducive to the facility of reference, and it ought at all times to be the chief object of an excavator to reduce his own *personal equation* to a minimum.'[52] This is an explicit scientific allusion; the 'personal equation' being then a well-established catechism, arising out of measured astronomical recording and a desire to diminish individual-viewer variability.

There is still another facet of Pitt Rivers' military career that must not be overlooked: his exposure to legal practice. From 1862 to 1866, it was as Assistant Quartermaster General that Pitt Rivers was stationed in Cork, Ireland, and it was then that he undertook his first archaeological fieldwork. While there he also acted as the prosecuting officer in the case of British non-commissioned officers accused of aiding the Fenians.[53] This familiarity with legal proceedings is crucial in that it clearly later influenced his archaeology, and it was only really first with his fieldwork that there was such a direct emphasis upon formalised *proof*.

When recording timber piles exposed near London Wall in 1866 he actually named two 'witnesses' to vouch for his observations, and Carter Blake and Rev. Heath apparently both testified to such following the paper's delivery.[54] He went even further in this direction during his

1878 investigation of the earthworks at Caesar's Camp, Folkestone, and in its report he stressed: 'In order that evidence obtained may be strictly reliable it should if possible, be of a character that might be *acceptable in a court of justice.*'[55] Indeed, in the second publication of his investigations at the Cissbury hillfort, to attest to the veracity of the work and its recording, he listed eight eminent colleagues – as if as jurors – who had viewed the site (with two 'fieldwork authorities' appending letters of verification).[56]

These two aspects of Pitt Rivers' military background – ordnance appraisal and legal proceedings – shared the adjudication of evidence and the nature of proof; in other words, *inquest/trial procedures.* In archaeology, such exercises effectively amounted to determination by 'collective viewing' and that more than one set of eyes saw the same thing and were convinced by a site's interpretation.

A noticeable omission in Pitt Rivers work is that of any serious application of photography as a formal basis of proof. Its military uses had been appreciated early,[57] with Fenton's Crimea War pictures providing the first documentary photographs of any wartime campaign, which have since become iconic of the period.[58] There is not the scope here to expound upon the more theoretical dimensions concerning 'photography as proof', which particularly arose in the last decades of the nineteenth century when, for the first time, advances in printing processes allowed for their direct reproduction. By the time Pitt Rivers published his four Cranborne Chase volumes (1887–98) photographs themselves could be and were included. He employed them both to illustrate artefacts and for scene-setting purposes, with formally posed 'team' shots well-conveying the mass scale of the enterprise.[59] Yet it seems telling that photographs were not used to illustrate soil sections, which had, after all, been a main source of proof-related dispute earlier.[60]

Crucial to this is the degree to which Pitt Rivers' archaeology changed upon his coming into his inheritance in 1880. Amounting to a rural near-retirement (he was then aged fifty-three), he was distanced from London learned society hubbub and at the same needed to publicly prove his results. Equally, through 'estate-life', he could fulfil his quasi-utopian 'archaeology-and-the-public-good' agenda and focus upon his abiding material/cultural *evolution* concerns, which were explicitly anti-revolutionary.[61]

The chronology of the General's excavations[62] not only reflects changes in his fieldwork practices, but – demonstrative of the laxity of non-wartime military duties – it also attests to just how much archaeology he undertook while in service. Moreover, leaving aside that he used the opportunity of commanding Guildford's West Surrey Brigade Depot to take bodily measurements of its militia for his own research

purposes, his Caesar's Camp excavations, for example, commenced using the labour of Royal Engineers personnel.[63]

'Savage weapons' and the science of war

Although the archaeological and ethnographic collection activities of individuals among the armed services' 'gentlemen officers' have been documented,[64] the same is not true of the fruits of such activities in Britain's many army museums. Variously displaying weaponry, uniforms and colours, their prime purpose was/is to promote *esprit de corps* through the documentation of their respective regimental/corps' history. Yet among their many trophies are, of course, overseas 'captures' that would now have to be classed as ethnographic objects, whether or not they were collected for such purposes.

Foremost among these were the collections of the RUSI.[65] These had an enormous impact on Pitt Rivers' development as an archaeologist. He joined the RUSI during the 1850s and served on its council in the following decade. Along with its library, the museum was established in 1831 in Whitehall (from 1895 housed in the Banqueting House of the former palace there); it was disbanded in the 1970s, with many of its collections dispersed to other military museums (the British Museum evidently acquiring many of the antiquities and ethnographic pieces). Its 1914 catalogue ran to 6546 entries, with many involving multiple un-numerated entries.[66] As evinced within Pitt Rivers' conclusion to his second 'Primitive Warfare' lecture, it was a display venue that clearly influenced his own collection:

> I have only a few words to say upon the defects of our ethnographical collections generally. It will be seen that in order to exhibit the continuity and progression of form, I have been obliged to collect and put together examples from many different museums; and, as it is, it will have been noticed that many links of connexion are evidently wanting [. . .]

> without connecting links which unite one form with another, *an ethnographical collection can be regarded in no other light than a mere toy-shop of curiosities, and is totally unworthy of science.*

> *Owing to the wide distribution of our Army and Navy, the members of which professions are dispersed over every quarter of the globe and have ample leisure for the pursuit of these interesting studies, this Institution possesses facilities for forming a really systematic collection of savage weapons, not perhaps within the power of any other Institution in the world. The time is fast approaching when this class of prehistoric evidence will no longer be forthcoming.*[67]

The contents of the RUSI Museum provide a yardstick for the General's own museum, especially concerning what constituted a 'systematic' collection, which the RUSI's was evidently anything but (Figure 4.2).[68] A hodgepodge of haphazard donations, the RUSI Museum was described in Charles Dickens Jr's *Dickens's Dictionary of London* of 1879:

> Upon entering, the visitor finds himself in a room devoted to African arms. There are spears and assegais of all shapes and sizes, belonging to the tribes of Abyssinia, Ashanti, Central and Southern Africa. Upon the floor stands a great variety of war-drums of various forms . . . The next room is devoted to modern arms. . . . The next room is devoted to Asiatic arms. There are some curious Chinese and Indian cannon and jingais, some suits of Indian chain-armour, together with primitive weapons from Borneo and the Polynesian islands. Beyond the Asiatic room is that devoted to the marine branch of the United Services. There are a great variety of fine models of ships of all shapes . . . At one end are models of small craft of all kinds, from the Cingalese outrigger and the Venetian gondola to the Chinese junk. In the next room is a model upon a large scale of the Battle of Trafalgar.[69]

Many prints, paintings, regimental colours, medals, uniforms, weaponry and ordnance featured highly in the Museum, with the latter two respectively having some 320 and 610 entries within the 1914 catalogue. There were also an enormous number of models (142), the vast majority ships, with those of artillery otherwise prominent. By today's standards the most eccentric entries are those that can be broadly classed as 'relics'. Apart from items recovered from shipwrecks, these related to fallen heroes (e.g. Cook, Nelson, Wolfe and Franklin) and renowned 'greats' (e.g. Wellington's Waterloo umbrella or the skeleton of Napoleon's horse, Marengo, now in the National Army Museum, London).

The RUSI's collections also encompassed antiquities, including a Buddhist terracotta unearthed in 1878 at a Khyber Pass fortress,[70] as well as weaponry attributed to the Bronze Age and Saxon periods variously from Ireland and dredged from the Thames. One of the largest categories, and that of greatest relevance for Pitt Rivers' researches, was its ethnographic material, and this he duly acknowledged in the lectures' introduction:

> . . . yet the fact of your possessing in the three large apartments that are devoted to your armoury, *one of the best assortments of semi-civilized and savage weapons that are to be found in this country, or, perhaps, in any part of the world*, is sufficient prove that it is not foreign to the objects of the Institution that the science of war should be ethnographically and archaeologically, as well as practically, treated.[71]

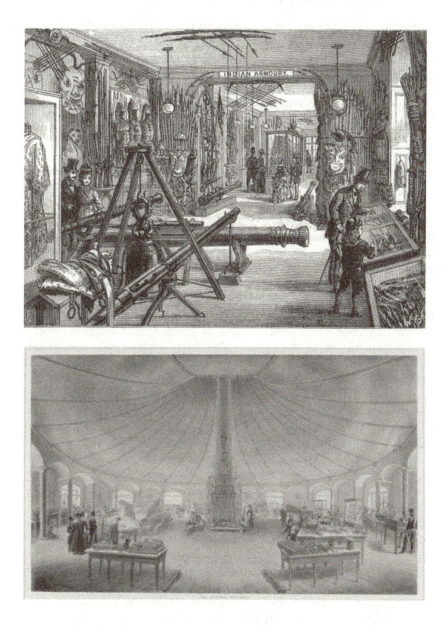

Figure 4.2 Military Collections: the Royal United Service Institution's Museum (top; from *Old and New London*, 1878, III, 344) and, below, 1828 watercolour showing interior of the Rotunda, Royal Military Repository, Woolwich (notice various fortification models in the foreground; British Museum: 1862,0614.202).

Running to *c*. 1300 catalogue entries in the 1914 catalogue, although nearly all warfare-related, the RUSI collection would have then been one of the larger ethnographic collections in Britain. Except that it omits many Australian- and New Zealand-sourced items (e.g. boomerangs and war clubs), that we know to have been in the Institute's collections, Dickens' description above generally reflects the range of the RUSI Museum's ethnographic holdings. Based on the published catalogue of 1914 alone, there is no ready means of establishing what material was present within the RUSI collections when Pitt Rivers was compiling his 'Primitive Warfare'. That said, the donations to, and purchases by, the museum annually listed in its journal provide some basis. Between 1859 and 1868 it acquired roughly 1024 items, with their category proportions varying from those in the 1914 catalogue. By far the largest category was ethnographic material (424, 41 per cent), with European weaponry/ordnance representing only approximately half that amount (*c*. 234, 23 per cent).

A more direct measure of the RUSI Museum's impact can be gleaned from those sources Pitt Rivers drew upon for illustrations accompanying his 'Primitive Warfare' lectures, with thirty-one of the pieces deriving from the RUSI's collections, as opposed to twenty-eight from his own (plus six from the British Museum). This is only apt, as what is usually dropped from most contemporary references to the arising paper is the 'Primitive Warfare' lectures' sub-title: 'Illustrated by Specimens from the Museum of the Institution'. Significantly, the RUSI Museum evidently did not heed Pitt Rivers' advice. As is evident in Dickens' 1879 account, they continued to display their overseas weaponry collections geographically and not in any kind of systematic typological manner. Ultimately, of course, just because Pitt Rivers was more systematic does not necessarily make his approach any more 'correct', with his ordering privileging *form* at the expense of *context*.

Pitt Rivers clearly held that combativeness and warfare were basic human conditions rooted in the animal kingdom. Although weapons formed only the third most numerous class within his own first collection,[72] it came to be characterised as a 'Museum of Weapons'.[73] All told, it included 246 firearms and related equipment, with this being a category absent from, for example, John Lubbock and John Evans' personal collections.[74] That Pitt Rivers' work on musketry provided the original impetus for his museum was apparent in his 'Typological Museums' address:

My attention was first drawn to this subject forty years ago, when, in the year 1852, I was engaged as a subaltern officer on the sub-committee of small arms at Woolwich . . . it occurred to me what an interesting thing

it would be to have a museum in which all of these successive stages of improvement might be placed in the order of the occurrence. *I made a collection of arms at that time, which was the foundation of the present museum.* Although this collection of arms was not a very good one, as my means of collecting were small, it led to *a museum of savage weapons* [. . .][75]

Equally telling is that upon delivering that 1891 paper Pitt Rivers exhibited diagrams of his collection, the first ones 'showing the evolution of the modern rifle and bullet through all its stages'.[76]

These references indicate just how central Pitt Rivers considered the development of the musket/rifle and his involvement with it. This was not just a matter of early career background but something he evidently held to be of fundamental importance and, almost forty years on, still an abiding concern.[77]

During the latter half of the nineteenth century the devastating results of unequal firepower in colonial wars became tragically obvious. Fully believing in the nation's empire and having such a deep-rooted awareness of cultural and material change – 'progress is like a game of dominoes [. . .] the fundamental rule of the game is *sequence*'[78] – Pitt Rivers surely would have seen such technological development as inevitable and, victims of specific atrocities aside, ultimately a force for social good. Yet it was the unforgiving pace of contemporary change that propelled what he saw to be the pressing need to salvage, through study and collection, the world's fast disappearing 'native arts' (see below). In fact, as someone so clearly appreciative of material culture diversity, references to both 'fury' and 'the scourge' within 'Primitive Warfare' can only suggest a degree of resignation and regret in the face of their loss:

> there can be little doubt that in a few years all the most barbarous tribes will have disappeared from the earth, or will have ceased to preserve their native arts. *The law which consigns to destruction all savage races when brought into contact with a civilization much higher than their own, is now operating with unrelenting <u>fury</u> in every part of the world . . . Whenever the generous influences of Christianity have set foot, there they have been accompanied by <u>the scourge</u>.*[79]

As early as 1839 Pritchard had pronounced 'On the extinction of human races',[80] and within the above passage Pitt Rivers cited the demise of the Tasmanian peoples, as well as the native peoples of Polynesia and the Americas. He also highlighted the threat posed to Australian Aboriginal peoples and the Maoris, with the New Zealand Musket Wars of 1818 to 1845 then standing as a marked example of just what degree of socio-political change firearms could incur.

[99]

To understand Pitt Rivers in his time, and that he was an active participant in such changes and that they affected all facets of his work/study, is crucial. Certainly, in much the same way as the British military's contribution to the recording of the past has generally been overlooked, so too has the impact of Pitt Rivers' army career upon his archaeology (and anthropology) been neglected. His military experience provided the basic skill sets by which he approached fieldwork and adjudicated evidence, and it was his ordnance work that propelled his concern with systematic typological collection. Yet it was not just a matter of him first being a soldier and then a career archaeologist. Reflective of the era's polymath personalities, and the opportunity for study pursuits then afforded to officers, between 1864 and 1877 *he became an archaeologist while still in service.* Indeed, thereafter, he evidently strongly identified with his role in the development of rifle musketry and, as someone acutely aware of change, he held his ordnance work to be something that uniquely marked his contribution to his time. Seen from this perspective, while deeply personal in its underlying orientation, it becomes essential to not just see Oxford's Pitt Rivers Museum as a 'museum of world cultures' (i.e. reinventing the ethnography/anthropology of old) but to also recognise its military-collection antecedents.

Acknowledgements

In this chapter's prolonged production my greatest debts have been to Mark Bowden, whose long study of 'the man' has greatly informed this effort, and Simon Schaffer for steering me through the context of the era's military science. That said, it has also benefited from the insights and due critique variously provided by many: Richard Bradley, Martin Carver, Will Carruthers, Robert Fleming, Dan Hicks, Arthur MacGregor, Tim Murray, Mike O'Hanlon, Alison Petch, Nathan Schlanger and Michael Thompson. Martin Jones, Cambridge's Emeritus George Pitt-Rivers Professor of Archaeological Science, provided Figure 4.1's Wor Barrow image from a family album that came with that chair's bequest.

Notes

1 R. E. M. Wheeler, *Archaeology from the Earth* (Harmondsworth: Penguin, 1954), p. 131; see also K. Hudson, *The Social History of Archaeology: The British Experience* (London: Macmillan Press, 1981), p. 7 on 'archaeologist-generals'.
2 Lieutenant-General. A. H. L. F. Pitt Rivers, 'Primitive Warfare: illustrated by specimens from the Museum of the Institution (Parts I–III)', *JRUSI*, 11–13 (1867), 612–45; (1868), 399–439; (1869), 509–39.
3 See C. Evans, 'Soldiering archaeology: Pitt Rivers and militarism', *Bulletin of the History of Archaeology*, 24 (2014), Article 4; N. M. Hartwell, 'A repository of virtue?

The United Services Museum, collecting, and the professionalization of the British Armed Forces, 1829–1864', *JHC* (2018), 77–91, fhy006, https://doi.org/10.1093/jhc/fhy006; N. Ramsey, 'Exhibiting Discipline: Military Science and the Naval and Military Library and Museum', in N. Ramsey and G. Russell (eds), *Tracing War in British Enlightenment and Romantic Culture* (Basingstoke: Palgrave Macmillan, 2015), pp. 113–31.

4 With the whereabouts of the originals unknown, London's National Army Museum (NAM) holds microfiche copies of Pitt Rivers' 'Arms' notebooks (Ref: 6803/343). Arguably their titling is misleading (the catalogue lists them as relating to 'the archaeology of weapons'), as they include nothing concerning his contemporary ordnance-related work. Apparently dating to the 1860s and running to 10 volumes (and over a thousand pages), they essentially represent his amassed 'Primitive Warfare' background researches on world ethnography and European prehistory. Ranging from classical authors to von Humboldt and the Danish archaeologist, Worsase, they attest to the enormous scope of his reading and are extensively illustrated with pasted-in traced line-drawings.

5 E.g. M. O'Hanlon, *The Pitt Rivers Museum: A World Within* (London: Scala Arts & Heritage Publishers, 2014).

6 G. Harries-Jenkins, *The Army in Victorian Society* (London: Routledge and Kegan Paul, 1977), p. 162.

7 I. Hernon, *Britain's Forgotten Wars: Colonial Campaigns of the 19th Century* (Stroud: Sutton, 2003).

8 E.g. P. D. Bonarjee, *A Handbook of Fighting Races of India* (Calcutta: Thacker, Spink & Co., 1899); H. Streets, *Martial Races: The Military, Race and Masculinity in British Imperial Culture, 1857–1914* (Manchester: Manchester University Press, 2004).

9 E.g. M. Diaz-Andreu, *A World History of Nineteenth-Century Archaeology: Nationalism, Colonialism and the Past* (Oxford: Oxford University Press, 2007).

10 E.g. B. F. Cook, 'British Archaeologists in the Aegean', in V. Brand (ed.), *The Study of the Past in the Victorian Age* (Oxford: Oxbow Monograph 73, 1998), pp. 139–54; H. Hoock, *Empires of the Imagination: Politics, War, and the Arts in the British World, 1750–1850* (London: Profile Books, 2010), pp. 243–72.

11 E.g. R. Hewitt, *Map of a Nation: A Biography of the Ordnance Survey* (London: Granta, 2010), pp. 20–42.

12 J. Douglas, *Nenia Britannica, or a Sepulchral History of Great Britain, from the Earliest Period to Its General Conversion to Christianity: Including a Complete Series of the British, Roman, and Saxon Sepulchral Rites and Ceremonies* (London: John Nichols, 1793).

13 K. Paddayya, *Essays in History of Archaeology: Themes, Institutions and Personalities* (Noida: Archaeological Survey of India, 2013), pp. 188–212.

14 S. Lysons, *An Account of Roman Antiquities Discovered at Woodchester* (London, 1797); R. Sweet, *Antiquaries: The Discovery of the Past in Eighteenth-Century Britain* (London: Hambledon & London, 2004), p. 104. Termed a 'druidical temple', in 1785 a circular megalith was exposed during levelling operations for an army parade ground at Mont St Helier, Jersey. Duly survey-recorded and retained, its stones were subsequently presented by the Island's Assembly to its retiring Governor, Field Marshall Conway, who had them re-erected in the grounds of his Berkshire house, they being dubbed by his cousin, Horace Walpole, 'little Master Stonehenge'; see C. Evans, 'Megalithic Follies: Soane's 'Druidic Remains' and the display of Monuments', *Journal of Material Culture*, 5 (2000), 347–66 (pp. 353–5).

15 W. Porter, *History of the Corps of Royal Engineers* (London: Longmans, Green & Co., 1889), Vol. II, Chapter 10; see also J. Fergusson, *Rude Stone Monuments in All Countries; Their Age and Uses* (London: John Murray, 1872), p. 120 on other Chatham 'sapper' excavations.

16 J. Narrien, 'Observations on a Roman encampment near East Hempstead, in Berkshire', *Archaeologia*, 10 (1821), 96–8. The antiquary Alfred Kempe in effect 'sponsored' the Sandhurst surveys to the Society of Antiquaries; see e.g. J. Kempe,

'Mr. Kempe's observations on the map of the Roman road', *Archaeologia*, 27 (1838), 414–16. For a period of five years he served with the Tower Hamlets militia and, prior to its 1828 publication in the Society's *Archaeologia*, a version of Kempe's first major paper – 'An investigation of the antiquities of Holwood Hill, in the parish of Keston' – appeared in the *Military Register* of 1814.

17 See R. Hingley, *Roman Officers and English Gentlemen: The Imperial Origins of Roman Archaeology* (London: Routledge, 2000), pp. 6–7; J. M. Mackenzie, *Propaganda and Empire: The Manipulation of British Public Opinion 1880–1960* (Manchester: Manchester University Press, 1984); J. M. Mackenzie, 'Introduction' in J. M. Mackenzie (ed.), *Imperialism and Popular Culture* (Manchester: Manchester University Press, 1986), pp. 1–16 (p. 3); see e.g. J. Secord, 'King of Siluria: Roderick Murchison and the Imperial Theme in Nineteenth-Century British Geology', *Victorian Studies*, 25 (1982), 413–42 on 'imperial science'.

18 See e.g. D. Crownover, 'Discoveries at Cyrene', *Expedition*, Spring (1963), 28–31.

19 E.g. Lieutenant-Colonel H. Rawlinson, 'Notes on some paper casts of cuneiform inscriptions upon the sculptured rock at Behistun', *Archaeologia*, 34 (1851), 73–6; L. Adkins, *Empires of the Plain: Henry Rawlinson and the Lost Languages of Babylon* (London: Harper Collins, 2003).

20 E. P. F. Rose, 'British pioneers of the geology of Gibraltar, Part 2: cave archaeology and geological survey of the Rock, 1863 to 1878', *Earth Sciences History*, 33 (2014), 26–58.

21 D. K. Chakrabarti, *A History of Indian Archaeology from the Beginning to 1947* (Delhi: Munshiram Manoharlal Publishers Pvt Ltd., 1988).

22 P. Meadows Taylor, 'On Prehistoric Archaeology of India', *Journal of the Ethnological Society of London*, 1 (1869), 157–81.

23 Paddayya, *Essays in History of Archaeology*, pp. 16–9; Wheeler, *Archaeology from the Earth*, p. 131. In 1868 just under a quarter of the membership (98 in total) of the Asiatic Society of Bengal were army officers. Under the chairmanship of T. H. Huxley, in 1869 the Ethnology Society of London organised a meeting on 'Ethnology and archaeology of India'. Aside from Meadows Taylor's 'On prehistoric archaeology in India' paper, this included Major Pearse's 'On the excavation of a large raised stone circle or barrow near the village of Wurregoan ...', with both published in the same volume of their journal (1869).

24 C. Warren, C. W. Wilson and A. P. Stanley, *The Recovery of Jerusalem: A Narrative of Exploration and Discovery in the City and the Holy Land* (W. Morrison, ed.; New York: D. Appleton, 1871); C. R. Conder and H. H. Kitchener, *Survey of Western Palestine: Memoirs of Topography, Orography, Hydrography and Archaeology*, 3 vols (London: Palestine Exploration Fund, 1881–85).

25 Markedly different from Pitt Rivers', Kitchener's 'celebrated collection' was auctioned by Sotheby's in 1938. Some eighty lots were of Greek, Roman and Egyptian origin and can be classed as antiquities; the remaining c. 220 items largely consisted of Chinese porcelain and Persian/Turkish faience.

26 A. Ulbrich and T. Kiely, 'Britain and the Archaeology of Cyprus I: The long 19th century', *Cahiers du Centre d'Etudes Chypriotes*, 42 (2012), 305–56.

27 In 1849 the Admiralty issued its *A Manual of Scientific Enquiry: Prepared for Use of Her Majesty's Navy and Adapted for Travellers in General* (London: John Murray, 1849). There, amid sections on astronomy and hydrography, and following Darwin and Hooker's respective contributions on geology and botany, Pritchard provided its 'Ethnology': 'The rudest or most simple stage of human society is not without its appropriate arts [...] The art of war, as practised by various nations, affords a wide field of observations', p. 433. In 1851, a sub-committee of the British Association for the Advancement of Science similarly issued its first *Manual for Ethnological Inquiry* (see e.g. J. Owen, 'Collecting artefacts, acquiring empire: exploring the relationship between Enlightenment and Darwinist collecting and late-nineteenth-century British imperialism', *JHC*, 189 (2006), 9–25, on naval expedition collection).

28 W. H. Smyth, 'Account of an ancient bath in the island of Lipari', *Archaeologia*, 2 (1830), 98–102; see also W. H. Smyth, 'On some Roman vestigia recently found at Kirby Thore, in Westmoreland', *Archaeologia*, 31 (1846), 279–88.

29 F. W. L. Thomas, 'Account of some Celtic antiquities of Orkney', *Archaeologia*, 34 (1851), 88–136.
30 J. H. Lefroy, 'On a bronze object bearing a runic inscription found at Greenmount, Castle Bellingham, Ireland', *Archaeological Journal*, 27 (1870), 284–313.
31 Hudson, *The Social History of Archaeology*, pp. 37–8.
32 C. L. Woolley and T. E. Lawrence, *The Wilderness of Zin* (Palestine Exploration Fund Archaeological Report; London: Harrison and Sons, 1914).
33 M. Heffernan, 'Geography, cartography and military intelligence: the Royal Geographical Society and the First World War', *Transactions of the Institute of British Geographers*, 21 (1996), 504–33.
34 G. Whitteridge, *Charles Masson of Afghanistan: Explorer, Archaeologist, Numismatist and Intelligence Agent* (Warminster: Aris & Phillips, 1986) and E. Errington, *The Charles Masson Archive: British Library, British Museum and Other Documents Relating to the 1832–1838 Masson Collection from Afghanistan* (London: British Museum, 2017).
35 Anon., 'Buddhist sculptures found near Jellalabad', *The Graphic*, 21 (1880/1), 293.
36 E. W. Bawtree, 'The brief description of some sepulchral pits of Indian Origin lately discovered near Penetanguishene', *Edinburgh New Philosophical Journal*, 45 (1848), 86–101.
37 See G. Williamson, *Observations on the Human Crania Contained in the Museum of the Army Medical Department, Fort Pitt, Chatham* (London: McGlasham & Gill, 1857).
38 R. Knox, *The Races of Men* (London: Henry Renshaw, 1850).
39 E.g. T. Murray, 'Excavating the Cultural Traditions of Nineteenth Century English Archaeology: the Case of Robert Knox', in A. Gustafsson and H. Karlsson (eds), *Glyfer och arkeologiske rum – en vänbok til Jarl Nordbladh* (Göteborg: University of Göteborg, 1999), pp. 501–15; Z. Magubane, 'Simians, savages, skulls and sex: Science and Colonial Militarism in Nineteenth-century South Africa', in D. S. Moore, J. Kosek, and A. Pandian (eds), *Race, Nature and the Politics of Difference* (Durham: Duke University Press, 2003), pp. 99–121.
40 B. Effros, *Incidental Archaeologists: French Officers and the Rediscovery of Roman North Africa* (London: Cornell University Press, 2018).
41 Diaz-Andreu, *A World History of Nineteenth-Century Archaeology*, pp. 247–55 and 265–8; for Prussian-German officers' recording of monuments within the lands of the Ottoman Empire from the 1890s see G. Stein 'Archaeology and Monument Protection in War: The Collaboration Between the German Army and the Researchers in the Ottoman Empire, 1914–1918', in J. Clarke and J. Horne (eds), *Militarized Cultural Encounters in the Long Nineteenth Century: Making War, Mapping Europe* (Cham, Switzerland: Palgrave Macmillan, 2018), pp. 297–317.
42 S. Piggott, *Ruins in a Landscape: Essays in Antiquarianism* (Edinburgh: Edinburgh University Press, 1976).
43 Rose, 'British pioneers'.
44 G. W. Jr Stocking, *Victorian Anthropology* (London: Collier Macmillan Pub., 1987), pp. 240–8; J. Owen, *Darwin's Apprentice: An Archaeological Biography of John Lubbock* (Barnsley, S. Yorks.: Pen and Sword Archaeology, 2013), pp. 47–50.
45 Darwin's correspondence similarly indicates that he had a wide contact network in the services, numbering more than 20 (including five colonels and the same number of admirals).
46 One of Pitt Rivers' daughters married John Lubbock, Darwin's neighbour in Bromley, Kent; see M. Bowden, *Pitt Rivers: The Life and Archaeological Work of Lieutenant-General Augustus Henry Lane Fox Pitt Rivers, DCL, FRS, FSA* (Cambridge: University Press, 1991), p. 35; see also Owen, *Darwin's Apprentice*, p. 45.
47 E.g. M. W. Thompson, *General Pitt-Rivers: Evolution and Archaeology in the Nineteenth Century* (Bradford-on-Avon: Moonraker Press, 1977), pp. 31–44; Stocking, *Victorian Anthropology*, pp. 180–1.
48 Thompson, *General Pitt-Rivers*, pp. 14–30; Bowden, *Pitt Rivers*, pp. 14–22; C. Evans, 'Soldiering archaeology'.

[103]

49 Lieutenant-General A. H. L. F. Pitt Rivers, 'On the improvement of the rifle as a weapon for general use', *JRUSI*, 2 (1858), 453–88; Lieutenant-General A. H. L. F. Pitt Rivers, 'On a model illustrating the parabolic theory of projection for ranges in vacuo', *JRUSI*, 5 (1861), 497–501.

50 J. Barrett, R. Bradley, M. Bowden and B. Mead, 'South Lodge after Pitt Rivers', *Antiquity*, 57 (1983), 193–204; C. Evans, 'Engineering the past: Pitt Rivers, Nemo and the Needle', *Antiquity*, 80 (2006), 960–9.

51 C. Evans, 'Modelling Monuments and Excavations', in S. de Chadarevian and N. Hopwood (eds), *Models: The Third Dimension of Science* (Stanford, California: Stanford University Press, 2004), pp. 109–37.

52 Lieutenant-General A. H. L. F. Pitt Rivers, *Excavations in Cranborne Chase*, Vol. 1 (Privately Printed, 1887), p. xvii, emphasis added; for military sketch-rendering (i.e. 'capturing landscapes') see also C. Kennedy, 'Military Ways of Seeing: British Soldiers' Sketches from the Egyptian Campaign of 1801', in Clarke and Horne (eds), *Militarized Cultural Encounters in the Long Nineteenth Century*, pp. 197–221.

53 Bowden, *Pitt Rivers*, p. 21.

54 Lieutenant-General A. H. L. F. Pitt Rivers, 'A description of certain piles found near London Wall and Southwark, possibly the remains of pile buildings', *Anthropological Review*, 5 (1867), pp. lxxi–lxxxiii.

55 Lieutenant-General A. H. L. F. Pitt Rivers, 'Excavations at Caesar's Camp, near Folkestone, conducted in 1878', *Archaeologia*, 47 (1883), 429–65 (p. 436), emphasis added.

56 Lieutenant-General A. H. L. F. Pitt Rivers, 'Excavations of Cissbury Camp, Sussex', *Journal of the Anthropological Institute*, 5 (1875), 357–90.

57 Captain R. E. Donnelly, 'Photography, and its application to military purposes', *JRUSI*, 5 (1862), 1–8.

58 Concerning Fenton's photography see e.g. S. Gordon, *Shadows of War: Roger Fenton's Photographs of the Crimea, 1855* (Royal Collection Trust, 2017). From an early date, selected Royal Engineers officers were trained in photography and this is reflected in their records of monuments in, for example, the North-west Frontier and Palestine. Indeed, the first aerial photograph of an archaeological site in Britain was taken, from a balloon, by one Lieutenant P. H. Sharpe of the Corps of Royal Engineers. During the First World War, the archaeologist O. G. S. Crawford served in the Royal Flying Corps and, thereafter, as an officer with the Ordnance Survey was the main figure responsible for the introduction of aerial photography into British archaeology; many of the archaeologists who served in the Second World War were involved in aerial photographic interpretation (see Evans, 'Soldiering archaeology', n. 1).

59 See e.g. Bowden, *Pitt Rivers*, figs. 39, 42–4.

60 E.g. Evans, 'Soldiering archaeology'.

61 R. Bradley, 'Archaeology, evolution and the public good: the intellectual development of General Pitt Rivers', *Archaeological Journal*, 140 (1983), 1–9.

62 See Evans, 'Soldiering archaeology', Table 1.

63 Lieutenant-General A. H. L. F. Pitt Rivers, 'On measurements taken of the officers and men of the 2nd Royal Surrey Militia according to the general instructions drawn up by the Anthropometric Committee of the British Association', *Journal of the Anthropological Institute*, 6 (1877), 443–57; Pitt Rivers, 'Excavations at Caesar's Camp', p. 436.

64 E.g. M. Wagstaff, 'Colonel Leake's collections: their formation and their acquisition by the University of Cambridge', *Journal of the History of Collections*, 24 (2012), 327–36; Owen, 'Collecting artefacts, acquiring empire'.

65 See Note 3. Having its origins in the Royal Military Repository (established in Woolwich in the 1770s as a training collection for cadets; see Figure 4.2), the Royal Artillery Museum opened in 1820 (see G. Russell, 'Romantic Militarisation: Sociability, Theatricality and Military Science in the Woolwich Rotunda, 1814–2013', in N. Ramsey and G. Russell (eds), *Tracing War in British Enlightenment and Romantic Culture* (Basingstoke: Palgrave Macmillan, 2015), 96–112); first established for teaching purposes, the Royal Engineers Museum collections date back to 1812.

66 A. Leetham, *Official Catalogue of the Royal United Services Museum, Whitehall, S.W.* (London: The Royal United Services Institution, 1914).

67 Pitt Rivers, 'Primitive Warfare' (1868), pp. 438–9, emphasis added.

68 W. R. Chapman, 'Arranging Ethnology: A. H. L. F Pitt Rivers and the Typological Tradition', in G. Stocking (ed.), *Objects and Others: Essays on Museums and Material Culture,* History of Anthropology Vol. 3 (Madison: University of Wisconsin Press, 1985), pp. 15–48; A. Petch, '"Man as he was and Man as he is": General Pitt Rivers' Collection', *JHC,* 10 (1998), 75–85; A. Petch, 'Chance and certitude: Pitt Rivers and his first collection', *JHC,* 18 (2006), 257–66.

69 C. Dickens (Jr), *Dickens's Dictionary of London* (London: 1879), quoted in *The Dictionary of Victorian London,* http://www.victorianlondon.org/entertainment/unitedservicemuseum.htm, accessed 1 August 2019.

70 Likely among the material shown in Evans, 'Soldiering Archaeology', Figure 1.

71 Pitt Rivers, 'Primitive Warfare' (1867), p. 612, emphasis added.

72 Lieutenant-General A. H. L. F. Pitt Rivers, *Catalogue of the Anthropological Collection Lent by Colonel Lane Fox for Exhibition in the Bethnal Green Branch of the South Kensington Museum, June 1874* (London: South Kensington Museum, 1874).

73 E. B. Tylor, 'Presidential Address to the Anthropological Institute', *Journal of the Anthropological Institute of Great Britain and Ireland,* 10 (1881), 440–58 (p. 458); see also A. Petch, 'Weapons and "the museum of museums"', *Journal of Museum Ethnography,* 8 (1996), 11–22.

74 J. Owen, 'A Significant Friendship: Evans, Lubbock and a Darwinian World Order', in A. Macgregor (ed.), *Sir John Evans 1823–1908: Antiquity, Commerce and Natural Science in the Age of Darwin* (Oxford: Ashmolean Museum, 2008), pp. 206–29.

75 Lieutenant-General A. H. L. F. Pitt-Rivers, 'Typological museums, as exemplified by the Pitt Rivers Museum in Oxford and his provincial museum in Farnham, Dorset', *Journal of the Society of Arts,* 40 (1891), 115–22 (pp. 118–19), emphasis added.

76 Pitt-Rivers, 'Typological museums', p. 120.

77 As evinced in a letter to Tylor concerned with his forthcoming election to the Royal Society, and setting straight the record of his achievements, as late as 1875 Pitt Rivers expressed that his main contribution was to musketry rather than anthropological science: '*I mention this as you … think as I do that my Anthropological contributions to Science alone do not afford my very weighty claim to recognition. Even tho you were kind enough to suggest to me to become a candidate for the Society. My School of Musketry work however was the result of many years hard work including experiments in connection with the small arms commission at Woolwich & Hythe and the translation of some of the official codes of foreign countries*' (British Library: ADD. 50254ff/84 Envelope f.88; emphasis added).

78 Lieutenant-General A. H. L. F. Pitt-Rivers, 'On the evolution of culture', *Proceedings of the Royal Institution,* 7 (1875), 496–520 (p. 520), emphasis added.

79 Pitt Rivers, 'Primitive Warfare' (1867), p. 620, emphasis added; see also e.g. J. W. Gruber, 'Ethnographic salvage and the shaping of anthropology', *American Anthropologist,* 61 (1959), 379–89.

80 J. C. Pritchard, 'On the extinction of human races', *Edinburgh New Philosophical Journal,* 28 (1839), 166–70.

CHAPTER FIVE

The officers' mess: an anthropology and history of the military interior

Lt Col Charles Kirke (Rtd) and Nicole M. Hartwell

Joining the Royal Artillery Mess – a personal reflection

It was the first of January 1970. I had transferred the previous midnight from another Service to the Royal Regiment of Artillery[1] and had reported for duty at the Royal Artillery Depot and Training Regiment at Woolwich.[2] I was welcomed at the Main Gate and shown the way to the officers' mess (known as the 'Royal Artillery Mess' or 'the RA Mess') to sign in and to be given a room. As I stepped over the threshold and up some stairs the chill of the January day vanished. The place was warm and welcoming, and vast – an enormous hall dominated by a seemingly endless staircase, and all well-lit. A Tompion bracket clock chimed sweetly above the reception desk as the Hall Porter handed me my key and told me how to find my room. 'But it's coffee time, Sir,' he said, giving me a friendly smile, 'would you like to leave your bags with me and go into the ante-room and join in?' I walked into a large soft-carpeted panelled room in which the officers from the resident training regiment were beginning to congregate. Easy chairs were grouped round low tables and a (closed) bar was off to one side. Nobody was very interested in an obvious youngster like me, so I walked alone to the end of the room to a small area that had paintings on the walls of battle scenes of artillery in action from past wars, some highly dramatic. Then the Commanding Officer came in, everyone stood up, and he waved at them to relax. He noticed me and, possibly concerned that I was one of his officers whom he had not met, asked me how long I had been in 'the regiment'. I looked at my watch. 'I joined the Gunners[3] ten hours ago, Sir.' He laughed and welcomed me and immediately called upon one of his junior officers to look after me and show me round. Gareth introduced himself and we drank coffee together, after which he took me on a tour of the mess.

We first entered the Dining Room, an enormous place with three long tables and a 'cross table'⁴ at right angles to them, and with life-sized pictures of British monarchs on the walls, alternating with huge mirrors.⁵ A statue of 'Armed Science' stood at the opposite end from the cross table, in an alcove. I then recovered my bags from the Hall Porter and Gareth led me up the staircase. On the first landing we went by a finely appointed room with large portraits of generals on the walls and a grand piano, and we passed further paintings of Senior Gunners as we climbed beyond it. On the way up he pointed out a 'living-in officers' TV room' for future reference, and when we reached the top I saw a large glass case containing two stuffed tigers in a jungle setting, a polar bear skin lying on a beautifully polished table and two separately mounted elephant's tusks over nine feet long, with a plaque saying who shot the elephant and when. We then turned right and down a few steps into a different place entirely. This was the officers' accommodation, a long corridor of single rooms with bathrooms at intervals – utilitarian compared with the opulence of where we had come from. Gareth quickly found my room and I unlocked it to see a plain set of furniture – a bed, a cupboard, a bookcase, a table and chair, and a small separate area containing a basin and a glass shelf. The window had curtains of a sort, providing modesty but no real barrier to light or heat.

'Come and see the regimental silver,' said Gareth, and I followed him out of the room and back down the stairs to the main hall. He led me to a startling place. Behind protective glass there was an arrangement of silver objects of a bewildering variety, beautifully clean and beautifully lit. There were horses and riders, trophies, guns, exotic objects from past campaigns, candlesticks, candelabra (one of them a spectacular example which had been presented by William IV), coffee sets, tea sets and a 22 carat gold Lonsdale Belt awarded to the boxing champion Bombardier Billy Wells in 1911.⁶ Gareth then explained that all this silver routinely came out at formal dinners to be displayed on the tables, as a matter of course.

The military interior: an introduction

The personal account above encapsulates the first impression of a British Army officers' mess by one of the authors of this chapter, Charles Kirke, at the time a newly arrived very junior Royal Artillery second lieutenant. In beginning with a personal experience this chapter seeks to understand the experience of entering and being part of a mess as a means of understanding military culture while asking how representative it is and whether it has wider applicability, most particularly

historically. It suggests that through personal insight we can, as researchers, better understand how officers experienced a mess in the nineteenth century, which is the main focus of this chapter.

This chapter situates the experience and behaviours of people, spaces and objects within the context of mess culture, a phenomenon that is second nature to those within a military context, but in need of explanation to those outside it. It is written in two parts: the first, written by Kirke, a military anthropologist, who draws broadly from social anthropology to model the types of social structures that define military domestic spaces, such as the mess. This is a personalised and theoretically informed reflection and acts as an introduction to the second part, written by Hartwell, a historian. The second half of the chapter provides a historical overview of the mess, the artefacts found within it and their role in military life. It is the purpose of this chapter to combine the authors' expertise to create a better understanding of the social milieu of the phenomenon of 'the mess' and the types of artefacts found there, by combining a model of British Army organisational culture with historical evidence and analysis.

British Army organisational culture

Human groups generally display regularities of behaviour in patterns that are unique to them. Such regularities of behaviour show that the group's members share common understandings of what is 'normal' or 'appropriate' behaviour – the 'rules of the game' for their group. These shared understandings are the essence of what is called 'culture', consisting in all learned behaviour shared within a group. In the setting of this chapter, the groups in question are British military officers in the context of the officers' mess.

The concept of 'culture' is framed in different ways by different academic disciplines, which can lead to misunderstanding and confusion when it is addressed without explanation. In this section, the approach draws from social anthropology, which originally focused on the study of small groups (say, 20 to 1,000 members, sometimes known by the term 'small-scale societies') and is thus well suited to the study of military units, and groupings within those units.

Although the British Army is an organisation (rather than a separate human group) populated by individuals from the wider society who choose to enter and leave it, previous anthropological research[7] has shown it to have a strong culture, permeating large areas of its members' lives both inside and outside its institutional boundaries. It embraces soldiers' everyday experience both on duty and off duty, and the bonding and cohesion of the military community.

In previous publications, Kirke has developed a model of British Army culture[8] which can be used to describe, analyse and explain the lived experience of British soldiers in the period 1700 to 2000, which therefore covers the historical period relevant to this chapter. The model has four zones of behaviour, technically *social structures*.

There is a *formal command structure*, namely the structure through which a soldier receives orders from the person at the top and carries these out. It is embedded in and expressed by the hierarchy of rank and the formal arrangement of the unit into layer upon layer of organisational elements. It contains the mechanisms for the enforcement of discipline and it provides the framework for official responsibility. There is an *informal structure*, which consists in unwritten conventions of behaviour in the absence of formal constraints, including behaviour off duty and in relaxed-duty contexts, and a *functional structure*, which captures soldiers' attitudes and feelings towards attributes and behaviour that can be called 'soldierly' – anything perceived as relevant to the business of being a soldier. This might include, for example, wearing equipment and accoutrements properly, military skills with weapons and acceptable behaviour in battle (aspects which are, however, also powerfully defined by the changing regimental/battalion organisation at any given time).

The *loyalty/identity structure* models ideas about belonging and identity. Each soldier is a member of a number of different groups, in ascending order of size. Soldiers owe allegiance to each of these groups as a corporate body in which all members share an identity and to which all belong. They are expected to give unequivocal support to the appropriate group at all levels – to maintain an attitude that each of them is 'the best' and to defend their reputation. However, expressions of identity and loyalty at any particular time would be framed by sets of comparison that may arise from any given situation. Thus in the infantry, a soldier would be expected to say, and believe, that he or she belongs to the best platoon in comparison to other platoons, the best company in comparison to other companies and in the best battalion of the best regiment in the British Army.[9] This results in a rich and flexible pattern of rivalry and of mutual support in different situations.

It is emphasised that this model is a tool, rather than a comprehensive description of everything in soldiers' lives (which would be impossible). It is designed to enable a researcher or other type of investigator to describe, analyse and explain the behaviour of British soldiers. It follows the concept summed up by Brian Wilson, in his work on soft systems modelling: 'Models (of any kind) are *not* descriptions of the real world [;] they *are* descriptions of ways of thinking about the real world.'[10]

[109]

An analysis of the officers' mess at Woolwich in 1970

Using this model of social structures allows additional insight into the formative experience in Woolwich in 1970 Kirke recounted earlier. The imposing staircase and enormous dining room – of more than average human scale – and the large portraits of royalty and of generals communicated rank and power, reflected the formal command structure by deliberately dwarfing those who entered the mess. In contrast, the ante-room with its easy chairs and low tables and the bar in the corner implied the possibility of conversation and conviviality in keeping with the needs and conventions of an informal structure. The TV room for those who lived in the mess was a further step towards informality and privacy. This contrasted with the paintings of gunners in battle, which reflected the functional structure (see also Mack, Chapter 2, for discussion regarding military paintings).

Nevertheless, the rooms in the mess could be made to reflect more than one social structure. The ante-room, for example, could be transformed from a relaxed space into a more constrained and official one during formal events. On these occasions particular forms of dress were prescribed and pre- and post- dinner drinks were consumed in a formal setting with senior guests who had to be respected, listened to and looked after. The dining room, so formal and grand in appearance, was equally the place where the officers who lived in the mess ate their meals and conversed on normal days, an informal activity. Likewise, the room with the piano might be used as a formal meeting room for regimental business, under the gaze of the portraiture, as well as a place in which to relax and chat, and to listen to music played by a member of the mess.

The regimental silver importantly functioned as a symbol of loyalty and identity. The silver guns obviously signified that this was a Royal Artillery Mess, the trophies and the candelabra were all marked as 'Gunner' in some way or another (with text, crests, lists of gunners' names), and the Lonsdale Belt was won by a gunner. Much of it, however, was also redolent of its military function. In many cases a single object reflected both the loyalty/identity structure and the functional structure, for example a silver model of a contemporary artillery piece. Similarly, those items deemed to be 'exotic', namely of non-European origin, reminded those who looked at them both of the colonial military exploits of the regiment and of its identity as their proud owner.

There was a clear and perceived difference between 'public rooms' and 'private rooms'. The public rooms represented a projection of the regiment – how it sought to present itself. The private rooms were for

the use and enjoyment of the living-in officers, but on the understanding that they could also use the public spaces when they were not required for formal occasions or when (as in the case of mealtimes at Woolwich) there was no alternative, within defined time limits that would not impinge on any formal occasion. This arrangement naturally affected the way that spaces were decorated and the choice of material items that were contained within them. Private and personal objects did not appear in the public rooms, and the artefacts and decoration of the public rooms reflected a desired projection of the regiment and its identity-forming activities.

The officers' mess: a historical perspective

While the first part of this chapter has examined the officers' mess through the lens of a model of British Army organisational culture, this second part, by Hartwell, considers the historical context of the officers' mess within the British Army, and provides an analysis of the types of artefacts that could be found in this setting, from regimental silver to pieces acquired on imperial campaigns. Aside from brief mentions of the necessity of paying mess expenses and expected standards of behaviour,[11] secondary source literature on the history of the British Army at home and abroad is remarkably silent on the subject of the officers' mess, especially the objects within it.[12] Such analysis is facilitated by the examination of primary source material including military memoirs, both military and civilian newspaper and journal articles as well as illustrations and photographs of officers' messes and their objects which currently reside in the collections of regimental museums, the National Army Museum and the Royal Collection. While it may be assumed that artefacts acquired during imperial military campaigns would feature heavily in the domestic spaces of the officers' mess, as will be shown, it is regimental silver that has primary value and thus a dominant position in this unique institution of the British Army.

The officers' mess as an institution

In a short query published in the *Journal of the Society for Army Historical Research* in January 1924, an anonymous contributor – J. E. H. N. – enquired, 'When was the Officers' Mess, as we know it now, first instituted, and how did Officers fare before then?'[13] A subsequent issue of the journal provided a number of different responses. It was claimed that the earliest discussion of an officers' mess in the field could be found in Thomas Simes' *The Military Guide for Young Officers*

published in 1772.[14] Simes, a captain who served in the Duke of Cumberland's army, was a prolific author who wrote on various aspects of life in the British Army.[15] In *The Military Guide*, he wrote the following:

> By this scheme each Field Officer and Captain is to contribute six guineas, and each Subaltern and Staff Officer one day's pay each, towards the purchasing of a dining tent, kitchen tent, and also to enable a sutler[16] to buy a cart and two horses, table linen, kitchen furniture, &c. Wine, punch, ale, cyder &c. being distinct articles, must be paid for by those only who chuse to call for them; and for each strangers' dinner, one shilling is to be paid by the inviter. No gentleman can have his dinner sent him from the mess, except in case of sickness, duty, or when under an arrest.[17]

A later account written by Lieutenant-Colonel A. Wilson, DSO, formerly of the 8th Gurkha Rifles, titled 'Old Army Customs', argued that this particular custom could be traced further, to 1754 and the British East India Company in Madras. In Minute 14, the Court of Directors noted that 'You are to make an allowance of five pagodas, or forty shillings, a day, to Colonel Adlercron, which we desire his acceptance of, to defray the expense of houserent and for keeping a table for himself, the Lt. Colonel, Major and such other officers as he shall think proper.'[18] Origins aside, in both accounts a number of key components of mess life can be evidenced: the mess fostered a sense of community; this was a space in which officers partook in recreation and rest which contributed to the welfare of the regiment; and those outside the military establishment had an opportunity to glimpse the intricacies of military life with an invitation to the mess.

Early understandings of 'the mess' centred upon the idea of communal eating; the word 'mess' itself derives from the Latin *missus*, meaning 'a portion of food or a course'. As we move into the late eighteenth to mid-nineteenth century, the idea of a formalised officers' mess comprising a series of public and private spaces (including a dining room, ante-room, reception-room and accommodation for livers-in) can be found. In 1829 the Adjutant-General's Office, Horse Guards (under Commander-in-Chief General Lord Hill), issued a memorandum that detailed regulations regarding expenses to maintain the mess: 'Thirty days' pay to be paid by each officer to the Mess-fund, on appointment, and an annual subscription, under the discretion of the Commanding Officer, but not exceeding eight days' pay, to be paid in support of mess contingencies'.[19] However, at this point in time the particulars of forming and maintaining a mess were still undefined and not standardised. Individual regiments made arrangements based on their own traditions and requirements.

[112]

In a letter to the editor published in the *United Service Journal and Military and Naval Magazine* in 1831, Captain F. Hawkins of the 89th Regiment made a plea for the publication of a guide that would detail not only 'the object and advantages of messes, [and] the orders extant on the subject', but also lists of items required (including cutlery, wares, newspapers and periodicals), local manufacturers and sources from which they could be purchased, expenses incurred (for the rent of furniture and upkeep) as well as rules by which members should abide.[20] Articles published intermittently in the journal and local newspapers during the 1830s and 1840s reflect Captain Hawkins' desire for clear rules and regulations, particularly due to a developing concern: mess extravagance.[21]

One of the catalysts for clarification was a controversy following the alleged misappropriation of an allowance instituted by the Prince Regent in 1812 'to enable every officer of the army at home to drink his pint of port or sherry free of duty'. It was argued that some regimental commanding officers had been 'led away by the desire of making a show, have expended most of this money in purchasing expensive articles of plate and glass, to gratify the vanity of one-fourth of their corps at the expense of the solid comfort and enjoyment of the remainder'.[22] Subsequent editions of the *Queen's Regulations and Orders for the Army* emphasised the responsibilities of the commanding officer to 'forbid the purchase of expensive and useless articles of plate, or a larger quantity of it than a mess may be fairly supposed to require'.[23]

While the *Queen's Regulations* addressed the need for commanding officers to ensure efficient management of the mess and prevent officers from incurring unnecessary mess expenses,[24] popular accounts were also published during this period urging officers to act in a restrained manner. In 1839, an anonymous author writing under the *nom de plume* 'Captain Tobias Shandy Oldfellow' counselled his younger readers to 'Observe the strictest economy at the mess; drink very little wine, and that only on proper occasions . . . avoid the idle and destructive habits of drinking, smoking, and snuffing'.[25] The ideal mess was a place that was 'quiet, yet cheerful, happy, and unanimous . . . no dissenting voice, no turbulent spirit, no quarrellings, and no debts'.[26] In the words of the poet Alexander Pope, Major Claudius Shaw concluded that 'at a well-conducted mess is to be found "The feast of reason and the flow of soul"'.[27]

In concert with the development of administrative guidelines and advice regarding appropriate behaviour, regiments began to develop their own rules and customs which all members of the mess were to abide by. Such customs addressed a number of different circumstances and issues including: hosting ceremonies to drink to the health of the

sovereign; the manner in which officers and guests entered the mess; where and when it was permitted to smoke; and how port was passed around the table ('as the hands of the clock move'). Certain actions were also forbidden, including bringing dogs into the mess: 'in most regiments a fine of five shillings is imposed on the owner of a dog found within the precincts of the mess'. A tradition also developed where it was prohibited to draw a sabre from its scabbard in the mess.[28] Guests were urged to acquaint themselves with such customs in order to avoid the potential for embarrassment.

In the peripatetic life of the British Army officer, the mess was home, a shared domestic environment where space and interior decoration served a communal social purpose. It was a semi-private space, part of British Army regimental culture, a mixture of the professional and the personal. It was also a predominantly male environment. Historical accounts note that women associated with the regiment as wives of officers were 'recognized as members of the regimental family', yet their opportunity to engage with mess life was usually limited to dining with their husbands' fellow officers on ceremonial occasions.[29] Marriage was, however, also seen as potentially detrimental to mess life as married officers were not obliged to pay full mess subscriptions and rarely dined at the mess; therefore a greater burden was placed on bachelor officers for the costs of upkeep and maintenance.[30]

Accounts of purpose-built messes with evocative descriptions of their interiors appeared in published professional military literature throughout the nineteenth century. Alongside illustrations and photographs of military interiors, they assist in developing an understanding of not only the spaces, but also the objects contained within this distinctive aspect of British Army life. Identifying the categories of objects to be found across officers' messes in the nineteenth century allows us to begin to unravel how they functioned in this particular space.

The officers' mess as a setting for objects

As a place of recreation and rest, the interlinked public and private rooms comprising an officers' mess encompassed various types of furniture including armchairs, dining tables and sideboards. As regiments regularly changed their station due to deployment in various operations during the nineteenth century it was important for furniture not only to be comfortable but also lightweight, durable and transportable, with fittings that could be removed. The War Office also provided furniture for hire and monthly inspections occurred to examine such furniture, which could lead to charges against a regiment or battalion 'for any deficiencies or for any damages which may have been caused by

wantoness or neglect, making every allowance for fair wear and tear'.[31] Contemporary accounts note that this furniture was rudimentary and included 'Windsor chairs and a dining-table and sideboard of Spartan simplicity'.[32] In some instances, purpose-built furniture handmade in the nineteenth century by local British craftsman, that has remained in the regiment, take pride of place in present-day messes; for example, a campaign table understood to be more than 200 years old can be seen in the Officers' Mess of the Princess of Wales's Royal Regiment.[33] Members of regiments also donated furniture: in 1885 Colonel O. R. Middleton presented an ornate wooden sideboard to the King's Own Royal Regiment in Bombay in 1885. By 1899 it had been transported to Whittington Barracks, Lichfield, and was used to display the silver of the 2nd Battalion's officers' mess.[34]

Regiments also acquired glass, porcelain and earthen and ivory wares, forming part of the officers' mess dinner service. A tradition developed whereby such items were commissioned especially for the regiment, and manufactured by local companies such as Spode of Staffordshire and Davenport. They often bore the regiment's badge or were decorated with elaborate borders incorporating symbols of the regiment and battle honours.[35] In some instances, full dinner services were commissioned for commemorative purposes. For instance, the 33rd Bengal Native Infantry commissioned a dinner service made by Crameld & Beckitt in order to mark their participation at the Battle of Kabul during the First Anglo-Afghan War (1839–42). A surviving earthenware soup bowl shows the colours of the regiment, with a central crest with the regiment's line number and acronym of their name, while the outer edges include the battle honours acquired by the regiment on various campaigns including 'Bhurtpoor' (Bharatpur), 'Laswaree' (Laswari) and 'Cabool' (Kabul).[36]

In order to evoke an atmosphere of warmth, civility and camaraderie, the walls of the mess were adorned with paintings, often depicting victories won by the regiment on the battlefield. For instance, in the Gordon Highlanders Museum's Lakin Room, a recreation of the dining room of the officers' mess,[37] Richard Caton Woodville's 'The Storming of the Heights at Dargai' takes pride of place. This was an attack undertaken during the Tirah Campaign (1897–98) where the Dargai Heights, held by Afridis, were stormed by the Gordon Highlanders and the 2nd King Edward VII's Own Gurkha Rifles, an action for which four Victoria Crosses were subsequently awarded. One of these Victoria Cross recipients – depicted in the centre of the painting – was the piper Sergeant George Findlater, who, although shot in the ankles and exposed to enemy fire, continued to play the pipes.[38] Here is an unmistakable representation of military heroism, which sought to inspire those who gazed upon the canvas during time spent in the officers' mess.

As well as battle paintings, portraits of the sovereign, past and present officers recognised for distinguished service, and Colonels-in-Chief were also displayed.[39] In the collections of the Royal Engineers there are a number of oil paintings that were commissioned and funded by members of the Corps, including a portrait of General Sir Charles Napier (1782–1853) by the Scottish portrait painter Sir Francis Grant, and of Field-Marshal Herbert Kitchener (1850–1916) by Arthur Stockdale Cope.[40] Officers of particular distinction might also feature in the officers' mess in bronze and plaster cast statues or busts. Artistic representations of these individuals sought to inspire officers to emulate their behaviour as they were understood to embody 'martial virtues' – reflected today in the 'values and standards' of the British Army – including courage, discipline and loyalty.[41]

In his 1899 book, *Social Life in the British Army*, the officer William Elliot Cairnes chose to highlight the display of military colours in the officers' mess. Made of silk and embroidered with battle honours that commemorate victories achieved, the colours are understood to this day to be iconic objects symbolic of the 'spirit of a regiment'.[42] While their use is now predominantly ceremonial, in the nineteenth century the colours functioned as an identifying and rallying point in battle. Infantry regiments of the British Army normally carried two colours mounted on a half pike: the King's or Queen's Colour and the Regimental Colour, and this custom is reflected in today's ceremonial practice.[43] For the Royal Artillery the guns were accorded equivalent symbolic status. The capture of colours by the enemy was considered to be a humiliation; their recovery, a restoration of honour. As articulated by Cairnes, their display in the mess as 'honored emblems bearing on their folds the record of many gallant deeds' was 'well calculated to fire the blood of youth or to quicken the slackening pulse of the old.'[44] These were significant objects designed to foster a sense of regimental identity and *esprit de corps*.

In surveying a series of nineteenth century officers' mess photographs the items that are particularly conspicuous are those made of silver. This chapter now turns to analyse the myriad ways that silver was accumulated in the collections of an officers' mess, as well as their varying functions, after which it will focus on artefacts acquired on imperial campaigns and the manner in which they are often adapted to fit within this distinct domestic environment.

The function of regimental silver

Regimental silver was reflective of mess culture, and to this day it plays a significant role in the traditions of the regiments of the British

Army. Arguably, the origins of the acquisition and use of silver in the officers' mess can be traced to the custom of individuals (often aristocrats who were appointed colonels) who raised regiments for the Crown and took 'into the field . . . family silver and plate in order to make life a little more comfortable'.[45] Images of dining rooms set for service in the officers' mess are abundant with silver for table use, including serving and entrée dishes, condiment sets, champagne coolers, wine jugs and ornate candelabras, interspersed with decorative floral arrangements.

During the nineteenth century 'plate funds' were established by regimental officers in order to commission impressive silver centrepieces that illustrated the history of the regiment which were manufactured by silversmiths such as Paul Storr in London and Messrs Elkington & Co. in Birmingham.[46] A striking example can be found in the collections of the Argyll and Sutherland Highlanders. Commissioned in 1870, the centrepiece commemorates officers from the 93rd Sutherland Highlanders who served in the Crimean War (1853–56) and the Indian Mutiny, or Uprising, of 1857–58.[47] Although perhaps famous for their actions at the Battle of Balaclava in October 1854, after which they were known for having formed 'The Thin Red Line', one side of this particular piece features a representation of an outwork at Sevastopol with 'shot-riven walls', a deceased Russian soldier, a wounded private and the regimental pipe-major. The other side shows a gateway tower of the Sikandar Bagh fortification at Lucknow which was stormed and captured by the Sutherland Highlanders under heavy enemy fire during the relief of Lucknow in November 1857, many steeled with thoughts of vengeance in the aftermath of the massacre of British women and children at Cawnpore (Kanpur).[48] It is understood that many Indian rebels who had risen against British East India Company rule lost their lives during this action, represented by the body of a deceased *sepoy* (infantry soldier) at the centre of one side of the piece.[49]

Such centrepieces – large in size and demonstrating high-quality metalsmithing (and other workmanship) – reflected British perspectives of the battles concerned. They are heavily personalised: the ebony plinth has two shields, one with the number and badge of the regiment, the other with a presentation inscription with the names of officers who contributed to the commission, a practice which sought to assure a lasting legacy of their time in the regiment. The shields are ornamented with cat's-tail grass, the badge of the Sutherland clan and the national emblem of Scotland, the thistle.[50] To emphasise the significance of such centrepieces they were (and are) often placed at the middle of the table or can be seen on display on a bespoke side table or stand.

[117]

From the late nineteenth to the early twentieth century local London silversmiths advertised their services in periodicals directly to Army officers, potential clientele, to create such centrepieces. A half-page advertisement published in 1900 in the *Illustrated London News (ILN)* for Hunt & Roskell Ltd was dedicated specifically to the creation of 'Military Trophies and Regimental Groups modelled, chased, and finished in the Highest Possible Style' with free estimates.[51] As Roger Perkins has argued, the burgeoning of military silversmithing in the latter half of the nineteenth century can be seen as a response to the abolition of purchase[52] during the Cardwell Reforms of 1870–71. During this period the virtue of lifetime service was reinforced, inspiring officers to acquire items for the mess that reflected regimental 'belonging'.[53]

Silver presentation pieces had pride of place in the officers' mess. These included items presented by or associated with serving or ex-regimental members to commemorate significant events such as promotion, marriage, retirement and even honouring the loss of a loved one or comrade on the battlefield. A poignant example can be found in the collections of the Royal Regiment of Artillery – the Willoughby Memorial – which 'commemorate[s] the heroic conduct of Lieutenant G. D. Willoughby, Bengal Artillery, in Defence of the magazine of Delhi on the outbreak of the Mutiny, 11 May 1857', after which Willoughby lost his life. The piece was presented to the mess by his brother officers.[54] As well as memorials, dignitaries and members of Royal Families entertained at the officers' mess often presented silver pieces in appreciation of the hospitality afforded to them.[55] Silver collections also included cups, bowls, or statuettes purchased by officers to commemorate their service in specific operations, as well as models marking technological changes funded by officers who made first use of the new technology, a practice that survives to this day.[56]

Regimental silver could be multi-functioning, highly symbolic of military victory yet also used for practical and ceremonial purposes. An example of this is the present-day use by the King's Royal Hussars at mess dinners of King Joseph Bonaparte's silver chamber pot, taken as a spoil of war at the Battle of Vittoria on 21 June 1813. The chamber pot is understood originally to have been presented to King Joseph by his brother, the Emperor Napoleon and was found in the King's personal carriage captured by the 14th Light Dragoons.[57] Since its capture in the early nineteenth century it has been used as a 'loving cup' by the regiment.[58]

Imperial encounters expressed in material form

The nineteenth century was a period in which the British Army undertook a series of colonial wars as the British expanded their imperial

horizon. While overseas, officers sought to recreate the mess in local buildings leased by the Army, or in the field a mess tent was established.[59] Significantly, however, artefacts acquired during imperial campaigns were not necessarily a consistent feature of the officers' mess at home. It is known that officers were collectors of trophies (both military and hunting) while stationed overseas. However it seems that at the imperial centre or metropole,[60] such objects were not necessarily transferred to the space of the officers' mess, and typically only featured as an 'accent' amidst the mess silver, or were used to decorate the walls of the officers' mess on specific honorary occasions.

A striking example of this can be found in an image in the collections of the King's Own Royal Regiment, which shows the officers' mess set for dinner in honour of General Sir Archibald Hunter (1856–1936) on 19 January 1899. Hunter had joined the King's Own 4th Lancashire Regiment in 1875, and undertook detached duty during the Gordon Relief Expedition of 1884–85. It was in joining the Anglo-Egyptian Nile Expeditionary Force under Lord Kitchener that Hunter distinguished himself, commanding the Egyptian Army Division during the Anglo-Egyptian reconquest of Sudan (1896–98).[61]

The King's Own did not serve during the Mahdist War (1881–99); therefore, an occasion to honour Hunter was considered an appropriate opportunity to adorn the officers' mess with artefacts associated with this particular conflict, including a Sudanese cotton *jibbah*, and a Mahdist flag flanked with Sudanese spears.[62] Although it is unclear whether these items belonged to Hunter, or if they were acquired for the purposes of the dinner, their display in such a space appears exceptional. Such artefacts seem to find a more appropriate setting in regimental museums, which – aside from the Royal Artillery Rotunda and the Royal Engineers Museum[63] – only began to be formally established in the early twentieth century. Prior to this period, they were displayed in officers' homes, were kept in storage at regimental headquarters and depots or were donated to the Royal United Service Institution Museum, established in London in 1831.[64]

One feature of the officers' mess which included scope to incorporate artefacts representing imperial encounters was the snuff mull, a large table box which held snuff, a powdered tobacco. Snuff mulls were often made of modified taxidermy created from animals which were associated with the regiment as a pet or a mascot. A feature of many Scottish regiments was the snuff mull comprising a ram's head. These could also be made from animals understood to be remarkable and acquired by the regiment while stationed overseas.[65]

Some unique examples can be found where snuff mulls are fashioned from military trophies comprising animal horns, antlers and tusks. In

the collections of Cornwall's Regimental Museum one can find an elephant tusk said to have belonged to the Zulu king, Cetshwayo kaMpande (1826–84). It is understood to have been taken from his residence during the Battle of Ulundi, 4 July 1879, by Brevet Major W. F. Dundonald Cochrane. The tusk was transformed into a snuff mull through a series of alterations, including being fixed onto an ebony wood plinth with four wheels so that it could be moved across the table while officers participated in the communal taking of snuff. The lid was mounted in silver and engraved with the badge of the 32nd Regiment. The provenance of the object is inscribed onto a plaque that sits at the front of the plinth and is shaped in the form of a Zulu shield with two assegais.

Trophies such as this tusk were ascribed value based on the perceived military prowess of the opponent. Cetshwayo and his Zulu Army were considered formidable by the British, especially in the aftermath of British defeat at the Battle of Isandlwana (22 January 1879). However, despite their trophy-like status, once such pieces were chosen for the setting of the officers' mess, they seem to have required refashioning as a practical or decorative item, and were mounted, silvered and inscribed. After such modification they were deemed suitable for use and display in the domestic environment of an officers' mess.

Lastly, the social life of the British Army officer on overseas service may also be represented in the officers' mess. Hunting was a regular pastime for officers on active service in China, Africa and India,[66] and hunting trophies, including animal skins and mounted animal heads (particularly stag heads) can also be seen adorning the walls of the dining room in photographs of the officers' mess situated both locally and abroad,[67] or were used as a decorative feature in photographs showcasing a regiment's display of silver.[68] As hunting was understood to be an ideal sport for an officer-gentleman, and analogies were often drawn between hunting for sport and imperial warfare,[69] it is perhaps unsurprising that hunting trophies – which provided a tangible testament of officers' skills in the field – were chosen to decorate the walls of the officers' mess.

Outlining the various types of artefacts that can historically be found in the space of an officers' mess allows a better understanding of how these objects functioned at a communal level. The final section of this chapter shows that the distinct methodological approaches of anthropology and history, as regards the function and history of the officers' mess, are united in concluding that in the British Army the mess functions by default as a space in which a shared military culture is lived out, and where it is intended that a unified culture is nurtured and sustained.

The mess as a space of shared culture

Throughout the history of the British Army the officers' mess has played a vital role in fostering a sense of regimental identity, tradition and comradeship, described internally as *esprit de corps*. Although many of the artefacts within the mess were instituted for practical purposes, the engraving of regimental insignia on items such as dinner services, glassware and cutlery made them highly personalised and reinforced a sense of mutual ownership, and in turn, the ideal of regimental unity.

While anxieties over mess extravagance were raised intermittently throughout the nineteenth century due to concerns that officers with lesser means would fall into debt, the purchase of silver and the presentation of opulence mirrored the habits and customs of the ideal candidate that was sought – one who embodied the 'officer-gentleman tradition'[70] and had access to private means. Such displays, as well as the furniture, artwork and colours, not only sought to foster 'habits of self-respect, of order, and good-fellowship' but also a sense of familiarity and home to individuals who belonged to the mess.[71] The presentation pieces in particular functioned as mnemonics and memorials as they were inscribed with the names of individuals who were formerly part of the regiment. Yet, as implied in the personalised reflection at the beginning of this chapter, these presentations also catered to new arrivals: they presented a vision of a mess that was not only welcoming but also sought to communicate the identity of the regiment and inspire allegiance.

Amidst the opulence was a sense of order and conformity. This is reflected in a photograph of the officers' mess of the 1st Battalion, Prince of Wales's Own West Yorkshire Regiment, in the 1890s (Figure 5.1). The items on the dining table – both practical and decorative – are evenly spaced; each place setting mirrors the other. Such conformity was reaffirmed through the wearing of mess-dress (a uniform that was distinguished from those worn for service, or for parade) and the expectation that a certain standard of behaviour and etiquette would be upheld by all to ensure that the mess was a place of 'harmony and concord'.[72]

In contrast, objects acquired while the British Army was stationed across the Empire appear not to have been the focal point of this space, unless understood to be prestigious acquisitions. These, in turn, invited modification in order to align with the domesticity that suffused the officers' mess. Hunting and other trophies – mounted, silvered and inscribed – echoed the lavish nature of silver centrepieces commissioned specifically to commemorate the history of a regiment, or its successes in battle during well-known campaigns (see Lidchi and Allan, Introduction). The regiment's role and victory in the acquisition of the object – rather

[121]

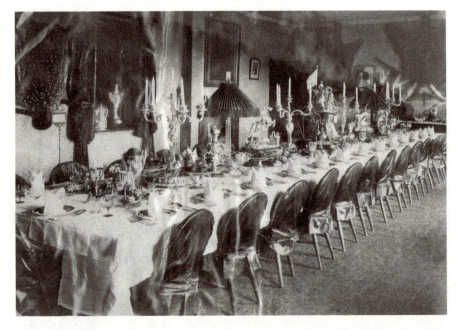

Figure 5.1 Officers' Mess, 1st Battalion of The Prince of Wales's Own (West Yorkshire Regiment), 1890s.

than its meanings and functions in their place of origin – took precedence. Such artefacts were especially coveted if they were understood to embody the power and authority of the vanquished enemy.

While grievances were raised by junior officers who struggled to keep up with the pressures of mess expenses, senior officers too articulated such anxieties. This is because they feared that their subordinates would be deterred from participating in mess life, which was of fundamental importance as it played a significant role in fostering regimental cohesion and unity in the British Army. As articulated in 1873 by J. E. Acklom, formerly a captain in the 28th Regiment,

> Properly managed, the regimental mess is one of the best, most excellent, and advantageous institutions of our army. Where officers are all chivalrous gentlemen, as they ought to be, nay, as in the British Army, they 'must be,' it unites the regiment together as one family. It brings each individual member, his habits, his manners, his education, and acquirements, under full cognisance of his brother officers. A man must be a gentleman, a boy must become a gentleman; he no longer belongs to himself; the name, the honour of the regiment, of which he is supposed to be a sample, is, to a great degree, in his keeping.[73]

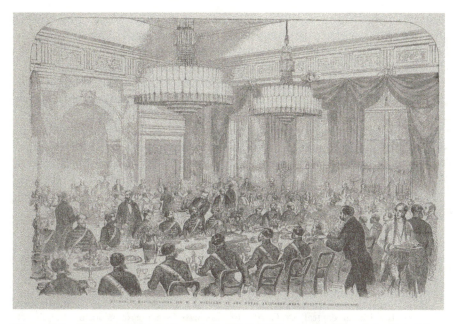

Figure 5.2 'Dinner to Major–General Sir W. F. Williams at the Royal Artillery Mess, Woolwich', *Illustrated London News* (12 July 1856), p. 28.

Conclusion

It will be seen from these descriptions of the institution represented by the officers' mess in the past, the objects that were found within them and the unifying milieu which the mess provided, that the model of British Army culture described in Part I of this chapter provides a convenient means of exploring their significance for, and relevance to, the lives of the officers. The mess was subject to formal regulation; for example, there were times and spaces for informal behaviour (though limited by the cultural construction of what was 'appropriate') and many of the displayed artefacts presented ideas of military function and regimental/battalion identity. Rather than being a place where its occupants might live entirely personal and idiosyncratic lives, time spent in the mess was an immersion in their unit's organisational culture.

Kirke's model enhances our understanding of different eras and suggests the usefulness of a framework to examine aspects of British Army culture, including the lived experience of being in the officers' mess, and attitudes to the collection, production and display of artefacts. The principles that emerge from the description and analysis of the Woolwich Officers' Mess in the 1970s therefore need not be

treated as specific to the Royal Artillery or to the 1970s. They could, and can, be discerned in every Army officers' mess. The distinction between public and private spaces, the decoration of the building and the objects within it and the incorporation of regimental silver as table decoration at formal dinners are part of the organisational culture of the British Army, the fundamentals of which have persisted for a considerable period, as demonstrated in Part II of this chapter. The image published in the *ILN* of a formal dinner at the Royal Artillery Mess at Woolwich in 1856 set in honour of Major-General Sir Fenwick Williams, known as the 'gallant defender of Kars' during the Crimean War (Figure 5.2), apart from differences in dress, might as well have represented a similar function in 1970, or, generically, mess functions anywhere since officers' messes became the norm.

Notes

1 The word 'regiment' may be confusing to those without domain knowledge of the British Army. Briefly, individual units are variously 'battalions' or 'regiments', depending on the part of the Army to which they belong, over which there are larger organisations to which they also belong, which are known as Regiments (note the initial capital) or Corps. In this case, we are considering the Royal Regiment of Artillery, which comprises a number of regiments (one of which, a training regiment, was stationed at Woolwich at the time and used the Royal Artillery Mess).

2 This chapter is written exclusively about officers' messes, with this personal reflection focused initially on that of the Royal Artillery Mess. In the remainder of this chapter, the scope is widened to other British Army officers' messes in the nineteenth century. The space available here cannot accommodate warrant officers' and sergeants' messes, nor Royal Navy wardrooms, gunrooms or chief and petty officers' messes, though all of these are interesting areas for future research.

3 'Gunner' is a colloquial term for a soldier of the Royal Artillery, applicable to officers and other ranks.

4 The cross table functioned as does a high table in other institutions.

5 For a photograph of the Dining Room as it was in 2007, prior to the relocation of the Royal Artillery Mess to Larkhill, see P. Guillery (ed.), *Survey of London: Woolwich* (London: Yale University Press, 2012), p. 333.

6 Royal Regiment of Artillery, *Regimental Heritage* (London, 1984), pp. 148–9.

7 See for example C. Kirke, 'Insider Anthropology: Theoretical and Empirical Issues for the Researcher', in H. Carrieras and C. Castro (eds), *Qualitative Methods in Military Studies: Research Experiences and Challenges* (London: Routledge, 2013), pp. 17–30; A. King, 'The word of command: communication and cohesion in the military', *Armed Forces and Society*, 32:4 (2006), 493–512; T. Thornborrow and A. D. Brown, 'Being regimented: a case study of the regulation of identity in the British Parachute Regiment', *Organization Studies*, 1 (2008), 355–76.

8 The most recent publication of this model is in C. Kirke, *Red Coat Green Machine: Continuity in Change in the British Army 1700 to 2000* (London: Bloomsbury, 2009), combined with C. Kirke, 'Orders is orders … aren't they? Rule bending and rule breaking in the British Army', *Ethnography*, 11:3 (2010), 359–80.

9 An infantry section comprises (depending on the role of the unit) about eight soldiers, a platoon about thirty, a company is composed of three platoons and a headquarters, a battalion of about four companies and a much larger headquarters, and a regiment of two to four regular battalions.

10 B. Wilson, *Soft Systems Methodology: Conceptual Model Building and its Contribution* (Chichester: Wiley, 2001), p. 4 (emphasis in original).
11 E. M. Spiers, *The Army and Society, 1815–1914* (London: Longman Ltd, 1980), p. 25; E. M. Spiers, *The Late Victorian Army, 1868–1902* (Manchester: Manchester University Press, 1992), pp. 103, 104, and 106; H. Strachan, *Wellington's Legacy: The Reform of the British Army, 1830–54* (Manchester: Manchester University Press, 1984), pp. 98, 112; D. French, *Military Identities: The Regimental System, the British Army, and the British People c. 1870–2000* (Oxford: Oxford University Press, 2005), pp. 126–8.
12 Including D. G. Chandler and I. Beckett (eds), *The Oxford History of the British Army* (Oxford: Oxford University Press, 2003). David French does briefly note that 'Each mess proclaimed the regiment's distinct and separate identity by collecting and displaying regimental relics, such as its silver plate, trophies, and Colours, and by maintaining its own distinct mess customs', *Military Identities*, p. 91.
13 'Notes, questions and replies', *JSAHR*, 3:11 (1924), 156.
14 'Officers' Mess', *JSAHR*, 3:11 (1924), 10–12.
15 V. J. R. Kehoe, 'The works of Captain Thomas Simes, 1767 to 1782', *JSAHR*, 78:315 (2000), 214–17.
16 A civilian merchant who sold provisions to an army.
17 T. Simes, *The Military Guide for Young Officers* (London: J. Millan, 2nd edn, 1776), p. 369; 'Officers' Mess', p. 10.
18 Lieutenant-Colonel A. Wilson, 'Old Army customs', *JSAHR*, 6:25 (1927), 134–8 (p. 137).
19 'General orders, circulars, &c.', *USJ*, Part 1 (1829), p. 384; Strachan, *Wellington's Legacy*, p. 112.
20 Captain F. Hawkins, 'Management of regimental Messes', *USJ*, Part 3 (1831), pp. 544–5.
21 Due to stories of extravagance some authors even called for the abolition of the practice. See 'Regimental Messes', *The Observer*, 29 August 1847, p. 6.
22 See 'General Order – Expenses of Regimental Messes, Horse Guards', *USJ*, Part 3 (1844), pp. 621–3.
23 *The Queen's Regulations and Orders for the Army* (London: Her Majesty's Stationery Office, 4th edn, 1868), p. 74.
24 *The Queen's Regulations and Orders for the Army* (London: Parker, Furnivall, and Parker, 3rd edn, 1844), pp. 129–31.
25 'Advice from an old to a young officer', *USJ*, Part 2 (1839), p. 84. In contrast, one anonymous commentator argued that it was not mess expenses that were the issue but rather the acquisition of debts due to dining and socialising in establishments outside of army barracks. See 'Editorial Notes', *USM*, Part 3 (1880), p. 241.
26 'Six months with the Expeditionary Army', *USJ*, Part 2 (1855), p. 26.
27 Major C. Shaw, 'On the depot system', *USJ*, Part 2 (1861), p. 37.
28 F. Levray, 'Etiquette in the mess-rooms of the British Army', *The Lotus Magazine*, 10:3 (1919), 106–9.
29 W. E. Cairnes, *Social Life in the British Army* (London: Harper & Brothers, 1899), pp. 30–1; French, *Military Identities*, p. 125. Parallels could be drawn between the officers' mess and gentlemen's clubs of the mid-to-late nineteenth century. See, for instance, A. Milne-Smith, 'A flight to domesticity? making a home in the gentlemen's clubs of London, 1880–1914', *Journal of British Studies*, 45 (October 2006), 796–818.
30 Cairnes, *Social Life in the British Army*, p. 32.
31 'War Office Circular 600, 19 June 1860', in *Royal Warrants, Circulars, General Orders, and Memoranda, Issued by the War Office and Horse Guards, August 1856–July 1864* (Glasgow: James Maclehose, 1864), pp. 103–4.
32 Cairnes, *Social Life in the British Army*, p. 41.
33 'Officers' Mess Dining Room', Princess of Wales's Royal Regiment website, www.armytigers.com/artefacts/1-pwrr-officers-mess-dining-room, accessed 1 January 2019.
34 S. A. Eastwood, *Lions of England: A Pictorial History of the King's Own Royal Regiment (Lancaster), 1680–1980* (Kettering: Silver Link, 1991), p. 48.
35 See, for instance, 'Earthenware dish, c. 1809 manufactured by John and William Ridgeway, part of the officers' mess plate of the 48th (Northamptonshire) Regiment', National Army Museum (NAM) 1989-09-84-1.

36 'Soup plate of the 33rd Bengal Native Infantry, c. 1842', NAM, 1962.03.40-1.
37 In 1994 the Gordon Highlanders were amalgamated with the Queen's Own Highlanders (Seaforth and Camerons) to form the Highlanders Regiment. In 2004, the Highlanders were amalgamated with other Scottish infantry regiments to form the Royal Regiment of Scotland.
38 E. M. Spiers, *Scottish Soldier and Empire* (Edinburgh: Edinburgh University Press, 2006), p. 126.
39 Colonels-in-Chief have often been members of the Royal Family (although not exclusively) appointed at the invitation of the regiment to hold this ceremonial role. On 21 November 1861, Queen Victoria presented a self-portrait oil painting by A. Melville to the officers' mess. See *Regimental Heritage*, p. 158.
40 Royal Engineers Institute, *The Pictures and Plate of the Royal Engineers Headquarters Mess Chatham* (Chatham: Institution of Royal Engineers, 1909), p. 3.
41 *Values and Standards of the British Army*, available at www.army.mod.uk/media/5219/20180910-values_standards_2018_final.pdf, accessed 1 January 2019.
42 R. Holmes (ed.), *The Oxford Companion to Military History* (Oxford: Oxford University Press, 2001), p. 212.
43 R. F. McNair, *The Colours of the British Army* (London: Day and Son, 1867), pp. x–ix.
44 Cairnes, *Social Life in the British Army*, p. 43.
45 Lieutenant-Colonel P. R. S. Jackson, *The Silver Room: The Royal Artillery Mess Woolwich* (London Royal Regiment of Artillery, 1976), p. 3.
46 For further examples see '"Tradition in silver": Officers' Mess silver at Burlington House', *Illustrated London News*, 14 January 1956, p. 61.
47 'Centrepiece for mess-table of 93rd Foot', *Illustrated London News* (3 December 1870), p. 580.
48 S. David, *The Indian Mutiny: 1857* (London: Viking, 2002), pp. 327–8.
49 It is unsurprising that the regiment sought to commemorate these two conflicts, as in the nineteenth century the Siege of Sevastapol and actions during the Indian Uprising were memorialised in various mediums, including prints and battle paintings. See, for instance, the watercolour of the storming of the Sikandar Bagh by Orlando Norie, NAM, 1987-06-12-1, *c*. 1858.
50 'The 93rd (Sutherland) Highlanders', *Illustrated London News* (3 December 1870), p. 580. Unfortunately, this piece was lost in a fire in 1980. See R. Perkins, *Military and Naval Silver* (Devon: Roger Perkins, 1999), p. 104.
51 'Hunt & Roskell Ltd.', *Illustrated London News* (10 November 1900), p. 697.
52 Whereby an individual of wealth and high standing could purchase a commission in a regiment they desired.
53 Perkins, *Military and Naval Silver*, p. 5.
54 Jackson, *The Silver Room*, pp. 50–1.
55 *Regimental Heritage*, pp. 144–5, 148–9, 159, 164.
56 *Regimental Heritage*, p. 229.
57 L. Balfour Oatts, *Emperor's Chambermaids: The Story of the 14th/20th King's Hussars* (London: Ward Lock, 1973), p. 167.
58 Perkins, *Military and Naval Silver*, pp. 33–4.
59 Cairnes, *Social Life in the British Army*, pp. 57–8. For an image of an officers' mess in the field see 'Omdurman: Officers' Mess, 1st Battalion Grenadier Guards, September 1898', Royal Collection, RCIN 2501909.
60 The distinction between the British imperial 'metropole' (or centre) and imperial 'periphery' is often referred to by scholars of the British Empire discussing the circulation of artefacts in the period of the nineteenth century. See, for instance, M. Jasanoff, 'Collectors of Empire: Objects, Conquests and Imperial Self-Fashioning', *Past & Present*, 184 (August, 2004), 111.
61 *Illustrated War News* (16 February 1916), p. 16.
62 '2nd Battalion, King's Own Royal Lancaster Regiment, Officers Mess, Whittington Barracks, Lichfield, arranged for dinner for General Sir Archibald Hunter, 19th January 1899', King's Own Royal Regiment Museum, KO0058/31.

63 On the Rotunda, see S. Werrett, 'The Arsenal as Spectacle', *Nineteenth Century Theatre & Film*, 37:1 (2010), 14–22.

64 For a history of the establishment of the museum and its evolving collections policy, see N. M. Hartwell, 'A repository of virtue?: The United Service Museum, collecting, and the professionalization of the British Armed Forces, 1829–1864', *JHC*, 31:1 (2019), 77–91.

65 See, for instance, 'Tortoise shell snuff mull with silver fittings, c. 1869', NAM 1954-07-7-1; 'The skull of "Plassey" the pet tiger of the 102nd Regiment of Foot, c. 1870', NAM 1958-02-34-1-1.

66 For one of the numerous published accounts of a British Army officer's hunting exploits, see J. Moray Brown, *Shikar Sketches: With Notes on Indian Field-Sports* (London: Hurst and Blackett, 1887). An anonymous author noted that 'Game is most abundant, and we are out shooting nearly every day, and our mess is kept well supplied with snipe, woodcock, pheasants and now and then a small kind of deer like the Indian jungle sheep', 'Journal during the Chinese Expedition in 1841 and 1842', *USM*, Part 3 (1878), pp. 102–12 (p. 107).

67 'Officers' Mess drinking room of 2nd Battalion, The Gloucestershire Regiment, Nasirabad, India, c. 1890', Soldiers of Gloucestershire Museum, GLRRM: 04725.9.

68 See, for instance, 'Mess Silver of the 1st (Duke of Connaught's Own) Bombay Lancers, 1902', NAM 1981-08-59-3.

69 S. Harrison, *Dark Trophies: Hunting and the Enemy Body in Modern War* (Oxford: Berghahn, 2014), p. 70.

70 Spiers notes that this tradition involved 'requirements of dress and deportment, an emphasis on honour and integrity, and a conformity with the manners and etiquette of polite society', *The Army and Society*, pp. 1–2.

71 'How to get recruits. By "Colonel"', *USM*, 29 (1904), pp. 610–20 (p. 612).

72 Spiers, *The Late Victorian Army*, p. 103.

73 J. E. Acklom, 'Our regimental mess table', *USM*, Part 2 (1873), pp. 524–9 (p. 528).

CHAPTER SIX

Seeing Tibet through soldiers' eyes: photograph albums in regimental museums

Henrietta Lidchi with Rosanna Nicolson

Photographs are simultaneously inscriptions and representations, whose ability to capture slivers of reality renders them persuasive over time. As material objects they have an elegiac quality which can promote a shared sense of the past, key to the preservation of individual and collective identities.[1] For these reasons they are fertile terrain for historical research, allowing us to ponder upon issues of creation, production and composition; of repetition, circulation and reception; as well as those of assemblage, materiality and meaning.

This chapter aims to address such issues in relation to the specific context of photographic albums and diaries, using visual material related to the 'Tibet Mission' of 1903–4 led by Colonel Sir Francis Younghusband (therefore also known as the Younghusband Mission) now to be found in regimental collections in the British Isles. Given its subject, this chapter is obviously indebted to the work of Clare Harris,[2] and here the aim is to provide additional insight into military albums beyond those she herself has published. Harris has noted the influence of military representations and collecting practices from the mid-nineteenth century in making 'the fantasy of Tibet tangible through the accrual of Tibetan things and their insertion into the heart of the British nation'.[3] This happened through the powerful influence of photographs generated by those undertaking this late imperial enterprise, criticised as it progressed for its aggression, as well as its defilement and looting of monasteries, actions which called into question the nature of British governance in India. The Tibet Mission occurred barely seven years after the 'punitive expedition' to Benin City, Kingdom of Edo, in present-day Nigeria, but was to receive far more opprobrium.[4] Photographs and reports of the Tibet Mission circulated widely thanks to activities of the four embedded journalists, including Edmund Candler for the *Daily Mail* and Perceval Landon collecting for the British

Museum and reporting for *The Times*,[5] with photographs also produced by Army officers and lower-ranking soldiers featuring in newspapers and periodicals such as *The Daily Graphic*, *The Illustrated London News*, *Black and White*, *The King*, *The Bystander* and *The Sphere*, which later entered collective regimental and individual albums.[6] The purpose here is not to consider how these photographs represent Tibet, which Harris has fully examined, but to explore the role of this documentary form in encoding and commemorating the experiences of members of the British Army on campaign. The images that remain, and the albums in which they are assembled, are fragments of the contradictory realities of colonial conflict seen through soldiers' eyes via the handheld Kodak camera, a significant instrument by which events, large and small, were captured as they occurred.

The early purpose of military photography

Writing in 1902, an anonymous author in *Scientific American* sought to compare the use of campaign photography across Europe, noting the distinct advantages of military photography and the quick uptake by the British of this technology.

Two photographs from the 1860s (Figure 6.1), in the collections of the Royal Engineers Museum, Gillingham, Kent, record the presence of the camera as a military piece of equipment in India and the Himalayas. They are present in a photograph album credited to and compiled by Colonel Arthur Moffatt Lang C. B.[7] They show cameras and photographic equipment in service at an early stage within the chronology of the album and provide testimony to the type of equipment used and its perceived usefulness in the pursuit of strategic and military objectives in India in the mid-nineteenth century. These two images are part of a series that documents the construction of the Hindustan–Tibet Road, which took place from 1863 to 1864, an event that reflected British trading interest in Tibet and the multiple attempts at diplomacy and communication to establish trade across the Himalayas that pre-dated the Tibet Mission of 1903–04. As such, these images are some of the earliest taken in the region.[8]

The inclusion of these photographs in what appears to be an individual album, inherited by a family member,[9] marks the Corps of Royal Engineers' early use of photography as a tool and technique, consistent with the increasing enthusiasm for the military application of photography from the 1850s.[10] Photography as technical innovation was quickly adopted by this group of military professionals, who were interested in immediacy, accuracy and recording, and whose role in exploration and surveying had traditionally required training to produce

Figure 6.1 Print from Lang's photograph album showing a wet plate travel camera lower right (numbered 23).

topographical drawings.[11] This was in the context of the military being important to the spread of photography throughout the Empire; officers and military surgeons were some of the first to adopt photography after its invention in 1839.[12] According to John Falconer, who has written a history of photography in the Royal Engineers, the primary initial use of photography was that of depicting warfare (such as Roger Fenton's Crimea photographs of 1854).[13] The development of photography as a technique and aspect of training was linked to its widespread use in India and its role in large domestic civil engineering projects, with sappers and miners initially trained in the South Kensington Museum (now the Victoria and Albert Museum).[14] The move of the Royal Engineers to Chatham House, London, and the abolishment of the depot at Woolwich, London, in 1850 coincided with a wider training programme for engineers and 'from that time on, all training and instruction of recruits for home and foreign service, including India, was carried out at Chatham'.[15] The development of an official photography course, pursued on an optional basis, in addition to field surveying, architecture, siege planning, telegraphy and demolition, began in 1856 and led to the engineers 'wielding cameras on a truly global scale'.[16]

Captain Henry Schaw,[17] Chief Instructor of the Telegraph and Photograph Schools from 1858 to 1864, wrote his 'Notes on Photography'[18] in 1860. Schaw argued that photography 'has now attained . . . a position of such acknowledged usefulness in reference to many of the arts and science in which the Corps of Royal Engineers are professionally interested'[19] that he felt compelled to provide specific guidance (building on other publications). His article covers processes, suppliers and equipment for those working domestically or in the field, so that all those interested could take advantage of this new technology. Early on in the article Schaw provides a clear ten-point list of the documentary uses of photography.[20] In its original order this included creating 'exact records of the progress of public works', 'copying plans', 'obtaining minutely accurate' representations of architecture, 'preserving exact representations' of defective buildings, recording the results of explosions and experiments, 'illustrating the making of military bridges' and 'showing the correct position for soldiers in various drills' and 'in surveying boundaries'. The instructions on scientific and regulatory objectives were then followed by those of more anthropological and political interest, namely 'obtaining portraits of remarkable persons and costumes of foreigners'.[21] In the Indian context this fitted in with a larger ambition of the government of India to comprehensively document the peoples of India,[22] which Harris notes concurred well with other survey forms: the map, the census and the museum.[23] James Ryan notes that later instruction books produced by the Royal Engineers (by William Abney) recommended that military photographers also have aesthetic and pictorial considerations in mind.[24]

In Lang's album the two candid pictures of equipment are pasted on a page with two other photographs.[25] They are on the lower range of the page; the left-hand image shows a small camp with the photographic equipment to the front right. The right-hand image is taken from above, showing a darkroom tent.

The photographs are numbered in pencil 23 (left) (Figure 6.1) and 22 (right) (Figure 6.2), but are not of the same location, inferred by the distinction of the trees (possibly firs and deodars) and elevations. Both are from the 1860s, seemingly 1863–64 based on the surrounding images, but may have been placed in the beginning of the album to situate the practice of photography and possibly comment on the larger photographic landscape on the same page, since the album overall covers the period from 1860 to 1875. The photographer is identified on the inside green cover: 'Photographs taken by Colonel A. M. Lang C. B of the Bengal Sappers and Miners, 1852–1888'.[26] Other photographs, however, point to a number being taken by Samuel Bourne (1843–1912), the British photographer who set up his influential photographic studio

Figure 6.2 Print from Lang's photograph album showing portable darkroom tent for development in lower right (numbered 22 in Lang's album).

with Charles Shepherd first in Simla (Shimla) and then in Calcutta (Kolkata) and Bombay (Mumbai), and who was active in the Himalayas/ northern India between 1863 and 1869.[27] Bourne's photographs are generally signed or numbered (as in this album), and it is known that Bourne followed a part of the Hindustan–Tibet Road in 1863, which he described as being open for about 100 miles (160 km),[28] which he then toured again in 1866–68. Within the frame of these two photographs, the photographic equipment stands alongside the British and Indian soldiers as well as local Indian labourers (regularly described as 'coolies') or porters, with the photographic equipment in sharper focus than the persons simultaneously 'captured'. The other aspect, of course, is that photograph 23 (Figure 6.1) denotes that there must have been two cameras present. This photograph therefore throws the identity of the photographer into doubt while signalling the presence of multiple recordings, which in turn highlights a key difficulty in looking at military photographs, namely the existence of multiple uncredited recordings of the same event.

Schaw in 1860 recommended two types of wet collodion cameras, one with a 'well seasoned mahogany body, brass-bound, with a sliding body', noting that there were more portable versions, and that those with an accordion body were lighter but less robust in hot climates.[29]

Though not entirely clear from the article, Falconer concludes that Schaw recommended the simultaneous use of two cameras. Activities in British Columbia in the 1860s infer that the use of two photographers was seemingly standard.[30] Schaw also advised that plates no smaller than 9 by 11 inches (approximately 23 by 28 cm) should be used for government purposes[31] and discussed the merits of different-sized plates (visible in this album), arguing that smaller ones were more appropriate for amateur purposes.[32] The tripod recommended by Schaw for smaller cameras is visible in photograph 23 (Figure 6.1), and it is possible we are given a glimpse of a portable darkroom/tent also recommended.[33] In photograph 22 (Figure 6.2) the portable darkroom tent is similar to that used by Bourne and as shown in a published photograph from the late 1860s.[34] An unusual detail is that photographic plates are visible in the hand of the local Indian porter moving away from the darkroom (figure in white, bottom far right) indicating the general dependence of such photography on local networks that allowed the securing of Indian labour and supplies.[35]

Colonel Arthur Moffatt Lang, the sometime photographer and compiler of the album, obtained his commission into the Royal (Bengal) Lancers in 1852, and shortly thereafter he experienced 'the most eventful period in his life'.[36] Moffatt Lang was involved in the Siege of Delhi, the Battle of Cawnpore (Kanpur) and the Capture of Lucknow during the Indian Uprising (or Mutiny) of 1857. By 1862 he was promoted to captain and transferred to the Hills Road Division in Shimla. Here he worked on the Hindustan–Tibet Road, an enduring, if dangerous, gateway to the region that required feats of courage and agility:

> [N]ative workmen [were slung] over from the tops of the almost inaccess-
> ible rocky scarps, who would jump holes in the face of the cliff, and fix
> steel jumpers or crowbars at the proper levels and distances, using them
> to support wooden platforms from which blasting operations could be
> undertaken. Gradually in this way a narrow roadway was worked out
> in the cliff. It required a good head to superintend all this overhanging
> work.[37]

Locating photographs 22 (here Figure 6.2) and 23 (here Figure 6.1) is not straightforward. Captioning and numbering are inconsistent, though pencil notes seem to agree with a separate, torn handwritten note which provides captions to only twenty-three photographs. These appear to link to these images, as well as to the larger photograph on the same page (numbered 2), suggesting a place near Mussoorie[38] rather than Shimla, namely a location some 260 kilometres south-west.[39] Some details and images coinciding with Bourne's photographs

in terms of locations, and the range of photographs included in the album, are linked to his earlier trip and Shimla, as well as his later trips and Mussoorie. However it is impossible to state more than this with certainty,[40] except that Bourne had a very effective commercial operation reaching areas where the Army were stationed and there is evidence to suggest that Bourne and Lang were acquainted. As noted in Bourne's accounts, he encountered and stayed with the British military during his travels and met surveyors.[41] A portrait photograph of Lang near the location of Taranda appears to be dated to 1863. The 23rd Sikh Pioneers' camp at Taranda is the subject of a credited photograph by Bourne in the album, one of three believed to have been taken by Bourne in that location in 1863–64.[42] There is no clear explanation why Lang was working with the 23rd Sikh Pioneers (seemingly visible in Figure 6.2), a regiment of the British Indian Army who had a long association with military activity in the Himalayas and who were later involved in the Tibet Mission.[43] By the late 1860s Lang was the Chief Engineer and Secretary to the Commissioner of Oudh.

Lang's privately owned album contains 250 photographs.[44] These range in terms of subject matter but have a clear emphasis on topographical views and surveying in which humans and buildings are dwarfed by the landscape, but in which journeys are mapped out. This is consistent with the stated military value of photography to document topographical features such as rivers, gorges, housing and trails to allow a new country to be surveyed and understood by an advanced corps of engineers.[45] The exceptions are portraits of groups of soldiers, villages scenes and the stiff ethnological group portraits of local women with the captions attributing an ethnic group and identifying location, consistent with the documentation and surveying of peoples at the time. Although women were working as porters during this period, as noted in the album, for obvious reasons, women feature less than men.[46] The different sizes of photographs and different formats disrupt a sense of a logical and chronological sequence. Inconsistent captioning (by different hands, possibly added over time) makes a clear understanding of purpose beyond documentation and collecting travel souvenirs difficult, including knowledge of when precisely photographs were taken or by whom. Moreover the use of available duplicate images produced by Bourne and Shepherd suggest these commercial (and more picturesque) images were integrated to supplement military recordings and provide a more comprehensive and diary-like account at a time when photography was a burdensome and tricky technology undertaken in difficult field conditions, and therefore did not always come with a guarantee of success.

[134]

Photography during the 'Tibet Mission' 1903–4

Much has been written critically about the Tibet Mission (or Younghusband Mission) of 1903–04, and the purpose here is not to provide new interpretations or lengthy descriptions of the historical circumstances, except to note that the name 'Mission', with its associations of reasonableness and diplomacy, has been roundly contested as a misnomer.[47] This was an invasion rationalised as being consistent with the British policy of steady expansion which sought to push back the imperial frontier in India.[48] British territorial expansion, which had been rapid in India until the Indian Uprising, slowed in the 1860s but galvanised once more from the 1870s due to perceptions of Russian territorial ambitions,[49] and hence specifically in this case, the seemingly successful Russian attempt at diplomacy in Tibet by 1902.[50] The Tibet Mission followed a nineteenth century that had seen wars between Tibet and its neighbours, and multiple thwarted attempts by the British to enter and develop treaty relations with Tibet, in part through dealing with the Qing imperial government, technically the suzerain power. The Qing dynasty (1644–1912) in the late nineteenth century was enduring its own political changes after the Boxer Uprising (Yihetuan Movement, 1899–1901) and the First Sino-Japanese War (1894–95). The Younghusband Mission followed many decades of British frustration, interference and attempts at establishing treaties and trading routes with Tibet, an area it considered largely cut off from the outside world,[51] and China.

By 1904, Tibetans were less willing to take advice or orders from the Qing emperor regarding the British threat. The Chinese *amban* (resident) in Lhasa representing the Qing emperor and the Tibetan authorities both ultimately proved incapable of stopping the British from entering the region. This meant that the Younghusband Mission proved more lengthy and arduous than the British expected, and it was ultimately devastating for the Tibetans since it brought their relationship with China lastingly into play, and exposed the region's potential vulnerability.[52] The Anglo-Tibetan convention, signed in the Potala Palace to conclude the invasion in September 1904, was negotiated but not signed by the Chinese *amban*. Younghusband and the Tibetan regent of the Dalai Lama as well as members of the three Great Monasteries and the National Assembly signed up to British terms.

In 1905, recently returned from Tibet, Lieutenant-Colonel H. A. Iggulden of the Sherwood Foresters and Staff Officer of the 'Tibet Mission Force' in his illustrated lecture 'To Lhasa with the Tibet Expedition, 1903–4',[53] provided a patriotic rationale for the imperial adventure on

the basis of the need to 'get into definite touch with the Tibetans, and come to a plain understanding on many important matters which had long been the subject of dispute'.[54] That Colonel Sir Francis Younghusband, accompanied by the 32nd Sikh Pioneers, did not manage to make headway with Tibetan representatives at Khamba *dzong* (fortress) on 18 July 1903 as part of the Tibet Frontier Commission (appointed by Lord Curzon) gave further support to the view that by October 'affairs had come to an *impasse,* and . . . the only means to make the Tibetans recognise the seriousness of the situation, was a further demonstration of force, and an advance into the heart of Tibet.'[55] Iggulden describes a sequence of events in military terms that can be read back into collective and individual military photographic albums, and his rhetoric chimes readily with newspaper reports such as those extracted and assembled in newspaper clipping books by members of the mission.[56]

The 'Mission Force' commander was James Ronald Leslie Macdonald of the Royal Engineers, promoted to brigadier-general, alongside Colonel Sir Francis Younghusband, political officer, Captain William Frederick O'Connor, mission secretary and intelligence officer, a Tibetan speaker, and Lieutenant-Colonel Waddell, a soldier and author of note, a scholar of Tibetan Buddhism, who was known for liking to combine 'medical kit', 'sword', 'trowel' and 'pen'.[57] Waddell officially took part in the dual role of principal medical officer and archaeologist[58] and was aided by David Macdonald, whose father was Scottish and mother was from Sikkim, and who therefore spoke Tibetan fluently. Both were sanctioned to make collections by the government of India. The Tibet Mission had a defining role in bringing Tibetan art into the popular imagination and into public collections,[59] and the wish to acquire curios, books and sacred items including manuscripts developed into an important aim of the mission, one which responded to a rising though ambivalent fascination with Tibetan culture and religious beliefs, as well as the perception of the dearth of important objects in major national and university collections.[60]

Also accompanying the expedition was John Claude White, Political Officer in Sikkim, deputy to Younghusband and official photographer. Claude White was equipped with a number of cameras (six in total), including a large and cumbersome panoramic format camera (likely a Thornton-Packard Royal Ruby) which required its own porters.[61] Claude White was likely the only photographer who was thus equipped. Harris notes that in contrast to Bourne, whose views were both topographical and picturesque, Claude White's photographs managed to create a sense of the sublime Himalayan landscapes punctured by the decisive and purposeful presence of British forces and their actions.[62] Other members of the campaign created images which dwelt on

buildings before and after 'fights'[63] (something Schaw recommended) and thus the poetry of military-inflicted architectural damage. This canon of imagery is composed of troops, landscapes and scarred buildings, an aesthetic which Paul Fox describes as a move away from the straight-forwardly picturesque towards a 'military sublime'.[64] Claude White's official record was later published in two volumes, and reproductions were bound in prestigious red leather albums presented as gifts to the leaders of the mission and members of the British government. Individual prints were also sold and disseminated more widely, inserted into individual and collective regimental albums.[65]

Scientific American in 1902 claimed that several hundred photographers worked for the British Army, stating that 'Military photography thus becomes an important part of a campaign. The pictures show the condition of troops at certain critical moments, their arrangements, the condition of the country, and technical points that cannot be illustrated in any better way.'[66] Other members of the mission used Folding Pocket Kodak cameras (available from 1895) or models FPK3 or FPK3A (Figure 6.3).[67]

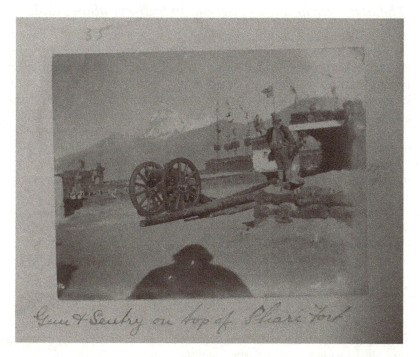

Figure 6.3 'Gun and Sentry on top of Phari Fort' with amateur photographer revealed by stark sunlight. The stance suggests the use of a handheld camera. Note numbers to the right side 17/19.

All those carrying a camera were aware that their exploits and photographs (and sketches) might well be featured in newspaper reports.[68] Some were loaned cameras to take photographs, which they sent home for compiling in albums.[69] Writing about the earlier Anglo-Egyptian campaign in the Sudan (see also Mack, Chapter 2), Paul Fox argues that the unprecedented presence of the handheld camera and the ease of developing film changed the manner in which colonial conflicts were presented and communicated.[70] Compared to extensively photographed Egyptian Sudan, which was also the object of European fascination, Tibet was under-represented. The presence of handheld cameras in the hands of military photographers, amateur and official, as well as journalists created both a dispersed means to document events as they were underway and a means to represent an unseen part of the world. For Harris photography undertaken during the Younghusband Mission 'installed Tibet within the imagined community' of transnational imperial Britain'.[71] Photography was both the means to capture an event and an event in itself.[72]

The domestic and the convivial in military photographs

As an early example of photographs made by military men and deposited in regimental museum archives, the Lang album, referred to earlier, raises considerations of private and public photography, anonymity and authorship central to many of the photographic albums produced by the Tibet Mission of 1903–04 now held in corps and regimental collections. The Royal Engineers Museum only has one other individual officer's album, which features a small number of images linked to the 'Tirah Expedition 1897–8' and the 'Tibet Mission Force 1903–4', which belonged to J. H. White and was donated by his son.[73] Here the layout is distinct, with a standard of one mounted photograph per page, captioned with an appended label and surrounded by a highlighting white line. A number of portraits are contained within, including a convivial group photograph of officers of the 3rd company of the 1st (Bengal) Sappers and Miners[74] wearing the clothes issued to members of the expedition in anticipation of the extremes of weather, including the long sheepskin 'Afghan' overcoat (known as 'Poshteen') (Figure 6.4).

These were issued in addition to vests, extra gloves, rugs, quilted and felted knee boots, woollen comforters, quilts and snow goggles, with officers benefiting from the additional luxury of chamois leather-lined clothing.[75] Later, near the end of the album, is a series of cartoons depicting the same officers, the caption suggesting the owner's own work (Figure 6.5).

The White photographic album is a modest (thirty-four photographs in total), people-focused personal diary. This is album as personal

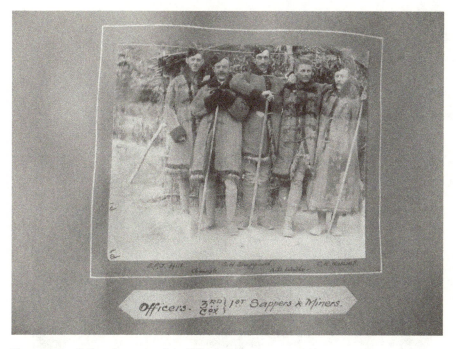

Figure 6.4 Officers' portraits from White album.

mnemonic, in which it does not seem that the compiler really attempted a chronology but a sketch of experiences, reflecting officers, soldiers and Tibetans: a memorial account of the conviviality and community of 'being there'. Harris, in seeking to read such photographs, notes the tension between the official deployment of photography and the randomness of personal accounts[76] which, while seeking to represent Tibet, were constrained by skill, logistics (such as being perpetually on the march) and inflected by personal experience (which varied according to regiment, battalion, event), something evident in the range of photographic content and albums in regimental and corps museums.

In individual soldiers' albums, however, there is a clear and consistent need to represent personal presence as well as regimental loyalty and identity. Photographs of small informal groups and more formal groups of officers or soldiers are a common feature in all military albums taken for memorial and official purposes, recalling the formal command structure, but equally the community and conviviality of the regiment. Some photographs are clearly ordered by rank or regiment, while others commemorate particular moments or events. Lieutenant Arthur Lovell Hadow of the Royal Norfolk Regiment in a

[139]

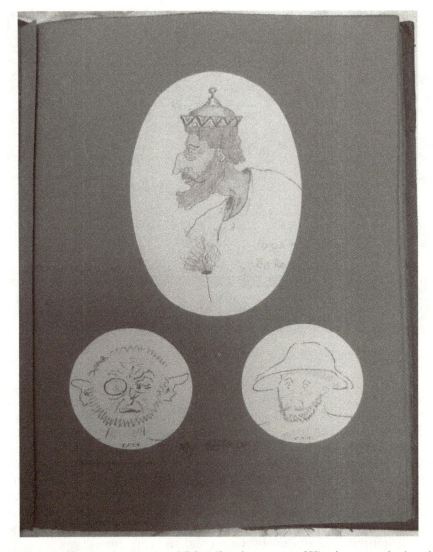

Figure 6.5 The cartoons captioned 'My officers', suggesting White's own work, though there seem two distinct styles. E. F. H. H is presumably E. F. H. Hill and C. H. H., C. H. Haswell (see officers in Figure 6.4).

letter to his mother after the resumption of hostilities at Gyantse *dzong* noted 'Yesterday all the officers of the force which has defended Gyantse for so long were photographed together and I had one of my Maxims[77] in the photo'.[78] The formal command structure and the

informal culture of the military written about by Kirke and Hartwell (Chapter 5) is reflected in the album compiled and owned by Captain Julian Lawrence Fisher DSO and now held by The Fusilier Museum, London.[79] This thirty-five page album[80] includes small single portraits and larger group photographs. In Fisher's album the distinctions between the different types of portraiture is clear. Based on composition there are a number of informal and impromptu portraits on page 8: 'Chichester',[81] 'Palairet'[82] and 'Self'. However, photographs on p. 2 of 'Colonel and Hewitt' and p. 3 of 'Hewitt and Sergeant Major' are duplicates of those featured in a bound collective photographic album also held by The Fusilier Museum (Figure 6.6).[83]

At the end of Fisher's album are four large-format individual photographs, two of which are group portraits. Here Fisher poses with twelve brother officers from all four companies that were mobilised as reinforcements in May 1904. They are depicted first in their regular uniform and then in their Tibet-ready clothing (similar to Figure 6.4). This 'before' and 'after' trope is a popular one in military photographs, as is men dressed in their warm clothing and photographs showing cold men in extreme conditions.[84] However in this pair of official photographs each officer is in exactly the same spot, thus creating a slightly comic effect as you flip from one to the other. The same two prints captioned more diligently with each officer's name and rank and entitled 'Group of Officers, 1st Batt. Royal Fusiliers, taken at Kang-ma, Thibet, on June, 24, 1904' can be found in what appears to be the Royal Fusiliers' formal collective album bound in red leather with the title 'Lebong to Lhassa and Back May 23 to October 28 1904' (Figures 6.6 and 6.7).[85] Here, intriguingly, the order of square format to panoramic images is reversed from the Fisher album, as if precedence is given to John Claude White's official photographs that share captions across other photographic albums in other regimental museums (though all are linked to the Royal Fusiliers).[86] There is some further duplication present in the amalgam of loose photographs held together in a boxed 'album'.[87] Here the prints are unmounted, some over-exposed and badly damaged. None are captioned. Nevertheless, more intimate scenes of regimental life are present, including one of a British soldier giving another a haircut and a shave as well as a seemingly relaxed market scene with Indian soldiers and Tibetan market holders. More revealingly as regards the production and circulation of photographs is that also present is a snapshot of the official portrait of the thirteen officers taken from a lower angle and on the left-hand side, presumably by a soldier with a handheld camera which shows his view of the staging of the photograph among the tents.[88]

Figure 6.6 Adjacent photographs from collective album showing officers and four of the seven members of the Royal Irish Rifles and one their two Maxim machine guns.

The diary of Lance Sergeant Alfred Stanley Dunning also in The Fusilier Museum, kept between 23 May and 5 August 1904, provides commentary on the commemorative role these photographs had for

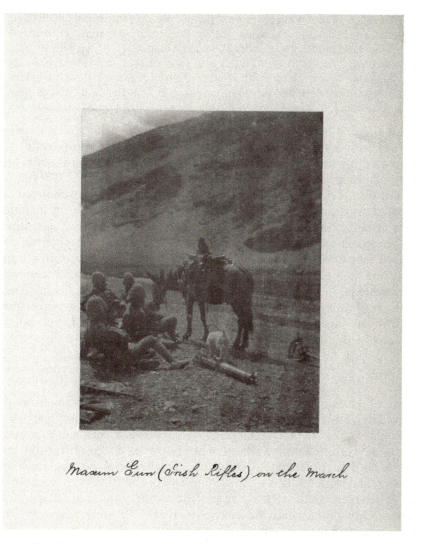

Maxim Gun (Irish Rifles) on the march

Figure 6.7 Adjacent photographs from collective album showing officers and four of the seven members of the Royal Irish Rifles and one their two Maxim machine guns. The small white dog appears in other photographs in the same album.

men who were part of the campaign as he describes the march from Jeluk to Gnatong [Gnathang] in May 1904:[89]

Jeluk, 30th.
 Start at 8:30 in file, we hadn't gone far before a couple of mules fell over the cliffs kits and all. We are now 13,800 feet [4,200 m] above the

sea level. And to see me you would think I was an esquimeaux [sic]! Coat made of a sheep skin, thick boots up to the knees a cap to cover the head and face and come down under the chin finished up with a pair of blue spectacles. The air is very rare and to move about makes one blow as though one was working hard. We rest at night in some native bungalow which are very dark and dirty but we imagine that they are Palaces after our last camp.[90]

In the Fisher album one photograph has soldiers sitting down with the caption 'food after the march'[91] giving a clear inflection of exhaustion or reward to an image repeated in the collective album but here captioned more dispassionately as 'group of officers Lhasa'.[92] This shows the latitude of interpretation as each individual image is exchanged and repeated in different contexts. Questions of kit, marching distance, camp conditions, transport, bland rations and the physical hardship of the campaign (including on return sun-blindness) are themes that emerge repeatedly in diaries[93] and articles,[94] and are shown in albums and captioned photographs. A Tibet Medal was issued as a campaign service medal in 1905 with a ribbon and a clasp inscribed 'Gyantse' and on the reverse a depiction of the Potala Palace, Lhasa as 'a special mark of Royal Favour for the successful undertaking, and the many privations endured by the recipients'.[95]

Views of Thibet: an album of the Royal Irish Riffles

Views of Thibet, compiled by the Royal Irish Rifles[96] and held by the Royal Ulster Rifles Museum, Belfast, is not credited to any particular photographer or owner.[97] Unlike those mentioned earlier it is a larger and more comprehensive album which appears to be an formal regimental photographic account, compiled after the end of the Younghusband Mission and which follows the chronology of the campaign, containing images that dovetail with those of officers' individual albums in The Fusiliers Museum, which are less exhaustive.[98] This link to the Fusiliers is important because only seven members of the Royal Irish Rifles served, as a Maxim gun team (with two machine guns), with the Royal Fusiliers (Figure 6.7).[99] Bound with a leather cover, the album opens with a reproduced photograph of Younghusband, O'Connor and Claude White (as well as Captain Parr who was commissioner for the Tibet Chinese Border) and includes 446 photographs which present the chronological sequence of the campaign and include seventy-five pages of photographs arranged five to a page, followed by eighteen pages of panoramic photographs (taken by John Claude White[100]) arranged four to a page from top to bottom.[101] This album is an intriguing puzzle, somewhat confirming Harris' observations that military photographic

albums, whether collective property (which she describes as official) or individual property (which she describes as personal), are descriptive in intention and reflective of soldiers experiences.[102] At the same time the album, ostensibly encapsulating the personal experience of seven soldiers, reflects wider concerns and experiences, and demonstrates how complex the combined product of such unidentified photographic, narrative and classificatory hands can be.

The Younghusband Mission that gathered in Siliguri and Gangtok at the end of 1903 included the 1st Section of the No.7 British Mountain Battery, the 12th Company of the 2nd (Madras) Sappers and Miners, the 3rd Company of the 1st (Bengal) Sappers and Miners, two Maxim gun teams from the 1st Battalion of the Royal Norfolk Regiment, the 23rd Sikh Pioneers, the 32nd Sikh Pioneers, the 8th Gurkhas and one section of the British and four sections of the Native field hospital.[103] All of the men had been through a medical examination to ensure that they were hardy enough for what was ahead, accompanied by many thousands of porters and beasts of burden.[104] The campaign moved toward Phari *dzong*, and then stalled for several months, only getting properly underway in March 1904. In May 1904 four companies (A, C, F, H) of the 1st Battalion of the Royal Fusiliers (hereafter Fusiliers) which included the detachment from 1st Battalion of the Royal Irish Rifles (hereafter Rifles) set out to join as a reinforcement,[105] arriving in Chumbi at the end of May 1904,[106] marching further to Gyantse to join the mission force, and were themselves joined in June by the 40th Pathans. The Rifles were led by Lieutenant (later Captain) J. C. Bowen-Colthurst, with Sergeant James Lyle, six riflemen and two Maxim guns.[107]

The mission force had arrived in April at Gyantse and the Gyantse *dzong* was surrounded by British forces and surrendered; however Brigadier-General Macdonald did not garrison at Gyantse *dzong* but stayed further south to secure supply lines, and Colonel Younghusband had his mission headquarters at Chang Lo Manor, which resulted in a steady build-up of Tibetan resistance by June. In consequence Gyantse *dzong* was retaken by the British on 6 July.[108] The Fusiliers and the Rifles by this time had joined the Tibet mission force covering 250 miles in 36 days of marching.[109] On 14 July, the mission force with the recently arrived reinforcements marched from Gyantse to Lhasa, arriving in August to be met by the Chinese *amban* and Nepali representative as well as the Tibetan regent (Ganden Ti Rinpoche) as the Thirteenth Dalai Lama (Thubten Gyatso) had already departed, travelling north to Mongolia. The Anglo-Tibetan convention was signed on 7 September 1904.

Views of Thibet[110] commemorates a continuous sequence of events that overlays the actual experience of marching by soldiers from Chumbi to Gyantse, and thence Lhasa, with events known to have

happened during the campaign which the photographs/photographers witnessed but which these particular soldiers did not. For example, the views at Phari Fort (Phari *dzong*) (Figure 6.3) were unlikely to have been taken by the Rifles since the mission force had left this location before the Fusiliers and Rifles were mobilised. An insight into the logic of the album (and its inconsistencies) is only possible because of the thoroughness of its uncommon and extensive handwritten index at the rear. The first page of this index states 'Index to Views of Tibet' and the subsequent index is divided two parts.

The shorter index is entitled 'Names of Camps from Silligori to Lassa'[111] and has a numbered list of camps/camp names (1–41) which correspond to the progress of the mission force with a final additional category (42) of 'Miscellaneous'. This index page also lists how many photographs ('No of Views') are linked to each cited camp, and then also identifies which of the images it has reallocated to the 'Miscellaneous' category. The first ten locations listed have few if any photographs associated with them. Photography begins in earnest at Chumbi (camp 13), the location where the Fusiliers and the Rifles joined the mission. Next are Tuna (camp 19), Guru (camp 20), Nani (Naini, camp 26),[112] Gyantsi (Gyantse, camp 26) and Lassa (Lhasa, camp 41). The brief index is then followed by a long and detailed 'Index of Views'. This lists each camp and numbers the corresponding views in a numerical sub-sequence, which it associates with a caption listed under the heading 'Purport'. In consequence each photograph has a unique number resembling a fraction which physically locates it (Figure 6.3).

The index reveals several interesting facts. The 'Miscellaneous' category is the largest single category with 142 images (30 per cent of the album). This mixes locations, and is the only one that features women, unnamed and largely included as types such as 'beggars', 'market stall holders', 'working fields', and identified through status and wearing regional clothing or regalia. This follows Schaw's anthropological and diplomatic categorisation and in consequence it also registers political events and important people, featuring mission officers, regiments and medical staff, as well as Tibetan, Chinese and Nepali dignitaries. It features dynamic events such as ferry crossings and social scenes mostly concentrated around Lhasa, and a few markets. All of Claude White's panoramic photographs of Lhasa are classified under 'Miscellaneous', inferring a distance from direct regimental experience and thus, by implication, importance. The square photographs directly allocated to named camps, five to a page, in contrast, are focused on views, manoeuvres, troops, camps, marching, transport, communication lines, buildings and architectural features, namely Schaw's first nine categories. A repeated element is the multiple images of transport (for

[146]

example of ekkas, boats and rafts), especially of the beasts of burden – mules, asses, ponies, yaks – probably linked to the complex logistics required to allow for traversing Tibetan terrain in winter and summer and the alarming rate of attrition as entire herds of animals died out for one reason or another.[113] This comprehensive indexing system gives an unusual candour to experiences many of which, paradoxically, neither the members of the Royal Ulster Rifles present, nor the album's regimental compiler are likely to have witnessed. Moreover what appears as chronology is a representation of expeditionary progress to Lhasa.[114] Namely it reflects the movement to Lhasa from Chumbi, rather than the chronology of the Fusiliers and the Rifles own campaign.[115] For example, the ferry points that are listed in sequence Barji Ferry (camp 35), Pati (Peto) Ferry (camp, 36) and Chaksam Ferry (camp, 37)[116] were encountered in a different order: the Chaksam Ferry crossing was used to cross the Brahmaputra River on the way to Lhasa and the Peto Ferry crossing was on the way back; thus they were several months apart.

The battle at Guru

Guru was the site of one of the first actions of the mission, now known among Tibetans as the Massacre of Chumik Shenko. By late March 1904 it was understood that the Tibetans were strengthening walls and forces at Guru. The British met with Tibetan officials, an event narrated in Younghusband's account and shown in *Views of Thibet* as photograph 20/5 'A Durbar with all the High Officials at Guru'.[117] The short conference with the Tibetans happened quickly: 'They rode up briskly with a little cavalcade, and we all dismounted, set out rugs and coats on the ground, and sat down for the final discussion.'[118] This was inconclusive and subsequently the British advanced and the standoff took place near a rough five-foot stone wall; the battle (referred to as 'fight' in the album and elsewhere) saw the British training their Maxim guns on Tibetan soldiers who were armed with matchlock rifles and swords, therefore not in equal measure. An estimated 700 Tibetans died, with a further several hundred Tibetans seriously injured to whom the British medical staff subsequently attended. Iggulden described the firing as 'causing terrible havoc and slaughter in which practically all the leaders and the flower of the Tibetan Army perished'.[119] Younghusband wrote in his memoirs 'it was a terrible and ghastly business' while denying it was a massacre.[120] Lieutenant A. L. Hadow of the Royal Norfolk Regiment, who was witness and participant as the Maxim machine gunner, wrote to his father 'As soon as my guns got to work the slaughter became terrible as the Tibetans fell in heaps . . . I got so sick of the slaughter that I ceased fire.'[121]

[147]

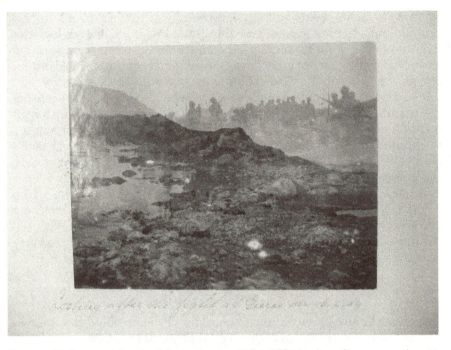

Figure 6.8 'Looting after the fight at Guru on 16.2.04'. The battle at Guru occurred on 31 March 1904, and so it is odd that the date here is wrong as it corresponds neither to the event nor the time that the Rifles marched through Guru (perhaps indicating a later compiler).

From the diary entries in one of the two newspaper clipping scrapbooks assembled by Bowen-Colthurst[122] of the Rifles it is clear that the Rifles and the Fusiliers passed through Guru on 19 June 1904, several months later. Nevertheless, the Rifles' album has a series of fifteen photographs over three pages linked to Guru which recreate a sequence of events recalling the confrontation in March. On the second page of three featuring Guru there are two photographs at the top captioned 'Troops nearing the hot springs before the fight at Guru'/ 'Troops marching through hot springs after the fight at Guru' and two at the bottom with captions 'Part of Guru after the fight'. In the middle (Figure 6.8) is a unique and unsettling photograph.

The photograph is a double exposure, thus two overlaid images. One is clearly a landscape view as seen by the irregular but diagonal line of the mountain starting on the top left of the image, and barely visible small figures in the bottom left register. The more prominent shadowy image laid over the landscape shows British Army and British Indian Army soldiers standing armed with weapons and bamboo staffs

[148]

surrounding accumulated horizontal forms which are likely the clothed bodies of dead Tibetans, mown down through the action of asymmetrical firepower. The caption states 'Looting after the fight at Guru on 16.02.04'. The presence of this opaque image, which was obtained from another regiment, and the caption that accompanies it cause the viewer to pause.

The following pages contain other thought-provoking images. There are two photographs depicting the stone wall, outlines of vultures and soldiers captioned 'Vultures awaiting their prey after the fight at Guru'. Although there was a fascination for Tibetan burial practices, there is something about the fight, the looting and the vultures that implies a critical stance, a tacit accusation, of scavenging on the battlefield.[123] The power and poignance arising from its inclusion does not appear to be accidental, or if an accident of production, it has been included for a purpose. The Rifles did not see action at Guru, the Maxim guns deployed belonged to the Royal Norfolk Regiment, and Hadow returning a few days later noted that bodies which had not been buried due to the frozen ground had been 'stripped by the camp followers'.[124] Bowen-Colthurst's diary entry for 19 June states briefly 'Sunday. Marched 13 miles to DOCHEN pass scene of fight at Guru, many bodies'.[125] Harris' research in particular in the National Army Museum, the Royal Geographical Society and the Royal Norfolk Regiment collections revealed the existence of some photographs of the dead and the dying in albums created by officers and other ranks. These photographs taken at Tuna, Guru and Gyantse were not as widely shared as certain officers were concerned that such evidence did not reach a public audience.[126] Comparison with these other images makes clear that the Rifles' double-exposed image of the aftermath was taken immediately after the violent event. This is further confirmed by a harrowing photograph of which there are three copies in the collective and unbound albums from The Fusilier Museum, whose content corresponds with the timing of the Fusiliers' and Rifles' march through Guru several months later.[127]

This double-exposed or montage-like photograph is unique to the album, the only one of its kind. There is an aura of stillness and confusion within it that reflects the atmosphere that allegedly followed the chaos. It feels reasonable to assume an intention, and possibly subversion, to the inclusion by its unknown but rigorous compiler, even if their reasons can never be fully known. The double exposure forces the viewer to stare in order to comprehend, something reinforced by the caption which might misdirect the viewer towards the presumed culpability of the British Indian Army forces clearly present. Though Hadow in his account attributed the retrieval of battlefield spoils to camp followers (and thus Indian forces and 'coolies') his diaries and activities point elsewhere, further confirmed by an amulet box (*gau*)

with a bullet hole collected by Major J. W. Ottley of the 34th Sikh Pioneers (mounted infantry), now part of National Museums Scotland's collection. The *gau*, labelled as warding off bullets,[128] is noted as being 'found after the action at Guru'.[129]

Were the battle and the double exposure not enough to lend this photograph an especially unsettling quality, the caption serves to clearly associate the devastation with another phenomenon not otherwise pictured, cited, nor mentioned in these military photographic albums, the phenomenon of looting (Figure 6.8).

Images and things: looting, curios and markets

'There are stringent orders against looting monasteries, unless they fire or make resistance.'[130]

The official line on the looting of monasteries, the robbing of private estates and the acquisition of battlefield spoils during the advance of the Tibet Mission to Lhasa was that it was banned and did not take place. Popular narrative accounts written by key members of the Younghusband Mission contain no significant admissions of impropriety.[131] Michael Carrington,[132] Clare Harris[133] and Tim Myatt[134] date the dawning of wider public and official awareness of the British Army's acquisitive activities to newspaper reports published around the siege and storming of Gyantse *dzong* from May to July 1904. According to Harris the Tibetan 'protracted opposition' justified British military ideas of entitlement to the loot with legitimacy being given to the idea that the building and the contents were the property of the British Army despite the passing of the Hague Convention barely five years earlier (see Thomas, Chapter 7, for discussion).[135] This position fuelled growing criticism, especially from the Indian press,[136] who were all too aware that the Indian revenue was liable for the cost of the expedition, estimated at fifty thousand pounds a month by end July 1904.[137] Possibly the clearest example of official denial is the statement given by the Secretary of State for India, St John Brodrick, in response to a parliamentary question in the House of Commons, 10 August 1904. Asked whether he had been 'directed to the fact that bales of loot, images of Buddha, and other objects, ostensibly pillaged from the monasteries of Tibet, have arrived at Darjeeling; and whether he will give strict injunctions to prevent any pillage', Brodrick responded that he had 'received no information as to the arrival at Darjeeling of objects ostensibly pillaged from the monasteries of Tibet. The Government of India are fully aware of the necessity of preventing pillage, and are taking all necessary steps.'[138]

Harris characterises the Younghusband Mission as one which cultivated a taste for Tibetan sacred art and artefacts through

[150]

customary military 'harvesting' and 'foraging' which 'converted [Tibetan] bodies, homes and monasteries into a treasure trove for the British'.[139] Michael Carrington, who was the first to systematically chart the divergence between official and private accounts, as well as the extent of valuable and vernacular objects taken, also notes that there was some disagreement and disquiet among members of the mission force, as well as select punitive measures to curtail the practice (especially for British Indian Army personnel, who were subject to stereotypical British views of race and class).[140] The complex entanglements and facts of such a history are evident in small ways, for example the diverse views and reports from Bowen-Colthurst. From 22 to 26 June, his brief diary entries notes marching to Gyantse, the despatch of two companies of Fusiliers to Niru (23 June), fishing, writing letters and doing washing, marching through the Red Gorge and to Naini (26 June) and serving during the battle.[141] Bowen-Colthurst's letter issued with regimental orders in July 1904 recounts events in Niru differently: '[t]hey found the sangars deserted, though the fires still burning: so they looted the monastery, destroyed about 6,000 rounds of Thibetan ammunition and secured some considerable amount of forage, grain and timber and a few odds and ends as swords and spears'. This despatch, which details further battles, is annotated by a handwritten coda: 'I regret writing such a cold-blooded letter.'[142]

Clearly the Younghusband Mission had expectations of British material reward with the allocation of funds by the government of India to Waddell (10,000 rupees) to collect Tibetan books and manuscripts for universities and museums. This was to be legal purchase. However, Waddell miraculously transformed this amount into an official collection of more than two thousand texts and manuscripts, sacred and valuable artefacts that were subsequently catalogued in the Indian Museum, Calcutta (Kolkata) with the larger proportion later expedited to London, Oxford and Cambridge, in addition to his private collection, which he later sold.[143] The taking of trophies on the battlefield or in monasteries, though absent from official accounts, is clear from many private diaries and correspondence. Lieutenant Arthur Hadow's correspondence to his mother held in the Royal Norfolk Regiment collection in Norwich Castle Museum, is an especially candid series of personal accounts,[144] which provides context for a collection catalogued by Hadow as trophies (from Guru and Gyantse) and curios (from Lhasa), some of which were donated to the Royal Norfolk Regiment Museum and which are currently on display labelled as such.[145] Hadow and others describe certain instances using words[146] that effectively identify the surreptitious nature of their takings, sometimes directly countering precise orders to stop looting.[147] Such first-hand accounts also mention

Waddell's greed and express scepticism as to whether his official role is a means of assembling a private collection.[148] They articulate how army rank and regiment dictated precedence and opportunity during looting events (see also Spiers, Chapter 1).[149]

A further sanctioned means of appropriation was the forcible sale of such things as grain, supplies, seeds and fodder from estates. Although official reports denied plunder, Tibetan accounts differ in their interpretation[150] and the explanation provided by the Royal Fusiliers provides insight into the tactics of persuasion. Noting that Tibetans in Lhasa were reluctant to surrender food supplies, the Fusiliers threatened 'to blow up the monastery' thus ensuring 'the free passage of food stuff to the camp, all of which was not plundered but paid for'.[151] Food is a preoccupation visible in the accounts by the Fusiliers and the Rifles, who regularly noted opportunities to supplement their diet through hunting and fishing, and appear to have regularly logged the acquisition of 'forage' and munitions after battle.[152]

Hadow's apparent candour (noted earlier) lends credence to his attribution of a Bhutanese dagger with leather sheath as a gift, presented to him by Trongsa Penlop, ruler of Bhutan, who accompanied the Younghusband expedition to Lhasa and was allegedly impressed by Hadow's use of the Maxim gun.[153] This illustrates a more general point that not all items 'snaffled', 'found', 'rescued' and sent on to family members, or later gifted or sold on to museums, were likely looted. Other opportunities presented themselves as markets sprang up near army camps, especially in Lhasa when the British mission force passed the time by hunting for curios or exotic souvenirs,[154] being especially attracted to valuable materials such as stone and silk. Lieutenant Thomas De Beauvoir Carey of the Fusiliers stationed in Lhasa noted that he 'bought a good many turquoises in the Bazaar, but I don't think they can be worth much as they are all in a rough state and of all colours, they are very expensive, as some people have spoilt the market by giving fancy prices'.[155]

Given the covetousness, competitiveness and preoccupation with material rewards that accompanied and grew during the Tibet Mission, and the scale of collections that subsequently came into the possession of national institutions, regimental collections and families, the comparative absence of photographs of objects and markets in regimental albums appears significant.[156] It is possible the combination of official denial and perceptions of misconduct and dishonour acted against the taking and inclusion of such images. A lone image in the collective Rifles album under the category 'Miscellaneous' shows a staged display of Tibetan metal artefacts on a table draped with a white cloth (Figure 6.9), whose formal assemblage is reminiscent of posed photographs of regimental silver (see Kirke and Hartwell, Chapter 5).[157] Originally

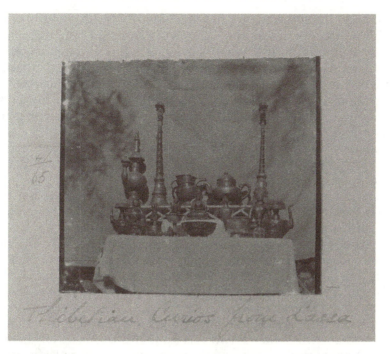

Figure 6.9 'Thibetan curios from Lhasa'. The display includes butter lamps, tea urns, a bell (*drilbu*), thunderbolt (*dorje*), statues of Buddhist deities, oboes and small trumpets.

mislocated as Chumbi and then corrected, it remains erroneously placed among photographs that depict the arrival of Trongsa Penlop in Chumbi in June 1904. None of the items in the photograph exist in the Rifles collection.[158]

Conclusion

As Roland Barthes reminds us, photographs have an uneasy relationship with truth, their evidential force and testimony bearing not so clearly upon the object which is framed by the lens, but the time the image recalls.[159] The Younghusband Mission ended the British 'position of imperial longing at the [Tibetan] border'[160] and was repeatedly recorded through the eyes of soldiers who over a period of under a year walked and battled their way over 800 miles from Sikkim and West Bengal, India, to Lhasa and back at an average altitude of 14,000 feet (approximately 4270 m). Military photography had a key role in tracing this endeavour and in so doing mythologising Tibet. Focusing on comparatively neglected archives, this chapter considers how photographs

[153]

can provide insights into formal and informal military culture and thus allow us to reassess the nature of albums and photography as military memorial forms. What is evident is that these photographic albums simultaneously record individual and collective experience, an experience shared among soldiers and officers whose readership and appreciation would likely operate on a higher level of recognition than that of the ordinary public. These albums, whether assigning individual authorship or ownership, or not, were created consciously as accessible amalgams of memories, the assembled product of multiple official and amateur photographers, narrators and cataloguers,[161] often brought together after the fact.[162]

There is, of course, the compelling question of what type of testimony these albums ultimately provide, since the subject of absence is as important as presence, namely how the visual evidence corresponds with written histories and personal accounts. A particularly intriguing album in this regard is the large collective album of the Royal Irish Rifles now held in the Royal Ulster Regiment Museum, compiled by unknown hands, evidently constituted of photographs from a number of sources, but catalogued and indexed with great care. As a comprehensive and unique account, created by a small regimental attachment that joined as a reinforcement, it contains two images that give pause. Of the more than 400 photographs with repetitive themes, two stand out: one of looting (Figure 6.8) and one of curios (Figure 6.9), which seem on reflection to visually encapsulate individual and communal military lives and the afterlives of material objects held in museums. Their inclusion and placement are not random, so this observation is a response to their intentional location within the album. The captioned image of looting is currently untraced in any other album, and as a double exposure is seemingly unique. As a rare image of looting, it highlights the virtual absence of visual representations of a customary phenomenon regularly registered in diaries. Pragmatic arguments can be given as to why looting is not easily captured by photography, but it is an absence all the same. The double-exposed image of soldiers poised for picking up the battlefield spoils is an unsettling sight, while strategically inserted and firmly positioned within the progress and business of the mission and thus by implication, regimental activities. It highlights the slippage in terminology of looting as a sanctioned military practice rationalised as retribution (as was the case in Benin 1897, as well as in Tibet 1903–4) (see Spiers, Chapter 1, and Tythacott, Chapter 8) in contrast to the customary (and sometimes unsanctioned) activity of acquiring trophies and weapons, something directly witnessed and repeatedly acknowledged by soldiers but absent from official accounts and almost all photographs. In contrast the display of curios from Lhasa, located in the broad category

of 'Miscellaneous', is a much more familiar sight, analogous to the display strategies not only of the military, in mess rooms, but equally in museums. However, its location in the album suggests something of its secondary and contextual importance in regimental terms. This appears contrary to the status and afterlives of the very 'spoils' and 'curios' that were brought back from Tibet. The persuasive and enduring international effect of the Tibet Mission was the conversion of thousands of sacred items and vernacular objects, taken by whatever means, into the celebrated phenomenon known as Tibetan art.

Notes

1 J. M. Schwartz and J. R. Ryan, 'Introduction: Photography and the Geographical Imagination', in J. M. Schwartz and J. R. Ryan (eds), *Picturing Place: Photography and the Geographical Imagination* (London: I. B. Tauris, 2003), pp. 1–19.
2 C. Harris, *The Museum on the Roof of the World: Art, Politics and Representation of Tibet* (London: University of Chicago Press, 2012); C. Harris, *Photography and Tibet* (London: Reaktion Books, 2016). This essay draws from the research work undertaken as part of the research funded by British Academy/Leverhulme on *Material Encounters*. During 2013–14, Harris was a member of the scholarly advisory board who met to discuss findings. We are indebted to her insights and work.
3 Harris, *The Museum on the Roof of the World*, p. 53.
4 *Ibid.*, pp. 66–7; M. Carrington, 'Officers, gentlemen and thieves: the looting of monasteries during the 1903/4 Younghusband Mission to Tibet', *Modern Asian Studies*, 37:1 (2003), 81–109 (p. 86).
5 In addition, there was Henry Newman and Mr Bailey for Reuters and Associated Press respectively, Harris, *The Museum on the Roof of the World*, p. 275, n. 6; Carrington, 'Officers, gentlemen and thieves', p. 93.
6 See S. Koole, 'Photography as event: power, the Kodak camera, and territoriality in early twentieth-century Tibet', *Comparative Studies in Society and History*, 59:2 (2016), pp. 310–45 (pp. 338–9).
7 Royal Engineers Museum, REMLA.4.106 (hereafter REMLA.4.106).
8 Harris, *The Museum on the Roof of the World*, pp. 82–3. Harris, *Photography and Tibet*, pp. 18–24.
9 The album (REMLA.4.106) was donated by Moffatt Lang's grandson, Brigadier R. A. Blomfield, in 1980.
10 See J. R. Ryan, *Picturing Empire: Photography and the Visualization of the British Empire* (London: Reaktion Books, 1997), Chapter 3. In the essay 'Military photography', *Scientific American* (16 August 1902), p. 102. G. E. W. notes that the Royal Naval College at Greenwich also had photography courses, with war ships having a darkroom and complete photographic outfit.
11 A. Birrell, 'Survey photography in British Columbia, 1858-1900', *BC Studies*, 52 (Winter 1981–2), pp 39–60 (pp. 40–1).
12 Ryan, *Picturing Empire*, p. 77.
13 J. Falconer, 'Photography and the Royal Engineers', *The Photographic Collector*, 2:1 (Autumn 1981), 33–64.
14 The Royal Engineers were heavily involved with civil engineering, including the building of places such as the South Kensington Museum, where they were initially trained, now the Victoria and Albert Museum. Falconer notes that the Royal Engineers were key to documenting the construction of the International Exhibition in 1862. By the mid-1850s photographers used in India by the Public Works Department also include army personnel assisted by Indians, and technical courses were available in India. Falconer, 'Photography and the Royal Engineers',

p. 36 and p. 44. See also R. Desmond, 'Photography in Victorian India', *Journal of the Royal Society of Arts*, 134:5353 (1985), 48–61. See also A. Birrell, 'Survey photography in British Columbia, 1858–1900', *BC Studies*, 52 (Winter 1981–2), pp. 53–4, 57. See Ryan, *Picturing Empire*, pp. 76–8.

15 Falconer, 'Photography and the Royal Engineers', p. 36.
16 Ryan, *Picturing Empire*, p. 78.
17 *Ibid.*, p. 37.
18 H. Schaw, 'Notes on photography', *Papers on the Subject of the Duties of the Royal Engineers*, New Series, 9 (1860), pp. 108–28.
19 *Ibid.*, p. 108.
20 *Ibid.*, p. 109.
21 *Ibid.*, p. 114.
22 Desmond notes specifically requested through memorandum in 1861, see Desmond, 'Photography in Victorian India', p. 55.
23 Harris, *The Museum on the Roof of the World*, p. 83.
24 Ryan, *Picturing Empire*, p. 82.
25 REMLA.4.106, opposite a page which formerly had two views but where one is lost.
26 REMLA.4.106.
27 Ryan, *Picturing Empire*, pp. 47–61.
28 H. Rayner (ed. and compiler), *Photographic Journeys in the Himalayas by Samuel Bourne* (Bath: Pagoda Tree Press, 2nd edn, 2004), p. 15.
29 Schaw, 'Notes on photography', p. 111.
30 Birrell, 'Survey photography', pp. 44–6.
31 Schaw, 'Notes on photography', p. 112.
32 *Ibid.*
33 *Ibid.*, p. 114.
34 Rayner, *Photographic Journeys*, p. 81.
35 Ryan, *Picturing Empire*, p. 55. See also Harris, who makes the same point regarding Tibetan photography and highlights Bourne's use of porters as props in his depicting of the Himalayan sublime, *Photography and Tibet*, p. 31, p. 60.
36 Royal Engineers (J. W. S.), 'Memoir: Colonel Arthur Moffatt Lang, C.B., R.E', *The Royal Engineers Journal*, 24:4 (October 1916), 165.
37 J. W. S., 'Memoir: Colonel Arthur Moffatt Lang', pp. 165–8.
38 Mussoorie was an important location for the British Army, with Dehra Dun a major centre of colonial administration and information gathering during this period.
39 REMLA.4.106. Pencil captions listed for photographs 1–23 seem to correspond with these photographs. This identifies photograph 22 as 'Undera [sic] Camping Ground' and 23 as 'Muldar [sic]. do. [ditto]' with Muldar then qualified further up in the list as fifteen miles outside Mussoorie and located in a pine forest. It has not been possible at this time to confirm where these locations are in the present day.
40 Some concordance can be found both in location and caption. In Lang's album (REMLA.4.106.), the pencil caption for photograph 1 corresponds very closely with photograph 1576 from the published Bourne and Shepherd catalogue (Rayner, *Photographic Journeys*, p. 144); however, neither the captions to 22 and 23 are evident in this published catalogue. Moreover, the Royal Engineers captions qualify location both in terms of distance and of numbers of marches from one location to another, absent in Bourne and Shepherd's known captions.
41 Bourne also seemingly travelled at one point in 1866–68 with a geologist or 'doctor' interested in geology. Rayner, *Photographic Journeys*, pp. 19, 80–81, 68, 71.
42 REMLA.4.106. The caption for the photograph in Lang's album has the inscribed number '199', which can be linked with Bourne's catalogue 'Camp, Officers, 23rd Pioneer, Tarunda' (Rayner, *Photographic Journeys*, p. 109), though the album caption is in different narrative order '23rd Pioneer Camp, on Taranda Ridge, 1863'.
43 A photocopied map associated with the album (REMLA.4.106) shows two journeys, one beginning in Shimla and one in Mussoorie.
44 See 'Royal Engineers Museum, Library and Archive, Gillingham, Kent: individual records', *Material Encounters Catalogue* (National Museums Scotland (NMS),

2016), available at https://www.nms.ac.uk/media/1150307/royal-engineers-ir.pdf, accessed 2 July 2019.

45 G. E. W, 'Military photography', p. 102; Schaw, 'Notes on Photography', p. 109.

46 REMLA.4.106. For example, 'Women of Kanawur (Our porters, July '64)' and 'Women of Hungrung (Our porters, July 64)', though seemingly one of the porters is in several photographs with her back to the camera, showing her headdress.

47 A. McKay, 'The British Invasion of Tibet, 1903–04', *Inner Asia*, 14: 1, Special Issue: The Younghusband 'Mission' to Tibet (2012), 5–25.

48 *Ibid.*, 5–25.

49 This intense rivalry between the British and Russian empires during the nineteenth century has become known as 'The Great Game', of which the Tibet Mission was one of its last manifestations.

50 The first photographer to enter Tibet was Russian, Gombojab Tsybikov according to Harris, a Buryat from Transbaikal. See Harris, *Photography and Tibet*, p. 57.

51 Lopez argues that the British view of Tibet as sealed off ran counter to evidence that from the eighteenth century Lhasa had large numbers of merchants from outside Tibet, and that monasteries drew monks from other countries. D. S. Jr., Lopez, *The Prisoners of Shangri-la: Tibetan Buddhism and the West* (London: University of Chicago Press, 1998), p. 8.

52 H. Diemberger, 'The Younghusband-Waddell Collection and Its People: the Social life of Tibetan Books Gathered in a Late-colonial Enterprise', *Inner Asia*, 14: 1, Special Issue: The Younghusband 'Mission' to Tibet (2012), pp. 131–171 (p. 162); H. Sanderson, 'Transgression of the Frontier: An Analysis of Documents Relating to the British Invasion of Tibet, *Inner Asia*, 14: 1, Special Issue: The Younghusband 'Mission' to Tibet (2012), 27–60.

53 H. A. Iggulden, 'To Lhasa with the Tibet Expedition, 1903-4', *JRUSI*, 49:1 (1905), 659–79.

54 *Ibid.*, p. 660.

55 *Ibid.*

56 This correspondence is particularly evident in the case of the Royal Irish Rifles collective photographic album (BELUR.AC.957) and the newspaper clipping books assembled by J. C. Bowen-Colthurst (BELUR.AC.4505 L and H) from the Royal Ulster Rifles Regimental Museum, whose album sequence follows that identified by Inggulden. See 'Royal Ulster Museum, Belfast: Individual records', *Material Encounters Catalogue*.

57 Diemberger, 'The Younghusband-Waddell Collection', p. 143.

58 His title was 'P.M.O. [Principal Medical Officer] and Antiquarian Collector of Buddhist Knowledge and Curios for the British Museum'. Here the British Museum means the British Museum, London, and the British Library, London. See I. Livne, *Tibetan Collections in Scottish Museum 1890–1930: A Critical Historiography of Missionary and Military Intent* (PhD Thesis, University of Stirling, 2013), p. 176.

59 See Harris, *The Museum on the Roof of the World*.

60 Carrington, 'Officers, gentlemen and thieves', pp. 81–109. Harris, *The Museum on the Roof of the World*; Diemberger, 'The Younghusband-Waddell Collection', pp. 131–71; T. Myatt, 'Looting Tibet: Conflicting Narratives and Representations of Tibetan Material Culture from the 1904 British Mission to Tibet, *Inner Asia*, 14:1, Special Issue: The Younghusband 'Mission' to Tibet (2012), 61–70.

61 Harris, *Photography and Tibet*, pp. 60–1.

62 Harris, *The Museum on the Roof of the World*, pp. 104, 109–112; Harris, *Photography and Tibet*, p. 61.

63 Particularly evident in BELUR.AC.957.

64 P. Fox, 'Kodaking a Just War: Photography, Architecture, and the Language of Damage in Egyptian Sudan, 1884-1898', in J. Clarke and J. Horne (eds), *Militarized Cultural Encounters in the Long Nineteenth Century, Making War, Mapping Europe* (London: Palgrave MacMillan, 2018), pp. 97–124. Citation here quoting Sarah James, pp. 107–8.

65 Harris, *Photography and Tibet*, pp. 61–3.

66 G. E. W., 'Military photography', p. 10.
67 Koole notes that Lieutenant Frederic Bailey of the mission force put in a special request for upgrading his camera in May 1903 just prior to the mission departing. Koole, 'Photography as event', pp. 312–18.
68 Harris, *The Museum on the Roof of the World*, p. 104.
69 This was the case with Lieutenant (later Lieutenant-Colonel) Arthur Hadow of the Norfolk Regiment, who sent photographs home to his mother for compiling into an album; some of those he refers to in his diaries do not seem to be present, however. His individual album shows that he included commercial prints. Items from his collection, his personal correspondence and a photographic album are now stored in Norwich Castle Museum. See also 'Royal Norfolk Regiment Collection, Norwich Castle: Individual records', *Material Encounters Catalogue* (NMS, 2016), available at https://www.nms.ac.uk/media/1150304/norfolk-ir.pdf, accessed 2 July 2019.
70 Fox, 'Kodaking a Just War', pp. 97–124. See also Harris, *Photography and Tibet*, p. 62.
71 See also Harris, *Photography and Tibet*, p. 62.
72 See Koole, 'Photography as event', pp. 317–18, who draws from Azoulay in distinguishing the photographic event and the event of photography. See Harris, *Photography and Tibet*; it is not known that any Tibetans took photographs during the Younghusband Mission.
73 Royal Engineers Museum, REMLA.5.23. See also 'Royal Engineers Museum, Library and Archive, Gillingham, Kent: individual records', *Material Encounters Catalogue*.
74 Initially, the 12th Company of the (Madras) Sappers and Miners, and the 3rd Company of the (Bengal) Sappers and Miners were involved in the Younghusband Mission.
75 Iggulden, 'To Lhasa', p. 662.
76 Harris, *Photography and Tibet*, p. 67.
77 Maxim machine guns were recoil machine guns named after their American-born British inventor (Hiram Stevens Maxim) and widely used by the British in colonial wars from 1886 to 1914.
78 The Royal Norfolk Regiment, Norwich Castle Museum, NWHRM 5069.10, A. L. Hadow to mother, 7 July 1904.
79 The Fusilier Museum, RFM.1141.9 (hereafter RFM.1141.9).
80 RFM.1141.9. The album is thirty-five pages long with nine pages of photographs in square format arranged five to a page (which are more personal and circumstantial) and twenty-two pages of photographs which have panoramic shots, three to a page (which are likely by John Claude White) and then four pages of single photographs. Two group shots, followed by the official shot of the departure of the Royal Fusiliers and then a commercial image of Darjeeling.
81 Lieutenant Arthur Claude Spence Chichester. The Fusilier Museum, Royal Fusiliers, RFM.ARC.2.093 (hereafter RFM.ARC.2.093), manuscript, J. P. Kelleher, *1st Battalion Royal Fusiliers (City of London Regiment), The Tibet Medal Roll* (2008), p. 25.
82 Captain Charles Andrew Hamilton Palairet. Kelleher, *1st Battalion Royal Fusiliers*, p. 24.
83 See for summary of these albums, 'The Fusiliers Museum, Tower of London: individual records', *Material Encounters Catalogue* (NMS, 2016), available at https://www.nms.ac.uk/media/1150306/fusiliers-museum-ir.pdf, accessed on 2 July 2019. This document states that RFM.ARC.2082 and RFM. 1149.1 have all the same images; this is in fact not entirely the case, though there is significant duplication.
84 Harris makes a similar point, noting that some photograph albums show men before and after campaign service on the Tibet Mission as a testament of survival. Harris, *Photography and Tibet*, pp. 64–5.
85 The Fusilier Museum, RFM.ARC.2082 (hereafter RFM.ARC.2082).
86 The captions which described Lhasa in terms of 'Piccadilly Circus' and 'Bond Street' in this collective album (RFM.ARC.2082) echo those found by Harris,

also associated with Claude White's panoramic photographs, in an unauthored Royal Fusiliers' album currently held by the National Army Museum. Harris, *Photography and Tibet*, pp. 61–2. The style of captioning echoes the rhetoric to be found in newspaper reports in the *Daily Mail* and *The Times* which likened the Potala to the Vatican, and was part of nineteenth-century writing about Tibet (see Harris, *Photography and Tibet*, pp. 61–2). This resonance is clearly visible in the newspaper clipping scrapbooks created by Bowen-Colthurst, Royal Ulster Rifles Museum, BELUR.AC.4505-H and BELUR.AC.4505-L (hereafter referred to as BELUR.AC.4505-H and BELUR.AC.4505-L respectively).

87 The Fusilier Museum, RFM.ARC.2081 (hereafter RFM.ARC.2081).
88 RFM.ARC.2081.
89 The Fusilier Museum, RFM.ARC.2089 (hereafter RFM.ARC.2089).
90 RFM.ARC.2089. See Kelleher, *1st Battalion Royal Fusiliers*, pp. 13–15.
91 RFM.1141.9, p. 6.
92 RFM.ARC.2082.
93 The number of miles marched daily by the Royal Irish Rifles is logged in the brief diary entries by Captain J.C Bowen-Colthurst at the front of one of his newspaper clipping books (BELUR.AC.4505-H). See also extracts from Corporal Percy Adam Coath's diary, The Fusilier Museum, RFM.ARC.2083.1 (hereafter RFM. ARC.2083.1) and 'The Fusilier Museum, Tower of London', *Material Encounters Catalogue*, RFM.ARC.2083.1. See also A. L. Hadow correspondence to his parents, The Royal Norfolk Regiment, Norwich Castle Museum, NWHRM 5069.10.
94 Iggulden, 'To Lhasa', pp. 659–79; Kelleher, *1st Battalion Royal Fusiliers*, p. 12.
95 Many of those officers in the formal group portrait received medals with and without clasp. Kelleher, *1st Battalion Royal Fusiliers*, p. 18.
96 The regiment changed its name from Royal Irish Rifles to Royal Ulster Rifles following Irish Independence in 1921.
97 The Royal Ulster Regiment Museum, BELUR.AC.957 (hereafter BELUR.AC.957).
98 RFM.1141.9, RFM.ARC.2081, RFM.ARC.2082 and RFM.ARC.2084.
99 Seemingly because the Fusiliers' Maxim gun team had not been fully trained to use pack animals. Kelleher, *1st Battalion Royal Fusiliers*, p. 3.
100 As Harris notes, this means that Claude White's photographs were widely available for inclusion in personal as well as public albums, *The Museum on the Roof of the World*, p. 106.
101 This is very similar to the album of Captain Julian Fisher (RFM.1141.9), which has five photographs to a page, and then features panoramic photographs. Through thirty-three pages of photographs, twenty-three have three panoramic views to a page. This disposition is also present in RFM.ARC.2082. Thus it appears to be somewhat of a convention to include the John Claude White views at the end.
102 Harris, *The Museum on the Roof of the World*, p. 106; Harris, *Photography and Tibet*, p. 62.
103 Iggulden, 'To Lhasa', p. 661.
104 Iggulden estimates 8000 porters and transport 'coolies' and more than 20,000 donkeys, yaks, ponies, mules and bullocks. Iggulden, 'To Lhasa', p. 677.
105 Argued by Kelleher on the basis that 'these taller better trained soldiers would overawe the Tibetans and that they would submit more readily to the daunting prospect of taking on seasoned campaigners.' Kelleher, *1st Battalion Royal Fusiliers*, p. 3.
106 BELUR.AC.4505-H.
107 J. W. Taylor, *Guilty but Insane: J. C. Bowen-Colthurst: Villain or Victim* (Cork: Mercier Press, 2016), p. 29.
108 The event commemorated by the Tibet Medal.
109 Kelleher, *1st Battalion Royal Fusiliers*, p. 5.
110 BELUR.AC.957.
111 Siliguri to Lhasa.
112 The Rifles saw their first action in Naini on their arrival in late June 1904. See Bowen-Colthurst diary in his newspaper clipping book (BELUR.AC.4505-H).
113 Such as anthrax and rinderpest. Iggulden, 'To Lhasa', p. 663.

114 It also reflects the progress recognised by the Tibet Medal which was awarded to those who served from Silgary (13 December 1903) to Lhasa (23 December 1904).

115 For example there is no implication of returning, which took from 28 September (when they left Lhasa) to 28 October 1904 for the Fusiliers and 3 November for the Riffles, Kelleher. *1st Battalion Royal Fusiliers*, p. 12; see also BELUR.AC.4505-H.

116 BELUR.AC.957.

117 BELUR.AC.957. A photograph recognisably taken on the same occasion (but not the same photograph) is published by Waddell in his memoirs captioned 'Parley with the Tibetan Generals before Guru'; see F. Younghusband, *India and Tibet* (London: John Murray, 1910) p. 154.

118 Younghusband, *India and Tibet*, p. 174.

119 Iggulden, 'To Lhasa', p. 668.

120 Younghusband, *India and Tibet*, p. 178.

121 The Royal Norfolk Regiment, Norwich Castle Museum, NWHRM 5069.10, Captain A. L. Hadow, letter to his father, 3 April 1904.

122 BELUR.AC.4505-H.

123 BELUR.AC.957. See Harris, *The Museum on the Roof of the World*, p. 52.

124 The Royal Norfolk Regiment, Norwich Castle Museum, NWHRM 5069.10, Captain A. L. Hadow, letter to his father, 6 April 1904.

125 The Royal Ulster Rifles Museum, BELUR.AC.4505-H.

126 Harris, *The Museum on the Roof of the World*, p. 105.

127 The photograph seems to illustrate the Bowen-Colthurst entry and shows bodies exposed for some time and stripped of all possessions. This photograph has different captions which may illustrate individual soldier's recollections and official interpretations; see RFM.ARC.2081, RFM.ARC.2083, and RFM.ARC.2084.

128 See also The Royal Norfolk Regiment, Norwich Castle Museum, NWHRM 5069.10, Captain A. L. Hadow letter to his father, 3 April 1904, where he mentions 'Guru' and the fact that the Tibetan forces 'put great faith in their charms to protect them from bullets'.

129 NMS, A.1905.355+A-B. Royal Museum Register of Specimens, Vol.10, 1903–1908. Harris notes that class and race clearly played into the transference of culpability for looting. Harris, *The Museum on the Roof of the World*, pp. 61–7.

130 Lieutenant Thomas De Beauvoir Carey's diary, RFM.ARC.1246, p. 40. See 'The Fusilier Museum, Tower of London', *Material Encounters Catalogue*.

131 Carrington systematically demonstrates how rationales and language in Waddell's account *Lhasa and Its Mysteries*, Percy Landon's *Lhasa* and Younghusband's *India and Tibet* were used to avoid the idea of dishonourable behaviour or lack of entitlement. Carrington, 'Officers, gentlemen and thieves', pp. 81–109.

132 Carrington, 'Officers, gentlemen and thieves', pp. 81–109.

133 Harris, in *The Museum on the Roof of the World* extensively discussions the issues relating to collecting in Tibet and should be referred to.

134 T. Myatt, 'Trinkets, Temples and Treasures: Tibetan Material Culture and the 1904 British Mission to Tibet', *Revue d'Etudes Tibétaines*, 21 (2011), 123–53; Myatt, 'Looting Tibet', pp. 61–70.

135 See Harris, *The Museum on the Roof of the World*, pp. 53, 58–61.

136 Carrington, 'Officers, gentlemen and thieves', p. 101.

137 See https://hansard.parliament.uk/Commons/1904-07-28/debates/d698cb09-59af-44d7-b6a6-2b2f70d9ca83/TheMissionToTibet, accessed 27 July 2019.

138 See parliamentary questions by Philip Stanhope to the Secretary of State for India 10 August 1904 https://hansard.parliament.uk/Commons/1904-08-10/debates/da7ded08-84ef-435e-9fb2-3337e9309a1a/AllegedLootingByTibetExpeditionaryForce, accessed 27 July 2019.

139 Harris, *The Museum on the Roof of the World*, pp. 58–63.

140 Carrington, 'Officers, gentlemen and thieves', pp. 89 and 106. See Harris, *The Museum on the Roof of the World*, pp. 61–7, p. 129. The Royal Geographical Society has the photographic album compiled by Lieutenant G. I. Davys, which Harris describes in more detail. In this album are two images of flogging by British

Indian Army of other soldiers. Flogging was the penalty inflicted for looting. Royal Geographical Society, F005/01593.

141 BELUR.AC.4505-H.

142 BELUR.AC.4505-H.

143 Harris, *The Museum on the Roof of the World*, Chapter 2, as well as Myatt, 'Looting Tibet', pp. 66–7.

144 There are sixty-two letters. See Royal Norfolk Regiment Collection, NWHRM.5069.10. See Harris, *The Museum on the Roof of the World*, for details of Hadow's collecting and activities.

145 For details of collections and display, and correspondence see 'Royal Norfolk Regiment, Norwich Castle', *Material Encounters Catalogue*.

146 Writing from Gyantse on 12 July 1904, Lieutenant Thomas De Beauvoir Carey notes to an undisclosed recipient 'I am sending you some things which I snaffled.' See extracts from Lieutenant Thomas De Beauvoir Carey's diary, RFM.ARC.1246, p. 32 in 'The Fusilier Museum, Tower of London', *Material Encounters Catalogue*.

147 See extracts from Lieutenant Thomas De Beauvoir Carey's diary, RFM.ARC.1246, p. 40 in 'The Fusilier Museum, Tower of London', *Material Encounters Catalogue*; see also Corporal Percy Adams Coath diary, RFM.ARC.2083.1. Coath provides no account of taking anything in Tibet, while commenting extensively on vegetation and, unusually, beauty.

148 See Harris, *The Museum on the Roof of the World*, for details of Waddel's collecting activities.

149 Carrington, 'Officers, gentlemen and thieves', pp. 102–4 and Captain A. L. Hadow's letter to his mother dated 18 April 1904 from Camp Gyantse, Tibet. See 'Royal Norfolk Regiment, Norwich Castle', *Material Encounters Catalogue*; see also extracts from Lieutenant Thomas De Beauvoir Carey's diary, RFM.ARC.1246 in 'The Fusiliers Museum, Tower of London', *Material Encounters Catalogue*.

150 See especially Myatt, 'Looting Tibet', pp. 61–70, who chronicles Tibetan interpretation of the looting of estates.

151 Kelleher, *1st Battalion Royal Fusiliers*, p. 5, RFM.ARC.2.093.

152 See for example, BELUR.AC.4505-H.

153 The Royal Norfolk Regiment Collection, NWHRM.3058.

154 As reported in newspaper articles such as 'The British withdrawal from Tibet: curiosities of the Campaign', *Illustrated London News* (15 October 1904), p. 545; 'Curio-hunting in Lhasa', from Edmund Candler, 'British Officers Find Little to Buy', *Daily Mail* (21 September 1904), p. 5; found in Bowen-Colthurst newspaper clipping book, BELUR.AC.4505-H and referred to by Corporal Percy Adam Coath, 14 August 1904, RFM.ARC.2083.1. See also Harris, *The Museum on the Roof of the World*, pp. 68–70.

155 See extracts from Lieutenant Thomas De Beauvoir Carey's diary, RFM.ARC.1246, p. 84 in 'The Fusilier Museum, Tower of London', *Material Encounters Catalogue*.

156 Only three images of markets exist in the 446 images in the Rifles collective album. Such paucity of presence of such photographs is also reflected in Lieutenant G. I. Davys' compiled album in the Royal Geographical Society, F005/01593.

157 See also Harris, *The Museum on the Roof of the World*, p. 72, for a photograph of officer's mess in Ambala.

158 Colour Sergeant J. Lyle donated a necklace and earrings from an unlocated monastery to the Royal Ulster Rifles Museum, BELUR.ARC.769.

159 R. Barthes, *Camera Lucida* (London: William Collins, Sons & Co, 1989), p. 89.

160 Quoted from Lopez, *The Prisoners of Shangri-la*, p. 40.

161 Harris notes that the album compiled by Lieutenant C. J. Davys held by the Royal Geographic Society has eleven fellow officers' photographs integrated with those of Jean Claude White with alternative interpretations. Harris, *Photography and Tibet*, p. 62.

162 Harris, *The Museum on the Roof of the World*, p. 106; Harris, *Photography and Tibet*, p. 62.

CHAPTER SEVEN

A regimental culture of collecting

Desmond Thomas

At a glance, the dearth of research that exists today in relation to regimental museums in the UK, and their collecting practices, is rather surprising given that the collections they hold represent a sizeable portion of the UK's military history and heritage. Due to the role of the various corps and regiments in the conquest, garrisoning and establishment of the British Empire, their collections house many objects which demonstrate, at least partially, the material culture of Britain's imperial and foreign policies from the seventeenth century onwards. However, the lack of scholarship on what are clearly important historical collections is explained partly by the way in which these museums were originally established and staffed. Regiments and corps are the largest permanent organisational units in the British Army and are the basic building blocks upon which it has been built. Most soldiers typically serve in a single regiment or corps for the duration of their career and come to see these units as their military family.

Until the 1880s regiments and corps had no geographical foothold and were constantly on the move around the world. As a result of this itinerant lifestyle it was important to retain objects that embodied the regiment's achievements as they promoted a sense of both identity and continuity. These collections were originally formed for the regiments and corps themselves with little thought given to their value for anyone outside the British Army.

In the late nineteenth century collections began to be moved into regimental museums that did allow, in varying degrees, public access, but there was no underlying philanthropic objective behind their development. Poorly funded during their early years, it was only in the 1950s that they began to receive official funding from the War Office, which was later continued by the Ministry of Defence.[1] British Army regimental collections are typically housed in small standalone museums,

and in this are quite unlike equivalent naval collections, which are centralised and now managed by the National Museum of the Royal Navy, reflecting the more homogenous structure of the Royal Navy itself. For much of their history regimental museum curators have predominantly been former military officers, usually male, who were instinctively interested in promoting the history, traditions and glory, as they perceived it to be, of their particular regiment. Typically staffed by those with a military background, and largely dependent on funding from the Ministry of Defence, the museums were unsurprisingly internally focused. Their collections were generally sorted and displayed by campaign, and the interpretation, if attempted at all, assumed the visitor had a pre-existing knowledge of the British Army and its seemingly endless nomenclature and jargon, which encompasses everything from headdress to weaponry.

Since the late 1980s there has been a gradual shift away from this approach. Regimental museums have made an effort to interpret their collections in a manner that engages with broader audiences while simultaneously increasing their engagement with the wider museum community. Perhaps most important of all has been the growing tendency by regimental museums, particularly within the past decade, to employ museum professionals to curate and manage their collections. These developments have been prompted by a variety of reasons including, but not limited to, threats to funding, generational shifts in popular attitudes towards imperialism, and the fact that less and less of the population have served, or even know people who have served, in the British Army. This lack of familiarity and personal connection has undoubtedly contributed to an increase in the public's perception of British military culture as a potentially esoteric and obsolescent subject, and one out of keeping with the drama and sensationalism of popular military history that is a staple of our television screens and bookshelves. Coinciding with all of this, and despite lingering suspicion in mainstream academic circles, has been the growing acceptance since the 1980s of military history as a bona fide academic discipline, which has helped encourage a fresh examination of these unique and important collections.

Surprisingly little has been written on the collecting practices of regimental museums. In consequence much of the opinion offered in this chapter will be based on the author's personal experiences as a curator working with Scottish regimental collections. The Museum of The Royal Regiment of Scotland was established in 2013 and is currently co-located with the Royal Scots Museum in Edinburgh Castle. It is the youngest regimental museum in Scotland and with a similarly young, and active, regiment to collect for, it is very much focused on

collecting contemporary and near-contemporary material. In this chapter, the collecting practices of this museum will be examined and where possible compared with a selection of more established regimental museums within Scotland. It will examine how the collecting practices of a newly established regimental museum compare to those of its famous forebears. This comparison will help to contextualise older regimental collections to explore how they were assembled and to propose how and why certain objects might have been acquired. Finally, it will consider the challenges that come with collecting contemporary regimental material.

The Royal Regiment of Scotland

On 28 March 2006, the Royal Regiment of Scotland was formed following the amalgamation of the six remaining, and much venerated, Scottish infantry regiments as part of a wider reorganisation effort by the Army to tackle issues related to operational capabilities, infrastructure and recruitment.[2] However, there was a constituency of opinion in Scotland that was outraged at what was seen as a calculated attempt by the then Labour government to eradicate the historic Scottish regiments.[3] The resultant indignation appeared to demonstrate an expression of Scottish national sentiment that crossed the political divide and was more meaningful than a simple show of support by the communities possessing links with the endangered regiments.

The amalgamation and disbandment of regiments has been a regular occurrence throughout the history of the British Army but the popular opposition in Scotland to such moves has always appeared more noticeable. For example, when the amalgamation of the Royal Scots Fusiliers and Highland Light Infantry was proposed in 1957 crowds of at least 20,000 gathered to protest on the streets of Glasgow. Similarly when the disbandment of the Argyll and Sutherland Highlanders was announced in 1968, a 'Save the Argylls' campaign was organised and a petition, supposedly bearing one million signatures, against its disbandment was delivered to Westminster.[4] The levels of active opposition that had been seen during the 1950s and 1960s had decidedly lessened by the time the most recent amalgamation was announced in 2004, yet it still appeared more pronounced in Scotland than elsewhere in the UK.[5] The formation of the Royal Regiment of Scotland also took place at a time when Britain was heavily committed militarily in both Iraq and Afghanistan. In light of operational commitments the act of establishing a regimental museum was given low priority and did not occur until 2013. As a consequence of this, the collecting that took place during what would prove to be the regiment's most operationally active period

to date was conducted with no curatorial input. This situation was certainly not unusual from a historical perspective. Indeed, the majority of objects that currently reside in the various Scottish regimental museums today were collected well before these museums were formally established.

Establishment and development

Collecting by members of the British Army (hereafter Army) likely began almost as soon as the first regiments were formed during the seventeenth century. Very little material from this early period survives in regimental collections today as no obvious repositories, outwith private homes, existed for such objects at that time. The officers' mess (as described in Kirke and Hartwell, Chapter 5) became an established feature in the landscape of regimental life during the eighteenth century and was a dedicated room or space where officers could eat and socialise together.[6] Over time objects associated with significant events and personalities in the regiment's history were accumulated and typically displayed in these locations, making them an important intermediary in the development of regimental museums.[7] The displayed objects would often have a small plaque or inscription explaining their significance, although sometimes senior members of the officers' mess would pass down the associated story orally to those joining the regiment. Such objects would include those meant for actual use within the mess and those meant purely for decorative purposes.

The hierarchy of value applied to these different things lay in the importance the regiment instilled in them, how they reflected important individuals and acts and how each object was located in the wider narrative about the regiment.

> The physical objects with which soldiers surrounded themselves are multifunctional. Superficially, a piece of silver in the Officers' Mess may be a drinking cup, a tunic may be an article of clothing, and the sign reading 'Corunna Road' may indicate a street running through a military installation. Once removed from literal function, the thistles and 'XCIII' engraved on the cup, the cut of the tunic and its blue facings, and the knowledge of the Retreat to Corunna bring an intimacy and importance of far greater value than the simple objects.[8]

The items in an officers' mess are, in physical terms at least, a snapshot of the regiment's history and heritage. Messes for non-commissioned officers also existed but there was little discernible difference in the types of material they held and displayed. For those that serve in a particular corps or regiment that unit often becomes their military family. This sense of family can also be quite literal with

the practice of sons following their fathers into the same corps or regiment being a regular occurrence. Being surrounded by material culture that reinforced this sense of continuity was therefore extremely important. The display and use of objects as described in the quote above not only served to encourage an *esprit de corps* and act as inspiration to those who viewed them, but also provided an opportunity for newcomers to learn the history of the regiment.

Surrounded by such material new members of the regiment understood that they were part of a unique organisation, with its own particular customs and traditions, and in times of war they would be expected to act in a manner that would uphold this corporate identity (see Kirke and Hartwell, Chapter 5). In the late nineteenth century, following the Childers Reforms, infantry regiments were assigned geographically defined recruitment areas and began to base their regimental depots in those locations. These depots housed displays of objects reflecting the history and heritage of their respective regiments and it was not long before former members of the regiment and their families began donating significant quantities of material to them. The displays in these depots fostered a distinctive identity that typically focused on heroic deeds and, where possible, links with the locality in order to inspire and attract potential recruits. Even today a regiment's identity and legacy play an important role in the choice of regiment made by potential officers and recruits.[9]

It would be from these early depot displays that future regimental museums would eventually emerge in the twentieth century. The progression from depot display to regimental museum varied greatly depending on regiment and corps. Yet the primary reason for establishing them was undoubtedly a dawning realisation by the regiments themselves that something had to be done with the collections that had been accrued. They contained items that were too important, in the value system of the regimental family, and in some cases too valuable in monetary terms, to be left to the vagaries of mess life and could not simply be disposed of or left to deteriorate.

The Royal Engineers are believed to have established the first regimental museum in the UK in 1875, but most regimental museums did not appear until the early twentieth century.[10] Their widespread establishment in the aftermath of the First World War was likely a reaction to the profound effect that conflict had on the Army in general and the feeling that permanent repositories should be formed to house what was increasingly being viewed as material of wider historical importance. Despite this, even by the 1930s many of the museums were either not open to the general public or had very restricted opening times.[11] Conscription was introduced in Britain during the First World

War, and was in place during the majority of that conflict and for the entirety of the Second World War before finally ending in 1960. Recruitment figures, therefore, had not been a pressing concern for the Army for quite some time but gradually had to be addressed in the wake of independence movements in countries in Asia and Africa with a change in British position on the world stage. The 1957 White Paper on Defence, written by the then Minister of Defence, Duncan Sandys, proposed a number of sweeping changes to the British armed forces in order to meet economic, international and military requirements.[12] Shortly after publishing the paper Sandys revealed to the Chancellor of the Exchequer at the time that the biggest threat to its success was fulfilling the necessary manpower requirements.[13] It is conceivable, therefore, that as the Army sought ways of attracting sufficient numbers of potential recruits to join up during this crucial Cold War period, regimental museums were once again perceived as venues that might prove helpful in attracting sufficient numbers of recruits.

During the late 1980s and early 1990s a number of articles highlighting issues of interpretation within regimental museums, their lack of relevance and their future direction began appearing in the *Museums Journal* and other sector publications. The more forward-looking regimental museums appeared to take notice and began introducing appropriate changes, attempting to reinterpret displays in a manner that was more accessible and provided more context, an approach that strongly echoed the developments in social history museums at the time.[14] Since then, like most museums, regimental museums have tried to do their best within the constraints of limited staff and funding. However, in more recent times a threat to regimental museums more dangerous than poor interpretation and perceived lack of relevance has emerged on the horizon: the ultimate removal of their main source of funding.

Under increasing pressure to reduce spending, the Ministry of Defence took the decision to cease funding certain regimental museums, beginning in 2017 with further tranches of cuts planned for 2022 and 2030.[15] These cuts were aimed at those museums that represented regiments or corps that will have been disbanded for decades by the time the cuts are implemented. When one takes into account that the funding provided by the Ministry of Defence pays for what is typically the only full-time member of staff, it becomes clear that the impact of this change has the potential to be fatal for those museums that have been targeted. While this move demonstrates that the Ministry of Defence is no longer willing to sustain museums of regiments that no longer exist for the sake of mere sentiment, this government department clearly continues to place value in the museums of those regiments that are still active.

This probably reflects the Army's continuing belief that regimental and corps museums still form part of their 'ecosystem', by offering a public showcase for the regiments and a way to directly and indirectly contribute to recruitment in a positive manner. Despite this, one suspects that regimental museums have not actually had much influence on encouraging young people to join the Army for many decades, and anyone who becomes a soldier after visiting a regimental or corps museum probably intended to follow that particular career path anyway. Nonetheless, it should be noted that the Ministry of Defence does not own these collections. Typically they are the property of regimental trustees, quite independent from the formal Army structure, and the Ministry of Defence has no direct influence over how they are displayed or interpreted. The threat to funding has understandably forced many regimental museums to closely examine their existing revenue streams and consider ways in which to survive in the long term. Those that have been most proactive have tended to take a more businesslike approach to running their museums while simultaneously reinterpreting their collections. In some cases this has meant refurbishing their entire museums in order to increase footfall and associated income. It is unclear at this point how the majority of regimental museums who are no longer linked to active regiments will fare in the longer term. However, it is difficult to see how many of them will be able to continue to operate.

Visitors to regimental museums can essentially be sorted into three distinctive groups: serving and former members of the regiment or military, visitors who possess specialist knowledge of military history and, finally, members of the general public who have little or no knowledge of military history or the British Army. Visitor data is not readily accessible, making it difficult to determine with confidence the percentage breakdown of overall visitors into each category, but it is readily observable that the majority of visitors to regimental museums today generally fall into the third category. This has been a gradual but continuing trend, and the traditional focus of regimental museums on the first two groups has changed in tandem. The task for military museums has been to find the right interpretative balance that engages with visitors of all knowledge levels. Anecdotal evidence would suggest that members of the regimental/military fraternity, as well as those with specialist knowledge, increasingly feel that the direction many regimental and military museums have taken in recent years has resulted in an approach that in their view is not only 'dumbed down' and 'politically correct' but focuses too much on educational activities aimed at school-age children. Interpretation must constantly evolve to meet the demands and expectations of visitors, and while regimental museums will always

value visitors with specialist knowledge they can no longer exclusively cater to what now represents a small proportion of their overall audience. Nonetheless, efforts to achieve a balance, and avoid alienating core visitor and stakeholder groups, can be controversial, as the National Army Museum, which tells the story of the Army from the British Civil Wars to the present, discovered when it reopened in 2017 following a major refurbishment (see also Massie, Chapter 10).[16]

Understanding how visitors to museums respond to the displays is difficult to ascertain in the absence of systematic surveys. However, a cursory examination of online reviews, increasingly considered valuable as an indicator of museum enjoyment, shows that visitors to the Royal Scots Museum and the Museum of The Royal Regiment of Scotland enjoy their visits (finding it 'interesting' and 'informative') even if some visitors fail to differentiate between displays in other parts of Edinburgh Castle with what they see in the aforementioned museums.

Despite the generally more progressive interpretive approach to be found in many regimental museums today they continue to display the same types of objects they have traditionally used to represent enduringly important themes of valour, identity, tradition and honour. Weapons, uniforms, medals, insignia, silverware, equipment and fine and decorative art are, and will continue to be, an intrinsic part of regimental material culture. Regimental collections are fundamentally about achievement and within them trophies, as an indicator of actual or perceived success, will always have a higher place in the hierarchy of value. Throughout recorded history, warriors in Western culture have placed value on the shattered spears and shields of their foes. In classical Greece such items were often presented as part of the battlefield trophy (a monument to commemorate a victory) and used in local temples and shrines.[17] Psychologically these trophies are perceived as the physical embodiment of victory over one's enemy. Furthermore, objects touched by war often project a special aura.[18] They are captivating and are often presented as evidence that this particular regiment met the enemy on the battlefield, overcame that test and achieved honour, individually and collectively, while carrying out its duty for sovereign and country.

One salient example of such an object would be the Napoleonic imperial eagle, part of a French infantry standard, captured[19] at the Battle of Waterloo, which is currently displayed in the Royal Scots Dragoon Guards Museum in Edinburgh Castle. Following the victory at Waterloo this battlefield trophy was adopted as a talisman by the regiment and in 1838 was incorporated into their cap badge, a distinguishing and important piece of regimental insignia, thus becoming an integral part of the regiment's corporate identity.[20] Upon

visiting any regimental museum one can find multiple variations of these types of object on display. The business of trophy taking, appropriation of the property of the enemy, is widespread in the culture of warfare, and was far from exclusive to the context of colonial warfare.

Regimental collecting today: a personal perspective

The Museum of The Royal Regiment of Scotland was established in July 2013, seven years after the formation of the regiment, and a little over a month later I found myself employed as its first curator. With previous experience of working with the collections of the National War Museum of Scotland, Royal Scots Museum and Gordon Highlanders Museum respectively I possessed a reasonable understanding of Scottish military collections, particularly those relating to the historic antecedent regiments. However, all of that previous experience had been with well-established collections and this new post was an entirely different proposition, given that I would effectively be developing the collection from scratch. Questions of where does one begin and how does one prioritise were uppermost, but it was an exhilarating if slightly daunting task that lay before me.

The regimental heritage officer (also my line manager) was in the process of putting a collecting policy together when I started. Although not consulted on its content, I felt confident in the direction our collecting should take given my previous encounters with regimental collections in Scotland. This might suggest a conscious desire to simply recreate a regimental collection that mirrored all the others but I do not believe that to be the case. The paraphernalia worn and used by regiments, while carrying out both peacekeeping and wartime duties, can possess a distinct similarity despite changing military tactics and technology. The purpose of regimental museums is to collect objects associated with the regiment's activities and the collection that forms over time should reflect that particular path through history, regardless of similarities that may exist elsewhere.

In the early period of the museum's life there was some confusion, or perhaps a suspicion, within the Scottish antecedent regimental museum community that it might attempt to collect pre-2006 objects that related to their respective regiments. This was never a consideration and the focus, therefore, was very much on items used from the formation of the regiment on 28 March 2006 onwards. There were, however, resonances from the past. For example, several Second World War-era British weapons that had been captured, or 're-captured' from the Taliban in Afghanistan were added to the collection, as curiosities and with a sense of a 'lost' object redeemed. More prosaically, antecedent regiment dress and

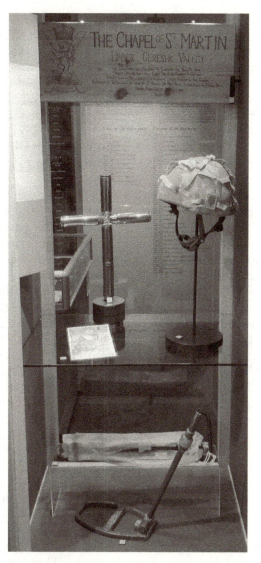

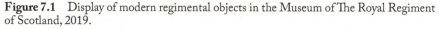

Figure 7.1 Display of modern regimental objects in the Museum of The Royal Regiment of Scotland, 2019.

accoutrements are still worn by members of the pipes and drums in each battalion of the new regiment, making them legitimate collecting categories for the museum as they now also form part of the Royal Regiment of Scotland's history. The boundaries and scope of what the museum should, and should not, collect therefore seemed relatively clear.

Although the Royal Regiment of Scotland was formed only in 2006, in the short period of time since it has been exceptionally active, seeing service in Iraq, Afghanistan, Northern Ireland, Cyprus, Bosnia, Sierra Leone and numerous countries around the world. However, the majority of the regiment's operational service to date has been in Afghanistan. The prolonged intensity of fighting and associated difficulties faced by the Army in Afghanistan have undoubtedly made it the defining campaign of the early twenty-first century, requiring it to change and adapt quickly to new equipment and tactics while compelling it to understand the important historical and cultural complexities of military operations in such a country.

The Royal Regiment of Scotland has received numerous operational awards for the gallantry and professionalism its officers and soldiers have displayed there, but not without cost to its personnel. Of the twenty-two members of the regiment who have lost their lives on active service to the end of 2019, twenty of those were as a result of operations in Afghanistan. This is a campaign that has an importance and resonance for the regiment unmatched by any other. Given the prominent place the war in Afghanistan has had in the regiment's operational life it is unsurprising that much of the current collection relates to its participation in this war. Indeed, 40 per cent of the existing collection (which totals approximately 600 objects) relates to Operation Herrick, the code name for British operations in Afghanistan between 2002 and 2014. It is my understanding that the museum holds one of the largest collections of Afghanistan war-related material in the UK. The collection consists of the usual regimental memorabilia: uniforms, weapons, insignia, equipment, flags, signs and maps used by members of the regiment, coalition forces (including the Afghan National Army and Afghan National Police) and the Taliban. However, it also contains some unusual items like a traditional civilian Afghan coat[21] that will be discussed below and even some bunches of plastic flowers,[22] gifted to a Royal Regiment of Scotland officer by members of the Afghan National Army during a handover ceremony.

The majority of Taliban-related items in the collection are captured weapons, which are typically Soviet in origin. Their practical application aside, these Soviet weapons would have possessed similar symbolism and prestige as war trophies among their Taliban owners, who presumably obtained many of them during the Soviet–Afghan War of 1979–89. Objects such as these have always found their way to regimental collections because, as trophies, they strongly embody the defeat of one's enemy. Nevertheless, it should be noted that the rules and regulations surrounding the acquisition of enemy material by members of the British armed forces have tightened over the last forty

years, possibly in response to UNESCO conventions against the trafficking and moving of cultural property and certainly in relation to UK firearms legislation and gun crime awareness.[23] Where once it might have been deemed acceptable for soldiers to take a firearm obtained on operational service back home in their backpack as a personal trophy, this is now strictly prohibited and, if attempted, apprehended soldiers face severe punishment.[24] While concerns about trophy weapons are most acute in relation to gun control and the reputational risk associated with the importation of unlicensed firearms into the UK, the ramifications are wider. Before units leave operational theatres they are required to have their vehicles and baggage searched for any prohibited items, captured or otherwise, by the Royal Military Police in a process officially referred to as Operation Plunder. It has been made clear to members of the British armed forces in official Defence Instructions and Notices, not publicly available but in common with international humanitarian law, that only military items related to the enemy are to be taken from operational areas and that private property or items that could be viewed as having historical, cultural or religious significance should not be removed under any circumstances. With such strict regulations in place it is difficult for the regiments themselves to bring back items that historically they would have acquired and transported with ease.

The Ministry of Defence are aware of the desire by regiments and their associated museums to make acquisitions related to campaigns that they have participated in. In an effort to meet this demand they have arranged for what is officially termed 'operational memorabilia' captured in Iraq and Afghanistan to be pooled and brought back to the UK, and for invited regiments to submit claims for items they desire. The Gordon Highlanders Museum in Aberdeen, for example, acquired the head from a large statue of Saddam Hussein that had been toppled in Basra in 2003 via this method. Interestingly, a member of museum staff claimed this object for the Gordon Highlanders Museum despite being aware that it lacked a particular connection to the regiment. The museum displayed it twice, once in 2004 and again in 2013, and on both occasions it was presented as a curio rather than a piece of Gordon Highlanders heritage. The regiment served in Iraq during the First Gulf War of 1990–91 and later, following amalgamation, in 2005–6 as part of Operation Telic, the code name for British operations there in 2003–11. However, the impromptu nature of how it was acquired, and the manner in which it was subsequently displayed, does not suggest any attempt to commemorate either experience.

The Museum of The Royal Regiment of Scotland obtained a slightly less imposing object in the form of a deactivated rocket-propelled

grenade (RPG) launcher from a similar stockpile of operational memorabilia in 2013. Apart from being recorded that it had been captured from the Taliban in Afghanistan there was no additional information provided. The specific provenance of regimental objects is extremely important, and those items that lack such direct association are considered as being of lesser value. That point was overlooked in relation to the RPG launcher because it was important for the museum to acquire an example that could illustrate one of the primary weapons used by the Taliban in Afghanistan. Not long after this acquisition, another RPG launcher that had been captured by a member of the regiment made its way to the museum. This example now has a greater value within the collection simply due to this tangible regimental link. In addition to enemy items the museum has battle-damaged objects worn and used by members of the regiment, such as a helmet struck by an RPG[25] and a Vallon mine detector partially destroyed by an IED (Improvised Explosives Device) explosion,[26] which are good examples of the archetypal objects commonly encountered in older, more established, regimental collections (Figure 7.1).

For a curator responsible for a modern and contemporary regimental collection, it is always interesting to compare our collection with historic ones, especially those held in Scotland. One object which one might not expect to find in a regimental collection is a distinctly coloured, traditional Afghan coat known as a *chapan* (Figure 7.2). An officer of the regiment was presented with this coat as a token of thanks from Afghan soldiers he had been responsible for training. This *chapan* was noted as being almost identical in appearance to a type often worn for official purposes by Hamid Karzai, the President of Afghanistan between December 2001 and September 2014. A photograph discovered online shows captured members of the Taliban wearing very similar examples, so this item obviously has several interesting contextual associations, being representative of the regiment's involvement in the campaign.

On receipt in the museum, its appearance brought to mind an article of clothing held in the Royal Highland Fusiliers Museum in Glasgow, which was categorised not as Afghan but Burmese and which was apparently obtained during the late nineteenth century.[27] Unfortunately, accession records have not survived and nothing is known about the precise circumstances in which it was obtained. Reflecting on what is known of the circumstances surrounding the acquisition of the Afghan *chapan* informed speculation about how such an object might come to reside in a regimental collection. Had the Burmese robe also been presented in a similar act of gratitude, had it been purchased, or had it, as a commonplace assumption about the nature of military collections

Figure 7.2 Traditional Afghan *chapan* coat gifted to a Royal Regiment of Scotland officer in 2011.

might suggest, been taken by force? It is likely that we will not be able to prove things either way.

Japanese items from the Second World War and Zulu items from the Anglo-Zulu War held in the Argyll and Sutherland Highlanders Museum in Stirling Castle are similarly reminiscent of Taliban items held in the Royal Regiment of Scotland collection. A Taliban flag and AK-47 assault rifle share a certain affinity with a surrendered Japanese sword and a Zulu spear. This is not simply due to the nature of their original function but also due to what they symbolise: physical representations of enemies that had the same terms of reference applied to them. The term 'savages' was used to describe both the Zulu[28] and Japanese[29] by British soldiers who had fought them, primarily expressed in relation to the manner in which they treated prisoners, the wounded and the dead. Yet simultaneously these enemies were begrudgingly respected for their doggedness and bravery as warriors on the battlefield. Having spoken to numerous British veterans of the war in Afghanistan

I have been left in no doubt that the Taliban were often viewed in a similar manner.

In recent years there have been greater levels of attention directed towards material in regimental collections deemed to have problematic provenance. A frequently used term is 'loot' but it is probably necessary to consider the use of this word because it is often incorrectly applied (see Lidchi and Allan, Introduction, as well as Lidchi, Afterword). Loot is asserted to have entered the English language, via the Army, in the late eighteenth century and has its origins in *lut*, a Hindustani word for robbery or plunder.[30] The current Oxford Dictionary definition of loot is *private*[31] property taken from an enemy in war. Arguably, from a military perspective, non-private property or, more specifically, property with a clear military application or association taken from an enemy in war cannot be labelled as loot and should, from the perspective of this regimental curator, be considered a legitimate war trophy. The French imperial eagle standard captured during the Battle of Waterloo mentioned previously is a war trophy that was obtained under circumstances that would likely still be considered legitimate by the current international rules of war. Sergeant Charles Ewart of the Scots Greys captured it when he engaged, and subsequently killed, a number of French cavalry and infantry soldiers, one of whom was carrying the eagle. This eagle was one of nearly 100 personally presented by Napoleon Bonaparte to his army in 1815, and each soldier was expected to defend it fiercely as it was a symbol of both the French emperor himself and of their unit identity. Conversely, a small silver filigree box[32] that was actually engraved on the base 'Loot from Lucknow, March 1858' and currently resides in the Black Watch Museum in Perth is arguably not, by modern standards, a legitimate war trophy, being private property ostensibly taken by a Scottish soldier during the Indian Uprising for its monetary value. I stress modern standards because it is important to note that before rules surrounding enemy property were formally codified in The Hague Conventions of 1899[33] and 1907[34] and the Geneva Convention of 1949,[35] items that we might now consider loot were viewed as acquisitions conforming to the legal standards at the time (even if many now perceive these as self-serving colonial legal constructs). Making the nuances of this controversial topic even more difficult for regimental museums to navigate is the presence of foreign non-military items, often viewed as 'exotic' because they did not conform to notions of the usual, in regimental collections, which were acquired either through gift or purchase. The Royal Scots Museum in Edinburgh Castle, for example, possesses a Chinese silk and wood screen[36] in their collection but very little was known about how it was acquired. The Royal Scots served in China

during the Second Opium War when the buildings of Yuanmingyuan, also known as the 'Old Summer Palace', were looted and burned to the ground in what must rank as one of the more ignominious acts of the Army during the nineteenth century (see Tythacott, Chapter 8). It was reasonable to suspect that the screen was one of the many items in British museums looted from Yuanmingyuan, and this had been the museum's long-standing assumption.

Wishing to interrogate that assumption, the museum contacted a specialist in Chinese material culture, who was invited to inspect the screen. The specialist's conclusion, based on an assessment of quality, was that it was unlikely to have been taken from Yuanmingyuan and that it was instead the type of item likely to have been sold to the Royal Scots officer, who had donated it to the museum, by a local merchant. This straightforward example underlines the need for further provenance research on this type of material in order for us to avoid making assumptions and to be better able to understand and catalogue our collections correctly.

The British armed forces today adhere to the rules governing the capture of enemy material during conflict as set out in the aforementioned international legal conventions. The rigorous rules and regulations that surround the collecting of operational memorabilia have undoubtedly had an impact on the collecting culture and practices of the modern soldier. Strong deterrents are in place for any breaches of military regulations; however, the same can be said for those sanctions on drug taking and other breaches of military regulations, yet those offences still occur on a reasonably frequent basis. Why then would collecting transgressions be any different?

It is difficult to know for certain what has brought about the change, but in addition to the clear directives and physical checks conducted (introduced under an initiative designated 'Operation Plunder'), it appears there is a marked increase in the awareness of unfavourable public perceptions by the ordinary soldier and as a result there is an increase in self-sanction for collecting in a manner that might reflect poorly not just on the Army but, even worse, given the hierarchies of loyalty typical in British military culture, on their own corps or regiment. This is certainly supported by the complete absence of anything that could be defined as loot being offered to the Museum of The Royal Regiment of Scotland since its establishment, even though it is not impossible that in the future such histories might be found. It is interesting to note that in early 2019 an American soldier faced investigation for allegedly looting items in 2009 from the Maiwand battlefield in Afghanistan.[37] Maiwand was the site of one of the principal battles of the Second Anglo-Afghan War in 1880 and a major British

defeat. While the disturbing and robbing of graves carries heightened sensitivity in its own right, the attention giving to the looting of British graves from a former British military incursion into Afghanistan was not without its ironies. Such acts, however, appear to be rare.

Challenges of modern regimental collecting

One issue that immediately became obvious in the early days of the Museum of The Royal Regiment of Scotland, during the sorting of the collections, was the lack of provenance that accompanied much of the material. The regiment had accumulated objects in the period before the museum had been established but these had not been examined or reviewed since. Some items had hastily scribbled Post-it notes attached to them containing useful details but the vast majority lacked any sort of documentation at all. This did not appear to be a deliberate eradication of provenance but more a case of members of the regiment simply not understanding the importance of either recording or communicating this information. Currently, when objects are donated there is a clear procedure in place so that all the details pertaining to provenance can be captured, but unfortunately this was not implemented before the establishment of the museum.

Researching the provenance of these early donated items has been a time-consuming and often frustrating task. Occasionally an object had an associated name, or a ZAP number, the Army personal identification number made from the first two letters of soldiers' surnames and the last four digits of their Army number, from which it was then often possible to identify the individual and contact them for further information. The provenance of many objects within the collection has been established in this manner.

The problems of provenance very much include the lack of it and this is commonly experienced with many of the historic collections in regimental museums. Establishing provenance, especially for the non-European material in these collections, can completely change future perceptions of items. Objects acquired 100 years ago or more, which some might now suspect of having been acquired under dubious circumstances, may have actually been obtained in unremarkable, and ethically sound, situations. However, without that all-important provenance we will always be left unsure. Undoubtedly there are non-military objects currently residing in older regimental collections that were taken at gunpoint but the misuse and application of a loaded word like 'loot' can be unhelpful. We should, I believe, exercise great caution before jumping to conclusions when discussing these items, and much research that is sensitive to the mores and terminology of the Army is still required.

In the early days in post it was difficult to identify and contact the correct person or persons within the regiment that might have been able to supply the museum with a particular object or piece of information we were seeking. This reflected a certain disconnect between an active regiment and its regimental museum, and in general, during this early period at least, that certainly seemed to be the case. Sometimes progress would be made with members of the regiment that I was able to meet, and pester, while they passed through regimental headquarters on official business. However, the communication, and by extension the relationship, between the museum and the regiment greatly improved in 2015 with the appointment of a heritage officer on the headquarters staff, a career soldier who had served in the regiment, retiring as a lieutenant-colonel. It was through his vast network of contacts and his understanding of the importance of collecting a range of objects representing the different activities and heritage of the regiment that we were able to acquire a greater number of objects for the collection. For the civilian curator, entry into this type of informal network is not a given.

Many of the objects that entered into the collection through this network are mass-produced and seemingly 'ordinary' items lacking craftsmanship, technical complexity or age, and have little or no monetary value. Their significance lies purely in their associations with experiences by the regiment and those that have served in it. Items such as portraits, colours and standards, silverware and medals are much more difficult to acquire, not specifically due to their monetary value but because they are used in day-to-day regimental life, which takes precedence over museum desires, and are therefore off limits, at least for the time being. These items will likely be offered to the museum in the future but for the time being patience must be exercised. It has been the author's observation that many officers and soldiers struggle to understand which objects might be interesting to the museum. More specifically, they often fail to see the potential historic value that a mass-produced piece of clothing or equipment with provenance has. Typically it is only if an item has suffered battle damage that they appreciate its value, but even this does not guarantee the object will be retained or offered to the museum.

In 2013 a Royal Regiment of Scotland officer was conducting a foot patrol in Afghanistan when he inadvertently stood on an IED. Thankfully the officer in question survived the incident although he did suffer a serious injury to this foot. The museum only learned of the event when a photograph of the officer's blast-damaged boot was featured in the regimental journal the following year. My immediate response was to track down the officer involved and enquire about the

whereabouts of the boot. Unfortunately, the individual informed us that although soldiers from his section had retained the boot following the incident and displayed it on a flag pole as an unusual good luck charm, a senior officer later noticed it contained some blood and ordered it to be thrown in a fire pit and destroyed.

IEDs are synonymous with the wars in Iraq and Afghanistan, and this blast-damaged boot would have been a unique addition to the collection. It represented not just a near-deadly incident experienced by a member of the regiment, but it also said something about the nature and tactics of the war itself. This unique item could have greatly contributed to the collection, and it was unfortunate to have missed the opportunity to include it, though no fault can be assigned to the officer or his troops for the oversight given its history. They were operating in a war zone, where life and death hung in the balance daily, so collecting items for the regimental museum could not have been high on their list of priorities. The 'loss' of this boot, and it was considered a loss to regimental heritage, highlighted the need for the museum to try and engage in a more meaningful way with members of the regiment in order to advocate for the museum and inform them as to what type of objects it would be interested in collecting. There followed a concerted effort to engage with the serving battalions (regimental sub-units of between 500 and 1000 soldiers), but with the increasingly hectic nature of modern military life the message will probably take time to permeate. It is probable that in the time before the existence of regimental museums many interesting and valuable objects were lost due to the officers and soldiers not realising their potential heritage value at the time.

A common difficulty many curators of contemporary collections experience is deciding what seemingly 'ordinary' modern items are worthy of collecting. One item that was offered to the museum and which I considered carefully before accessioning it, despite the direct regimental link, was a simple clear plastic water bottle[38] that had been used by a Royal Regiment of Scotland soldier in Afghanistan. Materially, this object is little different from millions of similar water bottles disposed of around the world on a daily basis. However, this particular water bottle represented a distinctive military story and merited retention in the collection.

A little-known fact about the war in Afghanistan is that the Ministry of Defence built a large water-bottling plant in Camp Bastion, one of the UK's main military bases in Afghanistan during the war, in order to supply coalition forces with fresh water. The bottles were both produced and filled on location, which saved the Ministry of Defence a considerable amount of money and prevented serious logistical difficulties.[39] With that contextual knowledge added and recorded, a simple

plastic bottle has the potential to help document and represent to museum visitors one of the practical logistical issues the Army faced while operating in a challenging environment such as Afghanistan, and I felt it should be added to the collection. This is very likely to be one of the few remaining examples bottled at Camp Bastion and in time will be a historically significant object.

Given the proximity in time to the recent wars in Iraq and Afghanistan, the museum has had to employ heightened sensitivity when displaying and interpreting particular objects related to these two conflicts. Recent displays of medals and other objects relating to a Royal Regiment of Scotland soldier who had been killed in Afghanistan involved close consultation with his widow, who had loaned us the objects, to ensure that she was content with the text accompanying the display. The commemorative function of a regimental museum is part of its reason for being, and this responsibility for a living regiment can be uniquely acute. The direct memory of earlier conflicts may fade with time, even if the commemorative aspect of displaying material is something all regimental museums tacitly view as important to regimental identity. However, in contemporary collecting, where the presence of death, injury and memory are so near at hand, close collaboration with lenders and donors is essential in order to build and safeguard trust, not just with the individual but also with the wider regimental family.

Conclusion

One way to approach the contemporary responsibility of collecting is to acquire effectively modern versions of objects in existing collections.[40] While I think it possible that curators may sometimes use historic collections as a reference point of sorts, curators of regimental museums are generally inclined to collect the material culture that reveal the activities, achievements and uniqueness of their particular regiment. How wars are fought, and the technology and tactics used to fight them, constantly changes and evolves, but as long as regiments go to war they will continue to generate and collect objects that represent similar themes of valour, identity, tradition and honour. Nevertheless, the types of objects collected by regiments, both historic and active, have not differed much over time. Both contemporary and historic regimental collections contain items that reflect the various activities of regimental life, albeit with a heavy focus on those related to battlefield activity and achievement. Where the contemporary regimental collection does differ, however, is on the subject of material that could be broadly defined as loot. The culture of collecting within the modern Army has fundamentally shifted, with tougher policing of memorabilia

acquisition at source, as well as a higher awareness among soldiers themselves of the negative publicity revelations of such activity would attract. Even in the unlikely scenario that an object that could be classified as loot managed to slip through the Ministry of Defence's own policing measures and was offered to a museum, it would almost certainly not be accepted.

The majority of regimental museums tend to be rather reactive in their collecting given that, for the most part, they already have sizeable collections and a steady stream of material continues to be offered to them on a regular basis, especially from the mass conflicts of the two world wars of the twentieth century. However, a regimental museum that specifically collects contemporary material has neither, and as a result must adopt a more proactive collecting approach. In time, as former members of the Royal Regiment of Scotland grow old and pass away, it is likely that the amount of material offered to our museum by former soldiers and their descendants will increase significantly, but in the meantime we cannot remain passive and must instead seek every opportunity to make additions to the collection when the opportunities arise.

The curator of a museum that has a relationship with an active regiment possesses an obvious advantage over curators of older regimental collections. This is because, given the right conditions, they are in the enviable position of being able to contact a person who can provide them with the precise context and detailed provenance information of an object almost instantly.

> If the whole purpose of collecting, traditionally, was to preserve the past, then the whole purpose of contemporary collecting is to preserve the present for the future.[41]

Although the above does, I believe, have some resonance for the curator of a contemporary collection, at present the Museum of The Royal Regiment of Scotland rarely, if ever, receives what might be considered 'historic' enquiries from members of the public.

Our archive contains numerous video interviews, digital photographs and other types of material that with the passage of time will be considered an important historical resource. The recent wars in Iraq and Afghanistan have been largely unpopular with the general public, have cost many lives and have achieved little in the way of apparent, quantifiable signs of success. As a result, they are destined to receive the close attention of historians and academics in the years and decades to come. Our collection and archive will hopefully assist researchers in understanding not just the overall British military role and strategy in these two conflicts but, perhaps more importantly, also connect with

the human experience of those individuals who fought in these wars on the ground. These particular objects' contexts, and how they are viewed, will likely change over time, but hopefully they will remain part of collections that continue to be valued and studied.

Notes

1 P. Thwaites, *Presenting Arms: Museum Representation of British Military History, 1660–1900* (London: Leicester University Press, 1996), pp. 46–7.
2 'Delivering Security in a Changing World: Defence White Paper', Ministry of Defence (December 2003), https://webarchive.nationalarchives.gov.uk/20121018172935/http://www.mod.uk/NR/rdonlyres/051AF365-0A97-4550-99C0-4D87D7C95DED/0/cm6041I_whitepaper2003.pdf, accessed 24 August 2018.
3 'Protest over merger of regiments', British Broadcasting Corporation, 18 December 2004, http://news.bbc.co.uk/1/hi/scotland/4106465.stm, accessed 30 October 2018.
4 S. Allan, 'Beating Retreat: the Scottish Military Tradition in Decline', in B. S. Glass and J. Mackenzie (eds), *Scotland, Empire and Decolonisation in the Twentieth Century* (Manchester: Manchester University Press, 2015), pp. 131–54 (p. 142).
5 A. Irwin, 'Reflections on the Scottish Military Experience', in E. M. Spiers, J. A. Crang and M. J. Strickland (eds), *A Military History of Scotland* (Edinburgh: Edinburgh University Press, 2014), pp. 795–812 (p. 806).
6 R. J. Dickinson, *Officers' Mess: Life and Customs in the Regiments* (Tunbridge Wells: Midas Books, 1977), p. 1.
7 P. Thwaites, *Presenting Arms: Museum Representation of British Military History, 1660–1900* (London: Leicester University Press, 1996), p. 149.
8 I. S. Kelly, *Echoes of Success: Identity and the Highland Regiments* (Leiden: Brill, 2015), p. 169.
9 S. K. Kayß, 'Regimental Traditions and Army Reputation', *Wavell Room*, August 2018, https://wavellroom.com/2018/08/14/traditions-and-army-reputation, accessed 25 October 2018.
10 Thwaites, *Presenting Arms*, pp. 29–30.
11 *Ibid.*, p. 158.
12 'Defence: Outline of Future Policy', Ministry of Defence, March 1957, http://filestore.nationalarchives.gov.uk/pdfs/small/cab-129-86-c-57-69-19.pdf, accessed 10 May 2019.
13 D. French, *Army, Empire, and Cold War: The British Army and Military Policy, 1945–1971* (Oxford: Oxford University Press, 2012), p. 172.
14 S. Wilkinson and I. Hughes, 'Soldiering on', *Museums Journal*, 91:11 (1991), 23–8 (p. 23).
15 G. K. Adams, 'Regimental museums prepare for MOD cuts', *Museums Association*, January 2016, www.museumsassociation.org/museums-journal/news/11012016-regimental-museums-prepare-for-mod-cuts, accessed 5 December 2018.
16 'The newly refurbished National Army Museum is full of inaccuracies and post-colonial guilt', *The Spectator*, June 2017, https://www.spectator.co.uk/2017/06/the-newly-refurbished-national-army-museum-is-full-of-inaccuracies-and-post-colonial-guilt, accessed 25 October 2019.
17 V. D. Hanson, *The Western Way of War: Infantry Battle in Classical Greece* (New York; London: Oxford University Press, 1990), p. 204.
18 S. Allan, 'Scottish Military Collections', in E. M. Spiers, J. A. Crang and Matthew J. Strickland (eds) *A Military History of Scotland* (Edinburgh: Edinburgh University Press, 2014), pp. 776–94 (p. 792).
19 Royal Scots Dragoon Guards Museum, 21214.
20 H. G. Parkyn, *Shoulder-Belt Plates and Buttons* (Aldershot: Naval & Military Press, 1956), p. 24.

21 Museum of the Royal Regiment of Scotland, SCOTS.2013.089.
22 Museum of the Royal Regiment of Scotland, SCOTS.2013.088.
23 UNESCO, *Protection of Cultural Property: Military Manual* (France: UNESCO Publishing, 2016).
24 'Former SAS soldier jailed over trophy pistol', *Forces Net*, April 2016, https://www.forces.net/news/tri-service/former-sas-soldier-jailed-over-trophy-pistol, accessed 30 November 2018.
25 Museum of the Royal Regiment of Scotland, SCOTS.2015.050.
26 Museum of the Royal Regiment of Scotland, SCOTS.2016.109.
27 Royal Highland Fusiliers Museum, 2019/80.
28 F. Emery, *The Red Soldier: Letters from the Zulu War* (London: Hodder and Stoughton, 1977), p. 235.
29 J. Thompson, *Forgotten Voices of Burma: The Second World War's Forgotten Conflict* (London: Ebury, 2009), p. 241.
30 R. Holmes, *Sahib: The British Soldier in India* (London: Harper Collins, 2005), p. 274.
31 Emphasis added.
32 Black Watch Museum, A212.1.
33 'Laws of War: Laws and Customs of War on Land (Hague II)', Yale Law School, 29 July 1899, https://avalon.law.yale.edu/19th_century/hague02.asp, accessed 10 May 2019.
34 'Laws of War: Laws and Customs of War on Land (Hague IV)', Yale Law School, 18 October 1907, https://avalon.law.yale.edu/20th_century/hague04.asp, accessed 10 May 2019.
35 'Geneva Convention for the Amelioration of the Condition of the Wounded and Sick in Armed Forces in the Field', International Committee of the Red Cross, 12 August 1949, https://www.icrc.org/en/doc/assets/files/publications/icrc-002-0173.pdf, accessed 1 June 2019.
36 Royal Scots Museum, EDNRS.3946.
37 'UK Accuses US Soldiers of Stealing Remnants of Historic Battle in Afghanistan', *Asharq Al-Awsat*, February 2019, https://aawsat.com/english/home/article/1609991/uk-accuses-us-soldiers-stealing-remnants-historic-battle-afghanistan, accessed 31 March 2019.
38 Museum of the Royal Regiment of Scotland, SCOTS.2016.064.
39 I. Carr, 'Supplying troops in Helmand with water', *UK Government*, 27 January 2011, www.gov.uk/government/news/supplying-troops-in-helmand-with-water, accessed 4 January 2019.
40 O. Rhys, *Contemporary Collecting: Theory and Practice* (Edinburgh: MuseumsEtc, 2012), p. 21.
41 *Ibid.*, p. 23.

Part III

The afterlives of military collections

CHAPTER EIGHT

Military histories of 'Summer Palace' objects from China in military museums in the United Kingdom[1]

Louise Tythacott

Between 7 and 9 October 1860, British and French troops looted buildings in the Yuanmingyuan, known by foreigners as the 'Summer Palace' (now the Old Summer Palace), to the north of Beijing. Ten days later, British soldiers set fire to the entire site, under the direct orders of the British High Commissioner to China, Lord Elgin (1811–63). The immediate trigger was the torture, in some cases to death, of several dozen prisoners, both British and Indian army troops, by the Chinese.[2] It took two days and over 4,800 men to incinerate the numerous buildings[3] – a destruction widely criticised in the West, most notably by the French writer Victor Hugo.[4]

The Yuanmingyuan was the main residence of the Qing imperial family. Initiated in 1709 by the Kangxi Emperor (r. 1662–1722), it was developed over the following century by his son and grandson, the Yongzheng (r. 1722–35) and Qianlong (r. 1736–95) emperors respectively. Spanning an area of three and a half square kilometres, the Yuanmingyuan included lakes, ponds, streams, canals, gorges, fountains, artificial hills and classical gardens.[5] There were forty acres (approximately 16 ha) of structures and hundreds of buildings – palaces, temples, shrines, pagodas, galleries, audience halls, libraries, theatres, model farms, a maze, mosque, aviary and market street – all built to the highest standards demanded by the imperial court.[6] The Yuanmingyuan also accommodated one of the finest art collections in the world: according to Thomas, had it survived, 'it would easily rival the Louvre as a global tourist attraction of world heritage'.[7] Today authorities in Beijing estimate that 1.5 million objects were looted from the Yuanmingyuan, and that many of these are now scattered around the world, in private collections and public museums.[8] This chapter focuses on objects taken from this palace in 1860, subsequently presented by officers to their regimental messes and now on display in five military

museums in the UK – the Royal Engineers, the Royal Marines, the Wardrobe, the Essex Regiment Museum and The Royal East Kent Regiment at the Beaney House of Art and Knowledge. It is concerned above all with the reformulations of the meanings of China's imperial objects at these specific sites of representation.

Military museums and 'trophies of war'

There are around 136 military museums in the UK,[9] one of the most numerous museum types, but one which has received relatively scant attention in the museological literature. The majority of these museums, as Jones notes, were set up from the 1920s onwards[10]: '[They] . . . were not formed to present war, but for the specific purpose of instilling and fostering in the regiment the *esprit de corps* which enables it to fight more effectively. The depiction of the past in regimental museums is required, therefore, to serve a powerful purpose.'[11]

A vital function of these museums, therefore, is to boost the *esprit de corps* or morale of a particular regiment. In this sense, regimental museums exist to promote a sense of identity, loyalty and shared history, and to inculcate into new recruits feelings of power and success. A recruit's attachment to their regiment – their rationale for going to war – is intended to be intensified upon viewing the collections. Through displaying the material culture of past campaigns, exhibitions are used to celebrate victories over the enemy: objects become emblematic of a regiment's triumph and conquest. Many military museums arrange their displays chronologically, by campaign, in order to clearly promote these messages. As Kirke notes, 'Regimental identity absorbs the object's meaning in a museum. Once an object is part of a regiment, it is very hard to break this. If taken away, it will damage the identity of the regiment. The idea that a looted object is not the regiment's is alien to the regiment . . . They are not loot, they are part of us now . . . There is a sense of a thread of history via objects . . . and identity via things.'[12] Objects function here, then, in very specific ways, as part of a wider military apparatus where material culture is harnessed to inculcate particular values.

One of the ways in which objects may be most effectively absorbed into the regiment's history is through repurposing. Previous uses may be erased and non-Western objects may be modified in order to forcefully assert, or overlay, Western military significance. At the Royal Artillery Museum in Woolwich, for example, are two guns believed to have been captured at the Dagu (known to the British as Taku) Forts during the Second Opium War, which supplied the metal to be melted down and reformed into Victoria Crosses, the highest British military decoration

for gallantry.[13] What better way to assert complete domination over an enemy in war?[14] Western inscriptions are also attached to Yuanmingyuan objects in order to underscore their military interpretations.

Yuanmingyuan objects on display in military museums may be conceptualised as trophies of war, a mode of collecting fundamentally characterised by power. As Hill argues, 'trophies . . . are objects onto which have been projected the social relations of mastery and domination'.[15] Yuanmingyuan loot, reconfigured as trophies, thus represents a regiment's pride in a victorious campaign. Objects here operate as metaphors for feelings of superiority. Classen and Howes write of collected artefacts as 'material signs of victory over their former owners and places of origin'.[16] Hevia refers to looted objects from the Yuanmingyuan as 'emblems of humiliation'.[17] Along with power is a sense of prestige inherent in this mode of collecting.[18] Indeed one of the characteristics of trophy collections is their triumphant display: 'The trophy simultaneously expressed victory, ownership, control and dominion. As such it has three qualities – it presents in material form, however incompletely, sets of practices; it triggers fantasies and memories; and it elicits admiration.'[19]

Military museums thus may be conceptualised as places which 'elicit admiration', or as shrines to war, where a regiment's most sacred objects are proudly on display. Jones notes how military collections are imbued with symbolism: 'Uniforms, colours, trophies and weapons, placed in displays . . . are vivid signifiers of those codes and activities which have informed soldiers' lives continuously for several hundred years and which still function in this respect today.'[20] Exhibitions of medals, he argues, reach 'to the heart of the role of the museum as the shrine of regimental tradition'.[21] Artefacts associated with Charles George Gordon, in particular, 'were revered almost as the relics of a saint'.[22] In a workshop on military collecting in 2013, Charles Kirke referred to a Zulu shield, obtained by a soldier who received the Victoria Cross, as 'sacred'.[23] It is the object's association with the highest military decoration in the West which renders it significant, rather than any previous, indigenous associations. The original meanings of non-Western objects in military museums are thus suppressed – or emphasised only when used to calibrate the heroism of the regiment in defeating the enemy.[24] The value of imperial Yuanmingyuan loot in these museums, therefore, is its ability to attest to the strength of a regiment in conquering the Chinese.

Yuanmingyuan material on display in military museums is used in general to tell a consistent story – as material proof of British superiority over the Chinese.[25] Concepts of multi-vocality or dialogic approaches apparent in other museums are rarely evident,[26] and there

is little engagement with the post-colonial critiques of collecting practices and debates around the ethics of acquisitions and restitution, which have influenced many other museum displays since the 1990s.[27]

The Royal Engineers Museum: religion and relics

The largest collection of material from the 'Summer Palace' in a UK military museum is located at the Royal Engineers Museum in Chatham, associated with the most famous 'sapper' of the nineteenth century, General Charles George Gordon (1833–85). Moving to its current location in 1986, the museum exists today to 'preserve and teach the history of the Corps of Royal Engineers'.[28] In the first gallery devoted to 'Early Engineers' are several large cases which exhibit Chinese objects.[29] The introductory text panel is entitled 'War in China, 1839–1901':

> During the 19th century the vast and decaying Chinese empire became an object of European trade rivalries and missionary activities. Britain was involved in three China Wars between 1839 and 1901.

> It was the British who first tried to open up China to opium exports and in 1840 required the East India Company to provide troops from India to enforce the trade. A consequence of that was the British acquisition of Hong Kong as a base in 1842 from which business could be conducted [. . .]

> When Britain tried to extend her trade a further military expedition in conjunction with the French was sent to Beijing in 1860 to force the Chinese government into acceptance. Royal Engineers proved invaluable in it by quickly reducing Chinese fortifications such as the Taku Forts that guarded Beijing.

While Britain is celebrated as the key country to initiate trade, China is characterised here in negative terms. There is no mention of the morality of the trade in drugs or the fact of its devastation on the Chinese population.

A large case devoted to Summer Palace loot dominates this gallery, the material having been taken by three Royal Engineers – Charles George Gordon, Lieutenant-Colonel E V Thompson and Lieutenant Richard Harrison (1837–1931) (Figure 8.1). The text panel is entitled 'The Second China War 1859–60 and the Destruction of the Summer Palace':

> In 1860 the Chinese emperor's Summer Palace near Peking (now Beijing) was destroyed by the Anglo-French expeditionary force. The order for the palace to be destroyed was in reaction to the ill treatment of hostages who had been held there. Controversially during this destruction a large number of objects were looted. The Summer Palace which was known as the Yuanmingyuan, or Garden of Perfect Brilliance, had been the

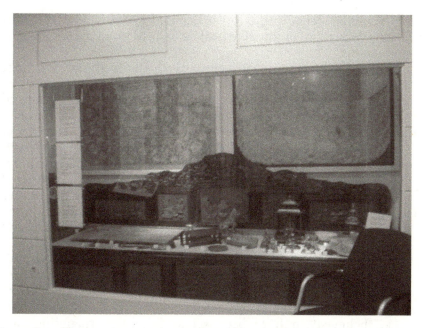

Figure 8.1 Photograph of display case with 'Summer Palace' loot, Royal Engineers Museum c. 2011.

favourite summer residence of the imperial court since the early 1700s and was part of an elaborate complex of gardens.

The destruction of the Yuanmingyuan is justified here on the basis of the 'cruel treatment of hostages', yet the looting is, nevertheless, acknowledged to be 'controversial'. There are inaccuracies in the text, however: the Yuanmingyuan was not a 'summer residence' but the main home of the Chinese imperial family; it was not destroyed by British *and* French, but by the British alone; and it has recently been disputed whether the hostages were actually kept there.[30]

Over thirty objects from China are on display, the largest of which is an imperial throne, acquired by Gordon and donated to his military headquarters.[31] The label for this reads 'Bench made from carved panels ... The rear sections are from a square imperial throne, while the front and end panels are of two further designs. The bench was presented to the Royal Engineers Officers' Mess by Gordon in the 1860s, where it remained until loaned to the Royal Engineers Museum in 1991.' Indeed, Hevia described it in 1987 in a central alcove of the officers' mess, when permission was required to view it in the barracks.[32] In its original location in a throne room in the Summer Palace,[33] it was reserved

for the emperor alone. In the Royal Engineers Museum today it has been transformed into a museological device – a stand used to display the objects.

Behind the throne, attached vertically to the wall, are two large cushion covers, 'from a throne in the Summer Palace' – one, taken by Lieutenant Richard Harrison at the 'sacking of the Palace', embroidered with an imperial five-clawed dragon;[34] the other, looted by Gordon, with bats around a lotus flower.[35] A volume of prints, 'Engravings of military campaigns of China's borders, brought to China by the Jesuit, Giuseppe Castiglione in the eighteenth century' and appropriated from the Yuanmingyuan by Harrison, is placed, opened, on the left-hand side of the throne. In the centre are two roof tiles from the Summer Palace: one in the form of a *qilin*, a mythical beast; the other, yellow glazed, noted as 'reserved for Imperial buildings'. On the right-hand side is a lotus shaped bowl 'cut from a single piece of jade', and given by Gordon to a 'brother officer' and 'likely to have been taken by him from the Summer Palace'.[36] The green roof tile and the jade bowl are also illustrated on a museum leaflet.[37]

A range of small metal Buddhist deity figures, placed on the throne, are also 'believed' to have been taken from the Yuanmingyuan: Amitayus, a deity of long life in a 'Chinese pagoda';[38] Cintamani Tara, 'a female deity, fifteenth or sixteenth century'; another Amitayus, 'probably eighteenth century.'[39] Harrison, in particular, had an interest in Buddhist images: Vaishravana, god of wealth; Tara, 'a female deity of long life'; 'the Protector', 'identified with the Emperor'; Dralha, 'god of war'.[40] Lady Harrison was able to gift Buddhist-related objects too: miniature coffins; Manchu beads, 'based on a Buddhist rosary'; an incense burning clock; a Buddhist libation cup 'made from a human skull'; a gilt bronze bell dated 1714, 'probably used for ceremonial occasions within the Summer Palace and imperial temples'.[41] No information is provided to justify this focus on religious things, yet it is evident that such small, portable and high value artefacts would have been attractive and easy for soldiers to remove.[42] These Buddhist items would clearly have been viewed by the British soldiers without reverence.[43] Deity figures thus function here, not in an atmosphere of reverence, as they would have been in the original temples, but rather as relics,[44] obtained by heroic men, and as trophies of the perceived superiority of one belief system over another.

The Royal Marines Museum: debased objects

The Officers' Mess of the Royal Marines Barracks in Portsmouth, built in 1867–68, was transformed into the Royal Marines Museum in 1975.[45]

The displays, which span three floors of the imposing building, are organised chronologically, from the early beginnings in 1664 to the present.[46] The Chinese objects are exhibited in an area devoted to the 'Opium Wars 1840–1900 and Crimea 1854–1865'. The text panel on 'China and the Opium War' reads 'China':

> By the 18th century China had the oldest and largest empire in the world. The Chinese treated all other states as inferior and considered all Europeans as barbarians. Only a few ports were open to foreign trade and while British traders wanted tea and silk, the Chinese had no need of British goods.
>
> The British were frustrated and the two empires clashed in what became known as the Opium War.

While this text characterises China as arrogant, in fact, as Ringmar has argued, it was the Europeans who perceived the Chinese as the 'barbarians' in the nineteenth century.[47]

Another text panel, 'The Opium War', even justifies drug usage:

> Opium was a commonly used drug in Victorian England. Doctors prescribed it for a variety of ailments ranging from toothache to hayfever and flu. Children were raised on it as a sedative medicine. The poet Coleridge, the composer Berlioz, and the anti-slavery crusader, William Wilberforce, all used the drug.
>
> The trade in opium was enormous and worth millions of pounds. The British Empire had the monopoly on the world's cultivation and export of opium. Although the Chinese had made opium taking illegal, the British encouraged addiction to create a new trade with China. In 1839, the emperor banned all trade in opium and punished it by death, which the British found intolerable and declared war.
>
> The Royal Navy and Royal Marines were involved in attacks on Chinese towns, forts and strong points during the 3 year war. The result was the defeat of China and the beginning of the end of their empire's power. Britain acquired Hong Kong and became master of the Far East.
>
> Further tensions led to a second war in 1856 with greater Royal Marine involvement and the capture of Peking.

A Buddha statue and a pair of cloisonné vases from the Summer Palace are displayed in the section on the 'Opium Wars and Boxer Rebellion'. The bronze Buddha figure is possibly eighteenth century, seated cross-legged on a lotus throne, its hands held close to the chest in a pose known as *dharmachackra mudra*. It is flanked by two *gu*-shaped cloisonné vases, probably dating to the late eighteenth century, with flanges on each corner throughout. The label in the display reads

'Chinese vases and a Buddha captured from the Emperor of China's Summer Palace, the *Yuen Ming Yuen* by Lieutenants Walter and Barker of the RMLI Battalion on 8 October 1860, towards the end of the Second China War'. Hevia has discussed the significance of objects associated with the Emperor of China,[48] and 'the use of the definite article "the" for those objects where a substantive link was drawn between these things and imperial sovereignty'.[49] The emperor's name and dates of his reign, however – Xianfeng (r. 1850–61) – are not included in this label, representing him as anonymous and ahistorical. While an exact date is specified for the collection (or 'capture') of the objects, their period of manufacture is omitted, portraying China as a timeless culture.[50]

The three imperial objects sit beneath everyday Chinese things taken during later campaigns. On the shelf above them is an opium pipe and finger extensions. Tiny embroidered shoes for bound feet are attached to the wall, just below a knife and chopsticks in a bamboo scabbard. Originally, a pigtail made of human hair was on display, though only the label remains.[51] Exhibited together, these items produce an image of Chinese culture associated with drugs, exoticism and cruelty – reducing the country to negative stereotypes. The Buddha looks strange placed low down on the base of the case. In terms of Buddhist practices this posturing is inappropriate: Buddhas should always be elevated, with their heads above human heads, not placed close to the floor, which is considered unclean. In front of the Buddha is a China medal – '1857–1860' – a placement which stamps the aura of military trophy on to these three beautifully crafted objects. Their proximity to a war medal signifies their role as artefacts of subjugation, although as noted within the same workshop in 2013 (see Endnote 23), this was reported as consistent with a military value system which would place medals higher within military regimes of value. Nevertheless, for the non-military viewer they appear debased, literally, through their low position, and the medal reminds us of the violent mechanism that transported them to Portsmouth, and their out-of-place and decontextualised display.

The Wardrobe: an imperial robe and five vases

The Wardrobe Museum in Salisbury Cathedral Close was originally built in the thirteenth century as a store house for the Bishop's documents and clothes. The regiment acquired the building in 1979, and opened a museum in 1981.[52] Today the Wardrobe holds the collection relating to the infantry regiments of Berkshire and Wiltshire from 1748. It is arranged in four ground-floor rooms and displayed chronologically, from the early beginnings to the present day.[53] In the

second gallery can be found a robe and five pieces of porcelain from the Yuanmingyuan, the property of the 99th Regiment of Foot, in a case on 'Crimea and Opium Wars'. Of the text panels inside the case, one of them – 'Oriental legacy' – has the sub-heading, 'From Calcutta to Pekin': '[T]he British and French forces . . . plundered the treasures of the Emperor's Summer Palace, which was set in pleasure gardens with panoramic views. The articles removed by the British officers were auctioned for about £30,000. The proceeds were split, one third to the officers and two thirds to the men . . . '

Another A4 text panel, placed in front of the Chinese ceramics in the case, is devoted to the 'Chinese Dragon Robe, Qing dynasty (1644–1911)'. The first and last paragraph state the following:

> In 1860, the 99th regiment . . . took part in an expedition to China and participated in the Second 'Opium War' and the 'sacking of Peking'. The robe was taken from the Imperial Summer Palace by the regiment which was under the command of Captain Henry Ely. The Chinese embroidered silk dragon robe from the Qing dynasty once belonged to the Emperor of China –Tao Kwang. It would have been worn as part of the 'auspicious' or semi-formal attire typically for celebratory occasions [. . .]

> In 1856, the Second Opium War began and ended, with the Chinese being defeated once more. As a result, they were forced to sign the Treaty of Tientsin, and the sale of opium was legalised. The British claimed that the Chinese people had a 'right' to this 'harmless luxury' without regard to its own government. Opium imports increased in unprecedented levels. By the end of the nineteenth century, an estimated quarter of the male population of China was addicted to the enhanced opium.

The robe is clearly perceived to be one of the most important objects in the Wardrobe's collection. Embroidered on yellow silk, a colour reserved for the emperor and key members of the imperial household, it is a *longpao*, or dragon robe, worn as part of *jifu* or festive dress, for semi-formal occasions, with five-clawed dragons, stripes at the bottom representing water and the Twelve Symbols.[54] Eight dragons are visible and a ninth is under the flap which fastens over the right-hand side. A photograph of the textile, with the five vases, is advertised on the sign-board in the grounds outside the building; the caption reads 'Why do we have a Chinese Emperor's Robe?' This image is also reproduced on the front cover of the main museum leaflet. *The Wardrobe Military Museum Textile Trail Catalogue*, which was produced in association with the National Association of Decorative & Fine Arts Societies (NADFAS), however, contests the gender attribution, by arguing that the robe belonged to an 'empress' instead.[55] An A4 page in their cata-logue is entirely devoted to its symbolism and design: 'The presence of

some of the imperial symbols in this particular grouping together with the colour of the silk and the longevity symbol design makes it likely that the robe would have been made for the empress dowager' (NADFAS). The two conflicting gender interpretations are not evident in the gallery, however, for all references in the museum displays are to the emperor. It is clear that this is not a garment of the highest quality: it is incomplete – lacking cuffs and sleeve extenders – and has an inappropriately high collar. According to Hill, it may never have been used, for it is 'seamed incorrectly and finished with a Nehru collar and barrel cuffs', leading her to speculate that Ely took an 'unfinished robe', 'tailored later for display'.[56]

Five porcelain vases in the case were also taken at the sacking of the Yuanmingyuan – three tripod censors with Qianlong reign marks and two large *hu* vases with Daoguang (r. 1821–50) marks,[57] the latter with inscriptions indicating they were 'reverently offered' to 'His Majesty The Emperor Tao-Kwang by his Chancellor, Chu Lin, in 1830'. Hill posits that the two *hu* vases, enamelled with the 'One Hundred Horses' theme in the style of the Jesuit Castiglione (1688–1766), may have 'appealed to soldiers due to the Western style of composition'.[58] An A4 translation of the ode on the two *hu* is typed out in full and placed on the side of the case. The name of the translator – Wm. S. Fredk. Mayers, Secretary of the Legation in Beijing – is included, with location and exact date (Canton, 1 June 1861). While the Western details of translation and possession are meticulously recorded and displayed, the circumstances under which the vases became the property of the officers' mess are noted as 'uncertain' in the museum's documentation (28799). It is remarked upon too that the lids of the three tripod censors went missing when taken from the Yuanmingyuan and all five 'suffered over the following years from the battalion's travels'.[59]

Hevia talks of the 'theft and the redistribution' of objects from the Summer Palace as a 'process of subversion', made particularly more intense when objects 'could be tied directly to the person of the Qing emperor'.[60] The yellow robe may thus have had a particular aura for Captain Ely and the soldiers of the 99th, perceived as it was to have been worn by the 'untouchable' emperor: the two *hu* vases with Daoguang reign marks, as we have seen, also have documentation confirming their imperial connections. These objects thus function as trophies of the victory of the regiment in conquering, not just the Chinese, but the Chinese ruling elite.

Essex Regiment Museum: a cloisonné incense burner

A gallery devoted to the 44th (Essex Regiment) opened in January 2010 at the Chelmsford Museum.[61] According to the curator, the museum was

the first generation to move out from 'behind the wire' into local authority care.[62] Today Chelmsford Museum covers natural history, Roman Chelmsford and Chelmsford's industrial heritage. Located on the first floor and arranged chronologically, the Essex Regiment Museum tells the story of the regiment from its origins in 1741 through major campaigns.[63] On the far left-hand side of the gallery, and hidden from view as you approach, is a case devoted to 'Trophies of War', where the star object – an imposing cloisonné incense burner from the Yuanmingyuan – is proudly on display. A text panel nearby discusses 'Trophies':

> Regiments, like school, colleges and families, gather relics. Some are bought, others presented, and many taken in battle as plunder or loot . . . Valuable and sometimes of religious or ethnic importance, they were placed in the Officers' Mess . . . From 1873 each Regiment had a Depot where items were left to be seen by guests and shown to recruits to promote Regimental pride . . . These collections often became Regimental museums.

An extended text devoted to the Summer Palace, on laminated sheets in the gallery, reads as follows:

> The Yuanmingyuan Palace, built in 18th and early 19th century, was destroyed by English and French forces on 18th October 1860, in what is condemned as the greatest act of cultural vandalism in modern history . . . as the palace was explored, 'gold watches and small valuables were whipped up by these gentlemen with amazing velocity, and as speedily disappeared into their capacious pockets'. On Sunday morning, 7 October, orders against looting were withdrawn and English and French soldiers rushed around taking every valuable which they could carry. What could not be carried away was destroyed. Some amused themselves by shooting the chandeliers, other by playing pitch-and-toss against large mirrors, while some armed themselves with clubs and smashed to pieces everything too heavy to be carried, finishing by setting fire to the emperor's private residence.
>
> Lord Elgin ordered that the palaces should be levelled with the ground. The French refused to assist but Elgin was determined. Soon flames appeared above the devoted structures, and long columns of smoke rose to the sky, until the smoke hung like a vast storm-cloud over Peking.

Accurate and well-researched, this is the most detailed discussion of the looting of Yuanmingyuan in any military museum in the UK. The label for the cloisonné reads 'Chinese Cloisonné vase. Looted by British and French troops from the Chinese Emperor's Summer Palace at Peking during the Second China War. | The destruction of the Summer Palace is regarded as one of the greatest acts of cultural vandalism of modern times.'

[197]

Figure 8.2 Cloisonné incense burner on display as part of the formal dinner setting for a ball at Warley Barracks, 1899.

The cloisonné was acquired by Lieutenant Thomas Orton Howarth of the 44th Foot who was serving with the Chinese Coolie Corps.[64] It is gilded cloisonné, with a reticulated and gilded knop and lion mask legs, and it most likely dates to the reign of Jiaqing (r. 1796–1820). It sits within a wooden frame, a bell from Sevastopol suspended over it and a Burmese Buddha placed high on top. A detail of the cloisonné is prominently illustrated in the leaflet devoted to 'Museum Services'. Hook notes this as 'a starred item':[65] it has been proudly exhibited since it was looted in 1860. In the pre-2010 gallery, it was placed on a wooden stand made for the regiment in India, a mannequin with an officer's uniform next to it.[66] In 1955, it was photographed in Warley Barracks, some miles from Chelmsford. Here it can be seen on the floor surrounded by medals on the walls, weapons and regimental uniforms.[67] In 1899, the incense burner was also illustrated in a photograph of a ball held at the barracks. Placed on its stand, it is the centrepiece of a table display, flanked by plants, silverware and flowers, and behind, on the wall, is a depiction of officers of the regiment (Figure 8.2). Perhaps the most striking trophy image is a photograph in 1864 of the 'Mess Dining Room, Belgaum' in the state of Karnataka, India, only four years after the China campaign. Two rows of

soldiers are seated either side of a long dining table, with the cloisonné taking centre stage at the back. The Yuanmingyuan loot would have operated here as a poignant symbol of success in a war these officers would have known only too well.

The cloisonné censer thus has had a rich and well documented past with the 44th Essex Regiment over the last 150 years, but what of its future life? The curator noted, 'I have given consideration to the day when the Chinese ask for restitution of looted treasures. My own recommendation would be to cede ownership and ask for the loan of the item in order that the history of this period can be illustrated in this country at a local level'.[68] This extraordinarily fine piece of imperial Chinese workmanship may well have a fascinating future existence.

The Buffs: 'Heroes and Villains'

The collection of the Buffs (Royal East Kent Regiment) is housed within a local authority museum – the Beaney House of Art and Knowledge in Canterbury. Following a £14 million refurbishment, the displays opened in September 2012 – the collections of the Royal East Kent Regiment having been previously stored at the National Army Museum (NAM).[69] The ethos of the museum, expressed in 2012, was 'to enable people to explore, learn, participate, and create using the permanent collections, special exhibitions, community engagement programme and educational activities as inspiration'.[70] Moving away from the traditional museo-logical galleries based on nineteenth-century classifications, the spaces have been renamed: 'The Front Room', 'The Garden Room', 'Colour and Camouflage', 'People and Places', 'Material and Masters'. The experi-mental approach was evident throughout, as was an awareness of the latest trends in museological display.

On the first floor is 'The Study' which includes a large case – a 'Cabinet of Curiosities' – evoking the origins of the collections at the Canterbury Philosophical and Literary Institution, which opened in 1825. Yuanmingyuan objects are displayed in a large case in the gallery devoted to 'Explorers and Collectors'. The Royal East Kent Regiment (originally known as the 3rd Regiment of Foot) is one of the oldest in the British army, with origins dating back to 1572.[71] The text associated with the Opium Wars reads 'China, 1860': 'In 1859 Britain and France wished to impose a trade treaty on China, which would open all of the country the Western merchants and legalise the opium trade. When the Chinese refused to admit a delegation, and fired on the British fleet trying to sail up the Pei Ho River, a Franco-British army, which included the Buffs, was sent to impose the treaty by force'.[72]

While the Buffs were left to garrison the Dagu Forts on the northern approach to Beijing, an officer, Colonel Mark Walker, was attached to the General's staff, and travelled to the capital. The gallery label notes, 'Many beautiful items were lost or destroyed, but some were auctioned'. Colonel Walker bought a vase, and possibly a box at the auction in Beijing, both of which are on display in a case on the Royal East Kent Regiment.[73] The porcelain is a deep red, with a silver rim made by silversmiths Cook and Kelvey in Calcutta as early as 1860. On the lid is an inscription: '1860, looted at Pekin and presented to the mess of his regt. By Col. Walker V. C.' The brass box was noted as removed from Beijing in 1860 by Walker, and presented to the mess of his regiment.[74] An inscription in Arabic on the lid reads, 'Allhamdu Lillah' ('Praise to God'). Around the side of the box is a silver plate with a badly worn inscription identical to that of the vase: 'Looted at Pekin and presented to the mess of the Regt By Bv Lt Col Walker 1st Batt the Buffs'.[75]

We see here how the biographies of these objects have been marked and reconfigured through the Western inscriptions indelibly attached to them. During a presentation as part of a workshop on military collecting in 2013, this image was part of a discussion during which it was clear that those with a military background were looking at different inscriptions from those with an anthropological one, showing their specific orientations when it came to material cultures.

The case on the Buffs is in a gallery devoted to 'Explorers and Collectors', where Greek and Egyptian archaeological material is displayed alongside objects from Asia, Africa, India and South America, brought back by soldiers, missionaries and diplomats. Interestingly, this new gallery presents a nuanced approach to collecting by discussing collectors as *both* 'heroes' and 'villains'.[76]

Conclusion: 'liberated' objects

In tracing the histories of Summer Palace loot in the West, Hevia has noted how such objects gained new meaning in different sites, which 'embedded them more deeply in alien discourses'[77] – and perhaps we can argue that the Western military museum is the most 'alien' discourse of all. Over the past few decades the museological literature has discussed the complexity of meanings attached to material culture in different spheres of representation,[78] and this chapter has demonstrated how Chinese imperial treasures have become absorbed into the ideological frameworks of military organisations and their museums in very particular ways.[79] We have seen the transformations of the significance of these objects in these sites of museological representation, as they are clearly intended to be read in terms of narratives of conquest

and power. Some displays of Yuanmingyuan loot remain traditional in interpretation, with objects conceptualised as 'trophies of war', used to inform and induct regimental recruits. Text panels promote the right-eousness of the British attacking China and the looting of the imperial collections. Indeed, somewhat in passing a curator referred to Summer Palace objects as liberated by the regiment, rather than looted from China. Other redisplays, however, have problematised these acquisitions by presenting objects in exhibitions which are more reflexive and crit-ical of the circumstances of encounter. In doing so, they touch upon important – and timely – issues regarding the relationships between China and Britain in the mid- to late nineteenth century.

Acknowledgements

This chapter is part of a wider project documenting the representation of Yuanmingyuan material. I have benefited greatly from participating in a series of workshops in 2013, 'Hidden in plain sight: non-European collections in military culture', funded by the RSE and the NAM, and organised by Henrietta Lidchi and Stuart Allan. My thanks to all those who were involved in this event. I am also grateful to the participants at the conference, *Yuanmingyuan in Britain and France*, held at the University of Manchester in July 2013. I would like to thank the following for their help with the research: Richard Kirkby; Polly Marshall; Ken Tythacott; Amy Adams and James Scott (Royal Engineers); Anna Lebbell (Royal Marines); Ian Hook (Essex Regiment Museum); Alastair Massey, Emma Lefley and Julian Farrance (NAM); Craig Bowen (The Beaney House of Art and Knowledge).

Notes

1 This chapter was originally published as L. Tythacott, 'Trophies of war: representing "Summer Palace" loot in military museums in the UK', *Museum and Society*, 13:4 (2015), pp. 469–88.
2 J. Hevia, *English Lessons: The Pedagogy of Imperialism in Nineteenth-Century China* (Durham and Hong Kong: Duke University Press, 2003), pp. 47–8; E. Ringmar, *Liberal Barbarism: The European Destruction of the Palace of the Emperor of China* (New York: Palgrave Macmillan, 2013), p. 154.
3 Hevia, *English Lessons*, pp. 74, 107; Ringmar, *Liberal Barbarism*, p. 4.
4 V. Hugo, 'The Sack of the Summer Palace', letter to Captain William Butler, November 25, 1861 (repr. and trans. in English in the UNESCO Courier, November 1985).
5 Ringmar, *Liberal Barbarism*, p. 37.
6 *Ibid*, pp. 37–42.
7 G. Thomas, 'The Looting of Yuanming and the Translation of Chinese Art in Europe', *Nineteenth-Century Art Worldwide: A Journal of Nineteenth-century Visual Culture*, 7:2 (2008), p. 13, www.19thc-artworldwide.org/index.php/autumn08/93-the-looting-of-yuanming-and-the-translation-of-chinese-art-in-europe, accessed 10 April 2013. See J. Hevia, 'Loot's fate: the economy of plunder and the moral life of objects from

the Summer Palace of the Emperor of China', *History and Anthropology*, 6:4 (1994), 319–45; J. Hevia, 'Looting Beijing: 1860, 1900', in L. He Liu (ed), *Tokens of Exchange* (Durham and Hong Kong: Duke University Press, 1999), pp. 192–213; and Hevia, *English Lessons* for a critical appraisal of the reformulation of Summer Palace objects as 'loot'; Ringmar, *Liberal Barbarism* for a detailed analysis of the destruction of the palaces; Thomas, 'The looting of Yuanming' for discussion of the relations between China and the French in relation to the looting of Yuanmingyuan; and K. Hill, 'Collecting on campaign: British soldiers in China during the Opium Wars', *JHC*, 25:2 (2012), 1–26 for an account of military collecting during the Opium Wars. For general discussions of the architecture of Yuanmingyuan, see Y. T. Wong, *A Paradise Lost: The Imperial Garden Yuanming Yuan* (University of Hawai'i Press, 2001) and C. B. Chiu, *Yuanming Yuan: Le Jardin de la Clarté parfaite* (Besançon, 2000).

8 According to the Director of the Yuanmingyuan, Chen Mingjie (see J. Macartney, 'China in worldwide treasure hunt for artefacts looted from Yuan Ming Yuan Palace', *The Times* (20 October 2009)).

9 www.armymuseums.org.uk, accessed 20 June 2014.

10 S. Jones, 'Making Histories of Wars', in G. Kavanagh (ed), *Making Histories in Museums* (Leicester: Leicester University Press, 1996), pp. 152–63 (p. 153).

11 *Ibid.*, p. 152.

12 NAM, workshop, 'Hidden in Plain Sight: Non-European Collections in Military Culture', April 2013.

13 I am grateful to Mark Smith, Curator, Royal Artillery Museum for this information (email, 8 May 2014).

14 It must be acknowledged that looting by soldiers was commonplace during wars at this time, as this was before Hague Conventions of 1899 and 1907.

15 K. Hill, *Culture and Class in English Public Museums, 1850–1914* (Aldershot: Ashgate, 2005), pp. 7–8.

16 C. Classen and D. Howes, 'The Museum as Sensescape: Western Sensibilities and Indigenous Artifacts', in E. Edwards, C. Gosden and R. Philips (eds), *Sensible Objects: Colonialism, Museums and Material Culture* (Oxford and New York: Berg, 2006), pp. 199–222 (p. 208).

17 Hevia, 'Loot's fate', p. 33.

18 Hill, *Culture and Class*, p. 7.

19 L. Jordanova, 'Objects of Knowledge', in P. Vergo (ed), *The new Museology* (London: Reaktion Books, 1989), pp. 24–39 (p. 32).

20 Jones, 'Making Histories of Wars', p. 152.

21 *Ibid.*, p. 159.

22 *Ibid.*, p. 153.

23 NAM, workshop, 'Hidden in Plain Sight', April 2013.

24 Jones, 'Making Histories of Wars', p. 157.

25 Hevia, 'Looting Beijing', p. 196.

26 A. Henare, *Museums, Anthropology and Imperial Exchange* (Cambridge: Cambridge University Press, 2005); E. Hooper-Greenhill, *Museums and the Interpretation of Visual Culture* (London and New York: Routledge, 2000).

27 J. Clifford, 'Museums as contact zones', in *Routes: Travel and Translation in the Late Twentieth Century* (Cambridge, Massachusetts and London: Harvard University Press, 1997), pp. 188–219; L. Peers and A. Brown (eds), *Museums and Source Communities: A Routledge Reader* (London and New York: Routledge, 2003); M. Simpson, *Making Representations: Museums in the Post-colonial Era* (London and New: Routledge, 1996); L. Tythacott, 'The Politics of Representation in Museums', in M. Bates (ed), *Encyclopedia of Library and Information Sciences* (London: CRC Press, Taylor & Francis Group, 3rd edn, 2010), pp. 4230–41.

28 *Guide to Royal Engineers Museum* (n.d.), p. 1.

29 Visited in May 2011.

30 Ringmar, *Liberal Barbarism*.

31 Ringmar, *Liberal Barbarism*, p. 73.

32 Hevia, 'Loot's fate', pp. 335, 341; Hevia, *English Lessons*, p. 329.

33 Personal communication, James Scott, 16 June 2014.
34 Royal Engineers Museum, 5101.39. Gift. General Sir Richard Harrison G.C.B.
35 Royal Engineers Museum, 4801.91. Gift. Miss S.E.R. Gordon.
36 Royal Engineers Museum, 6304.5.4.2. Gift. Dame Kathleen Courtney DBE.
37 Leaflet, Royal Engineers Museum.
38 Royal Engineers Museum, 5101.65.7.4. On the front of the leaflet is a photograph of Amitayas in the 'Chinese pagoda'.
39 Royal Engineers Museum, 5101.92.3. Gift: Lieutenant Colonel E. V. Thompson.
40 Royal Engineers Museum, 5101.65.3.2–5101.65.3.5. Gift: Lady Harrison.
41 There are other Chinese objects, not necessarily associated with the Summer Palace – a priming horn picked up at the storming of the Taku (Dagu), forks, a knife, headrest, tobacco pipe, razor, mallet, geomancer's compass, two fans, ceremonial pole-arm, matchlock musket, double swords and an imperial jacket.
42 S. Errington, 'What became authentic primitive art?', *Cultural Anthropology*, 9:2 (1994), 201–26.
43 G. Wolseley, *Narrative of the War with China in 1860* (Longman, Green, Longman and Roberts, 1862). Gordon, for example, was 'held to be an ideal of Victorian Christian morality and heroism'; see Jones, 'Making Histories of Wars', p. 153.
44 As Gale noted, 'It would be greatly to the advantage of the Corps and the Service at large if a proper building existed … for the reception of relics and objects illustrative of the lives of great soldiers' (1894, unpaginated – cited from Jones, 'Making Histories of Wars', p. 153).
45 Royal Engineers Museum, main text panel.
46 Visited in July 2011.
47 Ringmar, *Liberal Barbarism*.
48 Hevia, *English Lessons*, p. 86.
49 Hevia, 'Loot's fate', p. 334.
50 S. Price, *Primitive Art in Civilized Places* (Chicago: University of Chicago Press, 1991).
51 These objects are probably not from the Yuanmingyuan, although their exact provenance is not given.
52 www.thewardrobe.org.uk/museum/museum-history, accessed 20 June 2014.
53 Visited in June 2011.
54 G. Dickinson and L. Wrigglesworth, *Imperial Wardrobe* (Toronto: Ten Speed Press, 2000), pp. 44, 76–96.
55 The Wardrobe Military Museum Textile Trail.
56 Hill, 'Collecting on campaign', p. 20.
57 *Ibid.*, p. 18.
58 *Ibid.*, p. 18. The museum has other material from the Yuanmingyuan in store. In particular, a pair of sleeves embroidered in dark blue, thought to once be the property of the Empress of China, classified under 'Miscellaneous clothing'.
59 M. McIntyre, *The Wiltshire Regiment, 1756-1914* (Stroud: Tempus, 2007), p. 31.
60 Hevia, *English Lessons*, p. 86.
61 What was later to be known as the 44th Regiment of Foot was one of seven infantry regiments raised during the War of the Austrian Succession in 1741. The Regiment was amalgamated in 1958 and disbanded in 1992.
62 Personal communication, Ian Hook, 24 November 2011.
63 Visited in November 2011.
64 He died in Bombay on 23 January 1865 aged 27. He had already served in the Crimea (personal communication, Ian Hook, 13 May 2010).
65 Personal communication, 24 November 2011.
66 Ian Hook, personal communication, 22 May 2014. I am very grateful to Ian Hook for checking information (text panels) from previous displays.
67 According to Hook, the collection was displayed at Warley Barracks from 1938 to 1946. Personal communication, 24 November 2011.
68 Personal communication, 24 November 2011.
69 Visited in December 2012.

70 *Beaney Institute Guidebook*, 2012, p. 2.
71 Beaney House of Art and Knowledge in Canterbury, text panel.
72 Beaney House of Art and Knowledge in Canterbury, folder.
73 As are a screen from the Yuanmingyuan and two carved wooden dragons looted from the personal railway carriage of the dowager Empress of China during the Boxer Rebellion in Beijing in 1900. However, it is not known how they came into the possession of the Buffs, as the regiment did not take part in the Boxer Rebellion.
74 NAM, 2002-10-8-1.
75 The 'Bv' might mean Brevet. I am grateful to Craig Bowen, Museums and Galleries Development Manager, The Beaney House of Art and Knowledge (personal communication, 2 June 2014).
76 Beaney House of Art and Knowledge in Canterbury, text panel.
77 Hevia, 'Loot's fate', p. 320.
78 M. Ames, *Cannibal Tours and Glass Boxes: The Anthropology of Museums* (Vancouver: UBC Press, 1992); Henare, *Museums, Anthropology and Imperial Exchange*; Hooper-Greenhill, *Museums and the Interpretation of Visual Culture*; I. Kopytoff, 'The Cultural Biography of Things: Commoditisation as Process', in A. Appadurai (ed), *The Social Life of Things: Commodities in Cultural Perspective* (Cambridge: Cambridge University Press, 1986), pp. 64–91; C. McCarthy, *Exhibiting Maori: A History of Colonial Cultures of Display* (Oxford and New York: Berg, 2007); C. Steiner, *African Art in Transit* (Cambridge: Cambridge University Press, 1994); N. Thomas, *Entangled Objects: Exchange, Material Culture and Colonialism in the Pacific* (Cambridge, Massachusetts and London: Harvard University Press, 1991).
79 There are other military museums which hold Yuanmingyuan material, and unfortunately there is not enough space to discuss them in any detail in this chapter. For example, the Royal Hampshire Regiment Museum in Winchester has two silver jars, presented to the 67th Regiment by Major D. S. Miller, Captain W. H. B. Kingsley and Major F. W. Jebb. The Queen's Royal Surrey Regiment Museum, Clandon Park, Guildford has a vase and a 'Joss Head' (Ian Chatfield, personal communication, 2 March 2010). On display at Caernarfon Castle is a cloisonné jar from the Yuanmingyuan and a bronze Buddhist deity figure, taken by a Royal Welsh Fusilier during the Boxer Rebellion. There are a range of other looted objects from China (not necessarily from Yuanmingyuan) in military museums. For example, a screen from the Temple of Heaven taken in 1860 at the Royal Scots Regimental Museum in Edinburgh Castle (my thanks to Desmond Thomas, Curator, Museum of the Royal Regiment of Scotland for supplying information on this); the NAM has a painting of a Buddha taken by Garnet Wolseley from the Lama temple in Beijing in 1860, and a tiger headdress of a Manchu soldier from the Boxer Rebellion in 1900–01 acquired by Colonel Francis Garden Poole (visited September 2013. My thanks to Alastair Massie, Head of Academic Access, NAM, for showing these to me). The Royal Artillery Museum has a crossbow, bamboo shield decorated with a painting of the face of a tiger and guns (my thanks to Mark Smith, Curator, Royal Artillery Museum).

CHAPTER NINE

Indigenising folk art: eighteenth-century powder horns in British military collections

Stuart Allan and Henrietta Lidchi

Known variously as the French and Indian War, *la guerre de la Conquête*, and in its wider context as the Seven Years' War, the military campaigns fought in eastern North America between 1754 and 1763 saw France and Great Britain contest colonial dominance in the European-settled region of the continent. This global conflict, and the ultimate British victory, was part of a wider war between rival great power alliances, fought on land in Europe and South Asia, and at sea across the Atlantic and Indian oceans and the Caribbean and Mediterranean. The topography and strategic geography of the North American theatre of operations, running down what today constitute the north-eastern states of the USA, and the Maritime and Québec provinces of Canada, gave rise to two salient aspects of the conflict, namely the need for French and British regular forces to adapt their drill, tactics and equipment to suit the woodland environment through which much of the campaigning was conducted, and the requirement for close cooperation between the regular forces, provincial troops, militias and allied indigenous North American nations arrayed on either side.

This combination of conditions gave rise to a type of military artefact that has become highly collectible, prized among military history and historic firearms enthusiasts and, more widely, recognised as an expression of eighteenth-century American folk art. These are the engraved 'powder horns', modified cow horns sealed with a fitted plug at one end and with a stopper-fitted spout at the other, in which soldiers and colonial hunters carried gunpowder for charging their flintlock muskets and rifles. Powder horns were by no means unique to North America, being a commonplace part of the firearms technology of the day, but those associated with the French and Indian War (and the American War of Independence two decades later) were rendered distinctive by the practice of engraving them with human and animal

figures, patterns, names and place names, dates, crude heraldry, verses and maps. The knife and needle engravings, coloured and stained with dyes and soot, often connect them directly to individual engravers and owners, to military units and to events of the war. They are to be found in several public and private collections in Canada and the United States, including hundreds of examples in the New York Historical Society Museum and the published Gilbert collection at the Metropolitan Museum of Art.[1] Private collector and re-enactor interest has generated a detailed and discrete literature on the subject.[2]

So considerable are the numbers of these engraved powder horns which are known to have survived, even after filtering out the fakes and reproductions which are an acknowledged hazard of the collector market, it might not seem entirely surprising that examples should be present today in British military collections, apparently brought back to this country by officers and soldiers serving in the North American theatre. Decorated powder horns would doubtless have been recognised by British military officers as unusual and potentially collectible at the time, since powder horns formed no part of the prescribed and carefully regulated equipment normally issued to British infantrymen. Standard practice was that gunpowder for priming and charging the flintlock muskets carried by British soldiers was issued within pre-made paper cartridges, each containing a lead musket ball, and a measure of gunpowder sufficient to both prime the musket's flintlock firing mechanism and to create the explosion inside the musket barrel which propelled the ball on its ballistic journey towards the target. A much-rehearsed system of commands and drill movements governed the sequence for priming and loading the individual soldier's musket in unison with his fellow soldiers in the firing line, performed simultaneously in order to deliver the formation volley fire which was the basis of infantry tactics of the day. This automaton-like fire drill and discipline made the most effective use possible of flintlock musket technology, with its limited accuracy, range and reliability. It determined the conventional battlefield of European infantry warfare as a scene of tightly disciplined formations of soldiers standing and moving together to deliver firepower according to set systems of manoeuvre, while receiving enemy musket fire, artillery fire and cavalry attack.

It was, in contrast, the distinctive environment and related tactical challenges of the Seven Years' War in North America which rendered the powder horn an unusual, and temporary, expedient for British infantrymen. Military effectiveness in North America required a rethinking of tactics, and modification of equipment to suit. Skirmishing warfare in the Eastern Woodlands and Great Lakes was very different to the

conventional set-piece battles more typical of warfare in Europe and it required British military tacticians to repurpose their forces in order to emulate, at least in part, some of the skills of their colonial and indigenous allies and enemies. There was a heightened need for soldiers who could move rapidly, and fight in loose order, using the cover offered by the terrain and selecting individual enemy targets rather than volley firing. Uniforms, weapons and equipment were adapted accordingly and, in the most profound change to the military structure, units designated as 'light infantry' were recruited, specially trained and equipped as specialists in backwoods warfare. Complete regiments of light infantry were created dedicated to this purpose, and within regular infantry battalions similarly tasked 'light companies' were formed to supplement the more conventional capability of each regiment, which remained essential since the war also produced confrontations in which traditional European tactics were paramount.[3]

Issued with muskets cut down at the barrel, or short-barrelled musket carbines which were more portable and manageable in woodland and brush environments, these light infantrymen were, by nature of their more flexible, mobile role, less easy to supply with pre-made paper cartridges which were usually distributed through a battalion from a closely controlled central store, and were carried by the conventional infantryman in requisite quantities in a cartridge box suspended on the hip from a shoulder strap. For light infantrymen, who were potentially engaged in extended patrol work far from a battalion headquarters, the risk was that they would run out of cartridges and be forced to make them up under pressure and in an unsuitably damp environment. Powder horns filled with gunpowder were therefore a necessary back-up, matched with a pouch or pocketful of lead musket balls and wadding paper, which together allowed a soldier to prime and load his musket as required. Powder horns were light, water-resistant, and when worked by careful scraping, were sufficiently translucent to indicate how much powder they contained.

So far, so functional, but it was the customised decoration of these powder horns that made them at the time, and through to the present day, so attractive to collectors. On no account would soldiers have been permitted to personalise in this way their standardised government-issued weapons. These were, and remained, government property. At one level of accountability below this were the accoutrements such as belts and pouches, which were supplied to the soldier from regimental funds. Again, soldiers would not normally dare to decorate or deface them. Powder horns fitted into this second category but, perhaps because their decoration was already common practice for firearm-owning civilians and among less heavily regulated provincial troops

and colonial militias, and perhaps also because regiments purchased them locally and might receive them in an already decorated state, decoration was tolerated.

This book focuses on objects, colonial warfare and intercultural contact, and the powder horns featured in this chapter carry a heightened interest with regard to the last topic. Since powder horns were an innovation in terms of British infantry warfare, they were without a standard means of carrying them on the body. The horns themselves sat comfortably on a man's hip, but straps had to be improvised, either individually or collectively within a company or regiment. Two powder horns in British military museum collections are notable as the carrying straps attached have been fashioned from existing items evidently obtained from indigenous North American sources. These can be identified respectively as a set of prisoner cords and a burden strap or prisoner tie, both distinctive objects in the material culture of the Six Nations of the Iroquois or the Iroquois Confederacy (or Haudenosaunee, meaning 'People of the Longhouse') and the Huron-Wendat. If, as material and documentary evidence suggests, these composite objects are representative of alliance and trade between the British and their indigenous North American allies, a third artefact, an undecorated powder flask with a quillwork strap, seems to provide a contrast, having been recorded as a trophy of war taken by a British Army officer in 1775, during the American War of Independence.

The extensive literature on the Seven Years' War in North America offers analysis of the political and strategic motivations underpinning the alliance between the British and the Iroquois Confederacy, and includes work framed in terms of the impact of the conflict on Haudenosaunee culture.[4] Haudenosaunee material culture has its own extensive historiography that cannot be addressed here but was the focus of a major exhibition, in Bonn and Berlin in 2013–14, which featured one of the powder horns discussed later in this chapter.[5] This literature addresses objects collected by individual British Army officers during the Seven Years' War and the War of Independence; however, the motivations and assumptions behind acquisition and preservation of eighteenth-century indigenous North American artefacts, as well as their 'afterlives' in British military museum collections, has received less detailed attention.[6] The examples highlighted here, and the associated documentation, where it survives, allow us to reframe those powder horns with their locally produced straps as transcultural objects, and to consider their meaning as items deemed worthy of preservation in British military collecting culture.

Prisoner cords – Lieutenant John Longsdon's powder horn

The first example (Figure 9.1) is a powder horn preserved in the regimental collection of The Royal Green Jackets (Rifles) Museum at Winchester in Hampshire.[7] The museum combines the inherited collections of multiple antecedent units of the present-day regiment, each with specialisms in light infantry or rifle tactics of eighteenth- or early nineteenth-century origin. The inscription scratched into the cow horn body of the powder horn, alongside floriate decoration and a rudimentary rendering of British royal heraldry, places it squarely in time and place, featuring the owner's name, his regiment, the means by which he acquired it and the precise date and place of its acquisition: 'Bought By Lieut John Longsdon of ye: 3 Battalion of the Royal Americans FORT EDWARD YE 2 DAY OF AUGS/J L GR 1757.'

The 'Royal Americans' were the officers and soldiers of the 60th Royal American Regiment, which mixed officers and recruits sourced and transported from England with volunteers raised in North America, mostly among Protestant German and Swiss settlers, to create a regiment ultimately four battalions strong. The regiment's title reflected these mixed origins and its function, specifically tasked with woodland-style warfare in the North American theatre, but also capable of operating as conventional European infantry, as it did at the battles of Louisbourg and Québec in 1758–59.

Lieutenant John Longsdon is listed as an officer commissioned on 7 January 1756, one of the original officers of the regiment, and his name appears in the officers' list until 1759.[8] His presence at Fort Edward on 2 August 1757, recorded on the powder horn, associates him with one of the best-known actions of the history of the war, the siege and surrender of nearby Fort William Henry. Fort Edward on the Hudson River was part of a system of British forts in New York province, and is illustrated in a rough plan inscribed into the powder horn purchased by Lieutenant Longsdon.[9] On 2 August, Longsdon's battalion of the Royal Americans was split between Fort Edward and Fort William Henry on the shore of Lake George where, fourteen miles (approximately 23 km) away, the garrison was under siege from French regulars and colonial and Native American forces. The garrison at Fort Edward was unable to come to the aid of their disease-stricken counterparts at Fort William Henry before the latter was forced to surrender.[10] Although, according to the customs of European warfare, the terms of surrender permitted the defeated garrison to relinquish Fort William Henry and march towards Fort Edward under escort, skirmishing with French-allied Native Americans en route escalated into a general attack on the retreating

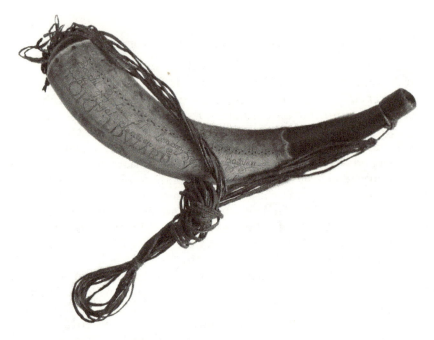

Figure 9.1 Lieutenant John Longsdon's powder horn.

column. This action became known to popular history as a central epi-
sode in James Fenimore's Cooper's 1826 novel *The Last of the Mohicans*,
wherein it was depicted as a general massacre, although in reality part
of the British force, including much of the detachment of the 3rd
Battalion Royal Americans, was able to defend itself and return to Fort
Edward in good order.

It is not possible to ascertain whether Lieutenant Longsdon
purchased his powder horn with or without the attached strap, and the
strap might therefore have been added after the date recorded on the
horn. What is clear is that the strap is of indigenous manufacture,
constructed of eight strands consisting of leather strips wrapped with
porcupine quill dyed red and yellow/white leaving a plaited appearance
and finished with black hair tufts. It is knotted along its length, making
its entire length difficult to determine. Nevertheless, the shortening
knot suggests that its original purpose was not as a shoulder strap.
Instead, it conforms to a type of artefact know in collections from
eastern North American and the Great Lakes area, described in con-
temporary accounts and in the scholarly literature as 'prisoner cords'.[11]
These long, brightly coloured and braided cords, of leather or vegetable

fibre in the north-east, and sometimes bison hair further south and west, were ornamented and strengthened by quillwork and deployed by male warriors, usually around the waist, to facilitate the securing of captives. Prisoner-taking was a characteristic element of indigenous North American warfare, whether captured from among an enemy war party, or from among colonial opponents. The acquisition of prisoners brought honour to the captor, offering the options of exchange for gain, adoption or assimilation into the village as a replacement for dead or captured warriors or, at the other extreme of fortune for the captive, the prospect of torture and execution in accordance with ritual and spiritual beliefs. The testimony of captives, and of witnesses to captivity, indicates that the combined braided strength of these individual cords made a very effective ligature for wrists, arms or necks.[12]

Since Lieutenant Longsdon would not have been in the business of taking prisoners in this way, it seems clear that this specific set of prisoner cords was adapted by or for him for the purpose of carrying the powder horn to which it still adheres. The questions raised by the combination of a colonial powder horn with an indigenous strap, and the relations that it evidences, cannot be adequately answered by reference to provenance information or additional documentary evidence. Like Lieutenant Longsdon himself, the powder horn parted company from the regiment long before it entered a regimental collection. Museum records indicate that it was acquired in 1955 from a retired Army officer who lived locally to the museum in Hampshire, and that it had formerly belonged to the antiquarian collector and numismatist W. J. Andrew, whose collection included seven mid-eighteenth-century North American powder horns.[13] In the absence of personal or regimental papers that shed light on the matter, it is unclear exactly how, in 1757, Lieutenant Longsdon or Longsdon's supplier procured the strap; if it was an adaptation fashioned by Longsdon as a personal preference; or if acquisition of prisoner cords from local indigenous sources, including British-allied war parties, was a solution to the carrying of powder horns adopted more generally by Longsdon's company, or indeed the whole battalion of the Royal Americans while on operational service.[14] Fortunately, a second powder horn, also with a distinctive strap attached, and now in the collection of National Museums Scotland (NMS), offers some indication of how this practice, if indeed it was more than an individual practice, might have come about.

Burden straps – Private James Cameron's powder horn

This second powder horn (Figure 9.2) is preserved in the military collections of NMS, having been acquired in 1931 by the former Scottish

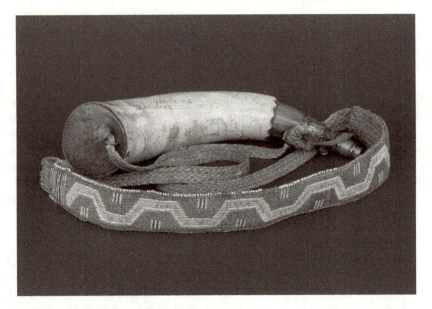

Figure 9.2 Private James Cameron's powder horn.

Naval and Military Museum, now the National War Museum, in Edinburgh Castle. It was a gift to the museum from the Edinburgh lawyer James Steuart, who was a collector of military artefacts and a Fellow of the Society of Antiquaries of Scotland.[15] As with the Longsdon example, this horn can be placed, dated and associated with an individual, in this case two individuals, by means of the decoration etched into it. It carries two names, one a Jonathan Webb, who is otherwise unidentified but who is likely to have been an American, possibly a provincial militiaman, and who, possibly as a trained engraver, is believed to be the source of at least two further documented powder horns created at Lake George.[16] The second name is James Cameron, '42 Royall Heylanders', a soldier of the British Army serving with the 42nd (Royal) Highlanders, the Scottish regiment better known as the Black Watch. The powder horn appears to place either Webb or Cameron, possibly both, in a specific location at a specific time, with the inscription 'Horn made at Leake Gorge, Sept 1, 1758'.

An encampment near the shore of Lake George was the site of the 42nd Highlanders' quarters at that time, south of the scene of its costly participation in the failed British assault on Fort Ticonderoga (or Carillon) two months earlier. The horn is further decorated with a representation of the British Royal Arms, crude representations of indigenous North American warriors, floriate devices and a rhyme, typical

of the genre, each of which elements are found in similar form on other examples. The standout feature of this horn is, again, the carrying strap, which seems to have been made by foreshortening a Haudenosaunee or Huron-Wendat burden strap. Burden straps were multipurpose items for load-carrying, typically with the weight borne across the forehead, and they are found as a consistent feature in curiosity and antiquarian collections from eastern North America and have made their way into present-day museums. Stephenson suggests burden straps (normally used by women) may have been employed, similarly to the bespoke prisoner halters that combine aspects of burden straps and prisoner ties (with a loop at one end, not present here) for the purpose of securing captives.[17] The example from NMS is made of woven and plaited nettle fibre, with a broader band of 'false embroidery' of dyed moose-hair in the central portion, creating colourful geometric patterns in blue, black, white, orange and green, delicately edged with white glass beads. The powder horn and burden strap are contemporary, with a powder horn associated with the 42nd Highlanders now in the Blair Castle collection, and with two powder horns engraved with maps of the theatre of operations preserved in the regimental collections at the Black Watch Museum, none of which feature straps of this kind.[18] But examples of powder horns with straps of indigenous manufacture are rare.

A few examples where engraved powder horns have indigenous North American carrying straps can be found in national institutions. The National Museum of World Cultures in the Netherlands has a powder horn with a cotton strap with white beads, porcupine quills and deer hair (c. 1760–70) linked to the 77th Highland Regiment that saw action in Cherokee territory in 1760.[19] The Metropolitan Museum of Art has a powder horn with a late 1770s engraving, attributed as Penobscot, and with a shoulder strap of linen and glass echoing a wampum belt and given a slightly later date (early nineteenth century).[20] The British Museum acquired a powder horn with a measure and brush with a shoulder strap of plaited wool strap ornamented with white beads acquired through the dealer and collector W. H. Oldman, who seemingly obtained it from Boswell Castle between 1925 and 1935 and thus the estate of the Earls of Home, dating to the American War of Independence.[21] More intriguing is the powder horn currently held by National Museums Liverpool engraved with a record of the British Siege of Havana (1762) with the Royal Arms of Great Britain, clipper ships and armed men, to which is appended what appear to be prisoner cords decorated with dyed porcupine quills, metal cones and dyed deer hair.[22]

It is unclear whether all the men of the light company of the 42nd Highlanders used indigenous burden straps to carry their powder horns.

[213]

It is possible that conventional European straps at times needed replacement. But an intriguing explanation of the relations of supply appears in manuscript sources held in the regimental collection at the Black Watch Castle and Museum in Perth, Scotland. The orderly book of Captain William Stewart records that by the spring of 1759 the men of the 42nd had been issued with burden straps, or 'tumplines' as they were called by Europeans, to tie up their blanket rolls for sleeping in the field: 'The Regiment to be under orders on Wednesday morning with their linen, breeches, leggings and packs tied up properly with their toplines [tumplines], the officers to be in their leggings also'.[23] The mention of leggings presents the possibility of further adaptation of indigenous North American clothing and accoutrements, as these leggings were not conventional uniform and might have been made up from wool cloth of Haudenosaunee manufacture.[24] A later entry from Stewart's orderly book for 1761, when the regiment was at Staten Island, refers also to 'leggans' worn with the kilt in place of tartan hose. A further 1761 orderly book entry, made at Montreal, reflects the issue of tomahawks to the Light Company in place of conventional swords, 'Received into the stores . . . the supernumary [sic] Tomihawks and Powder Horns and Shot Bags belonging to the Light Infantry Company also to be delivered into the store'.[25] These records seem to indicate that the tumpline strap was not therefore a personal souvenir or trophy of the campaign collected privately or fashioned into a strap either by one of James Cameron or Jonathan Webb, but an item adapted from those issued in more numerous quantities to British soldiers, and presumably purchased locally by the British supply agents from their indigenous allies. The manufacture and supply to order of products such as burden straps, prisoner cords and material for leggings to the British Army's commissariat is otherwise, as yet, largely undocumented, but this regimental record on its own supports the assumption that a system of trade was in operation.[26] That tomahawks are also mentioned is significant, because as Jonathan King notes, tomahawks by the late eighteenth century were not only an item of trade and alliance, including those of European manufacture, but equally a means by which 'Indian-ness' was represented and understood in the British view, with tomahawks a prominent feature of British representations of indigenous North America, whether in paintings, performances or collections.[27] Their availability as collectibles is further indicated by the presence of an Haudenosaunee or Huron-Wendat burden strap as part of the Murray collection of mid-eighteenth-century indigenous artefacts at Blair Castle, Perthshire, seat of the Murray family as Dukes of Atholl. Through the Murray family we can glimpse the microhistories by which indigenous artefacts of eastern North America arrived in

Britain through links to the 42nd Highlanders. The existing collection held in Blair Castle was principally assembled by Captain George Murray, Royal Navy, whose brother James Murray was commissioned to raise one of three additional companies for the 42nd Highlanders in 1757. James Murray may have been the source for the burden strap, as well as the pipe tomahawk (dated 1757) and two powder horns (with maps of the Albany and Mohawk rivers and the Great Lakes). He served in the French and Indian War until he was wounded in 1758 at the assault of Fort Ticonderoga. Captain James Murray is likely, indeed, to have been at the fort at Lake George, the apparent source of his Private Cameron's powder horn. Entangled with the Murray family and held in private hands until 2005 was the private collection largely assembled by Lieutenant Alexander Farquharson. Alexander also joined the 42nd Highlanders in 1757 through the support of his relative and patron, James Farquharson, Laird of Invercauld, in Aberdeenshire, whose wife Lady Sinclair was born Amelia Murray, sister to James. The Farquharson collection prior to sale consisted of seventeen items that drew from a number of sources including the Huron-Wendat, the Haudenosaunee and the Anishinaabe of the eastern Great Lakes, purchased *in situ* and conveyed, according to letters sent by Alexander Farquharson, to amuse and delight his patrons. In a letter of 1761, from Staten Island Camp, New York, he wrote that he was gathering 'a little casket of Savage Curiosities for you and Lady Sinclair, I pick up everything I can find that is either rare or curious'. Alexander Farquharson left for Cuba in 1761, where he died of fever in 1762.[28]

The knowledge that Private Cameron's powder horn, with its Huron-Wendat or Haudenosaunee shoulder strap, was carried by a Scottish Highlander opens a possible dimension to the biography of this object through its relevance to recent work in comparative history. This is based on ideas about affinity between Highlanders and indigenous North Americans: peoples identified as 'tribal', connected through clanship and warrior cultures and with a history of dispossession or co-option by encroaching powers.[29] The related contention that there were *in situ* understandings and cultural exchanges between 'Gael' and 'Indian', based on their status as peripheral peoples, ostensibly subtly different from other colonial relationships, is perhaps plausible in specific contingent contexts more than in generalities. The exchange of material culture, as well as of language and oral culture, has been invoked to support this interpretation, in relation to the adoption of tartan and glengarry bonnets by indigenous North Americans. In consequence the revelation of intercultural transfer of objects in the opposite direction, of Highland soldiers of the British Army using prisoner ties and tumplines has an appeal, represented in the current Scotland Galleries

at the National Museum of Scotland, through exhibition of a late nineteenth-century/early twentieth-century Glengarry-style bonnet, decorated with indigenous beadwork, from the Great Lakes region.[30] Published treatments of any such phenomenon are however alive to the dangers of generalisation, and mindful of one essential correspondence between these two peoples, namely the manner in which both were retrospectively romanticised by the societies that had dominated and assimilated them. Romanticisation of the American frontier was a wider phenomenon, and there is robust reason to conclude that the light company Highland Soldiers of the Black Watch were necessarily more attuned to forest warfare, or to relations with indigenous allies, than were their counterparts in Lieutenant Longsdon's Royal Americans, or in any other British units deployed in the theatre. Sentiment born of historical experience was not evident, certainly, in the 1760 campaign in which Highland troops burned their way through Cherokee towns. The training, equipping and deployment of British soldiers in the mid-eighteenth century were hard-nosed, utilitarian matters in which cultural affinities among allies and enemies were, at best, incidental.

We offer some other considerations. It is possible that British light troops of the mid-eighteenth century serving in eastern North America might have tended to romanticise their unconventional campaigning experiences. In adapting to warfare in a new and challenging physical and cultural environment, they might conceivably have embraced and projected an early manifestation of the culture of irregular warfare, shared among themselves to set them apart from their more conventional, regular infantry counterparts. This phenomenon can be observed through the organisational and material culture of British irregular warfare and special forces organisations of the twentieth and twenty-first centuries, where individuality and informality have been celebrated to demonstrate distinction from, and by implication superiority over, the conventionally trained and tasked military mainstream. Artefacts, notably weapons, exclusive to the exponents of irregular warfare were especially valued and became symbolic of military organisations that considered themselves 'special' in mid-twentieth-century parlance, appearing as emblems in cap badges and other insignia.[31] In the mid-eighteenth century North American theatre of war, disdain and distrust were the most common currency among professional British officers and soldiers towards the relative indiscipline and inexperience of provincial troops and militias fighting alongside them. Hostility towards indigenous allies on grounds of perceived racial and cultural inferiority was expressed in terms of contempt for their mode of warfare. Nevertheless, there were occasional expressions of guarded respect for the military competence of colonist and indigenous combatant respectively,

in recognition of their superior experience of fighting in the environment and their skill with weaponry.[32] In this situation, the preservation by British soldiers of decorated powder horns as mementoes, and their return to the UK after the campaign, might be indicative of a recognition of value, not solely as, by then, well-established curiosities, but additionally as a means of memorialising the time when a company or regiment fought as irregulars. They were indicative of a type of warfare of which British officers and soldiers who had not served in North America would have had no experience and little understanding. Matthew Dziennik notes from a contemporary description that in 1767, in Dublin, the 42nd Highlanders were still displaying indigenous North American connections through collections of 'trinkets' and (unspecified) aspects of their dress.[33] Such distinction would confer prestige. After the Seven Years' War, weapons and indigenous North American artefacts entered British permanent collections, provincial museums and coffee house displays in greater abundance, and thus the nature of the powder horns with their indigenous accoutrements would have clear resonance.[34] The powder horn thus enhanced might therefore have represented levels of prestige and curiosity based on the direct association with warfare, honouring the period when a company or regiment 'fought with the Indians'.

The popularity of such a growth in supply and demand for indigenous North American items may explain why the powder horns now residing in military collections did not enter these collections directly, but came through private collectors during the twentieth century. Whatever their preservation beyond the term of their immediate utility on campaign, their afterlives have been seemingly determined by their status as 'Indian curiosities', the collecting of which was fashionable among certain British military officers serving in North America seeking to demonstrate their taste and education by bringing or sending such curiosities home to display as evidence of their travels, worldly experience and intellectual credentials. The Seven Years' War had an impact on availability, creating in Britain a lively market for indigenous artefacts, which by the 1770s and 1780s had evolved, making these affordable and prevalent, and thus available at auction. As recounted by Bickham, the dismantling of museums in the early nineteenth century allowed the re-circulation of wampum belts, weapons, clothing, tomahawks and war clubs through auctions including from the Leverian Museum a '"curiously carved" Indian powder horn' sold for less than five shillings (1806).[35] These items were inevitably curiosities.

Ruth B. Phillips has discussed two paradigms of collecting present in the eighteenth century as a consequence of British presence and alliances with indigenous North Americans. She notes that a key

characteristic of curiosity collection is a series of individualised, 'self-standing items' that demonstrate 'a distance from the original contexts of making and use that opens up the possibility of a self-reflexive and ironic mode of appreciation.'[36] The proceeds of this collecting motivation, both among senior and more junior officers, is to be found, as we have seen, preserved in a number of family and other collections. However, for these two powder horns and their indigenous carrying straps, the first moment of cross-cultural transfer was not intellectual curiosity but a practical military matter of supplying an army with necessary accoutrements. In consequence, as material evidence of cross-cultural contact, they may represent something closer to what Phillips describes as one of 'embodiment and participatory episodes', the instances where individual British officers experienced deeper relationships and exchanges with indigenous allies through the adoption of clothing and adornment. These fuller souvenirs were evidence of the knowledge and understanding which British officers gained through their more meaningful encounters with indigenous worlds, such that it was possible that 'When he donned aboriginal clothing, the British soldier moved bodily into the middle ground, just as did aboriginal leaders . . . when they accepted and wore presents of British clothing.' Carrying their personalised powder horns by means of straps obtained from the British Army's indigenous allies, Lieutenant Longsdon and Private Cameron could have been following instructions or been conforming to the fashion among fellow officers and soldiers. We might recognise in these composite European–colonial–indigenous artefacts the reflection of a collective participatory episode experienced by the 60th Royal American Regiment and the 42nd Royal Highlanders, or at least by the light companies differentiated from the main body of the army or from the regular companies of the regiment. Practising irregular and 'Indian' warfare, these British soldiers were wearing and *using* Iroquois objects, at least initially.

The adaptation of Iroquois material culture into the everyday accoutrements of British soldiers during the mid-eighteenth century extends what is understood of the role of artefacts in negotiating relationships between the indigenous, colonial and colonising powers. We lack details of the supply of burden straps and prisoner ties, but it may be surmised that, from the supply side, there was more to this trade than a straightforward exchange of goods. From the complex ritual meanings of wampum beads and belts, through gifts of pipes and weapons, to the ostensibly more straightforward supplying of tobacco, the giving and receiving of objects and goods was a method through which the Iroquois Confederacy among others sought to establish and exemplify relationships with Europeans based on reciprocity and mutual

respect. Making burden straps and prisoner ties available to the British for tying up blankets, for carrying powder horns and for other practical purposes, indigenous suppliers not only stood to gain favour by aiding the British, they gained some advantage through mutual reliance. The utility of these Haudenosaunee manufactures, demonstrably connected to military competence in operations in their own environment, moved the British closer to the Haudenosaunee and their ways of warfare. It shifted them into the 'middle ground' of mutual comprehension between indigenous and European experience, as delineated by Richard White in his study of interactions over two centuries in the Great Lakes region.[37] Here we have evidence that the supply line for accoutrements ran intriguingly in the opposite direction from the phenomenon, more commonly remarked upon, of the assimilation of European military clothing and equipment by indigenous North Americans, a practice which the colonial powers were quick to recognise and encourage.[38] The latter could be practical, as in the adoption of firearms technology, but it was also symbolic, as with the receipt and wearing of silver and pewter medals bearing images of European royalty, and the assimilation of the gorget, an article of European military clothing, or more accurately armour, originally a throat protector, which had involved into a symbol of a European army officer's rank worn suspended around the neck.[39] By way of comparison, it is worth restating that the powder horn straps carried by British soldiers may be argued to have both practical and symbolic functions in British military culture.

Porcupine quill straps – Major William Gaull's priming flask

By way of contrast, and to conclude we consider a third powder horn (Figure 9.3) carried with an indigenous quillwork strap, likely Haudenosaunee, and preserved in a British military collection, which presents a rather different message. This is a teardrop or pear-shaped horn flask, brass-mounted, of a size and form that suggests its original purpose might have been for carrying the fine grain powder used for priming flintlock firing mechanisms for musket or rifle. The strap of multiple strands of leather was wrapped in dyed porcupine quills to form a zigzag or thunderbolt pattern in a plaited style of red, black, white and yellow, ending as they attached to the flask with wrapped quillwork and tin cones. This strap is similar to those attached to bandolier bags and to that in the Warnock collection attached to an engraved powder horn decorated with a map of military forts and towns along the Hudson River valley in New York State, and a representation of the British royal coat of arms.[40] This smaller priming flask has not been decorated or personalised by engraving, and what we know of its

Figure 9.3 Major William Gaull's priming flask.

provenance comes from later museum documentation. It is preserved together with an associated knife, the handle, sheath and carrying strap of which are all decorated with brightly coloured quillwork dyed red, yellow, black and white.

Until recently, the objects resided in the Redoubt Fortress Military Museum, Eastbourne, in the collections of the Royal Sussex Regiment, which recorded them on acquisition as having been 'taken from the body of an Indian who was killed by Major William Gaull, 35th Regiment, during American War of Independence'.[41] We have moved forward twenty years to the 1770s, into a different conflict involving British forces in north-eastern North America and, on the basis of existing documentation at least, we are presented with an example of an object taken from an indigenous North American as a trophy of war. It appears therefore to embody none of the nuances relating to alliance

and negotiation present in our assessment of the two earlier examples, and conforms instead to a more conventional story about military collecting, seemingly representative of the practice, near ubiquitous in Western and other modes of warfare, of taking and retaining objects as trophies, most commonly weapons, from the person, body or stores of a vanquished enemy.

The published regimental history records that Major William Gaull was commissioned as captain, 35th Regiment on 31 May 1765, and retired as major in January 1776.[42] The active service of the 35th during 1775, in which we may assume Gaull was present, was centred on Boston. The regiment's grenadier and light companies fought at the Battle of Bunker Hill, on 17 June 1775, and engaged in skirmishing warfare in the months following until the British evacuation of Boston in March 1776.[43] As with the two earlier French and Indian War powder horns, the powder flask and knife did not transfer directly from regimental officer or soldier, in this case Major Gaull, to the regimental collection. The museum acquired the objects two centuries later, in 1963, from the dispersal of the museum collection of the Royal United Service Institute (RUSI), the professional and scientific institute of the Royal Navy and British Army established in London in 1831. The Institute's purposes, promoting military learning and an empirical approach to soldiering, were represented in its museum collections and included efforts to cultivate and demonstrate knowledge of other cultures.[44] The objects associated with Major Gaull were presented to its museum in 1872 by a private individual 'G.P.S. Camden Esq.', who has not been traced.[45] It appears likely that somewhere between being taken by Major Gaull in the theatre of war, and the arrival in the United Service Museum (RUSI Museum), they attained the status of Indian curiosities or military trophies while passing through the hands of one or more collectors. It is noteworthy that it is only in the (later) official published catalogue of the collection, and not in the first record of museum acquisition, that the telling detail appears: 'taken from the body of an Indian *killed by* Major William Gaull' (emphasis added), suggesting an additional, distinctly personal dimension to the object's status as a war trophy.[46] This and the other earlier published descriptions also employ the term 'scalping knife', common to these knives, with traded iron blades, a lurid association and sensationalist title which adds to the weapon's credentials as a curiosity and as a war trophy. In 1910 an independently published description of the RUSI Museum overlooked its educational and empirical collecting aspirations, recording and illustrating this small assemblage of indigenous North American artefacts plainly as war trophies, among many others, under the heading 'Our National Museum of Victory'.[47]

[221]

The near fifty-year gap between Major Gaull's military service and the arrival of the flask and knife in the RUSI Museum collection leaves room for doubt. The possibility certainly exists that flask, knife and knife sheath were acquired by Major Gaull less dramatically as souvenirs of North American service and as 'Indian curiosities' and that they subsequently circulated as such, even if they accrued added value as war trophies on the way. It is notable that later documentation in the regimental collection includes a reference to the Battle of Bunker Hill.[48] This association might have been made solely on the basis that the costly British victory at Bunker Hill, still a feature of the popular memory of the American War of Independence, was the main action in which the 35th Regiment fought, and was therefore the outstanding regimental event to which the artefacts could be related. Indigenous North Americans were present in small numbers at Bunker Hill, fighting on the American side against the British, but the likelihood of a close and mortal encounter between a British infantry officer and an indigenous combatant in this conventional European-style battle does not seem high.[49]

The status of war trophy ascribed to the objects acquired by Major Gaull might nevertheless be indicative of British attitudes towards indigenous involvement in the American War of Independence. The war split and reshaped the pattern of allegiances based on political and military expediency among and within indigenous nations, including members of the Iroquois Confederacy. There was a prevalence of support for the British, and the relations of respect and military alliance that had been a feature of the French and Indian War endured. But the mutual respect born of old alliances was fragile. Those indigenous nations who allied themselves with the rebel colonists, including those of New England and Nova Scotia who might conceivably have been encountered by Major Gaull's 35th Regiment in Massachusetts, can have attracted little other than the most extreme prejudices and contempt of their British enemies, whose attitude towards the war was already hardened on account of its basis in colonial insurrection. Conversely, for the majority of indigenous nations, including the Haudenosaunee, who remained aligned with the British against the American revolutionaries, the ultimate British defeat brought loss of lands and political influence, and loss of cohesion as emigration split them between the rival European polities of Canada and the United States of America. In this context of scorn on the one hand, and defeat and dislocation on the other, the war trophy aspect added to an Indian curiosity, such as that acquired by Major Gaull, might have suited the diminished status of the indigenous and formerly allied warrior in British eyes during the late eighteenth and early nineteenth centuries.

Museum afterlives

The three military and intercultural artefacts that are the focus of this chapter came into their respective regimental, or national, military collections in the early to mid-twentieth century, and it remains to consider what made them valued acquisitions and exhibits in their new museum contexts. The creation of these museum collections during this period offered a natural permanent resting place for these objects which, as discussed above, appear to have circulated in private collections beforehand. Longsdon's powder horn was donated in 1955 to the King's Royal Rifle Corps collection, which had been formed during the 1920s and housed thereafter on army premises at the Rifle Depot, Winchester, the depot being the permanent administrative and recruiting base of a British infantry regiment at this period.[50] The regiment had been aware of the powder horn's existence in a local private collection since as early as 1927.[51] The Royal Sussex Regimental Museum was established in 1930, again on army premises at the regimental depot in Chichester. Gaull's powder flask and knife entered the collection in 1963, at the point when the regimental collection was mostly in store following the closure of the depot, and as arrangements were underway to secure public display locally.[52] James Cameron's powder horn was acquired 1931 by the Scottish Naval and Military Museum in Edinburgh Castle, which began actively collecting material relating to the Scottish regiments in 1930, with their assistance, an initiative which pre-dated the development of formal regimental museum collections in Scotland, including that of the Black Watch at the Regimental Depot in Perth, formed in 1924.[53] Although each of these three acquisitions might have retained the value attendant on an 'Indian curiosity' through their carrying straps, we can safely assume that their desirability for each collection was principally derived from their direct connections to the service of the named individual officers and soldiers who could be placed in the chronology of particular regimental histories. Their value will have been heightened as being rarities, deriving as they did from the relatively early history of the respective regiments. Then, as now, it was part of the purposes of regimental museums to present the fullest possible story of their own campaign histories, these being the basis of a regiment's honour and prestige among their peers. The interpretation of history illustrated through collections in a regimental museum was, and is, often linear, with much attention paid to a regiment's origins. While UK military museums typically contain substantial collections relating to the nineteenth- and twentieth-century service of their regiments, artefacts that

survive from the earlier phases of regimental history, especially from material pre-dating the era of French Revolutionary and Napoleonic wars are, unsurprisingly, much rarer.

For the lay observer of British military culture, the importance of being able to represent the longevity of a regiment's history might not immediately be apparent. But in the British Army, longevity is one of the keys to seniority, based on the concept of precedence. Since the establishment of the standing army following the 1660 Restoration, and indeed before, prestige has, in broad terms, been accorded on a sliding scale to those regiments deemed closest to the sovereign, and to those with the longest unbroken histories. This concept may first have been manifest in the physical positioning of regiments in the order of battle, with the most senior accorded the position of honour on the right of the line, but it became meaningful in the very embodiment of the Army, especially as its overall size waxed and waned according to strategic requirements. As the Army expanded in wartime by creating new regiments, it contracted in peacetime by disbanding them. In the midst of these changes, usually operated on the principle of last in, first out, the oldest regiments were the ones which endured. The core of this 'old army', apparently immutable, pre-dated the rapid expansion of the Army in wartime during the 1790s. The nuances of class, tradition and military function complicate the picture, but in essence the demonstration of longevity was, and remains, integral to a regiment's fundamental sense of itself.[54] In the face of late Victorian army reforms, many of the older regiments discovered that they were less immutable than they wished to assume, and a considerable proportion of the infantry regiments that formed museums during the early twentieth century were hybrids, created by a series of regimental amalgamations enacted in 1881, typically formed by the joining of an older regiment to a younger one. Each of these amalgamated regiments would subsequently take as its point of origin the formation of the oldest of its constituent parts, and it would be from that point of origin that twentieth-century museum displays would typically commence. The museum display of powder horns derived from a regiment's service on foreign campaign service in North America, during the eighteenth-century wars of Britain's first Atlantic empire, would therefore embody regimental longevity and an unbroken tradition of global military service. This applied equally to the powder horn in the Scottish national collection, which exemplified the longevity of the Scottish military tradition in the British Army and, in this spirit, placed in history, and in the order of precedence, the 42nd Highlanders (or Black Watch) as the Army's oldest Highland regiment.

For military museums, therefore, the 'Indian curiosity' element of the powder horns' biography recounted here added interest and

historical value by helping to place artefacts visually in place and time within a regimental, or national, tradition. Their dazzling, indigenous carrying straps may have been ancillary to the main axes of value from the military perspective. The principal interest was likely in the inscriptions and personal associations, and indeed the current gallery display label for Lieutenant Longsdon's powder horn makes no reference to the strap.[55] Conversely, the focus of this chapter has been to reconsider the powder horns in relation to their point of transference from the indigenous North American culture to the British military culture, and therefore to their meaning as composite intercultural objects symbolic of political and economic relationships, even to the point of questioning the identification of Major Gaull's powder flask as a war trophy. In this respect these artefactual witnesses can challenge some of the more obvious assumptions which might be made about military collections, suggesting that the material legacies of colonial warfare are not inevitably representative of looting or trophy taking, whatever the asymmetry of the power relations involved. A more nuanced view of the meanings of their object biographies can offer to inform us not only about the intermingling of cultures in eighteenth-century North America, but also about the cultural history of the British Army then and since.

Notes

1 S. V. Grancsay, *American Engraved Powder Horns: A Study Based on the J. H. Grenville Gilbert Collection* (New York: Metropolitan Museum of Art, 1945).
2 See, for example, J. S. du Mont, *American Engraved Powder Horns: The Golden Age 1755 to 1783* (Canaan: Pheonix, 1978); T. Grinslade, *Powder Horns: Documents of History* (Texarkana: Scurlock, 2007).
3 D. Beattie, 'The Adaption of the British Army to Wilderness Warfare, 1755–1763', in M. Ultee (ed.), *Adapting to Conditions: War and Society in the Eighteenth Century* (Tuscaloosa: University of Alabama Press, 1986), pp. 56–83. For details of the equipment and uniform changes, see R. Gale, *A Soldier-like Way: The Material Culture of the British Infantry 1751–68* (Elk River: Track of the Wolf, 2007), pp. 121–2.
4 T. J. Shannon, 'War, Diplomacy and Culture: The Iroquois Experience in the Seven Years' War in North America', in W. R. Hofstra (ed.), *Cultures in Conflict: The Seven Years' War in North America* (Lanham, Md.: Rowman and Littlefield, 2007), pp. 79–103; D. P. Macleod, *The Canadian Iroquois and the Seven Years' War* (Toronto: Dundurn/Canadian War Museum, 1996).
5 S. S. Kasprycki (ed.), *On the Trails of the Iroquois*, Kunst- und Ausstellungshalle der Bundesrepublik Deutschland, Bonn, 22 March to 4 August 2013; Martin-Gropius-Bau, Berlin, 18 October 2013 to 6 January 2014 (Berlin: Nicolai Verlag, 2013). See also R. W. Hill Snr, *War Clubs & Wampum Belts: Hodinöhsö:ni Experiences of the War of 1812* (Brantford: Woodland Cultural Centre, 2012).
6 D. Idiens, 'Early Collections from the North American Woodlands in Scotland', in J. C. H. King and C. F. Feest (eds), *Three Centuries of Woodlands Indian Art* (Altenstadt: ZKF, 2007), pp. 10–15; S. Jones, 'Caldwell and DePeyster: Two Collectors from the King's Regiment on the Great Lakes in the 1770s and 1780s', in King and Feest (eds), *Three Centuries of Woodlands Indian Art*, pp. 32–43.

7 Royal Green Jackets (Rifles) Museum, WINGJ:2006.1761; see 'The Royal Green Jackets (Rifles) Museum, Winchester: Individual Records', *Material Encounters Catalogue* (NMS, 2016), available at http://www.nms.ac.uk/media/1150310/royal-green-jackets-ir.pdf, accessed 31 May 2019.

8 Captain N. W. Wallace, *A Regimental Chronicle and List of Officers: The 60th, or The King's Royal Rifle Corps Formerly the 62nd, or The Royal American Regiment of Foot* (London: Harrison, 1879), pp. 73–7.

9 The 'Lake George School' of powder horn engravers, working in this network of forts, is discussed in W. H. Guthman, *Drums A'Beating, Trumpets Sounding: Artistically Carved Powder Horns in the Provincial Manner, 1746-1781* (Hartford: Connecticut Historical Society, 1993), pp. 84–153.

10 L. Butler, *The Annals of the King's Royal Rifle Corps*, 5 vols (London: Smith, Elder & Co., 1913–32), I (1913), pp. 44–5, quoted in D. P. Marston, 'Swift and Bold: The 60th Regiment and Warfare in North America 1755-1765' (Master of Arts thesis, Montreal: McGill University, 1997), pp. 42–3.

11 The literature and material evidence is analysed in R. S. Stephenson, 'The Decorative Art of Securing Captives in the Eastern Woodlands', in J.C.H King and C.F. Feest (eds), *Three Centuries of Woodlands Indian Art*, pp. 55–67 and R. S. Stephenson 'Iroquois War and Warfare', in Kasprycki (ed.), *On the Trails of the Iroquois*, pp. 112–26. The assessment of the straps featured in this chapter derives in the main from Stephenson's work.

12 On the significance of prisoner capture in Iroquois warfare, see D. Richter, *The Ordeal of the Longhouse: The Peoples of the Iroquois League in the Era of European Colonization* (Chapel Hill, N.C: University of North Carolina Press, 1992), pp. 32–8.

13 'The Royal Green Jackets (Rifles) Museum, Winchester: Individual Records', *Material Encounters Catalogue*.

14 The Regimental Magazine for 1927 indicates that Andrew exhibited this private powder horn collection, including that which had belonged to Lieutenant Longsdon, at a meeting of the British Numismatic Society, London on 26 January 1927, in connection with the bicentenary of the birth of General James Wolfe, posthumously celebrated for his victory at Québec in 1759. R. Byron, *The King's Royal Rifle Corps Chronicle* (Winchester, 1927), p. 220.

15 NMS, M.1931.581.

16 P. Zea, 'Revealing the culture of conflict: engraved powder Horns from the French & Indian War', *Historic Deerfield* (Summer 2008), 20–7; Grancsay, *American Engraved Powder Horns*, catalogue numbers 209 and 711, p. 48 and p. 65.

17 Stephenson, 'The Decorative Art', pp. 56–8; J. C. H. King, *Thunderbird and Lightning: Indian Life in Northeastern North America, 1600-1900* (London: British Museum, 1982), pp. 74–5; Kasprycki, *On the Trails of the Iroquois*, pp. 81–2.

18 'Black Watch Museum and Castle, Perth: Individual Records', *Material Encounters catalogue* (NMS, 2016), available at https://www.nms.ac.uk/media/1150294/black-watch-ir.pdf, accessed 2 June 2019.

19 National Museum of World Cultures, Rv-924-82, purchased at auction in 1893. See also P. Hovens and B. Berstein (eds), *North American Indian Art. Masterpieces and Museum Collections in the Netherlands* (Altenstadt: ZKF, 2015), pp. 108–9.

20 Metropolitan Museum of Art, 37.131.16a; 39.87b, from The Collection of J. H. Grenville Gilbert, of Ware, Massachusetts, Gift of Mrs. Gilbert, 1937. Current catalogue records notes that the powder horn is possibly of Penobscot manufacture made for a Massachusetts soldier during the Penobscot expedition of 1779–80. Grancsay, *American Engraved Powder Horns*, pp. 31–2.

21 British Museum, accession number Am1949,22.143.a-b. According to current British Museum research the composite item is likely associated with William Home, Lord Dunglass (1757–81), who served with the Coldstream Guards during the American War of Independence and died of wounds received at the Battle of Guildford Court House. It remained in the collection of the Earls of Home *c.* 1781–1935.

22 www.liverpoolmuseums.org.uk/wml/collections/ethnology/americas/item-383330.aspx, accessed 14 June 2019. This item was previously in the collection of Norwich Castle Museum and Art Gallery.
23 Black Watch Museum, Regimental Archive, A758, Captain William Stewart's Orderly Book for 1759, entry for 30 April 1759. See also J. U. Rees, 'The use of tumplines or blanket slings by light troops,' *The Continental Soldier*, 8:2 (1995), 27–9, and, on the etymology of 'tumpline', G. S. Zaboly, 'The use of tumplines in the French and Indian War', *Military Collector and Historian*, 46 (Fall 1994), 109–13.
24 R. Gale, *A Soldier-like Way*, pp. 97–8.
25 Black Watch Museum, Regimental Archive, A758, Captain William Stewart's Orderly Book for 1759, entry 15 October, and Orderly Book for 6.4.1761 – 5.8.1761, entry for 20 April 1761. A further typed copy of the Order Book of the Royal American Regiment at Québec 1759 – Feb 1760, RSM MS.1/14 in the Royal Sussex Regiment collections, mentions the supply to men of powder horns (300), snow shoes and moccasins (entries 11 November; 6 December; 13 December 1759).
26 Other passing references in original military sources are noted in Zaboly, 'The Use of Tumplines'.
27 J. C. H. King, 'Ball-headed Clubs in Ninteeth-Century Europe: Projecting Power Among Woodlands Perfomers', in J.C.H. King and C.F. Feest (eds), *Three Centuries of Woodlands Indian Art*, pp. 75–84 (p. 76); see also T. Bickham '"A conviction of the reality of things": material culture, North American Indians and empire in eighteenth-century Britain', *Eighteenth-Century Studies*, 39:1 (2005), 29–47.
28 R. B. Phillips and D. Idiens, 'A casket of savage curiosities: eighteenth-century objects from north-eastern North America in the Farquharson Collection', *JHC*, 6:1 (1994), 21–33; D. Idiens, 'Early Collections from the North American Woodlands in Scotland', pp. 10–15; R. B. Phillips, 'Reading and writing between the lines: soldiers, curiosities, and Indigenous art histories', *Winterthur Portfolio*, 45:2/3 (2011), 107–24.
29 M. Newton, 'Celtic Cousins or White Settlers? Scottish Highlanders and First Nations', in K. Nilsen (ed.), *Rannsachadh na Gàidhlig 5* (Sydney: University of Cape Breton Press, 2011), pp. 221–37; C. G. Calloway, *White People, Indians and Highlanders. Tribal Peoples and Colonial Encounters in Scotland and America* (Oxford: Oxford University Press, 2008). See also M. P. Dziennik, *The Fatal Land: War, Empire and the Highland Soldier in British America* (New Haven: Yale University Press, 2015), pp. 118–22.
30 NMS, A.1984.67. A beaded Glengarry-style cap from the collections of the Royal Ontario Museum (989.15.16) and James Cameron's powder horn from NMS appear as illustrations in Calloway, *White People, Indians and Highlanders*, pp. 101 and 138. Cameron's powder horn also appears as an illustration in Dziennik, *The Fatal Land*, p. 119.
31 S. Allan, 'Individualism, exceptionalism and counter culture in Second World War special service training', paper presented to *Waterloo to Desert Storm: New Thinking on International Conflict, 1815-1991*, Scottish Centre for War Studies, Glasgow University, 24–25 June 2010 (NMS Research Repository, 2011), available at http://repository.nms.ac.uk/id/eprint/276, accessed 2 June 2019.
32 S. Brumwell, '"A service truly critical": the British army and warfare with the North American Indians, 1755–1764', *War in History*, 5:2 (1998), 146–75.
33 Dziennik, *The Fatal Land*, p. 120.
34 Bickham, 'A Conviction of the Reality of Things', pp. 35–6.
35 *Ibid.*, p. 40.
36 This and following two quotations, Phillips, 'Reading and writing between the lines', p. 123.
37 R. White, *The Middle Ground: Indians, Empires and Republics in the Great Lakes Region, 1650-1815* (Cambridge: Cambridge University Press, 2012).
38 On the pre-existing cultural environment of material assimilation, see T. J. Shannon, 'Dressing for success on the Mohawk Frontier: Hendrick, William Johnson, and the Indian Fashion', *The William and Mary Quarterly*, 53:1, Material Culture in Early America (1996), pp. 13–42.

39 N. J. Frederickson and S. Gibb, *The Covenant Chain: Indian Ceremonial and Trade Silver* (Ottawa: National Museums of Canada, 1980), pp. 23–33; S. Wood, 'The British Gorget in North America', *Waffen und Kostümkunde*, 26:1 (1984), pp. 3–16.

40 Warnock collection, WC8908007. Available at http://www.splendidheritage.com/Cell/DataPages/WC8908007.html, accessed 31 May 2019.

41 Redoubt Fortress Military Museum, accession register, 3 August 1963.

42 R. Trimen, *An Historical Memoir of the 35th Regiment of Foot* (Southampton: Southampton Times, 1873), p. 200.

43 *Ibid.*, pp. 49–51.

44 N. Hartwell, 'A repository of virtue?: the United Service Museum, collecting, and the professionalization of the British armed forces, 1829–1864', *JHC*, 31:1 (2018), 77–91.

45 Anon, 'Additions to the Museum', *JRUSI* (January, 1873), p. 30.

46 Lieutenant Colonel Sir A. Leetham, *Official Catalogue of the Royal United Service Museum* (London: Keliher & Co, 7th edn, 1924), p. 18.

47 E. Fraser, *Greenwich Hospital and Royal United Service Museum* (London: Wells, Gardner, Darton & Co., 1910), p. 219.

48 'Redoubt Fortress Military Museum, Eastbourne: individual records', *Material Encounters Catalogue* (NMS, 2016), available at https://www.nms.ac.uk/media/1150301/redoubt-ir.pdf, accessed 31 May 2019.

49 G. Quintal Jr., *Patriots of Color, 'A Peculiar Beauty and Merit', African Americans and Native Americans at Battle Road & Bunker Hill* (Boston, MA: Division of Cultural Resources, Boston National Historical Park, 2004); C. G. Calloway, *The American Revolution in Indian Country: Crisis and Diversity in Native American Communities*, Studies in North American Indian History (Cambridge: Cambridge University Press, 1995), pp. 85–107.

50 http://rgjmuseum.co.uk/our-story/history-of-the-museum/, accessed 1 June 2019.

51 Byron, *The King's Royal Rifle Corps Chronicle*, p. 220.

52 http://mediafiles.thedms.co.uk/Publication/ES/cms/pdf/The%20Royal%20Sussex%20Regimental%20Collection.pdf, accessed 1 June 2019.

53 First accessions register of the Black Watch Museum, Black Watch Museum Regimental Archive. On the history of the NMS military collection, see S. Allan, 'Scottish Military Collections', in E. Spiers, J. Crang and M. Strickland (eds), *A Military History of Scotland* (Edinburgh: Edinburgh University Press, 2012), pp. 776–94.

54 On precedence, see D. Ascoli, *A Companion to the British Army 1660-1983* (London: Harrap, 1983), pp. 67–94.

55 'The Royal Green Jackets (Rifles) Museum, Winchester: Individual Records, *Material Encounters Catalogue*.

CHAPTER TEN

Community consultation and the shaping of the National Army Museum's Insight gallery

Alastair Massie

The National Army Museum (NAM), a non-departmental public body funded by the Ministry of Defence, received its royal charter in 1960 and moved from premises at the Royal Military Academy Sandhurst to its present site in Chelsea in 1971. It is the flagship museum of the British Army, dedicated to preserving the Army's history and communicating its role in society, past and present, to the general public. With this aim, the NAM has been closely concerned with maintaining its contemporary relevance and, as a result, had long contemplated plans for redevelopment. When its new director arrived in 2010, these plans received fresh impetus, reflecting a desire to renew the physical infrastructure and to cater for the additional visitors anticipated during the period of commemorations around the hundredth anniversary of the outbreak of the First World War in 2014. This chapter considers how the redevelopment of the galleries at NAM provided the opportunity to renew understandings of collections that were assembled as a result of colonial warfare in the past conducted in regions of the world where the British Army retains an interest in the present day. Through community consultations and workshops held in the run up to the redevelopment, staff at the museum worked with participants to discuss the entangled histories and complex legacies of collections arising from the Panjab, India (during the Anglo-Sikh Wars), West Africa, specifically Ghana (during the Anglo-Asante Wars) and the Sudan, during the Mahdist War.

Redeveloping the National Army Museum, 2010–17

In 2011 the Museum's masterplan was published and, the following year, an application was made to the Heritage Lottery Fund (HLF) for half the cost of a 23.5-million-pound redevelopment. To this the HLF

Figure 10.1 The Insight Gallery at the National Army Museum with, left to right, the Panjab, West Africa and Sudan cases.

responded encouragingly: initial support to take forward the Museum's bid received advance funding of £350,000. Among the commitments that the Museum gave in return was to undertake outreach work which would maintain the Museum's profile while delivering services to 250,000 people over the two years it was intended the Museum would be closed for building work. Transformational change was also promised. New galleries were planned with a thematic approach to the history of the British Army, superseding the chronological galleries developed previously. The themes for these quickly suggested themselves. First, 'Battle', because audience research had shown that the question most often asked was: 'What does it feel like to be in a battle?' 'Soldier' was another, because the second most asked question was 'What is it like to be a soldier?' The third theme was to be 'Army', presenting the British military as an institution and showing its structures and ethos. A fourth was 'Society', to examine how the Army has interacted with society at large from the Civil Wars of the mid-seventeenth century to the present day. There was provision, however, for a fifth permanent gallery, although its rationale took longer to establish. It was provisionally entitled 'Discovery', because it would be adjacent to the museum's new reading room and was envisaged as leading the visitor towards engagement with the library and archive centre.[1] The title held until close to NAM's reopening to the public, when the gallery was renamed 'Insight' in recognition that several other museums already had galleries titled 'Discovery', with 'Insight' suggesting an invitation to engage and reflect (Figure 10.1).

The first approach (or theme) for the Discovery/Insight gallery mooted in 2013 was that it should invite visitors to 'Become a History Detective'. The thematic voice, it was suggested, should be that of 'the Friendly Curator'. Sub-themes included 'Courting Controversy', the

examination of controversial people, topics or terms, as well as of objects with difficult histories; 'Objects in Focus', to explore the way that objects can communicate historic context; and finally 'Object ID', to show how medals, cap badges and photographs could enable better understanding of the British Army's organisational culture and history, and the experiences of those who served.[2]

At the beginning of 2014, the plans for Discovery/Insight were put to a focus group which concluded that the content, while analytical, was too inwardly focused on the functions of the NAM and its own work. From the curatorial perspective, there was also the suspicion that Discovery/Insight was becoming a place where objects which did not easily fit in the other thematic galleries but were deemed too important to omit were to be located. The gallery team continued to grapple with the problem of identifying a unifying theme for Discovery/Insight: a plan was urgently needed because a decision from the HLF on whether it would commit funding for the new National Army Museum was imminently expected (funding would eventually be granted in May 2014). Eventually, the Head of Learning, by drawing upon the 'Vision for Learning and Engagement' he had himself written the year before, won agreement that the document's stated objectives, the developing of 'engagement opportunities and the empowering of communities through involvement in the research, interpretation and presentation of NAM's collection in ways that foster understanding of cultural material and shared heritage', should serve as the gallery's credo. Community engagement was now to be central to the gallery's purpose.[3]

The wider framework within which this method of approaching Discovery/Insight would sit was formulated at the same time. An informed assessment of where the British Army currently had contingency plans to deploy in the event of an international crisis quickly led to the realisation that these were all locations where the Army possessed a history; this, by extension, perfectly illustrated the old dictum that, while times change, interests remain the same. Certainly, British worldwide strategic interests have remained relatively constant over the past two centuries, if not longer. It is also true that, in light of Britain's expansionist imperial past, few other armies have seen service in so many different parts of the world, or have encountered and interacted with a wider range of peoples and cultures. Even today, Britain remains one of the few countries that seek to maintain the military capability to project power worldwide. The historical relationships that the Army forged around the world in the past – both positive and negative – have a bearing on how the Army prepares for future potential operations. Europe, the Middle East, Africa and South Asia remain British preoccupations today just as they were yesterday. A rationale for the gallery had

thus finally been established. Collections relating to the imperial past could be presented with interpretations that linked them to the globalist present. Discovery/Insight's cases would feature objects that had been collected by members of the British Army while serving in different regions of the world; and, in presenting such objects, the gallery would create the opportunity to explore the up-to-date views of those communities upon whom the British Army had impacted historically, with the Army's worldwide impact – reflected in the NAM collection – examined through co-curation and reinterpretation of the relevant material culture.[4]

The securing of different perspectives for Discovery/Insight from a variety of community groups would necessarily draw upon the outreach work that the HLF had required the NAM to undertake (as one of fifty objectives in an activity plan that would earn 50 per cent of matching funding to redevelop the Museum). The successful 'War and Sikhs' project, for instance, undertaken in conjunction with the Anglo-Sikh Heritage Trail organisation, influenced the choice of the Panjab as one of the regions that the gallery would address. Historic Panjab (before the British creation of the North-West Frontier Province in 1901) had extended as far as the border with Afghanistan, and indeed Afghanistan long resented the loss of western Panjab to the Sikhs in the 1810s. Today, British troops are still posted in Afghanistan, as they have been since 2001. This part of the gallery was named 'Empire' in recognition of the fact that, after the British defeat in the War of Independence in what is the now the United States, India became for a time the chief locus of the British Empire. From the 1780s to the 1840s, Britain defeated and conquered a variety of independent Indian states. The last to succumb, during two wars in the 1840s, was the Sikh Kingdom of the Panjab; but its military capability was recognised and its warriors – with a long martial tradition – were considered so formidable that the British pursued the policy of incorporating Sikh soldiers into the army of British India. For 100 years the Sikhs provided the British Indian Army with its shock troops.[5]

The exclusion of East and South-East Asia from the gallery at this stage was perhaps surprising because much existing outreach work, in partnership with the Ming-Ai (London) Institute, had already been undertaken. Indeed, two gilt bronze (over wood) staff finials[6] in the shape of a sculptured dragon's head, removed in 1900 during the Boxer Uprising (1898–1900) from the palanquin (or *jiao*) of the Dowager Empress of China, Tzu Hsi (1834–1908), had been intended to serve as a key object in Discovery/Insight as long ago as planning for 'Be a History Detective'. However, some of the other of the NAM's most interesting objects from China, acquired during the sacking of the Yuanmingyuan,

known to the British as the Summer Palace (now the Old Summer Palace), in the north of Beijing, in 1860, were on long-term loan to the Beaney Museum in Canterbury, so it was decided that other regions of the world would be highlighted, even if the work involved in contacting further relevant community groups and conducting workshops with them would have to begin immediately. The Near East, strategically important because of its natural resources, principally oil, was selected instead for inclusion in the gallery under the theme of 'Resource'. This recognised that successive British governments have used the Army to protect resources, or British access to resources, when a threat to them ran the risk of harming the country's economic interests. And within the Near East, Egypt has long been of especial concern to Britain, at the outset because it lay across the shortest route to India. This prompted a military intervention in 1801 and, after the opening of the Suez Canal in 1869 cut seaborne transit times to India drastically, an occupation of Egypt in order to safeguard control of the canal following the nationalist revolt led by Colonel Urābī Pasha (Urabi Pasha al-Misri, 1839–1911). In a historical example of what has become known in relation to more recent military interventions as 'mission creep', the British subsequently occupied the Sudan. Later, in the twentieth century, Suez became chiefly important to Britain for shipments of Middle Eastern oil through the canal, leading to an ill-fated military intervention in 1956.

The third region to be represented was West Africa. As seen from the British Army's deployments there in the last twenty years – to Sierra Leone in 2000 and again in 2014 – this is an area in which Great Britain pursues an active strategic security policy. That this interest has developed out of a colonial legacy seems clear. One can argue that, looking at global history, it is no coincidence that in 2014, when the West African ebola outbreak occurred, Britain took responsibility for combating the outbreak in Sierra Leone, its former colony, just as France did in its former colony Guinea, and the United States did in Liberia, the state for freed slaves which it had originally sponsored. Calling this part of the gallery 'Legacy' is a retort to the old saying that trade follows the flag – that opportunities for commerce occur in the wake of conquest – because it was otherwise with the British in India, as well as in West Africa; here the Army intervened after trading links were already established. When the Asante kingdom threatened British trade it was subjugated by a series of nineteenth-century British expeditions to the African interior. The removal by the British Army of Asante symbols of power, such as the great brass basin of the *Aya Kese*, served to assert the paramountcy of British authority.

For contrast, the gallery also covered two European regions at home and abroad with which the British Army has distinctive relationships

and where it currently maintains a presence, Scotland and Germany. As a constituent part of the UK, Scotland was located under 'Home', and was a topical subject to consider in this manner in 2014 because of the Scottish independence referendum. The display addressed the warrior culture of clan society, the Jacobite wars and the subsequent incorporation of Highland regiments into the British Army from the middle of the eighteenth century to support Britain's imperial ambitions (a phenomenon which was echoed in the later Sikh experience). 'Alliance' explored the British Army's relationship with Germany, to show that, contrary to popular perception encouraged by two world wars in the twentieth century, Britain has historically cooperated with Germany in maintaining the balance of power in Europe. However, since strictly speaking neither of these regions are part of imperial history in the manner that is addressed in this volume, the focus of this chapter is on those sections of the gallery which treat the Panjab, West Africa and the Sudan.

In developing the above sections highlighting certain regions of the world, it was understood that the tone of the gallery should be carefully considered, and it was hoped that with its multimedia mix of textual interpretation, artefacts and audio and video footage derived from interviews and engagement programmes, a forensic and analytical atmosphere would pervade, a cross between an intelligence headquarters and a laboratory.

Reinterpreting empire:[7] the Panjab case

Within the Discovery/Insight gallery a large display case was set aside for each region of the world being covered. The centrepiece of the Panjab case would be the reconstruction of a fortress turban, or *dastar boonga*, and placed around it would be assorted weaponry, including a sword or *shamshir*[8] associated with the Maharaja Ranjit Singh (1780–1839), ruler of the Sikh Kingdom at its zenith in the first half of the nineteenth century (see Voigt, Chapter 11). The other weapons populating the case included a *khanda* sword,[9] straight with two edges and heavy-bladed; a *pesh-kabz* dagger,[10] originally designed for penetrating chainmail armour and captured from the Sikh army at the Battle of Gujarat, 1849; the *baghnakha*, or 'tiger's claw',[11] a weapon with four sharp claws concealed in the palm of the hand; a *katar*,[12] a stabbing weapon with a grip that enables it to be used at close quarters with the whole weight of the warrior's 'punch' behind it; and a *dhal*,[13] a small steel shield with, in this instance, brass edging, four domed iron bosses and a surface covered with engraved floral patterns and *koftgari* work in silver and brass.

As already stated, the interpretation of the artefacts in this case benefited from workshops and handling sessions previously undertaken with community groups. The 'Brothers in Arms' project, funded by the Esme Fairbairn Collections Fund, had partnered with the United Kingdom Punjab Heritage Association (UKPHA) to introduce NAM curators to specialists in Indian martial arts and Indo-Persian arms. UKPHA also helped facilitate a series of reinterpretation workshops with members of the British Sikh community, the first of which focused on the period of the Sikh empire in Lahore (1800 to 1845) with its highlight the aforesaid *shamshir* linked to Maharaja Ranjit Singh. This was donated to the NAM by Major V. C. P. Hodson, a collateral descendant of Major William Hodson (1821–58), who was notorious for having captured the last Mughal emperor, Bahadur Shah II, during the Indian Uprising of 1857–58, and subsequently executing the emperor's sons, bringing the Mughal empire to a close. Derived from information supplied by the donor, the NAM catalogue credits Maharaja Ranjit Singh as the original owner, and on this basis it is assumed that William Hodson acquired it during the dispersal of the contents of the Lahore Treasury following the defeat of the Sikhs by the British in the First Anglo-Sikh War of 1845–46 (see Voigt, Chapter 11). Hodson, then serving with the 2nd Regiment of Bengal Native Infantry, was present during the occupation of the Sikh capital by victorious British forces in February and March 1846.[14] It appears likely that Hodson changed the hilt to one of 'Mameluke' design, traditionally favoured by British officers, while retaining the Persian blade. In this respect, the sword represents a hybrid of influences in British imperial military culture, since the Mameluke sabres which became fashionable first in the French and then in the British armies were derived from Egyptian Mamluk weapons encountered as these two European powers competed for control of Egypt at the outset of the nineteenth century.

The workshop, however, presented an opportunity to test many of the assumptions made about the weapon's provenance. The gold *koftgari* inscription on the blade, for instance, normally denotes that the owner was a person of note; yet, prior to this workshop, the inscription on the blade had never been translated. Would it substantiate a direct link to Ranjit Singh? High-resolution images of the inscription were sent out to experts recommended by the workshop and the view which emerged was that the sword carried a dedication to Shah 'Abbas of Iran as well as the purported signature of a notable Iranian swordsmith, Asad Allah Isfahani, active 200 years before. At first sight, this surely lent credence to the otherwise questionable contention that this one sword among many taken from the Lahore Treasury really was Ranjit Singh's personal weapon. Excitement at this new revelation, unfortunately,

was somewhat dampened by the emergence of evidence that Indian swords bearing this cartouche are relatively commonplace. In addition, the sword is not of the quality one would expect, nor is the inscription of a high level of craftsmanship. The provenance, it appeared, was not what had been claimed by the documentation, but this casting of doubt on the origins of the *shamshir* notwithstanding, the enthusiastic interest in it expressed by participants in subsequent workshops remained undimmed, with one stating that she felt closer to the Maharaja Ranjit Singh as a result of handling the sword.

The Indo-Persian weapons volunteer session associated with the community engagement programme 'War and Sikhs' was another work-shop which was well-received, with the *khanda* receiving close scrutiny. The sword possessed, according to one participant, 'absolutely amazing balance, nice clear wootz patterning on the top of the sword, beautiful weight to it, a lot of gold detail still left on what I call the *chimta*, or reinforcer'[15] (i.e. the lower half of one side of the blade, blunted to allow the weight of the palm being placed behind it when wielded two-handed). Yet for this particular participant we can perhaps surmise – without, it is hoped, being impertinent – that it was more than simply the sword's ease of handling which commended the weapon to him. The *khanda* gave its name to the pre-eminent symbol of the Sikh religious faith adopted at the beginning of the twentieth century, a symbol which, besides the *khanda* itself, also incorporates two curved *kirpans* – small, critically symbolic daggers given to Sikh initiates – and the *chakkar* – a sharp-edged throwing steel quoit. For this individual therefore, handling the *khanda* might have evoked an engagement with an integral part of Sikh religion and cultural identity expressed through a historic reverence for weapons and martial prowess.

The extent to which weapons are bound up with Sikh identity is best expressed by the *dastar boonga* or fortress turban, traditionally worn by the Akali Nihang, the Sikh warrior order. Of exaggerated height and with fabric of a dark blue hue – the colour of Vishnu and Kali – the fortress turban was bound up with the hair, stiffened by a *tora* (wire braid which also created a protective mesh for the head in battle) and had woven into it a variety of weapons, including *chakkars* and *kirpans*, theoretically employed in combat as a last resort. In one workshop, Sikh martial arts expert Nidar Singh demonstrated how to tie the various layers of the fortress turban, drawing attention to the manner in which the *chakkar*, stacked up around the conical turban in multiple fashion, was used in battle, whether hurled like a frisbee or spun around the finger before being launched at an opponent. Singh surprised other members present by showing how the *baghnakha*, incorporated more rarely in the fortress turban, was not employed as a

knuckle-duster – as the existing catalogue entry asserted – but as a weapon concealed in the palm of the hand, enabling an antagonist to be either raked by its claws or gripped painfully.

As Mangat and Singh Rahal have written elsewhere, 'The turban has long been an article of faith for Sikhs and various changes have taken place in its shape, size and colour across the five hundred years of Sikh history.'[16] To substantiate its authenticity, the reconstructed fortress turban now in the gallery only utilised items with an established provenance. The *chakkars*, for instance, were presented to Colonel F. A. Hamilton by one of the very few Sikhs enlisted in the 8th Indian Light Cavalry,[17] and the *tora*[18] was brought from India by Major-General Boyce Albert Combe, commander of the Rawalpindi District, 1899–1903. The end result allows the visitor to appreciate the *dastar boonga* as something at one and the same time practical and symbolic, with weaponry that could be both protective (*in situ* the *chakkar* was an effective form of armour) as well as employed offensively, and which is literally bound together with materials of real religious significance, such as the *tora*'s *chand*, a half-moon device representative of Shiva.

In so far as the fortress turban was the preserve of the Akali Nihang, who, when Ranjit Singh reorganised the Sikh army – or Khalsa – on Western lines, were relegated to the margins as an irregular force, it is ironic that once the British began recruiting Sikhs into the army of, first, the East India Company, and afterwards that of the Raj, it was the ferocious martial tradition of the Akali, subsequently channelled through the Khalsa, that was most highly prized. Their achievements, moreover, continue to strike a chord, with one young Sikh workshop participant, after witnessing the *dastar boonga* being tied, remarking that the Akali were equivalent to the SAS, the special forces regiment of today's British Army. When the question was later asked of one participant whether it was appropriate that an object such as the *shamshir* associated with Ranjit Singh (or Sikh treasures in other museums) should be in the UK rather than either India or Pakistan,[19] her view was that while a measure of indignation at the historic appropriation of objects might be justified, there was not, in her opinion, any guarantee that if they were in a museum in South Asia they would be better looked after than they currently are in museums in Britain. The questions over where this heritage should best be placed were observed to be complex, not least in light of the later twentieth-century migration of many Sikhs from the Panjab to form Sikh communities all over the world. As a consequence of colonial and post-colonial history, Sikhs living in the UK have access to objects reflecting the clash and subsequent interrelationship between Sikhs and the British Empire, such as the sword in the NAM.

[237]

Reinterpreting legacy: the West African case

As stated, whereas the NAM could draw on existing engagement work to create film content showing members of the Sikh community interacting with some of the artefacts which were selected for display in the Panjab case, it was otherwise with securing community participation to support interpretation of objects in the Sudanese and West African cases. Moreover, access to the Sikh community had been facilitated by one of the NAM's community curators whose own Sikh heritage was an asset in encouraging participation. The museum was however able to secure the assistance of a dynamic curatorial assistant for a year from the arts and education charity 'Cultural Cooperation'. He was able to make fruitful contact with the Green Kordofan organisation – which elicited participants with a Sudanese background for one of the workshops – and Black History Walks, Star 100, Royal Holloway African-Caribbean Society, Asante Development, the Ghanaian Language School and Listen, Speak and Learn, for the West African (specifically Ghanaian) workshop.

The objects chosen for the gallery's West African case were all acquired during the various Anglo-Asante Wars of the nineteenth century (1823–31; 1863–64; 1873–74; 1895–96; 1900). The first three items – a war trumpet made from the tusk of an elephant and covered in stingray skin;[20] a throwing knife or *trumbash*;[21] and an ammunition belt,[22] made of hide with eight charge pouches, five sheaths containing knives, a wooden powder horn and bullet box – were ostensibly battlefield trophies. To provide a contrast, the second three – comprising a so-called 'executioner's cap'[23] acquired by a soldier of the 14th West Yorkshire Regiment in 1896, a small 'stool'[24] removed from the palace of King Prempeh at Kumasi the same year and the symbolic large brass basin, the *Aya Kese*,[25] taken from outside the royal mausoleum at Bantama – could all be described as possessing a cultural significance, acquired as an assertion of political, as opposed to purely military, dominance.

Although the stool, because examples in Asante iconography are both literally and metaphorically perceived as seats of power, was initially regarded by the NAM as the most important object intended for the case, this belief proved incorrect. Research suggested that the *Aya Kese* was much more than simply the sacrificial bowl described by Thomas Edward Bowditch in 1819,[26] but an item of religious and political power which was said by King Prempeh, following his deposition by the British in 1896, to contain the souls of the entire Asante nation.[27] This elevated its significance considerably and raised the possibility that display would elicit the demand for its return to Ghana. A meeting with the Foreign and Commonwealth Office to ask its advice was requested.

Accordingly, when the various objects were presented at the West African workshop held on the premises of Durning Hall, the Aston Mansfield community centre in Forest Gate, London, there was an expectation that the *Aya Kese* would be the chief talking point. Even if its size (approximately 120 cm, nearly 4 ft, in diameter) and weight in the end precluded it being transported to the workshop, there was a series of images, letters, photographs, illustrations and a PowerPoint available to showcase its story. The focus of interest, however, was otherwise. Rather than the religious and cultural artefacts looted from the Asante capital Kumasi in 1874 and 1896 exciting comment, the most significant items to be featured, as far as those attending the workshop were concerned, were the trophies believed to have been taken from the battlefield – the war horn, throwing knife and ammunition belt. The war horn was captured during the First Anglo-Asante War in an otherwise unsuccessful battle fought on 21 January 1824 when the British Governor of the Gold Coast, Sir Charles McCarthy, was killed. By touching it, one participant said that they were able to appreciate the craftsmanship involved in making the war horn and how, by the expedient of covering it in stingray skin, the user's grip would have been improved. Similarly, the throwing knife, brought back from the Fourth Asante War in 1896, and sickle-shaped with a hammered iron double-edged 'beak', was praised for its tactile quality: the fact that it was possible to feel the weight of the weapon and its edge made it a favourite, as did too an appreciation of its unusual design. It did not matter that the knife was actually of Congolese manufacture: the fact it passed through the hands of an Asante warrior demonstrated the vitality of African trade at the time, of the continent's unity as well as its ingenuity, as one attendee put it.[28]

The ammunition belt or *ntoa*, worn around the waist, elicited an empathetic response from participants (Figure 10.2). The belt's purposefulness was commended and the decorative use of cowry shells – traditionally a means of demonstrating wealth in Africa – was considered an appropriate embellishment for the possession of someone who sought to project their status. Although the NAM catalogue entry identifies the *ntoa* as having belonged specifically to a named individual 'Prince Bonny' before passing into the hands of Colonel Evelyn Wood VC, prominent in the Third Anglo-Asante War battles of Amoaful and Esaman (it was eventually donated to the NAM in 1965 in memory of the publisher Sir Newman Flower, a friend of Wood's), no particular emphasis was placed on this evidence when the belt was inspected by the workshop's participants. Instead, the assumption was made that the former owner had been an Asante warrior chief, the original donor having supposed the belt captured from an enemy. As later research

Figure 10.2 Ammunition belt attributed to Prince Charles of Bonny.

established, however, Prince Charles of Bonny was in fact an ally of the British from the coastal Kingdom of Bonny who had been educated in England.[29] The *ntoa* therefore likely falls into the category of a diplomatic gift rather than a trophy. Also, the belt's intricate design, associated with the brown-stained cowry shells which adorned it, now became explicable in terms of the *ntoa* originating from the western African littoral, where seashells naturally abound.

So, for museum staff working on the development of the gallery, a question remained as to why weapons and military equipment were deemed by those attending the workshop to be of greater relevance to them than a religio-cultural artefact such as the stool, which went unremarked upon in the taped interviews, or the executioner's cap, which again elicited no comment (other than the useful information that it was made from the skin of the 'grasscutter' rat). It was perhaps tempting to think that this was because, as with many Sikh respondents, the participants could more readily identify with a heritage of military prowess and resistance, especially in the setting of a military museum. At the same time, the museum has to be mindful of the complexity of national identities, and not assume that workshop participants of Ghanaian background would necessarily identify with cultural or religions aspects of specifically Asante heritage. There was, however, something in common between Ghanaian and Sikh responses to the standard question asked of the workshops' participants as to whether

the objects they had viewed, or others like them, should be 'repatriated'. There was the same disclaimer made that 'perhaps I should be angry' with how some artefacts were 'looted', but perhaps because many participants present at the workshops were second generation residents of the UK, they appeared to be comfortable with the fact that the objects were in Britain where they could be viewed and even, in the context of the Museum's workshops, handled. As it was put by one participant, it was the fact that the Museum now has the objects which becomes the interesting question. Where did an object come from? How did it get here? And how does it link back to Ghana now? In short, the objects became, in an unexpected outcome to the workshop, a key to unlocking the issue of legacy: Ghanaian participants suggested that they had too rarely heard stories relating to their own background, but now that they had, they realised it was a bigger part of them than they had imagined, and that their heritage in this regard was important.

Reinterpreting resource: the Sudan case

When, as explained previously, the concept of the 'Resource' case was that it examined why the British had historically been strategically invested in the control of Egypt, why was the display now highlighting the Sudan? The reason was that the NAM only possessed one artefact from the 1882 Egyptian campaign, a tripod stool,[30] a piece of campaign furniture of Western manufacture reputedly taken from Colonel Urābī Pasha, the defeated leader whose nationalist revolt had prompted the British intervention in his country. Consequently, to develop the necessary content for the display, the NAM in a sense had to replicate what the British had done historically and pivot from Egypt to the Sudan, using objects collected by British soldiers in the course of the two expeditions to the Sudan in 1885 and 1898 led by, respectively, Major-General Sir Garnet Wolseley and Major-General Herbert Kitchener. But, in our doing so, did this not explode the notion that the British presence in a region defined as now including the Sudan had anything to do with the safeguarding of a resource, such as the Suez Canal? Fortunately, to preserve the integrity of the approach, one needed only to identify the motivation behind the final British conquest of the Sudan, which was water, the guarantee of access to which had necessitated the securing of the upper reaches of the River Nile from not only the Sudanese *Ansar*, the Sufi Muslim followers of Muhammad Ahmad, but, as the confrontation at Fashoda would demonstrate, from the French as well. Later, with a certain symmetry, the resource that the Nile represented would help precipitate the final collapse of British standing in the Middle East when Colonel Nasser,

angered by the withdrawal of American and British financial support for the High Aswan Dam, nationalised the Suez Canal in retaliation and set in train the series of events that led to the ill-fated Anglo-French intervention in Egypt in 1956.

The objects chosen for the 'Resource' case included a Sudanese hippopotamus hide shield[31] taken at the Battle of Tofrek in March 1885, an arm knife and scabbard[32] collected by Sir Garnet Wolseley and a *jibbah* coat[33] acquired by General Sir Francis Grenfell from his defeated opponent the Emir Abdel Rahman Wad El Nejumi, who was killed at the Battle of Toski (Tushkah) in 1889. Supplying all of the display's remaining items was a haul of trophies collected after the final crushing defeat inflicted on the Ansar at Omdurman in 1898 (see also Spiers, Chapter 1, and Mack, Chapter 2), including a Persian-style *kulah khud* helmet,[34] a *nihas* kettle drum[35] presented to the British royal family, and a wristlet of Ethiopian gold[36] and a hockey stick-shaped wooden throwing club,[37] both acquired by Major-General Villiers Hatton (1852–1914), who commanded the 1st Battalion Grenadier Guards at the battle.

The fifteen attendees for the workshop held at the NAM's collections storage facility at Stevenage came from Bradford, Sheffield, London and Liverpool, with connections to the Sudan that extended to Khartoum, Kordofan, Darfur and Juba. Few had met before but the facilitator from the Green Kordofan organisation – recognising the long shadow cast over current Sudanese politics by Muhammad Ahmad, the Mahdi, the Islamic leader of the 1880s who had fought the British in the First Sudan War (Mahdist War) – ensured that participants felt content to attend while holding different views of the Mahdi's legacy. A minority of attendees preferred to be filmed in silhouette for their interviews.

The workshop included a respectful exchange of views on the political situation in Sudan today, which in turn informed the discussion of the objects on display. The object that was found most evocative was the *nihas* drum, because of its ubiquity in Sudanese society. The *nihas*, we learned, was used for conveying many different messages: a warning for war, a request for help from neighbours, a call to get in the harvest. The significance of the *nihas* was more poignant for those participants who had been brought up in the Sudan; younger participants favoured the shield, or *daraga*, as they did exclusively, and the *kulah khud*, although in the latter case without elaborating why. The shield reminded one British-born member of the Sudanese community of the accounts he had heard when young about the Ansar commander Osman Digna. Another of the workshop's participants was struck with how efficiently the *daraga* was designed for the purpose it was intended. What looked like a bullet hole through the shield made him speculate as to the fate of the owner.

Consideration of the *jibbah* prompted the most wide-ranging discussion. Because its stylised patchwork was intended to evoke the Ansar espousal of poverty – only threadbare clothing required patching – the workshop's participants expected the example they were shown to project this quality. In fact it was well-sewn, with fine thread work, properly tailored and a design which was far from random and patches seemingly arranged systematically, or 'fashionised' as one participant put it. Another participant commented that they had not seen an example before even in the National Museum of Sudan, so handling one was a novel experience. A third said the NAM should use the *jibbah* that had belonged to the Emir Wad El Nejumi in its display – an equally well-made garment but one which, because it was quilted, was heavier – and, on his recommendation, this *jibbah* was substituted for the one brought to the workshop.

The *jibbah* was the object that provoked debate about the relevance of the artefacts in the workshop, and of the Mahdiyya (or Mahdist era) more generally, to the Sudan of today. For one attendee the *jibbah* was, as an icon of the Mahdiyya, the most powerful object precisely because it linked the past with the present, a present where the Mahdi's great-grandson is still leader of the opposition Umma party and the Mahdi is still revered by many as the man who united the peoples of the Sudan and threw off the yoke of Egyptian (or Turkish, as it is usually referred to) overlordship. Yet there is a further dimension to this. Long-standing political and cultural tensions divide the Sudan between the Arab and Muslim north and the sub-Saharan, predominantly Christian, south. The culmination of the estrangement was the secession of South Sudan in 2011, although instability has remained such that currently 300 British troops are stationed there with a United Nations peacekeeping mission. The majority of participants in the workshop were from the south and regarded the Mahdiyya as a dark time, particularly under the rule of Abdullah Ibn Muhammed, the Khalifa, who succeeded to power on the Mahdi's death in June 1885.

Yet for one participant, whose great-grandfathers on both sides were in the Mahdist movement, the way in which the *jibbah* and *daraga* were made, and the *kulah khud* worn, reflected a civilisation in which the Ansar imbued society with, as he felt, a proper understanding and attitude. He considered that British-produced illustrations of the time which were placed on show in the workshop (and are to be found in NAM's collections) did not reflect the strength and intelligence of the Mahdist movement, and used derogatory stereotypes to portray its adherents. Whereas the objects could speak for themselves, he enjoined the NAM to be vigilant in how it interpreted the story of the Mahdiyya in its captions and descriptive text, suggesting that a more balanced or

[243]

'right' interpretation could help reconnect young people of Sudanese descent with their history, to which another attendee remarked that there could never be a right way to tell a story which suited everybody, and that since so much of what was held in European museums from overseas was, in his view, stolen, technically the only 'right' thing that could be done was to return the artefacts to their country of origin.

Conclusion: the birth of a gallery

In summary, the Sudanese workshop had added another perspective to the understanding of extra-European objects in the NAM already expressed by members of the Sikh and West African communities who had engaged with NAM collections. One participant in the Sudanese workshop summed up a sentiment conveyed through all three of the sets of workshops when he stated that, in his opinion, 'objects remain dead unless they become part of a story of a living community'. In the post-colonial era, where we see the British imperial past increasingly contested in public discourse, the National Army Museum was argu- ably taking a radical step in seeking to reassess collections derived from colonial warfare and present them in terms of heritage that is shared. For a military museum promoting engagement with the his- tory and culture of the British Army and an understanding of the roles it performs in the present day, the considerations which emerged within the community workshops were complex, and the connections between the colonial past and contemporary responses from workshop participants were neither linear nor predictable. The resulting displays embody a more reflective presentation of collections whose origins in colonial warfare tell complex stories, but one where their colonial contexts and the questions they raise are actively addressed, through labels, interviews and interpretations. In the final analysis, it is for NAM visitors to decide for themselves whether the exercise provides additional insight, balance and open-mindedness in presenting these types of collections so that they provoke reflection on the past and the present, which is something they have been able to do, without charge, ever since the new NAM opened its doors in March 2017.

Notes

1 For more detail on this process, see the NAM's Annual Reviews and published Accounts, 2010–17, www.nam.ac.uk/accounts-and-reviews, accessed 3 May 2019.
2 NAM Institutional Archive, electronic files, '(Discovery gallery) History Brief', 20 July 2013.
3 NAM Institutional Archive, electronic files, 'Design Brief Template, Discovery', 15 April 2014.

4 NAM Institutional Archive, electronic files, 'Discovery: Theme, Subtheme, Storyline', 5 March 2014.

5 On the ideology behind the incorporation of distinctive regiments of Sikhs, Gurkhas and Scottish Highlanders into the British and Indian armies, see H. Streets, *Martial Races: The Military, Race and Masculinity in British Imperial Culture, 1857–1914* (Manchester: Manchester University Press, 2004).

6 NAM, 1959-11-228. They were acquired during the Third China War by Brigadier General Alfred Gaselee, who commanded the British contingent of the multinational force that occupied Beijing and liberated the besieged Legation Quarter in August 1900.

7 The sections on the Panjab and West Africa which follow draw heavily upon N. Mangat and J. Singh Rahal, 'Community Engagement and the Re-interpretation of Extra-European Weaponry in the New National Army Museum, UK', in T. Crowley and A. Mills (eds), *Weapons, Culture and the Anthropology Museum* (Newcastle upon Tyne: Cambridge Scholars, 2018). Mangat and Singh Rahal's chapter is, in turn, a substantial re-working of the – by comparison – insubstantial lecture which the present author gave at the Horniman Museum's conference 'Weapons and the Anthropology Museum' in February 2015.

8 NAM, 1951-09-12.

9 NAM, 1956-05-22.

10 NAM, 1970-03-18. The inscription on the reverse of the weapon's tang reads: 'This dagger was taken by the Scinde Horse, from the chief in command of the Affghan Cav[ly] at the Battle of Goozerat and presented by L[t] Malcolm and his brother officers, to Col[l] the Hon[ble] Henry Dundas, commanding the Bombay Division of the Punjaub.'

11 NAM, 1984-07-43.

12 NAM, 1956-05-25.

13 NAM, 1963-10-343.

14 See G. H. Hodson (ed.), *Hodson of Hodson's Horse: Or, Twelve Years of a Soldier's Life in India, Being Extracts from the Letters of the Late Major W S R Hodson* (London: Kegan Paul, Trench, 1883), pp. 13–14.

15 NAM, War and Sikhs: Indo-Persian weapons volunteer session, www.youtube.com/watch?v=4neArxPAviE, accessed 3 May 2019. Wootz was a steel alloy widely used in blade production in India and exported throughout the Middle East and Europe. *Chimta* is ordinarily the name of a Panjabi musical instrument but the resemblance in its appearance to the wootz patterning on the *khanda's* reinforcer means that the term has acquired an additional meaning.

16 Mangat and Singh Rahal, 'Community Engagement', p. 168.

17 NAM, 1957-08-23.

18 NAM, 1960-08-213.

19 This question, intended to prompt the voicing of an opinion on the topical issue of the repatriation of artefacts in British museums, became standard in the West African and Sudanese workshops which followed. It could be objected (and has) that the exercise is self-serving and intended to elicit a desired response, but where the answers made illustrate wider points, and are genuinely illuminating, they have been included in this essay.

20 NAM, 1963-10-187.

21 NAM, 1960-08-15.

22 NAM, 1965-07-13.

23 NAM, 1960-02-47.

24 NAM, 1963-10-227. The NAM's catalogue entry states that 'This Asante stool is known as a *Mmaadwa*, a female stool. In the Asante matrilineal society, this is meant to symbolise the soul of society. The curved seat, as well as the rounded ridges and woodwork, denote the "gender" of the stool.'

25 NAM, 1963-10-182.

26 T. E. Bowditch, *Mission from Cape Coast Castle to Ashantee, with a Statistical Account of That Kingdom, and Geographical Notices of Other Parts of the Interior of Africa* (London: John Murray, 1819), p. 289. Major-General Robert Baden-Powell,

writing in his book *The Downfall of Prempeh* (London: Methuen, 1900), shared Bowditch's view of the primary purpose of the *Aya Kese* before going on to remark 'The bowl has now been brought to England' (p. 13). He himself had in fact removed it from Bantama, later passing it to the Royal United Services Institution from whence it came to the NAM in the early 1960s.

27 E. Akyeampong, 'Christianity, Modernity and the Weight of Tradition in the Life of "Asantehene" Agyeman Prempeh I, c.1888-1931', *Africa: Journal of the International African Institute*, 69 (1999), 279–311.
28 See also Mangat and Singh Rahal, 'Community Engagement', p. 171.
29 E. Wood, *From Midshipman to Field Marshal*, 2 vols (London, 1906), 1, p. 262 mentions 160 men under Prince Charles of Bonny joining the British force for the expedition against the Asante.
30 NAM, 1950-10-13.
31 NAM, 1980-07-42.
32 NAM, 1963-10-285.
33 NAM, 1960-08-101-2.
34 NAM, 1963-10-186.
35 NAM, 1963-05-13.
36 NAM, 1963-11-120.
37 NAM, 1963-11-85.

CHAPTER ELEVEN

Mementoes of power and conquest: Sikh jewellery in the collection of National Museums Scotland

Friederike Voigt

Museum interpretations of jewel-encrusted works of art, enamelled gold and world-renowned gemstones from the royal courts of India tend to emphasise the value of these precious items and their refined artistic taste. The focus on their extravagance and technical perfection seems intended to provoke admiration, and the association with a wealthy elite, individual maharajas or Mughal emperors adds further to their fascination. Given the link of these objects to Indian royalty, it is surprising that the question of how these symbols of power and status became available for acquisition by private and public collections has received comparatively little attention. This chapter provides a strong corrective to that by bringing the complex and entangled history of a small group of Indian gold and silver jewellery in National Museums Scotland (NMS) and its relation to the dispersal of the Sikh treasury in Lahore (Lahore Toshakhana) to the fore.

These ornaments have historically been associated with Maharaja Duleep Singh (1838–93), the last sovereign ruler of the Sikh Kingdom, also known at various times as the Lahore State or Panjab.[1] The museum received the jewels as part of a large bequest of coins by Major Donald Christian Strachan Lindsay Carnegie of Spynie and Boysack (1840–1911) in 1911. Over the past century, their interpretation in the museum context has shifted from being seen as striking curiosities and representations of Duleep Singh's ostentatious lifestyle in exile to providing a source for the reassessment of the historical relation between India and Britain.[2] In their portrait of the Maharaja, 'Casualty of War' (2013), British Sikh artists The Singh Twins contrasted their personal views of the jewellery as remnants of the former splendour and power of the Sikh Kingdom and as spoils of war and conquest.[3] The exhibition 'Indian Encounters' at NMS in 2014–15 interpreted these objects as testimonies of personal experiences of the British Empire. The display

juxtaposed mementoes brought back by Archibald Swinton (1731–1804), a captain in the East India Company's army at the time of Britain's early military expansion into India, with the belongings of Maharaja Duleep Singh, who lost his kingdom to the East India Company and lived for most of his life in exile in Britain. For a group of young Sikhs from Glasgow the exhibition became a source to explore their cultural roots in Scotland and to create responses to these historical objects from a contemporary Scottish-Sikh perspective.[4] Recently, Anindya Raychaudhuri has analysed Duleep Singh's life story and The Singh Twins' intellectual and artistic involvement with him in 'Casualty of War' in the framework of nostalgia and home in order to demonstrate how Duleep Singh as the first British citizen of Sikh descent and his legacy have contributed to the building of emotional and intellectual spaces where British Asians can find meaning and identity.[5]

The main events that led to Maharaja Duleep Singh's deposition and his exile from Panjab are as follows. Duleep Singh succeeded his father Ranjit Singh (1780–1839) on the throne of the Sikh Kingdom in 1843. As he was still a minor, his mother, Maharani Jind Kaur (1817–63), acted as his regent. The British recognised Duleep Singh as the legitimate heir and continued the peace agreements they had concluded with Ranjit Singh. At the same time, they watched the internal weakening of the Sikh state and the political division of its leaders with a view to occupying Panjab. As the Governor-General of India, the Earl of Ellenborough (1790–1871), stated in a report in May 1844, 'Everything is going on there as we could desire, if we looked forward to the ultimate possession of the Punjab.'[6] Without delay, Ellenborough prepared the British Army for a possible conflict.[7] As a result of the strengthening of the Company's military presence along the Sikh–British frontier of the Sutlej River, diplomatic tensions between the Sikh state and the British government in India increased, with Sikh forces eventually crossing the river in December 1845.

The defeat of the Sikh army at Sobraon two months later and the occupation of Lahore by British troops terminated the First Anglo-Sikh War. Although Duleep Singh was reinstated on the throne, the Treaty of Lahore, which he signed on 9 March 1846, forced him to surrender to the British the region south of the Sutlej and significant territories between the rivers Beas and Indus which later became the princely state of Jammu and Kashmir. An additional agreement from December 1846, commonly known as the Treaty of Bhyrowal, gave the British government nearly unlimited power over the internal and external affairs of the Lahore State. Its terms dictated that for the protection of the young Maharaja and the support of his government a British resident would be installed at the court in Lahore.[8] The Maharani Jind

Kaur was prevented from exerting any further political power. She was replaced by a Council of Regency formed of Sikh leaders who acted 'under the control and guidance of the British Resident'. These measures prepared the Sikh state for its complete subjugation which the Earl of Dalhousie (1812–60) pursued from the moment he took office as Governor-General in January 1848. He saw this as a step 'indispensible [sic] to the security of the British territories' in India.[9]

In October of the same year, Dalhousie declared the Lahore State directly at war with the British government, a decision which placed the resident in the capital in a dilemma: 'We cannot continue to protect and maintain a state which we declare to be at war with us.'[10] Although Duleep Singh was under the guardianship of the British government, and in the words of Lord Ellenborough 'a mere child' who had 'practically been a prisoner for many months', Dalhousie held him responsible for the Second Anglo-Sikh War (1848–49) which was triggered by Sikh uprisings against the British interventions in Panjab. Dalhousie subsequently forced Duleep Singh to abdicate.[11] Concerns expressed by Henry Lawrence (1806–57), the resident at the time, over the annexation of Panjab and the deposition of the Maharaja as 'unjust' and 'impolitic' in the light of the British government's promises to him were rejected by Dalhousie.[12] Consequently, Duleep Singh lost his throne, his entire property was confiscated and he was sent first to Fatehgarh and in 1854 to Great Britain.

Duleep Singh's story has become well known over the last twenty years. The loss of his kingdom, his tragic life in exile and his unsuccessful later rebellion feature in narrative histories of his life. They have inspired artworks, video games and the film 'The Black Prince' (2017).[13] This chapter is rather centred on a particular moment in this history – the dispersal of the Lahore Toshakhana, the treasury of the Sikh Kingdom, which once included Duleep Singh's jewellery now in the NMS collection. Revisiting archival documents and published personal accounts of the time, I locate these ornaments in the events that followed the Maharaja's surrender at the end of the war in 1849. I uncover their trajectories as they moved from being the possessions of an Indian sovereign ruler to those of the Governor-General of India and finally to the ownership of a Scottish collector, and disentangle their complex narrative.

When the jewellery items were sold in London a few years after the Maharaja's death in 1893 by his son and heir, Prince Victor Duleep Singh, it was a legal transaction far from the battlefield. The injustice that preceded this sale has, however, become an inherent part of the meanings attached to these enamelled bracelets, emerald studded pendants and gold vessels in the museum's collection. Equally, the

personal experiences of the British Empire in India by their respective owners, from Maharaja Duleep Singh to the Earl of Dalhousie and Major Lindsay Carnegie of Spynie and Boysack, have invested these objects with layers of different messages. These ornaments therefore not only represent what the Maharaja once possessed but they also stand as symbols of everything else that was taken from him by agents of the British Empire. In the process of unfolding this history it will become clear that both Duleep Singh himself and his jewellery were trophies of war and conquest.

Lindsay Carnegie of Spynie and Boysack: A collector's passion

Lindsay Carnegie's jewellery collection included items linked both directly to Maharaja Duleep Singh and indirectly through Dalhousie's collection. They came to Britain in different ways but originated from the same source – the dispersed Lahore Toshakhana. Why and how did Lindsay Carnegie acquire these pieces?

Lindsay Carnegie of Spynie and Boysack was first and foremost a numismatist. It seems that out of a general interest in metalwork and more specifically in the workmanship of precious metals, he assembled a collection of coins and a number of artefacts, including Maharaja Duleep Singh's jewellery. Unfortunately, not much is known about Lindsay Carnegie's life. In the introduction to his review of Lindsay Carnegie's coin collection, Nicholas Holmes gives a few facts on the collector's military career in the British Indian Army and later, his numismatic activities in Britain.[14] Born in 1840, the sixth son of William Fullarton Lindsay Carnegie of Spynie and Boysack,[15] Lindsay Carnegie was commissioned into the Bengal cavalry in 1858 and retired as a major after twenty-three years of service.[16] On his return to Scotland he settled in St Andrews in the early 1880s, where he lived as a respected member of the local society until his death thirty years later.[17] Lindsay Carnegie clearly possessed substantial financial means – he left an estate worth over £60,000 (five million pounds sterling today)[18] – which allowed him to dedicate his life to collecting.[19]

His numismatic collection, although unpublished during his lifetime, was recognised by his contemporaries as 'one of the best, if not the best, collections known of British gold coins from the time of the Black Prince down to the present day'.[20] Strangely, this appraisal overlooked the substantial number of Indian coins which constitute about one quarter of the more than 3500 coins in Lindsay Carnegie's collection. Given their breadth – they range from ancient Indo-Greek coins to copper, silver and gold coins of the Mughal Empire, to British India issues – it is likely that Lindsay Carnegie arrived in India with an

interest in numismatics and made his first acquisitions while he was serving there in the military.[21]

This is supported by the 106 artefacts that formed part of his collection, the majority of which (a total of seventy) come from India.[22] As with the Indian coins, no primary sources which could reveal the circumstances of acquisition seem to have survived. However, in a few instances there are labels in Lindsay Carnegie's handwriting still attached to items which demonstrate how meticulously he noted down facts that were of importance to him.[23] We can therefore assume that the more detailed information on objects in the museum register originates with him too and was transferred from labels that were sub- sequently destroyed. The conclusions that follow, regarding the manner in which he assembled his collection and his criteria for collecting, draw from this register.

An analysis of the relevant entries shows that there are two distinct attributions for Carnegie's Indian artefacts. The first group includes objects associated with a specific place name in India. There are cast bronze figures of Hindu deities from southern India and gold and silver ornaments and brass, copper and tinned utensils and vessels from nor- thern India. The detailed information on the provenance of some items, referring to a particular valley or group of people, suggests that he bought these items while he was in India. The acquisition of these artefacts, particularly those made from gold and silver, was consistent with his collecting focus on metal coins. The brass and bronze items might reflect on his interest in different decorative techniques, or in the use of metal in combination with other materials such as leather, shell, glass and coral.

For the second group of objects the register provides the name of a private collection or an auction house as source of acquisition. It is likely that Lindsay Carnegie started collecting these items after his return to Scotland, initially employing Spink and Son, a specialist for metal collectibles, to buy coins for him.[24] The artefacts in his collection that are associated with Maharaja Duleep Singh were also purchased for him by Spink and Son. These items were sold by Prince Victor Duleep Singh at Christie, Manson and Woods' in London in 1899.[25] The 114 lots of this sale included 'Indian gold jewellery', 'Indian pure gold vases, cups and bowls' and 'silver ornaments' which were 'formerly the property of the late Maharajah Duleep Singh and the Maharajah Runjeet Singh, of Lahore'. All seventeen numbers entered in the museum register with the description 'formerly the property of Maharaja Duleep Singh' can be matched with the respective lots in Christie's sale cata- logue that were bought by Spink. The price realised for these seventeen pieces amounted to £260.00, equivalent to a sum of £26,500 today.[26]

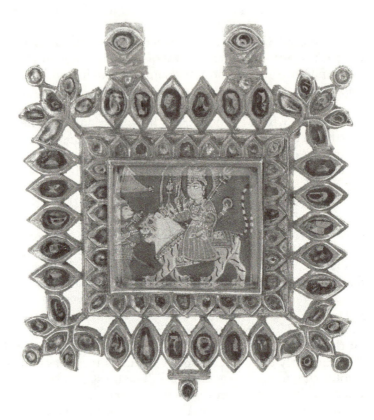

Figure 11.1 Pendant (amulet) of gold inlaid with rubies, emeralds and peridot and with a casket at the back. Beneath the central rock crystal the triumphant Hindu goddess Durga riding on a lion-tiger, preceded by Hanuman carrying a battle-standard. Northern India, 1800-1850. Formerly in the possession of Maharaja Duleep Singh (1838–93).

Among the pieces Lindsay Carnegie acquired in this way were items of pure gold such as a pen case and a drop-shaped betel box; bracelets, earrings and a rose-water bottle made of enamelled gold; and small figures of Hindu deities, incense burners and an antimony holder all made from silver (Figure 11.1).

A year before these ornaments were sold at Christie's, a larger number of items related to the Sikh court had become available at Dowell's in Edinburgh. *The Unique and Exceedingly Valuable Collection of Oriental Arms, Armour, and Objects of Eastern Art, of Supreme Historical Interest Which Came into the Possession of the Marquis of*

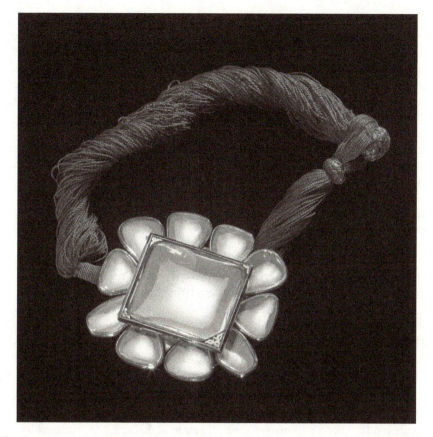

Figure 11.2 Armlet (*bazuband*) of gilded silver set with large stones of rock crystal and attached crimson silk threads to fasten it around the upper arm. The back is made of gold and enamelled in translucent red, green and dark blue with a flower vase. Northern India, 1800-50. Formerly in the collection of the Earl of Dalhousie (1812-60).

Dalhousie, K.T., When Governor-General of India, 1848–55 was very prestigious and Dowell's was fortunate to be asked to handle it.[27] The NMS register states for eight pieces in Lindsay Carnegie's collection a connection to the Earl of Dalhousie, who had been made a marquess in 1849 in recognition of the annexation of Panjab. One item, an armlet (Figure 11.2),[28] seems to match the description of lot 404 in Dowell's sale catalogue, 'Silk armlet with large crystal encircled by ten smaller crystals; finely enamelled back'.[29]

Unfortunately, the catalogue does not provide information on previous ownership or place of origin for any of the items that were acquired at this sale by Lindsay Carnegie. The silk armlet with its

large crystals set in gilded silver is nevertheless very similar to an upper arm ornament, or *bazuband*, which Duleep Singh's half-brother and immediate predecessor to the throne of Panjab, Maharaja Sher Singh (r. 1841–43), is wearing in a portrait by the Hungarian painter August Schoefft (1809–88).[30] The *bazuband* can therefore be assumed to come from the Sikh court. For the other seven pieces which Lindsay Carnegie acquired from Dalhousie's collection it is currently not possible to establish a Sikh connection, nor can they be identified unambiguously in Dowell's sale catalogue. They include two chased silver boxes (lot number 414 or part of 415), a figure of Buddha in gold and silver (lot numbers 395, 396 or 397), a pair of chased and perforated silver anklets (possibly lot number 398), a silver bracelet of interlaced wire (lot number 400) and two silver filigree card cases (part of lot numbers 400 or 415).[31] Lindsay Carnegie's name does not appear among the bidders in this auction, which suggests that he had the services of an agent there as well.

Because of the lack of written records we can only speculate about Lindsay Carnegie's motivation in acquiring these personal ornaments. Christie's emphasised in their catalogue the provenance of the Indian gold jewellery as 'formerly the property of the late Maharajah Duleep Singh and the Maharajah Ranjeet Singh of Lahore', while Dowell's enthusiastically marketed the sale as an opportunity for buyers to participate in what the catalogue describes as Dalhousie's personal triumph:

> On the termination of the Second Sikh War, 1849, the Punjaub was annexed by Lord Dalhousie. Of the treasure at Lahore accumulated by Runjeet Singh, which came into Lord Dalhousie's possession, was the Koh-i-noor diamond (now in the imperial crown), the emerald cup and bow ring mentioned below, and all the Sikh swords, daggers, armour, etc.[32]

In contrast to the auctioneers' advertisement, the historical association, splendour or exclusiveness of these items does not appear to have been a crucial selection criterion for Lindsay Carnegie. His purchases were modest compared to the significance of the mementoes available on both occasions. The sales at Christie's and Dowell's undoubtedly provided an opportunity for him to buy Indian material of good quality which complemented his existing collection of gold and silver jewellery from northern India. There is no evidence that the association of these items with the names of Maharaja Duleep Singh and the Marquess of Dalhousie added to their value in his eyes. The wide range of jewellery techniques represented in the gold and silver items from across the South Asian subcontinent in Lindsay Carnegie's collection suggests

that his primary interest was the working of precious metals and the skills it involved.

The Lahore Toshakhana: the dispersal of Maharaja Duleep Singh's possessions

With the annexation of Panjab, the Governor-General, the Earl of Dalhousie, achieved what he thought had long been overdue – receiving for the British government the benefit of and recognition for the administration of Panjab through its possession.[33] He turned his attention immediately to the liquidation of the Lahore Fort (or as it was known by the British at the time, Lahore Citadel), including the disposal of all the moveable property belonging to the Lahore State. His resolution was driven by two considerations, the prospective financial gains and the immense symbolic value of some of its treasures. I first address the strategic decisions influencing the sale of the property and their effect on Duleep Singh. Dalhousie took overall responsibility to ensure that the maximum profit would be achieved for the East India Company. His political mind, on the other hand, was preoccupied with the creation of memorials of the conquest and annexation of Panjab by the British. In the subsequent section, I deal with the extraction of historically significant items or groups of objects from the Lahore Toshakhana by Dalhousie and, specifically, the Sikh treasures he personally acquired.

Following the defeat of the Sikh army in the last and decisive battle of the Second Anglo-Sikh War at Gujrat, the Maharaja Duleep Singh assembled his court for the last time on 29 March 1849. The sole purpose of this durbar, held publicly at the Lahore Fort, was the signing of the terms granted to him by the Earl of Dalhousie, on behalf of the East India Company. Members of Duleep Singh's Council of Regency had been consulted the night before, but had been left with no choice but to agree to Dalhousie's conditions. At the age of ten, Duleep Singh relinquished for himself and for his heirs all rights to the sovereignty of Panjab. The terms stated that Duleep Singh would retain his title and receive annually four lakh (400,000) rupees as a pension for himself, his relatives and the servants of his late government, under the proviso that he remained obedient to the government of India and resided at a place selected for him by the Governor-General.[34]

Most important for this chapter is the second clause of the agreement. It determined the confiscation of state property 'of whatever description, and wheresoever found' to the East India Company.[35] The scale of this administrative decision is difficult to comprehend from this sentence alone and yet it is often used to describe the course of the events

at the time. In a letter to his wife Lena, Dr John Spencer Login (1809–63) explains, from his perspective as Duleep Singh's guardian, the impact this clause had on his ward's life:

> [. . .] every article of property in the possession of the Maharajah was declared to be State property, and appropriated by the British Government under the terms which had been granted to him; his Highness being merely permitted to retain, by the courtesy of the Governor-General and the local authorities, such articles as were considered necessary for his personal use.[36]

Login, who previously had been employed as a surgeon in the East India Company, was appointed Governor of the Lahore Fort on 6 April 1849 and placed in charge of the young Maharaja.[37] His letters from this time, published by his wife in 1890, are one of the main sources used here to reconstruct the range and value of the confiscated property in the fort and the sequence of events through which it was dispersed. Login's reports are supplemented with information held in the British Library's India Office Records and from British Parliamentary Papers. The following account is as comprehensive as these available sources currently allow.

Over the nine months following his appointment Login prepared and carried out the gradual liquidation of the Lahore court under the supervision of the Board of Administration that governed the annexed Sikh Kingdom, now the Panjab province. He was expected to discharge former government servants and reduce Duleep Singh's retinue, which he accomplished promptly. His empathy and ability to listen helped him to deal effectively with the wide range of people he was responsible for. Although Login recommended most of them for pensions and gratuities, his efforts were nevertheless recognised as saving the British government large sums of money.[38] Without formal training as civil administrator, Login found the itemising of the belongings of the Lahore court an arduous task. The rich contents of the Lahore Fort had stayed untouched during the war. The British presence in Lahore from 1846 had prevented theft and made it a safe place to store state property removed from elsewhere. Login arranged for the review of all types of property, from livestock to costly furniture, valuable dresses and pictures in the Farashkhana (servants' quarter) and the Maharaja's gold, silver, brass and copper vessels in the custody of the commandant and the cooks. Stores with Ranjit Singh's camp equipment, including cashmere tents, carpets and curtains, were inspected, as were magazines with guns and ammunition. On the basis of Login's inventories, the board of government in Calcutta (Kolkata) steadily released groups of property for disposal. Elephants and camels, carriages, gold and silver trappings, horses, mules and breeding mares were sold in a public auction in Lahore in May

1849.[39] In August Login received orders to sell the embroidered elephant *jhuls*, large carpet-like coverings for the animals' backs.[40] If a good result seemed unlikely, objects were retained, as in the case of the shawl, the satin and the silk tents.[41] In a few instances the sources give sale proceeds: the grain stored in the fort yielded more than four thousand rupees, while distilled waters, preserved and dried fruits and drugs, which were cleared from the Maharaja's Gulabkhana (royal distillery), generated nearly two thousand rupees.[42]

The most valuable part of the confiscated property, however, was the Lahore Toshakhana. Through its association with Ranjit Singh and as the place where the famous Koh-i-Noor diamond was kept, it captured the imagination of British officials visiting or resident in Lahore at that time. Login, who had been made keeper of the treasury, set a particular day in the week to reduce the disruption of his work caused by the frequent requests to see the former Lahore Toshakhana. Lady Login's cousin was one of those who marvelled at its unimaginable wonders:

> I wish you could walk through that same Toshakhana and see its wonders! The vast quantities of gold and silver, the jewels not to be valued, so many and so rich! The Koh-i-noor, far beyond what I had imagined; and perhaps above all, the immense collection of magnificent Cashmere shawl, rooms full of them, laid out on shelves, and heaped up in bales, . . . [43]

Login made the Toshakhana his personal responsibility. Working with Misr Makraj, the treasurer to all the former Sikh Maharajas, he drew up lists and statements of the entire contents from April 1849. He audited valuable drawings and costly fabrics and counted bags full of precious rings. He estimated that the state jewellery alone would probably be worth a million, with individual rings valued at 6,000 rupees.[44] By June he had arranged the jewels in purpose-made boxes and a month later the inventory of the Lahore Toshakhana was ready to be sent to the Governor-General. In addition to the jewels the list included 761,743 rupees in uncoined gold and 127,185 rupees in silver, cashmere shawls at a value of 123,988 rupees, silks of 74,850 rupees and the contents of the arsenal estimated at about 800,000 rupees.[45] Login awaited orders as to their disposal. No decisions were made until December 1849, however, when Dalhousie visited Lahore and the Toshakhana and also saw the Koh-i-Noor for the first time. Following this visit, the government appointed the Calcutta firm Lattey Brothers & Co to sell the largest part of the confiscated Toshakhana property including the most significant items. By the time this decision was made, Login had left Lahore to accompany Duleep Singh into exile in Fatehgarh.

Lattey Brothers expected to auction the identified lots within three months. The process was, however, delayed and the government did

not sanction the sale until the end of August 1850. In addition, Dalhousie requested to be sent each sale catalogue for his approval at least a month prior to the items being advertised. The treasury was finally sold in Lahore in what appears to be nine auctions, each spread over several days, between about October 1850 and March 1851. We know that on at least one occasion 800 copies of sale notices were circulated.[46] However, when Duleep Singh later campaigned for compensation for his losses through these sales, he was able to discover the catalogues of only two auctions, one of which took place on 2 December 1850 (seventh sale) and the other one on 10 February 1851.[47] Each catalogue listed about a thousand objects: fabrics and clothes; cashmere shawls; crystal and jasper cups and vases; plain and enamelled silver drinking vessels and rose-water sprinklers; perfume holders; a gold jewellery set with imitation diamonds and real emerald drops and valuable pearl necklaces; silver gilt and enamelled bangles, anklets, nose and toe rings, forehead ornaments and earrings; gold armlets set with diamonds and rubies; a holder for plums worn in the turban; a gold elephant and horse trappings; silver tent poles and large tents; firearms and swords; and miscellaneous items such as a jewelled looking glass, miniatures of Ranjit Singh and a small assortment of elegant English jewellery. The auctions in December and February were very likely consecutive sales, which Susan Stronge believes were the last two and contained the most valuable material.[48] There is, however, evidence of another sale, probably held in March 1851. Lattey Brothers submitted the sale proceeds only at the end of April 1851, which completed their commission.[49]

On the demand of traders in Lahore, a further 54 ingots of gold in the Toshakhana, valued at 193,379 rupees were disposed of in June 1851.[50] The remaining miscellaneous items in the treasury – still enough to fill eleven sales – were sold by the Lahore auctioneers Messrs. Gibbon & Co between March and June 1852. These must have been less valuable articles, given that only about 30,000 rupees were achieved in the first four auctions.[51]

The Lahore State jewels, not including the Koh-i-Noor, had been valued by Login at 1,641,035 rupees. The total amount realised by the Toshakhana sales was 1,658,803 rupees, or about 17 million pounds sterling today.[52] The East India Company's net proceeds, after the auctioneers' commission had been deducted, amounted to 1,575,857 rupees. Dalhousie considered the result satisfactory.[53]

The Company's gains were Duleep Singh's loss. Dalhousie's terms left the Maharaja in a position worse than that of some of the members of his Council of Regency, whose *jaghir*s, or grants of revenue from estates, which had been endowed to them by the Sikh state, were confirmed. It was Login's responsibility to select those items from the

state property that he considered necessary to the deposed Maharaja. On 10 April 1849 Login wrote already with Duleep Singh's move into exile in mind 'Now that I know what I can keep for him out of the accumulated property, I must take care that his possessions are not diminished by robbery or pilfering. What he does not require to take with him I shall have sold for his benefit, and purchase Company's paper for him.'[54] In this respect, Login had the full support of the Board of Administration, Henry Lawrence, his brother John and Charles Grenville Mansel.[55] Login was aware of the sensitivity of his position as keeper of his ward's former possessions: 'I am most careful not to take any advantage of my position in any way, for it is a most delicate one with respect to my little charge.'[56] In letters to his wife, Login more than once expressed his hopes for Duleep Singh. He expected that the Maharaja would be able to live a lifestyle at least equivalent to that of a member of the British aristocracy, 'considering what *he* has lost, and *we* have gained'.[57] Login was anxious to impress Dalhousie with the beautiful surroundings in which Duleep Singh had grown up, and to influence in this way his decision on the Maharaja's exile. Among the special objects Login had in mind for Duleep Singh were Ranjit Singh's splendid tents and the so-called silver bungalow.[58] The latter object exemplifies Login and Dalhousie's opposing perspectives on Duleep Singh and the Lahore Toshakhana. The bungalow was made for Ranjit Singh in Kashmir, a place famous for its distinct silverwork. Large enough for children to play in, Login wished that Dalhousie would agree for it to be given to Duleep Singh or that the Maharaja could present it to the Prince of Wales together with a set of armour and dresses that had already been selected.[59] Dalhousie's plans were, however, different. He thought the bungalow would not sell for anything but its value as old silver, estimated at 35,000 rupees, and suggested it for acquisition into the museum of the East India Company.[60] The East India Company's Court of Directors in turn decided that the item had 'no value as a subject of curiosity' and should therefore be sold.[61] The silver bungalow was finally broken up and the bullion remitted to Bombay (Mumbai) for coinage. It yielded an assayed value of 69,514 rupees.[62]

In addition to the items of personal use Login had permission to select for the Maharaja, Dalhousie allowed property from the confiscated treasury to the value of one lakh (100,000) rupees to be retained by Duleep Singh.[63] This is about 6 per cent of what the East India Company gained later from the sale of the property. No complete record has come to light so far of the items Login chose, but it seems likely that at least some of Duleep Singh's possessions sold at Christie's in 1899 came from the Toshakhana.[64] One item, a large horse ornament set with emeralds and diamonds (lot 46), is explicitly associated in the catalogue

with Maharaja Ranjit Singh. Among the items Lindsay Carnegie acquired are three *makara*-headed bracelets (lots 39–41) and the breast pendant (Figure 11.1) with an image of the Hindu goddess Durga (lot 27). Contemporary depictions of Ranjit Singh suggest that they might also date from his time.[65] Until further proof has been found, the catalogue can give an impression of what Login's jewellery selection for Duleep Singh might have looked like. Seventy-eight of the 109 lots with Indian objects listed gold ornaments, many of them enamelled and studded with precious stones: thumb rings and head and nose ornaments; finger rings; bracelets, anklets, pendants and necklaces; jade amulets, brooches, turban ornaments, snuff bottles and antimony holders; horse head ornaments, gold inlaid daggers, rose-water bottles, cups, arm guards, figures of Hindu deities, a fly whisk, a sword belt and a child's shield. A further seventeen items – ewers, beakers, bowls and a writing case – were of pure gold. The remaining fourteen lots were silver, copper and brass ornaments: figures of deities, incense burners, boxes, armlets, writing cases and a silver service.

Dalhousie's jewellery allowance of one lakh rupees formed part of the personal belongings Duleep Singh was permitted to take with him when he left Panjab on 20 December 1849. Through the allocation and careful selection of these possessions, after everything had been taken away from him, British officials contributed, piece by piece, to the creation of a new identity for Duleep Singh.

Peerless mementoes: the Earl of Dalhousie's acquisitions from the Lahore Toshakhana

In the Governor-General's opinion the confiscation of the Sikh property was essential for two reasons. Firstly, to pay off the debts due by the Sikh state to the British government of India, resulting from liabilities of the Treaty of Lahore from 1846, and as compensation for the expenses of the Second Anglo-Sikh War. Secondly, and more importantly, he was anxious not to leave any assets that Duleep Singh could use to challenge British rule in Panjab in future.[66] His confiscation of the state property and Duleep Singh's removal from Panjab followed the same logic as deposing the Maharaja – to erase any memory of an independent Sikh nation.[67] In Dalhousie's eyes, nothing in the Lahore Toshakhana embodied Sikh sovereignty more than the Koh-i-Noor. He excluded in the terms the diamond, historically a symbol of defeat, from the confiscated property and determined that the Maharaja should surrender it to Queen Victoria.[68] This decision was not undisputed by the East India Company. In a postscript to a letter announcing that the Koh-i-Noor was on its way to London, Dalhousie impressed passionately

on Lord Broughton, the President of the Board of Control, not to allow the Company's Court of Directors to present it to the Queen because 'it is her own, surrendered to her by Dhuleep Singh . . . her own spoil surrendered by her enemy, and which ought to be delivered to her minister for her'.[69] As Dalhousie saw it, the Koh-i-Noor had 'become in the lapse of ages a sort of historical Emblem of Conquest in India. It has now found its proper resting place.'[70]

Following his visit to Lahore and the Toshakhana in December 1849, Dalhousie reserved further items of the treasury for other purposes than sale. For Queen Victoria he selected two of the best and most complete sets of arms and armour once belonging to Maharaja Ranjit Singh, remarkable for their beauty and historical associations; for the Prince Consort the sword presented to Ranjit Singh by the Maratha ruler Maharaja Yashwant Rao Holkar on his retreat after defeat by Lord Lake's army; for the Court of Directors two sets of armour and the so-called Sword of Rustam, notable for its ancient blade; and singular books and documents worthy of preservation in the East India Company's museum in London. The Court of Directors, furthermore, ordered the Golden Throne to be transmitted to London.[71] All these objects were selected for their symbolic rather than material value. While Dalhousie was resolved not to leave any mementoes to the Sikhs, he created new tokens of historical significance for the Empire and himself. He was given permission by the Court of Directors to retain for himself a collection of weapons associated with the Tenth Guru Gobind Singh:

> if the Court are not solicitous regarding them I should feel gratified by receiving their permission to purchase them from the Toshakhana for myself. They have naturally much interest in my eyes; and would form a Memorial which would hereafter be highly prized as well by myself as by those who may follow me.[72]

Dalhousie acquired other historically significant pieces from the Toshakhana, such as a cup and an archer's ring, each carved out of a single emerald. Interestingly, the ring had a history of conquest very similar to the Koh-i-Noor. Both stones once belonged to the Afghan ruler Shah Shuja Durrani (1785–1842), who lost them to Ranjit Singh in 1813. The cup and the bow ring were offered for sale by private treaty when a part of Dalhousie's collection in the possession of his eldest daughter, Lady Susan Georgiana Broun (1837–98), was sold at Dowell's in Edinburgh in December 1898.[73] Both pieces remained unsold and stayed in the ownership of Lady Susan's husband, William Hamilton Broun, for at least another decade.[74] Kunz believed in 1917 that the ring had come into a private collection in Philadelphia.[75] It is very likely that more items in the auction catalogue came from the

Sikh court but only a few have a provenance, such as two gold inlaid suits of armour associated with Duleep Singh (lot 37 and 44), a guru's *kalgi* (lot 388) and several items by Mulraj (1814–51), the Dewan of Multan, who led the Sikh rebellion against the British in the Second Anglo-Sikh War (lots 391, 392 and 416). The silk armlet Lindsay Carnegie acquired from Dalhousie's collection was among the forty-odd pieces of oriental jewels, deities, girdles, anklets and silver boxes with hardly any provenance attached.[76]

Conclusion

Ironically, Dalhousie's ambition to eliminate any memory of an independent Panjab has contributed to the development of a contemporary global Sikh identity. Duleep Singh has become a symbolic ancestor to British Sikhs, and artefacts linked to the last Maharaja and the Sikh court in Lahore connect Sikhs worldwide in their search for identity. In 2018, the London-based collector Davinder Toor acquired a pair of Maharani Jind Kaur's earrings for over £180,000. As he explained, it is not a question of to whom such items should belong but how they can be shared as legacies of Anglo-Sikh history.[77]

The jewellery Dalhousie permitted Duleep Singh to retain, and which the Maharaja took with him to Great Britain in 1854, has inspired new mementoes. In their portrait of the Maharaja in 'Casualty of War' The Singh Twins have embedded the pieces in the NMS collection in the visual narrative of his story. The painting has since created its own trajectory, being displayed in places that are associated with Duleep Singh's life in Britain. In 2013, his portrait was unveiled at Stromness in Orkney, the birthplace of Duleep Singh's guardian, Sir John Login. During the 'Thetford and Punjab Festival' in 2018 it was the centrepiece of a special exhibition at Ancient House Museum in Thetford, Suffolk. The festival celebrated the cultural link between Thetford and Panjab, commemorating Duleep Singh, who lived at nearby Elveden Estate from 1863 to 1886 and is buried in the churchyard of St Andrew & St Patrick in Elveden. When The Singh Twins were invited to participate in the Royal Academy Summer Exhibition in London in 2016, they originally chose Duleep Singh's portrait to represent their artistic work.[78] An expression of their Sikh identity, the work epitomised their challenge to receive recognition as British Sikh artists as part of the British mainstream.

For the display of Duleep Singh's ornaments at NMS the challenge of their complex history persists. That they are shown next to 'Casualty of War' in the permanent gallery 'Artistic Legacies' can only be a first step of engaging with this particular legacy. Yet approaches to the

spoils of war in the past should also not be assumed to have been monolithic. While Dalhousie saw in the accumulated wealth of the Toshakhana a source of money and trophies, Login deliberated an alternative with regard to the Koh-i-Noor. He proposed 'that the Queen's subjects all over the Empire should be allowed to embrace the opportunity of showing their love and goodwill, by offering it to her'. Login thought a sum of £200,000 to purchase the Koh-i-Noor would be appropriate and possible to raise.

> It [the diamond] would have more value in her eyes, given her in this way by her people, as a token of their respect and honour, the money to be spent for the good and benefit of her new subjects here, by making the Punjab to bloom like a garden. This may easily be done, by giving employment to the 100,000 men who have been cast adrift, making roads, bridges and canals, and establishing schools among them, and thus showing that we are above taking anything from them in a shabby way.[79]

This chapter has sought to expose the complexity of historical events which underpin colonial collecting and thus must be taken into account when looking at resulting material culture of all kinds. In particular it has created a more nuanced picture, shifting the narrative by bringing in the viewpoints of different agents. Login's quote above demonstrates how varied were the perspectives of the British involved in these events. Nevertheless, the fact remains that in the relationship between Dalhousie, Login and Duleep Singh it is still difficult to hear the boy Maharaja's voice. We do know that he understood what he had lost, even if he was not able to comprehend the full extent and the lasting implications of this loss. Login wrote in a letter to his wife on 5 September 1849, 'When I congratulated him on his appearance, he innocently remarked, that on his *last birthday* he had worn the Koh-i-noor on his arm!'[80]

Notes

1 When referring to the Sikh state I use 'Panjab' instead of 'Punjab', except when the term appears in quotations, in recognition of the colonial context from which this spelling originated. Panjab, Persian for 'five rivers', denotes the territory of the Sikh Kingdom, or 'Land of Five Rivers'. The Partition of India in 1947 divided the British province Panjab between Pakistan and India. See also 'Punjabi Community', Hansard, HC Deb, 7 March 2000, vol. 345, cols 141-8WH, https://hansard.parliament.uk/Commons/2000-03-07/debates/07b16da0-17e9-4eed-add0-1982e3d038ec/PunjabiCommunity, accessed 2 July 2019.

2 Lindsay Carnegie's bequest went on display in its entirety soon after it had been received (T. Carlaw Martin, *Report for the Year 1911–12 on The Royal Scottish Museum, Edinburgh* (London: His Majesty's Stationary Office, 1912), p. 13). A small selection of the jewellery was included in the exhibition 'Treasured: Wonderful Things, Amazing Stories' at the National Museum of Scotland (NMS) from 14 Nov 2008 to 1 Jan 2011. The whole group was first shown at Stromness Museum in Orkney (1 Apr to 30 Sep 2014) before it went on display in the exhibition 'Indian

Encounters' at NMS (14 Nov 2014 to 1 Mar 2015). Duleep Singh's former possessions were also included in the virtual trail of Sikh material culture in Britain by the Anglo-Sikh Heritage Trail.

3 M. Sharma, 'Two at a time: How the Singh Twins have crafted a seamless artistic identity', *Firstpost* (11 July 2016), www.firstpost.com/living/two-at-a-time-how-the-singh-twins-have-crafted-a-seamless-artistic-identity-2881174.html, accessed 30 June 2019. For a reproduction of the painting, see NMS collection database, accession number V.2013.31. For an interpretation of the painting, see NMS, Explore our Collections, Stories, 'Casualty of War: A Portrait of Maharaja Duleep Singh', www.nms.ac.uk/explore-our-collections/stories/world-cultures/india-in-our-collections/india/casualty-of-war/, accessed 30 June 2019.

4 F. Voigt, R. Nicolson and L. Bennison, 'Panjab connections: a Young Roots heritage project at National Museums Scotland', *Journal of Museum Ethnography*, 30 (2017), 24–48.

5 A. Raychaudhuri, *Homemaking: Radical Nostalgia and the Construction of a South Asian Diaspora* (London: Rowman & Littlefield, 2018), pp. 21–46.

6 Letter from the Governor-General of India, Lord Ellenborough to the Duke of Wellington, 9 May 1844; see R. C. A. Colchester (ed.), *History of the Indian Administration of Lord Ellenborough, in His Correspondence with the Duke of Wellington* (London: Richard Bentley and Son, 1874), p. 437.

7 Colchester, *History of the Indian Administration*, pp. 437–39.

8 For the wording of the Treaty of Lahore and the Treaty of Bhyrowal, see G. Singh (ed.), *Maharaja Duleep Singh, Correspondence*, History of the Freedom Movement in the Punjab, vol. 3 (Patiala: Punjabi University, 1977), pp. 664–74.

9 Letter from the Governor-General of India to the Secret Committee, 7 April 1849, see UK Parliament (ed.), *Papers Relating to the Punjab, 1847–1849. Presented to Both Houses of Parliament by Command of Her Majesty* (London: Harrison and Son, May 1849), p. 665.

10 Singh (ed.), *Maharaja Duleep Singh*, p. 64.

11 'The Punjab Booty', Hansard, HL Deb, 26 May 1851, vol. 116, col. 1404, https://api.parliament.uk/historic-hansard/lords/1851/may/26/the-punjab-booty, accessed 2 July 2019. On 17 September 1848, for protection Duleep Singh had been placed together with the crown jewels and all other property under the guard of an East India Company military force at the Lahore Fort.

12 Singh (ed.), *Maharaja Duleep Singh*, p. 67.

13 See, for example, M. Alexander and S. Anand, *Queen Victoria's Maharaja: Duleep Singh, 1838–93* (London: Weidenfeld and Nicolson, 1980); R. R. Chakrabarty, *Duleep Singh: The Maharaja of Punjab and the Raj* (Birmingham: D. S. Samra, 1986); C. Campbell, *The Maharajah's Box: An Imperial Story of Conspiracy, Love and a Guru's Prophecy* (London: HarperCollins, 2000); N. Sarna, *The Exile: A Novel Based on the Life of Maharaja Duleep Singh* (New Delhi: Penguin, 2008); P. Bance, *Sovereign, Squire & Rebel: Maharaja Duleep Singh and the Heirs of a Lost Kingdom* (London: Coronet House, 2009); C. Campbell, *Victoria's Rebel Maharaja: Duleep Singh, Last King of the Sikhs* (London: Kashi House, 2018); F. Harrison, *Duleep Singh's Statue: East Anglia's lost Maharajah* (Oxford: Signal Books, 2018). For a discussion of The Singh Twins' painting 'Casualty of War', Sarna's novel and a video game by Ubisoft based on Duleep Singh's story, see A. Raychaudhuri, *Homemaking*.

14 N. M. M. Holmes, 'The Lindsay Carnegie Collection at the National Museums of Scotland', *The British Numismatic Journal*, 74 (2004), 145–59 (pp. 145–6).

15 W. Fraser, *History of the Carnegies, Earls of Southesk, and of Their Kindred*, vol. 2 (Edinburgh: T. Constable, 1867), p. 430.

16 H. G. Hart, *The New Annual Army List, Militia List, Yeomanry Cavalry List, and Indian Civil Service List, for 1881* (London: John Murray, 1881), p. 406.

17 Lindsay Carnegie is recorded with an address, probably that of a relative, in Edinburgh at 4, Grosvenor Crescent from early 1879 (*Supplement to the London Gazette of Tuesday, 25 February 1879* (26 February 1879), issue 24685, p. 1647,

www.thegazette.co.uk/London/issue/24685/page/1647, accessed 2 July 2019; A. M. Cunynghame (ed.), *Post-Office Edinburgh & Leith Directory 1878–79* (Edinburgh: Murray and Gibb, n.d.), p. 124). The 1881 Census for Scotland (taken on 3 April) lists Lindsay Carnegie as an active member of Her Majesty's Indian Army, living at 6 Playfair Terrace, St Andrews (National Records of Scotland, roll no. cssct1881_125). It would seem that he retired from active military service between April and December 1881 as he is not mentioned in the Army List for 1882 (H. G. Hart, *The New Annual Army List, Militia List, Yeomanry Cavalry List, and Indian Civil Service List, for 1882* (London: John Murray, 1882), p. 406). Regarding his social life in St Andrews, see Lindsay Carnegie's obituary 'Major Carnegie, of St Andrews, a popular and generous citizen, passes to his rest', *Evening Telegraph and Post* [Dundee] (16 May 1911), p. 2.

18 L. H. Officer and S. H. Williamson, 'Five ways to compute the relative value of a UK pound amount, 1270 to present', *Measuring Worth*, www.measuringworth.com/ukcompare/, accessed 2 July 2019.

19 'Fife Folk's Estates', *Courier* [Dundee] (1 September 1911), p. 6.

20 *Evening Telegraph and Post* [Dundee], p. 2.

21 A distant relative of the Lindsay Clan, John Lindsay (1789–1870) was a famous numismatist of his time, who also published widely on the subject (T. S. Lindsay, 'John Lindsay, the Numismatist', in J. Lindsay (ed.), *Publications of the Clan Lindsay Society*, 6 vols (Edinburgh: Lindsay & Co., 1911), II, pp. 79–83). He could have been a source of inspiration for the young Lindsay Carnegie. Lindsay Carnegie's bequest to NMS included sixty volumes on numismatics (Martin, *Report for the Year 1911–12*, p. 13). Although it is no longer possible to establish the individual titles which belonged to his bequest, it is very likely that at least some, if not all, of the six publications by John Lindsay, which are listed in the NMS library catalogue today, originally formed part of Lindsay Carnegie's reference library. Four of them were published between 1839 and 1852 and thus would have been available to Lindsay Carnegie before he went to India.

22 NMS, A.1911.400 to A.1911.505 and A.1911.508.

23 NMS, A.1911.469 +A and A.1911.471 still have original labels attached. The information given on them is reflected in the register entries.

24 Holmes, 'The Lindsay Carnegie Collection', p. 147.

25 Christie, Manson and Woods' is now Christie's. *Catalogue of a Valuable and Interesting Collection of Indian Gold Jewellery, Richly Studded with Rubies, Emeralds and Diamonds, and beautifully Enamelled in Translucent Colours; Indian Pure Gold Vases, Cups and Bowls; Silver Ornaments; and a few French and English Gold and Silver Snuff-Boxes; The Property of H.H. The Prince Victor Duleep Singh, and formerly the property of the late Maharajah Duleep Singh and the Maharajah Runjeet Singh, of Lahore*, Christie, Manson and Woods, 8, King Street, 19 June 1899 (London: William Clowes).

26 Officer and Williamson, 'Five ways to compute the relative value'.

27 Dowell's, *Catalogue of the Unique and Exceedingly Valuable Collection of Oriental Armour, Arms, and Objects of Eastern Art, of Supreme Historical Interest which came into the possession of the Marquis of Dalhousie, K.T., when Governor-General of India, 1848–55; also, Service of Old Silver Plate, War Medals, Oriental Shawls & Embroideries, etc., and the Casket of Personal Jewels and Lace of the late Right, Hon. Lady Susan Georgiana Broun, Colstoun House, Haddingtonshire*, Dowell's Rooms, 18 George Street, 7 and 8 December 1898 (Edinburgh: A. & D. Padon).

28 NMS, A.1911.452.

29 Dowell's, *Catalogue of the Unique and Exceedingly Valuable Collection of Oriental Armour*, lot number 404.

30 For a reproduction of the painting, see F. S. Aijazuddin, *Sikh Portraits by European Artists* (London: Philip Wilson, 1979), plate II.

31 These items have the following NMS accession numbers: four small silver boxes A.1911.437 to A.1911.438 and A.1911.481 to A.1911.482; Buddha figure A.1911.476; a pair of anklets A.1911.449+A; and a bracelet A.1911.448.

32 *Dowell's List of Heritable and Moveable Property for Sale*, Dowell's Rooms, 18 George Street (Edinburgh: s.n., 1898), p. 380.
33 UK Parliament, *Papers Relating to the Punjab*, pp. 662–63.
34 The Government of India, 'Terms granted to the Maharajah Duleep Sing, Bahadoor, ...', in UK Parliament, *Papers Relating to the Punjab*, Inclosure 9 in no. 51, p. 653.
35 *Ibid.*
36 Lady [L.] Login, *Sir John Login and Duleep Singh* (London: W.H. Allen & Co., 1890), p. 139.
37 *Ibid.*, p. 153.
38 *Ibid.*, p. 183.
39 British Library, London, India Office Records and Private Papers (hereafter IOR), R/1/1/689, Foreign Department, File Internal A., February 1885, Nos. 82–6, *Abstract of correspondence regarding the disposal of the Toshakhana and other property of the Sikh darbar at Lahore, and elsewhere, and the removal of Maharaja Dhulip Singh from the Punjab*, entry 'Dr. Login's rubkár, dated 19th May 1849', p. 18.
40 Foreign Department, 'List of papers in the case of Maharaja Dalip Singh, of which the Government of India is already in possession of copies', p. 2.
41 Foreign Department, 'Correspondence' no. 39 (21 February 1850) and no. 366 (25 February 1850), p. 7.
42 Foreign Department, 'Dr. Login's records', p. 17.
43 Login, *Sir John Login*, pp. 181–2.
44 *Ibid.*, p. 168.
45 IOR, E/4/804, India Political Department, 'Answer to Governor General's letter of 29 December 1849', 15 May 1850, paragraph 141, p. 639.
46 Foreign Department, 'Abstract of the correspondence in file A33', no. 12 (14 January 1851), p. 9.
47 Maharaja Duleep Singh (ed.), *A Reprint of Two Sale Catalogues of Jewels & other Confiscated Property Belonging To His Highness The Maharajah Duleep Singh, Which Were Put Up To Auction And Sold At Lahore, In the Years 1850 and 1851, by The Government of India. With Introductory Remarks.* 1885.
48 S. Stronge, 'The Sikh Treasury: The Sikh Kingdom and the British Raj', in Brown, K. (ed.) *Sikh Art and Literature* (London and New York: Routledge, 1999), pp. 72–88 (pp. 78–80).
49 Lattey Brothers recommended the re-evaluation of the state jewels before the next sale which was sanctioned on 5 February 1851. Duleep Singh's reprinted second sale catalogue dates from 10 February, which would have been too early. Lattey Brothers paid the net proceeds in April 1851, which suggests that the re-evaluated jewellery could have been sold at the end of March or at the beginning of April. See Foreign Department, 'Abstract of the correspondence in file A33', no. 29 (1 February 1851) and no. 108 (22 April 1851), p. 9.
50 Foreign Department, 'Abstract of the correspondence in file A33', no. 144 (29 May 1851) and no. 680 (2 June 1851), p. 9.
51 Foreign Department, 'Abstract of the correspondence in file A34', no. 255 (15 March 1852), no. 256 (18 March 1852), no. 259 (22 March 1852) and no. 264 (7 April 1852), pp. 10–11.
52 In 1850, the official exchange rate between a pound sterling and the rupee was 1:10, www.wikiwand.com/en/Indian_rupee#/Historic_exchange_rates, accessed 30 June 2019.
53 IOR, E/4/817, 'India – financial', 15 September 1852, paragraph 138, p. 102.
54 Login, *Sir John Login*, p. 155.
55 *Ibid.*, p. 172.
56 *Ibid.*, p. 160.
57 *Ibid.*, p. 157. Dalhousie's perspective was the opposite: 'He is old enough to be sensible of what he has lost, but old enough too to appreciate what he has gained.' IOR, Mss Eur F213/24, letter 'The Governor General to the Queen', 6 February 1850, p. 332.
58 Login, *Sir John Login*, p. 163.
59 *Ibid.*, pp. 186–7.

60 IOR, P/199/22, India Proceedings, 20–27 December 1850, 'Minute by the Governor General of India', 13 December 1850, no. 109, paragraph 9, p. 271.
61 IOR, E/4/809, letter 'The Court of Directors to the Governor General', 16 April 1851, pp. 476–7.
62 Foreign Department, 'Abstract of the correspondence in file A-22-30', no. 874 (29 May 1854), p. 6.
63 Login, Sir John Login, p. 175. Also mentioned in IOR, E/4/804, letter 'The Court of Directors to the Governor General', 15 May 1850, paragraph 139, p. 635.
64 See Christie, Manson and Woods', Catalogue of a Valuable and Interesting Collection. Login mentions in a letter that he had selected a diamond aigrette and star. See Login, Sir John Login, p. 175. These might be the jewels Duleep Singh is wearing in a line and stipple engraving by Daniel John Pound from 1854, made after a portrait photograph by John Jabez Edwin Mayall, in the National Portrait Gallery, London, reference NPG D10941, www.npg.org.uk/collections/search/portrait/mw18875/Maharaja-Duleep-Singh, accessed 30 June 2019.
65 See, for example, O. Untracht, Traditional Jewelry of India (London: Thames & Hudson, 1997), p. 332, fig. 749.
66 IOR, Mss Eur F213/24, letter 'The Governor General to the President', 7 April 1849, p. 133.
67 UK Parliament, Papers Relating to the Punjab, p. 663.
68 Ibid., p. 653.
69 Original emphasis. IOR, Mss Eur F213/25, letter 'The Governor General to the President', 15–16 May 1850, p. 58.
70 IOR, Mss Eur F213/24, letter 'The Governor General to the President', 7 April 1849, p. 134.
71 IOR, E/4/809, letter 'The Court of Directors to the Governor General', 16 April 1851, paragraph 1, p. 473. The Golden Throne was among the items transferred from the East India Company's museum in Leadenhall Street, London to the South Kensington Museum, today the Victoria & Albert Museum, in 1879. See https://collections.vam.ac.uk/item/O18891/maharaja-ranjit-singhs-throne-throne-chair-hafiz-muhammad-multani/, accessed 30 August 2019.
72 IOR, P/199/22, India Political Consultations 20–27 December 1850, 'Minute by the Governor General of India', 13 December 1850, no. 109, paragraph 8, p. 271.
73 Dowell's, Catalogue of the Unique and Exceedingly Valuable Collection of Oriental Armour, p. 27. The estimated value was £5,000 at the time (c. £550,000 in July 2019 according to Officer and Williamson, 'Five ways to compute the relative value'). See 'Sale of the Dalhousie Relics', Scotsman (8 December 1898), p. 5.
74 See T. H. Hendley, Indian Jewellery, Extracted from the Journal of Indian Art 1906–1909 (London: W. Griggs & Son, 1909), p. 116 and catalogue nos. 1014 and 1016.
75 The ring is described and illustrated in F. G. Kunz, Rings for the Finger (New York: Dover Publications, reprint, 1973; 1st edn. Philadelphia: J.B. Lippincott Company, 1917), p. 103.
76 For an account of the first day of the sale, see Scotsman (8 December 1898), p. 5. Unfortunately, the guru's kalgi and the silk armlet were part of the second day, on which the Scotsman did not report. Among the successful bidders on the first day were representatives of two Edinburgh jewellers, Messrs Hamilton & Inches and Messrs Mackay & Chisholm. Both jewellers bought gold inlaid sabres, daggers and shields and could therefore have been Lindsay Carnegie's source for buying the silk armlet. Further bidders included the Glasgow Museum, which acquired a dagger with a jade handle, set with rubies and emeralds, and a Mr Tunstall, Nelson, who paid 27 guineas for one of Duleep Singh's suits of armour. The highest price of the day, 200 guineas (£23,000 in July 2019 (Officer and Williamson, 'Five ways to compute the relative value')) was paid by Messrs Mackay & Chisholm for a large bronze bell 'taken from the Great Pagoda at Rangoon' (Dowell's, Catalogue of the Unique and Exceedingly Valuable Collection of Oriental Armour, lot no 78).

77 See interview with Davindor Toor at www.kashihouse.com/whats-on/maharani-jind-kaurs-jewellery-goes-for-record-price, accessed 30 June 2019.
78 Concerns over the environmental conditions at the exhibition venue unfortunately prevented the loan of the painting.
79 Login, *Sir John Login*, p. 177.
80 *Ibid.*, p. 175, emphasis in original.

Afterword: material reckonings with military histories

Henrietta Lidchi

Dividing the Spoils was devised and extensively discussed at a time when the question of provenance research and reckoning with the colonial past of collections, through prominent among a number of scholars and museum professionals, was not subject to the heightened attention that has more recently surrounded it. The context in which this volume will appear is noticeably different.

In 2017 to 2019, the circumstances that galvanised the questions of colonial spoils and their fates into the forefront of public discourse were an unlikely synergy between international politics and popular culture. In November 2017, the debate was triggered politically by a speech by French President Emmanuel Macron, in Ouagadougou, Burkina Faso. In an unprecedented move for a European statesman, President Macron announced that it was no longer acceptable that African cultural heritage had a larger foothold in museums in Paris than in Dakar, Lagos and Cotonou and suggested the need for a serious reconsideration of issues around the current retention of such objects in national collections across Europe.[1]

Consistent with the high intellectual standards of French public life, President Macron shortly thereafter commissioned a report on the question of colonialism, collections and return from two prominent scholars, Felwine Sarr and Bénédicte Savoy, who set about the task through extensive international consultation.[2] This intervention, unique for a European head of state, was quickly buoyed in the public imagination by the Afrofuturist filmic event that was *Black Panther*, released by Marvel Studios in February 2018. Notable here was a relatively short, early scene, commented on and quickly shared across social media, in which the hero's nemesis (Killmonger) stands in a museum, *qua* the British Museum, and gazes intently at the content of key African displays. He proceeds to question and correct the arrogant

(female) curator, and possibly permanently incapacitate her by poisoning her cup of coffee. Killmonger then seizes his ancestral objects, an action that is described within the terms of the film (and echoed as such widely outside) as a long-overdue act of redistributive justice.[3] The barely concealed Docklands location with some rather poor signage does not convincingly stand in for one of the most prestigious museums in the European world, located in its own historic building in Bloomsbury – but that is hardly the issue. The point being made, and widely understood, is that the question of imperial or colonial collecting is no longer reserved for the privileged or exclusive discussion and adjudication of the scholarly community and museum directors.

In July 2018, these events were followed by the German Museums Association (Deutscher Museumsbund) publication *Guidelines on Dealing for Collections from Colonial Contexts*, funded and subsequently publicly endorsed by the Federal Government Commissioner for Culture and the Media.[4] This thorough document seeks to provide professional guidance to those in the museum sector working with colonial collections, where colonialism is defined as a relationship based on domination in which the colonised lose self-determination.[5] The *Guidelines* provide a nuanced history and lengthy summary as a framework for working through the circumstances that have yielded German museum collections, providing a threefold differentiation regarding collections and their colonial circumstances: collections that reflect formal colonial rule, those that reflect informal colonial rule and those that reflect colonialism.[6] The *Guidelines* evoke the systematic methodology previously applied to another category of highly contested object, namely the type of provenance research used to track and trace objects through multiple hands in order to establish a near continuous chain of possession for personal property alienated during the Second World War era (1933–1945) in Europe and thus make them eligible for restitution claims under the processes put in place after the agreement of the Washington Principles in 1998.[7] The *Guidelines* provide definitions, a glossary and short essays, as well as reading lists, in order to provide wider contextual understanding of museological history in Germany.[8] This move towards addressing German colonial history is part of a wider trend to renew German ethnological museums at a moment when their collections have finally settled in their home institutions following reunification in 1990. As noted by Sarr and Savoy, it is also nestled within the evolving controversy surrounding the rebuilding of a Prussian palace (the Hohenzollern Palace or Stadtschloss) in Berlin to house the former ethnological and Asian art collections now known as the Humboldt Forum.[9] This city landmark was formerly occupied by the Palace of the Republic, built in 1973–76,

which served as a public and representative space in the former German Democratic Republic. The Palace of the Republic was a building iconic to many but was nevertheless levelled to make way for a new vision of the Federal Republic of Germany with Berlin as its capital. The imperious overtones of this gesture, with its eradication of a difficult history, were not lost on a number of inhabitants of the formerly divided city, the location of the 1884–85 conference in which European powers set about formalising their self-styled division of Africa. In tone and content, the *Guidelines* is a measured undertaking with what appears to be significant economic and political traction. Greater alignment is now displayed among various agencies and interests in Germany with a seemingly more informed media and clear ministerial and financial support being aimed at the issue of colonial heritage, defined as a necessary aspect of processing the German past.[10] The matter is conceived of as having an important role in the 'common social culture of remembrance' which is described as the basis on which German civil society can grow and be maintained.[11]

The German *Guidelines* nevertheless received a comparatively muted reception when set against the Sarr and Savoy publication, which was eagerly anticipated by the international media and the museological fraternity. Published in English and French, *Restituer le Patrimoine Africain*[12] is a deftly aimed polemic targeted at a French public largely convinced of the benefits of viewing non-Western art within a value system defined by the high call of *arts premiers*, and thus more wedded to artistic movements which remain of value in France such as modernism and primitivism.[13] This habitual *mise en valeur* distinguishes French attitudes to the objects emerging from a colonial context in an ever-expanding European debate, as the French cultural establishment continues to hold firmly to the aesthetic value of objects and their connective role in French national public life.[14] Arguably, the French also remain institutionally more phlegmatic about the process whereby the colonial and post-colonial life histories of objects have largely involved the stripping away of identities in order to insert them into new narratives of value.[15] Indeed a broad critique levelled at the Sarr and Savoy report is that it gives no weight to the accrual of heritage value and personal feelings that attach themselves to objects and collections over time as they move from one location to another, and as they are accessioned into private lives and museum collections, and that their transcultural roles, identities and histories are therefore overlooked.

Different ways of doing things are in evidence across the European context as they consider some of the more ignoble chapters in several national histories. Just before the high-level announcement by the

Federal and State Ministers for Culture in Germany, consciously intended to follow that of President Macron, the *Süddeutsche Zeitung*[16] contrasted approaches between Germany, the Netherlands and France, arguing that the French with their elaborate proposals and the Germans with their extensive federal structure had been slightly caught off guard by the pragmatism of the Nationaal Museum van Wereldculturen, the museum in the Netherlands whose March 2019 publication *Objects: Principles and Process*[17] seemed to offer a swifter approach to these difficult questions on more generous terms. This perceptive summary of European methodology noted that each country proffered a different solution, with presidential pressure being enacted on museums in France (top down) while museums in the Netherlands were seeking to influence the Dutch state (bottom up)[18] such that the Dutch Minister of Culture, Education and Science swiftly laid plans in March 2019 to set up a commission for a national conversation, subsequently confirmed in October 2019 and scheduled to report in September 2020.[19] As the issue continues to be publicly discussed, the thoroughness of the German museological approach remains in evidence with the amended and expanded edition of the German *Guidelines*, enhanced by non-European and indigenous perspectives, followed in July 2019 barely a year after first publication in 2018.[20]

Each initiative attempts a nationally salient reshaping of the relationship between claimants, nation states and museums in the context of national imperial histories and contemporary realpolitik. In the UK, where museums are part of the cultural sector *and* a devolved matter, run at the national level as non-departmental government bodies by governing boards of trustees (for the nation), institutional attitudes remain obscure, with clear direction being taken solely in the arena of human remains.[21] British museums have remained relatively silent throughout the recent debate despite the fact that the bronzes and ivories that came onto the world art market as a consequence of the 'punitive expedition' to Benin City, as capital of the Kingdom of Edo, of 1897, a British naval military colonial intervention (see Mack, Chapter 2), remains the most frequently cited instance of colonial spoils and gains considered ill-gotten. The conspicuous position of the 'Benin Bronzes' as exemplars of the issues in question is derived from their ubiquitous presence as status objects in the collections of the world's major art museums, as a consequence of the British practice of selling prize at auction (see Spiers, Chapter 1), a fact conspicuously referenced in the *Black Panther* narrative.

Reasoned scepticism in the face of enthusiastic media attention and multiple government initiatives may be consistent with an awareness that there are levels of mimicry and competitive edge to this profoundly

European museological debate. Its avowed and public purpose may be driven by ideas of repair and the moral health of civil society, but the consequences of this revisionist impetus are still uncertain and may possibly even result in new asymmetries of power or new forms of convenient historical erasure. Given the extent and complexity of European colonial history, the primary focus on sub-Saharan African collections in the articulation of this debate seems unnecessarily restrictive, and may indicate the influence of a rapidly reconfiguring global geopolitical landscape noticeably at play on the African continent. The scramble to address colonial histories and the possibility of return to Africa (a continent whose countries compose 25 per cent of the member states of the United Nations) should be viewed against the new political and economic realities and anxieties in Europe, not least that of maintaining a foothold in resource-rich former colonial territories while China's and Russia's influence continues to grow.

Although many of the documents and initiatives mentioned above seek to widen and bring nuance to ideas of colonial collecting, in the popular imagination this is a phenomenon almost entirely rooted in the idea of looting, and thus illicit acts of appropriation (or 'abduction', as used by Mack, Chapter 2). This perception further perpetuates an undifferentiated interpretation of all museum collections deriving from beyond Europe as being the direct result of imperious governments and vengeful armies seizing artworks to distribute or potentially defray military costs, or of greedy soldiers secreting objects in their knapsacks for the purposes of gift giving, private pleasure or profit. Surprisingly then, the public and international discussion which addresses colonial wars and their institutional afterlives, accords few, if any, column inches or ministerial statements to the question of military museums or their collections. This omission further highlights the paucity of understanding of how the military collected and appropriated, of how objects were dispersed and apportioned between national public institutions, military museums and private owners, and of the roles of these objects in military culture.

A further gap in understanding concerns the variation of practices across Europe. British museums, for example, benefited by commissioning collections from those who accompanied military expeditions (for example, see Spiers, Chapter 1, and Mack, Chapter 2) or from buying at auctions where prize was sold (see Spiers, Chapter 1, and Tythacott, Chapter 8). Dutch museums, in relation to Indonesian collections, benefited from direct allocations once key objects were placed in the primary collection of what is now the National Museum of Indonesia in Jakarta,[22] and were thus retained after Independence in 1949 by the Republic of Indonesia. Senior military officers and government officials

of both countries during the colonial period reserved especially important trophies and gifts to be sent to their sovereigns as symbols of national imperial victory[23] (see Voigt, Chapter 11). In the post-colonial period, national museums in both countries repatriated (though rarely in the quantities requested) or sold back objects linked to looting on military expeditions.[24]

This neglect of military history and an apparent lack of interest in how military codes and conventions have historically framed and legitimised the taking of objects on military campaign is a factor which constrains future interpretation and understanding of the nature and sources of these objects in their current museum settings. This critic-ally impacts the ability to do research on the provenance of objects that is required in a reasoned, thorough approach to these issues: the need to compare categories of objects, to establish networks of people and to create likely chains of circumstances and possession in a context where the original possessor, be they individual or communal, may not have been recorded, may not easily be established and, in the case of certain cultural contexts, may not necessarily be considered the recognised or legitimate owner.[25]

If there is any logical consequence to the current interest in colonial collecting it is that curators working on non-European material culture will, in the immediate future, have to develop a far better understanding of military history and military culture to deal successfully with the challenges that new kinds of provenance research will require of them. In the British context this means an appreciation that the British Army[26] was a fluid and ever-changing entity, whose identity is heavily based its history of campaign service, perpetuated through regiments that retain their relationship with these past events even as the Army's structure evolves. This, as Kirke and Hartwell show (Chapter 5), is a culture guided by formal and, equally importantly, informal rules, whose history is kept alive through transferred memory, with war ser-vice in the past requiring that respect and honour was served to earlier generations of combatants, who are emphatically remembered through activities that anthropologists might describe as ritualised. The cul-ture of memory is constructed in one respect around the military officers' or sergeants' mess as a domestic and semi-public space, important because it embodied the sense of home for a peripatetic regi-ment and as such was the former home of many regimental collections.

Provenance research in the broader museological context will equally require a more flexible appreciation of what constitutes military material culture, beyond weapons, the latter assiduously collected during the colonial period and deposited in many national museums, but which, in the post-colonial period, have been of diminishing interest

and are now rarely displayed in world culture galleries or exhibitions, or indeed researched by their holding institutions.[27] However, as the chapters in this book suggest, and as new research findings within a larger follow-up project is increasingly evidencing, an approach based on material culture theories and provenance methodologies, aware of military history and culture, offers a new appreciation of what at first glance appears to the outsider to be the idiosyncratic and disparate nature of military colonial collections. Unsurprisingly, military hierarchies of collecting and display do not conform to the canonical categories that are classically associated with 'ethnographic' objects,[28] even if the sources of the collections heavily intersect. Questions of how materiality and value perform in a military context are key, especially if we are to consider properly the role of things as they move from the closed, quasi-domestic comfort of the mess to the public setting of the military museum. Regimental museums have, until recently, been most consciously targeted at an audience of military personnel, featuring a requisite pilgrimage at the beginning of a military career seen as fostering an *esprit de corps* which helps to preserve the inherited history of a regiment or corps through generations, and that might later on serve to promote cohesion and resolve in combat situations.

Museum collections of non-European and indigenous cultures were developed in the nineteenth and twentieth century through a number of channels, and there are plentiful theorisations that pertain to collectors in which the missionary and the military are recognised. For the professional collecting of ethnography Michael O'Hanlon has provided a convenient characterisation of primary, secondary and circumstantial to codify the role of collecting within a given field expedition. This threefold categorisation helps chart the relation of academic anthropology to fieldwork which has typified British social anthropology since the early twentieth century, and is sometimes understood to have provided the best documented museum collections.[29] Nevertheless, during the 1990s much was written about tourist art and souvenirs in historic collections, putting forward the view that objects now resting in museum collections express a variety of social and political entanglements, presented (as gifts) or made to be sold (as souvenirs) rather than taken (as loot).

As one reviews this literature on collecting histories, it is clear that military collections are both absent and distinctive. Ethnographic collecting has traditionally had aspirations to collect in order to represent cultures or cultural forms that are extant: living, in the midst of transition or change or in decline. The material culture or artforms that it seeks to extract – traditional and contemporary – stand for aspects of culture that are judged salient to the understanding of a

[275]

culture as a larger series of processes including how it expresses itself materially (or immaterially). Military collecting takes place in the midst of heightened political circumstances, in extremis amidst conflict and death, as well as among fallen combatants – friend or foe. The special nature of this environment with its associations of sudden, violent and premature termination of life explains a number of unusual features of the value systems embodied in military collections, which on the surface appear aberrant when compared to 'ethnographic' collecting and display practices.

A distinctive, and possibly paradoxical, factor is the tangible influence of what might be termed 'sentiment'. Military collections and military displays are unexpectedly emotional assemblages with their own hierarchies of value, intimately associated with people: heroes, fellow combatants, worthy opponents, despised enemies and the named and the unnamed. They are especially tied to campaign histories, and therefore traditions of warfare, and to a sense of community within military organisations. They are part of the living history and memory culture of the regiment. Key events are extensively and repeatedly memorialised, a practice clearly evident in the prevalence of colours, or standards, and the reason why those enemy standards that are captured take pride of place in military displays (see Kirke and Hartwell, Chapter 5). Trophies, mementoes and souvenirs are distinctive features of military collecting. However this memorialising culture is especially evident in the repeated presence in military museum collections of objects best described as relics and reliquaries. Steven Hooper, who has long worked with the material culture of the Pacific, has provided a useful theory of relics.[30] His distinction between body, contact and image relics[31] provides a means to begin to appreciate the emotional nature, and ritualised function, of military museum collections that can appear on the surface to be both idiosyncratic and disparate.[32] In particular, Hooper discusses the type of relic-related behaviour and artefacts that are linked to national heroes including fallen heroes such as Vice-Admiral Lord Nelson. His discussion of the afterlife of hair removed from Nelson's body transports us quickly, in form and intention, to a military example of recent salience related to this volume.

Until March 2019, the National Army Museum (NAM) had in its collections a composite object linked to Emperor Tewodros II and the punitive attack on his city fortress at Maqdala, Ethiopia, by a British military expedition in 1868. This artefact was acquired in 1959 through a private donor.[33] It was formed of three separate things: a letter in Amharic with the emperor's seal functioning as a background to a small piece of card positioned on the bottom right of the letter on which writing in pencil identified the pieces of hair attached (sewn) to the card

as that of Emperor Tewodros II (known to the British at the time as Theodore). The emperor's letter has been translated, and its content is known to be linked to the capture and retention of the British envoy and prisoner, Hormuzd Rassam, who was moved to Maqdala[34] as a hostage, one of the reasons used by the British to justify the 1868 military intervention. The 'gruesome souvenir'[35] was noted to have been acquired after the emperor's suicide by Lieutenant-Colonel Cornelius James (1838–89) of the Bombay Staff Corps of the British Indian Army while creating his unofficial posthumous watercolour portrait of the emperor.[36] The material assemblage was given to the NAM in 1959 with the following details: 'Framed letter bearing the great seal of Emperor Theodore, also a lock of Theodore's hair taken after death, with translation and six other documents'.[37] As a composite object it can only be understood through the idea of a reliquary and relic: the combination of letter and mounted hair samples are layered presentational codes that serve to ritualise and which are associated through touch and body with a vanquished enemy. Looking at the NAM's collection, James appears to have acquired two such locks of hair. The composite relic was one of two artefacts held by the museum that contained hair samples from Emperor Tewodros II: the other was also a lock of hair, also mounted on card (pinned) and seemingly a gift given by James to his future wife and her female relatives, possibly consistent with the role of hair as a loving memento (part of a Victorian language of mourning, courtship and friendship) linking the living and the dead.[38]

In 2018 recognising the relevance of the 150th commemoration of the storming of Maqdala, there were two initiatives that sought to address this moment in the British imperial past, one in a national museum and one in a military museum. According to their current documentation the Victoria and Albert Museum (V&A) acquired Ethiopian ritual items and clothing through various official channels including the Foreign Office (1868) and also connected to the imprisoned civil servant Hormuzd Hassam, the Secretary of State for India (1869), H. M. Treasury (1872),[39] as well as through the sale of articles from Major Trevenen James Holland of the Bombay Staff Corps (1869), who, with his colleague Sir Henry Montague Hozier of the 3rd Dragoon Guards, provided the only official account of the expedition on the orders of the secretary of state for war.[40] A small display, *Maqdala 1868*, was created by the V&A for the 2018 anniversary using twenty pieces from the collection. The display was located in the museum's silver gallery, which while apparently incongruous in light of the contested history context was institutionally consistent with classification of some of the work as part of a decorative art collection,[41] in particular the ritual items, such as the eighteenth-century gold alloyed crown[42] and the gold chalice[43] probably

from the Church of Our Lady of Qwesqwam, near Gondar. The interpretation within the display covered Ethiopian cultural history at the time, the history of the campaign and, most affectingly, the poignant personal stories of the members of the Ethiopian Royal Family, whose clothes, photographs and jewellery all featured. In a non-military context the fate of Emperor Tewodros II, his second wife Queen Terunesh, who died a captive, and of their son only serves to emphasise the unsettling nature of colonial histories, eliciting justifiable empathy given that Prince Alemayehu Tewodros's destiny, after his parents' death, was to be one of a number of ill-fated child wards[44] of Queen Victoria (see also Voigt, Chapter 11). Dying prematurely in his enforced exile after the clash with the British Empire had deprived him of both his parents, and in the care of those in whose name the military campaign against his dynasty was conducted, Prince Alemayehu Tewodros's remains are buried at Windsor.

The V&A sought to structure its interpretation of the Maqdala collections in three ways – through documents of the time (conveyed in black labels), through contemporary community narratives (red labels) and in the institutional voice (white labels). Through balance in size and adjacency, this colour coding approach signalled the equivalence of different categories of interpretative voice, thus representing the simultaneity of different perspectives revolving around this difficult and intertwined history. *Maqdala 1868* texts cited oppositional British views of the time recorded by Hansard, notably from William Gladstone, the then prime minister, who voiced disquiet at the abduction of sacred items during a military campaign but ultimately did nothing to rectify the injury (see also Spiers, Chapter 1).[45] The V&A's 2018 display prompted renewed demands for return of objects from the Government of Ethiopia, originally made in 2008, which were answered in public by a proposal by the V&A for long-term loans and better dialogue.[46]

More quietly, but ongoing since April 2018, the questions of the NAM's composite Tewodros relics, and in particular the hair samples, were being discussed between the museum's management and the Ethiopian Government. In March 2019, the two sets of hair samples were transferred in a small ceremony by the director, Justin Maciejewski, DSO, MBE to H E Dr Hirut Kassaw, Ethiopia's Minister of Culture, Tourism and Sport. The hair samples were handed over, contained in a small box draped with the flag of the Republic of Ethiopia (and thus reminiscent of military funerals) to be transferred to the Ethiopian National Museum prior to being interred with the remains of the emperor. The press release and media reports[47] that accompanied this gesture in the context of wider discussion about colonial collections included some understated, but intriguing clarifications regarding the

thinking behind this act of return. The NAM worked within the terms of existing English legislation, namely *The Human Tissue Act* (2004)[48] rather than under a broader understanding of restitution or repatriation. This required two perceptual shifts. Firstly, a generous and permissive interpretation of the 2004 Act was mobilised, as this normally excludes hair, nails and teeth as body parts that naturally separate from the body in life. This recognised the deliberate act of retrieval in a situation of war, which is known to have taken place in this case. The identification of hair as a pertinent human remain in this case was tacitly acknowledged when the NAM director was quoted saying 'We very much look forward to the occasion when we can hand over these symbolic human remains to the people of Ethiopia.'[49] Secondly, to allow for the hair, and the hair alone, to be returned, the composite relic had to be disassembled. Only the hair was presented in the small coffin to Ethiopia's Minister of Culture, Tourism and Sport. The frame, the letter and the card mounts on which the hair samples had originally been placed for both the composite relic and the other item were retained and remain in the possession of the museum. This accommodation could be seen in a narrow sense as a bureaucratic interpretation of an existing piece of legislation to allow a national institution to return an element of its collection in response to a powerful request linked to a well-known and contested historical episode. It can also be seen in a more straightforward sense as a gesture of goodwill, a demonstration of mutual recognition and regard, an affective link between the NAM and the claimants. The intersection here revolves around the understanding of these items as reliquaries and relics, having heightened sentimental and symbolic value. The combinations of paper items (be they letters or mounts) and hair are simultaneously contact and body relics and are permanently entangled in questions of national history, tragedy, heroism and martyrdom, wherever they are placed. This intriguing case study suggests a shared understanding on behalf of the military, represented by the museum, and the claimants and recipients of the object, represented by the Ethiopian Government, of the emotional power and value of the fragments, and in particular of the composite object, holding a letter, and the mounted hair lock as a material encapsulation and embodiment of a complex transcultural history. As noted by Hooper (and Mack, Chapter 2) the disentangling of person/object is not always easily achieved,[50] even if the gesture of return in this instance required precisely such an action. One interpretation of this case of return was a tacit agreement to divide the spoils which for both parties have invested political, emotional and ritual value, with the transfer of the hair as body relics out of the NAM collection, but the retention of the papers and mounts as touch relics within it.

[279]

Opening up the field of military collecting to more forensic investigation, testing the proper understandings of historical circumstances and setting out an appreciation of military collections and the performance of material culture brought back from campaigns overseas requires a critical attentiveness, not a comfortable acceptance of long-held assumptions. As historian and anthropologist James Clifford has recently noted, a commitment to complexity and to interdisciplinarity requires detailed provenance research, a certain quality of ironic distance, a sense of the longue durée of these issues and their contingent conclusions and, in particular, a form of transgressive hope.[51] The hope is that we can trust ourselves and others to challenge historical orthodoxies, to value the work that we mutually undertake and to proceed with sensitivity and respect as we work through the evidence. In so doing we may produce fuller understandings of the legacies that these transcultural histories bestow on us and that the resulting collections require us to address.

Notes

1 As reported for instance by S. Gignoux, 'Emmanuel Macron promet à l'Afrique des restitutions d'œuvres africaines « d'ici à 5 ans »', La Croix (28 November 2018), www.la-croix.com/Culture/Expositions/Emmanuel-Macron-promet-lAfrique-restitutions-doeuvres-africaines-dici-5-ans-2017-11-28-1200895496, accessed 30 May 2019; V. Noce, 'French President Emmanuel Macron calls for international conference on the return of African Artifacts, The Art Newspaper (26 November 2018), www.theartnewspaper.com/news/french-president-emmanuel-macron-calls-for-international-conference-on-the-return-of-african-artefacts, accessed 30 May 2019; N. Thomas, 'We need to confront uncomfortable truths about European colonial appropriation', The Art Newspaper (29 November 2017), www.theartnewspaper.com/comment/macron-repatriation, accessed 30 May 2019.

2 F. Sarr, and B. Savoy, Restituer le Patrimoine Africain (Paris: Philippe Rey/Seuil, 2018), pp. 141–64.

3 See, for example, C. Haughin, 'Why museum professionals need to talk about Black Panther', The Hopkins Exhibitionist (20 March 2018), https://jhuexhibitionist.com/2018/02/22/why-museum-professionals-need-to-talk-about-black-panther/, accessed 30 May 2019; L. Ragbir, 'What Black Panther gets right about the politics of museums', Hyperallergic (20 March 2018), https://hyperallergic.com/433650/black-panther-museum-politics/, accessed 30 May 2019.

4 Deutscher Museumsbund/German Museums Association, Guidelines on Dealing with Collections from Colonial Contexts (Berlin: German Museums Association, 2018).

5 Ibid., p. 11.

6 Ibid., pp. 16–23.

7 The Washington Principles on Nazi-confiscated Art are a set of undertakings endorsed by forty-four governments as a consequence of the conference on Nazi Looted Assets that took place in Washington, DC, United States on the 3 December 1998. These have been followed up by further declarations and restitution commissions in a number of European states. See, for discussion of their principles, history and application, E. Campfens, 'Nazi-looted art: a note in favour of clear standards and neutral procedures', Art and Antiquity, 22:4 (2017), 315–45.

8 The 2018 report runs to a lengthy 128 pages; see Guidelines on Dealing with Collections from Colonial Contexts.

9 Sarr and Savoy, *Restituer le Patrimoine Africain*, pp. 12 and 18. Savoy, as an academic working in Paris and Berlin, is uniquely placed to connect French and German developments, being influential in both contexts.
10 See, for example, C. Hickley, 'Culture ministers from 16 German states agree to repatriate artefacts looted in colonial era', *The Art Newspaper* (14 March 2019), www.theartnewspaper.com/news/culture-ministers-from-16-german-states-agree-to-repatriate-artefacts-looted-in-colonial-era, accessed 30 May 2019; C. F. Schuetze, 'Germany sets guidelines for repatriating colonial-era artifacts', *New York Times* (15 March 2019), www.nytimes.com/2019/03/15/arts/design/germany-museums-restitution.html, accessed 30 May 2019.
11 Kultusministerkonferenz, 'Erste Eckpunkte 1 zum Umgang mit Sammlungsgut aus kolonialen Kontexten 2 der Staatsministerin des Bundes für Kultur und Medien, 3 der Staatsministerin im Auswärtigen Amt für internationale Kulturpolitik, 4 der Kulturministerinnen und Kulturminister der Länder 5 und der kommunalen Spitzenverbände', Anlage II, z. NS 1. Kultur-MK, 13 March 2019, Berlin, p. 1, available at www.kmk.org/fileadmin/pdf/PresseUndAktuelles/2019/2019-03-25_Erste-Eckpunkte-Sammlungsgut-koloniale-Kontexte_final.pdf, accessed 30 May 2019.
12 Sarr and Savoy, *Restituer le Patrimoine Africain*.
13 As noted during the building of the Musée du Quai Branly, now Musée du Quai Branly Jacques Chirac, named after the President so influential in its development and known for his connoisseurial interest, and nationally mourned after his passing in September 2019 in the museum itself. See S. Price, *Paris Primitive, Jacques Chirac's Museum on the Quai Branly* (Chicago: University of Chicago Press, 2007).
14 A critical article in 2019 published in *The Art Newspaper* argued, following a conference called to discuss the Sarr and Savoy report, that it is being quietly buried by French political and museum authorities, as the French policy context develops in an opaque and contradictory fashion. V. Noce, 'France retreats from report recommending automatic restitutions of looted African Artefacts', *The Art Newspaper* (5 July 2019), https://www.theartnewspaper.com/news/france-buries-restitution-report, accessed 10 October 2019.
15 J. Wiener, 'Object lessons: Dutch colonialism and the looting of Bali', *History and Anthropology*, 6:4 (1994), 347–70 (p. 350).
16 J. Häntzschel, 'Begründete Zweifel', *Süddeutsches Zeitung* (12 March 2019), www.sueddeutsche.de/kultur/restitution-begruendete-zweifel-1.4364409, accessed 30 May 2019.
17 Nationaal Museum van Wereldculturen, *Return of Cultural Objects: Principles and Process* (Leiden: NMVW, 2019) and Nationaal Museum van Wereldculturen, 'The National Museum of World Cultures identifies the principles on the basis of which the museum will assess claims for the return of objects of which it is the custodian', press release (7 March 2019), www.volkenkunde.nl/en/about-volkenkunde/press/dutch-national-museum-world-cultures-nmvw-announces-principles-claims, accessed 30 May 2019.
18 Häntzschel, 'Begründete Zweifel'.
19 As announced in the letter sent on 10 April 2019 by Ingrid van Engelshoven, the Minister of Education, Culture and Science to the Second House of the Dutch Parliament.
20 The July 2019 version of the guidelines benefited from an international consultation process in October 2018 which sought to widen the debate by including non-European and indigenous perspectives as invited speakers and as authors in the written report. The new guidelines stress the need for equity collaborative working between German museums and objects' countries of origin. The 2019 report is 200 pages long. Deutscher Museumsbund/German Museums Association, *Leitfaden: Umgang mit Sammlungsgut aus kolonialen Kontexten, 2. Fassung 2019* (Berlin: Deutscher Museumsbund, 2019).
21 T. Flessas, 'The repatriation debate and the discourse of the Commons', *LSE Law, Society and Economy Working Papers*, 10 (2007), www.lse.ac.uk/law/working-paper-series, accessed 30 May 2019.

22 See, for example, F. Bringreve, D. Stuart-Fox with W. Ernwati, 'Collections after Colonial Conflict: Badung and Tabanan 1906-2006', in P. J. ter Keurs, *Colonial Collections Revisited* (Leiden: Leiden University Press, 2013), pp. 160–62.

23 R. B. Phillips, 'The Other Victoria and Albert Museum: Itineraries of Emprie at the Swiss Cottage Museum, Osborne House', in M. Wellington Gathtan and E. Troelenberg (eds), *Collecting and Empires: An Historical and Global Perspective* (London: Harvey Miller Publishers, 2018).

24 Such initiatives have not been systematically studied, though there are instances of museum collections being returned in small quantities to nations post independence. For some reference to cases see J. van Beurden, *Treasures in Trusted Hands: Negotiating the Future of Colonial Cultural Objects* (Leiden: Sidestone Press, 2007).

25 This would in particular apply to objects that are communally owned, or that due to their sacred nature cannot be owned, but equally to those looted from treasuries that already contained looted material.

26 Though in this volume the British Army is the focus, it is of course the case that the British Royal Navy was also involved in campaigns, for example in 1897 during the Benin Punitive Expedition.

27 A recent edited collection attempts to rectify this absence: T. Crowley and A. Mills (eds), *Weapons, Culture and the Anthropology Museum* (Cambridge: Cambridge Scholars Publishing, 2018).

28 This is demonstrated in the critique Tythacott (Chapter 8) makes of the display strategy arising in regimental museum with collections coming from the Yuanmingyuan or 'Old Summer Palace', Beijing.

29 M. O'Hanlon, 'Introduction', in M. O'Hanlon and R. L. Welsh (eds), *Hunting the Gatherers: Ethnographic Collecting, Agents and Agency in Melanesia* (Oxford: Berghahn Books, 2000), pp. 12–15.

30 S. Hooper, 'A cross-cultural theory of relics: on understanding religion, bodies, artefacts, images and art', *World Art*, 4:2 (2014), 175–207.

31 *Ibid.*, p. 194.

32 N. Hartwell, 'Artefacts of Mourning from the Indian Uprising', in A. Rihter, *War and Peace, Fear and Happiness 110 Years since the End of World War 1* (Ljubljana: ICOMAM, 2020) pp. 92–105.

33 NAM, 1959-09-171.

34 A translation of the letter was found in an album of photographs belonging to Colonel Cornelius Francis (Frank) James; NAM, archives, 1959-09-170.

35 M. Bailey, 'London museum returns emperor's hair – taken by a British officer as a war trophy – to Ethiopia', *The Art Newspaper* (21 March 2019), www.theartnewspaper.com/news/maqdala, accessed 30 May 2019.

36 Ryan argues that General Napier wished for a posthumous photograph of the deceased king. See J.R. Ryan, *Picturing Empire: Photography and the Visualization of the British Empire* (London: Reaktion Books, 1997), p. 82.

37 NAM, 1959-10-71.

38 NAM, 1959-09-171, C. Gere and J. Rudoe, *Jewellery in the Age of Queen Victoria: A Mirror to the World* (London: British Museum Press, 2010), pp. 164–5.

39 Through the activities of Richard Holmes manuscripts curator of the British Museum, who followed the campaign.

40 T. J. Holland and H. Hozier, *Record of the Expedition to Abyssinia by Order of the Secretary of State for War*, 3 vols (London: Her Majesty's Stationery Office, 1870).

41 Many of the artefacts became part of the collections of the Metalwork Department, now part of Sculpture, Metalwork, Ceramics & Glass Department, explaining the internal logic as to why the display was placed in this gallery.

42 V&A, M.27-2005.

43 V&A, M.26-2005.

44 Prince Alemayehu's wardship and guardianship was the subject of a debate in Parliament on 8 March 1872. https://hansard.parliament.uk/Commons/1872-03-08/debates/507237b7-cfa8-4b5b-bd46-bdad6aaeda0e/Abyssinia%E2%80%94PrinceAlamayon, accessed 2 June 2019.

45 This was part of a longer debate about the prize system and the entitlement of the British Museum to use national funds for the purchase of such objects. William Gladstone (House of Commons debate 30 June 1871) condemned the taking of the gold crown and chalice from Maqdala as religious objects, and contended that these should not be in public collections as this would cause the consequence that they could not be alienated in the future, which indeed is presently the case. https://hansard.parliament.uk/Commons/1871-06-30/debates/0e763636-72ee-4a5c-bb3f-f6b19e10922f/AbyssinianWar%E2%80%94Prize%E2%80%94TheAbanaSCrownAndChalice, accessed 2 June 2019.

46 M. Bailey, 'Ethiopia toughens position on Maqdala treasures calling for full restitution', *The Art Newspaper* (20 April 2018), www.theartnewspaper.com/news/ethiopia-toughens-position-on-maqdala-treasures-calling-for-full-restitution, accessed 30 May 2019; A. Cordrea-Rado, 'UK museum offers Ethiopia long term loan of looted treasures', *The New York Times* (4 April 2018), www.nytimes.com/2018/04/04/arts/design/v-and-a-ethiopian-treasure.html?searchResultPosition=1, accessed 30 May 2019.

47 M. Bailey, 'London museum returns emperor's hair – taken by a British officer as a war trophy – to Ethiopia', *The Art Newspaper* (21 March 2019), www.theartnewspaper.com/news/maqdala, accessed 30 May 2019; M. Bailey, 'London's National Army Museum to return emperor's hair to Ethiopia', *The Art Newspaper* (4 March 2019), www.theartnewspaper.com/news/london-s-national-army-museum-to-return-emperor-s-hair-to-ethiopia, 30 May 2019; Embassy of the Federal Democratic Republic of Ethiopia, London, 'Culture Minister visits British Museums on debut visit to the UK', 29 March 2019, www.ethioembassy.org.uk/culture-minister-visits-british-museums-on-debut-visit-to-the-uk/, accessed 30 May 2019; A. Marshall, 'Living things, with no bone or tissue, pose a quandary for museums', *The New York Times* (21 March 2019), www.nytimes.com/2019/03/21/arts/design/museums-human-remains.html, accessed 30 May 2019.

48 The English and Welsh legislation here differs from the Scottish legislation (Human Tissue (Scotland) Act 2006), consistent with the political devolution of the UK.

49 NAM, 'National Army Museum responds to repatriation request from Ethiopia', www.nam.ac.uk/press/national-army-museum-responds-repatriation-request-ethiopia, accessed 30 May 2019.

50 Hooper, 'A Cross-Cultural Theory of Relics', p. 199.

51 J. Clifford, 'Ishi's Story', in J. Clifford, *Returns: Becoming Indigenous in the Twenty-First Century* (Cambridge, MA: Harvard University Press, 2013), p. 101.

ARCHIVAL SOURCES

Argyll and Sutherland Highland Museum
N-D4, CUN.B, diary, Capt. Boyd A. Cunningham
N-D1, MacD, diary, Private John MacDonald

Black Watch
Regimental Archive, Captain William Stewart's Orderly Book for 1759, A758

British Library
Add.52,389 Gordon MSS
Add.50254ff/84, Envelope f. 88, Letter, Pitt Rivers to Tylor
India Office Records and Private Papers:
E/4/804, Despatches to India and Bengal (Original Drafts), April 1850–June 1850
E/4/809, Despatches to India and Bengal (Original Drafts), April 1851–May 1851
E/4/817, Despatches to India and Bengal (Original Drafts), September 1852–November 1852
Mss Eur F213/24, Letters from persons in India and elsewhere, 1849–50
Mss Eur F213/25, Letters from persons in India and elsewhere, 1850–51
P/199/22, India Proceedings, 20 December 1850–27 December 1850
R/1/1/689, File Internal A., February 1885, Nos. 82–6, Abstract of correspondence regarding the disposal of the Toshakhana and other property of the Sikh darbar at Lahore, and elsewhere, and the removal of Maharaja Dhulip Singh from the Punjab, 1884–85

Gordon Highlanders Museum
PB 174, diary, Lieutenant-Colonel Sir Nevil Macready

House of Commons Parliamentary Papers
Papers Relating to the Massacre of British Officials near Benin and the Consequent Punitive Expedition, C. 8677 (1898)

National Army Museum
1950–10–13, Jourdain collection
1959–09–170, photograph album, Colonel Cornelius Francis (Frank) James
1974–04–36–3, Lieutenant R. F. Meiklejohn, 'The Nile Campaign'
6803/343, microfiche, Lieutenant-General A. H. L. F. Pitt Rivers' 'Arms' notebooks

Institutional Archive, electronic files, 'Discovery: Theme, Subtheme, Storyline', 5 March 2014

Institutional Archive, electronic files, 'Design Brief Template, Discovery', 15 April 2014

Institutional Archive, electronic files, '(Discovery gallery) History Brief', 20 July 2013

National Museums Scotland
Royal Museum Register of Specimens, Vol.10, 1903–1908, A.1905.355+A-B

Norwich Castle Museum
NWHRM 5069.10, The Royal Norfolk Regiment, A. L. Hadow correspondence to his parents

Redoubt Fortress Military Museum
Accession Register, 3 August 1963

Royal Archives
VIC/ADD E/1/7336, Duke of Cambridge MSS

Royal Engineers Museum
REMLA.4.106, photograph album, credited to and compiled by Colonel Arthur Moffatt Lang CB
REMLA.5.23, photograph album, compiled by J. H. White

Royal Geographical Society
F005/01593, photographic album compiled by Lieutenant G. I. Davys

Royal Naval Museum
1985/275.1, H. J. G. Hood, 'The Benin Disaster'

Royal Sussex Regiment
RSM MS.1/14, Order Book of the Royal American Regiment at Québec 1759 – Feb 1760, Typed Copy

Royal Ulster Rifles Regimental Museum
BELUR.AC.957, photograph album, compiled by J. C. Bowen-Colthurst
BELUR.AC.4505 H, newspaper clipping books, compiled by J. C. Bowen-Colthurst
BELUR.AC.4505 L, newspaper clipping books, compiled by J. C. Bowen-Colthurst

University of Durham, Sudan Archive
304/2/26, Major J. J. B. Farley, 'Some Recollections of the Dongola Expedition'

The Fusilier Museum

RFM.1141.9, photograph album, compiled by Captain Julian Lawrence Fisher DSO
RFM.ARC.1246, diary, Lieutenant Thomas De Beauvoir Carey
RFM.ARC.2081, photograph album
RFM.ARC.2082, photograph album
RFM.AR.2083.1, diary, Corporal Percy Adam Coath
RFM.ARC.2084, photograph album
RFM.ARC.2089, diary, Lance Sergeant Alfred Stanley Dunning

Guidebooks and museum leaflets

The Museum of The Royal Welch Fusiliers, Caernarfon Castle
Guide to Royal Engineers Museum
Beaney Institute Guidebook, 2012
Essex Regiment Museum, leaflet
Royal Engineers Museum, leaflet
The Rifles (Berkshire and Wiltshire) Museum, leaflet
The Wardrobe Military Museum Textile Trail

BIBLIOGRAPHY

Acklom, J. E., 'Our regimental mess table', *USM*, Part 2 (1873), pp. 524–9

Adkins, L., *Empires of the Plain: Henry Rawlinson and the Lost Languages of Babylon* (London: Harper Collins, 2003)

Aijazuddin, F. S., *Sikh Portraits by European Artists* (London: Philip Wilson, 1979)

Akyeampong, E., 'Christianity, modernity and the weight of tradition in the life of "Asantehene" Agyeman Prempeh I, c.1888–1931', *Africa: Journal of the International African Institute*, 69 (1999), 279–311

Alexander, M., and S. Anand, *Queen Victoria's Maharaja: Duleep Singh, 1838–93* (London: Weidenfeld and Nicolson, 1980)

Allan, S., 'Scottish Military Collections', in E. M. Spiers, J. A. Crang and Matthew J. Strickland (eds), *A Military History of Scotland* (Edinburgh: Edinburgh University Press, 2014), pp. 776–94

——, 'Beating Retreat: the Scottish Military Tradition in Decline', in B. S. Glass and J. Mackenzie (eds), *Scotland, Empire and Decolonisation in the Twentieth Century* (Manchester: Manchester University Press, 2015), pp. 131–54

Allan, S., and A. Carswell (eds), *The Thin Red Line: War, Empire and Visions of Scotland* (Edinburgh: National Museums Scotland, 2004)

Ames, M., *Cannibal Tours and Glass Boxes: The Anthropology of Museums* (Vancouver: UBC Press, 1992)

The AMOT Guide to Military Museums in the UK, 2010/11, The Army Museum Ogilby Trust (Third Millennium)

Anderson, D., and R. Grove (eds), *Conservation in Africa* (Cambridge: Cambridge University Press, 1987)

Anon, 'Additions to the museum', *JRUSI* (January, 1873), p. 30

Appadurai, A., 'Introduction: Commodities and the Politics of Value', in A. Appadurai (ed.), *The Social Life of Things: Commodities in Cultural Perspective* (Cambridge: Cambridge University Press, 1986)

Appadurai, A. (ed.), *The Social Life of Things: Commodities in Cultural Perspective* (Cambridge: Cambridge University Press, reprint 2001)

Ascoli, D., *A Companion to the British Army 1660–1983* (London: Harrap, 1983)

Asher, M., *Khartoum: The Ultimate Imperial Adventure* (London: Penguin Books, 2007)

Atkinson, C. T., *Regimental History – The Royal Hampshire Regiment*, Vol. 1 (Glasgow: The University Press, 1950)

Bacon, Commander R. H., *Benin: The City of Blood* (London: Edward Arnold, 1897)

Baden-Powell, Captain R. R. S., *Pig-Sticking or Hog-Hunting: A Complete Account for Sportsmen, and Others* (London: Harrison, 1889)

——, Major R. S. S., *Downfall of Prempeh: A life with the Native Levy in Ashanti, 1895–6* (London: Methuen, 1896)

——, Colonel R. S. S., *The Matabele Campaign* (London: Methuen, 1897)

——, Major R. S. S., *The Sport of Rajahs* (Toronto: G. N. Morang, 1900)

——, Major-General R. S. S., *Sport in War* (London: Heinemann, 1900)

——, Lord Lieutenant-General R. S. S., *Marksmanship for Boys* (London: Pearson, 1915)

Baker, W. J., and J. A. Mangan (eds), *Sport in Africa: Essays in Social History* (New York: Holmes and Meier, 1987)

Balfour Oatts, L., *Emperor's Chambermaids: The Story of the 14th/20th King's Hussars* (London: Ward Lock, 1973)

Bance, P., *Sovereign, Squire & Rebel: Maharaja Duleep Singh and the Heirs of a Lost Kingdom* (London: Coronet House, 2009)

Barczewski, S., *Country Houses and the British Empire, 1700–1930* (Manchester: Manchester University Press, 2014)

Barrett, J., R. Bradley, M. Bowden and B. Mead, 'South Lodge after Pitt Rivers', *Antiquity* 57 (1983), 193–204

Barringer, T., and T. Flynn, *Colonialism and the Object: Empire, Material Culture and the Museum* (London: Routledge, 1998)

Barthes, R., *Camera Lucida* (London: William Collins, Sons & Co, 1989)

Bates, D., *The Abyssinian Difficulty: The Emperor Theodorus and the Magdala Campaign 1867–68* (Oxford: Oxford University Press, 1979)

Bawtree, E. W., 'The brief description of some sepulchral pits of Indian origin lately discovered near Penetanguishene', *Edinburgh New Philosophical Journal*, 45 (1848), 86–101

Beattie, D., 'The Adaption of the British Army to Wilderness Warfare, 1755–1763', in M. Ultee (ed.), *Adapting to Conditions, War and Society in the Eighteenth Century* (Tuscaloosa: University of Alabama Press, 1986), pp. 56–83

Beckett, I. F. W. (ed.), *Wolseley and Ashanti: The Asante War Journal and Correspondence of Major General Sir Garnet Wolseley 1873–1874* (Stroud: History Press for the Army Records Society, 2009)

Bennett, E. N., *The Downfall of the Dervishes, Being a Sketch of the Final Sudan Campaign of 1898* (London: Methuen and Co, 1898)

Bickham, T., '"A conviction of the reality of things": material culture, North American Indians and empire in eighteenth-century Britain', *Eighteenth-Century Studies*, 39:1 (2005), 29–47

Birrell, A., 'Survey photography in British Columbia, 1858–1900', *BC Studies*, No. 52 (Winter 1981–2), 39–60

Boisragon, Captain A., *The Benin Massacre* (London: Methuen and Co., 1897)

Bonarjee, P. D., *A Handbook of Fighting Races of India* (Calcutta: Thacker, Spink & Co., 1899)

Borrett, H. *My Dear Annie: The Letters of Lieutenant Herbert Charles Borrett, The King's Own Royal Regiment Written to his Wife, Annie, during the Abyssinian Campaign of 1868* (Lancaster: King's Own Royal Regiment Museum, 2003)

Bowden, M., *Pitt Rivers: The Life and Archaeological Work of Lieutenant-General Augustus Henry Lane Pitt Rivers, DCL, FRS, FSA* (Cambridge: Cambridge University Press, 1991)

Bowditch, T. E., *Mission from Cape Coast Castle to Ashantee, with a Statistical Account of that Kingdom, and Geographical Notices of Other Parts of the Interior of Africa* (London: John Murray, 1819)

Bradley, R., 'Archaeology, evolution and the public good: the intellectual development of General Pitt Rivers', *Archaeological Journal*, 140 (1983), 1–9

Bringreve, F., D. Stuart-Fox with W. Ernwati, 'Collections after Colonial Conflict: Badung and Tabanan 1906–2006', in P. ter Keurs, *Colonial Collections Revisited* (Leiden University Press: Leiden, 2013), pp. 146–185

Brockway, L. H., *Science and Colonial Expansion: The Role of the British Royal Botanic Gardens* (San Diego, California, 1979)

Brumwell, S., '"A service truly critical": the British army and warfare with the North American Indians, 1755–1764', *War in History*, 5:2 (1998), 146–75

Butler, L., *The Annals of the King's Royal Rifle Corps*, 5 vols (London: Smith, Elder & Co., 1913–32)

Byrne, S., A. Clarke, R. Harrison and R. Torrence (eds), *Unpacking the Collection* (New York: Springer, 2011)

Byron, R., *The King's Royal Rifle Corps Chronicle* (Winchester, 1927)

Cairnes, W. E., *Social Life in the British Army* (London: Harper & Brothers, 1899)

Calloway, C. G., *The American Revolution in Indian Country: Crisis and Diversity in Native American Communities*, Studies in North American Indian History (Cambridge: Cambridge University Press, 1995)

——, *White People, Indians and Highlanders: Tribal Peoples and Colonial Encounters in Scotland and America* (Oxford: Oxford University Press, 2008)

Cammack, D., *The Rand at War 1899–1902: The Witwatersrand and the Anglo-Boer War* (London: James Currey, 1990)

Campbell, C., *The Maharajah's Box: An Imperial Story of Conspiracy, Love and a Guru's Prophecy* (London: HarperCollins, 2000)

——, *Victoria's Rebel Maharaja: Duleep Singh, Last King of the Sikhs* ([London]: Kashi House, 2018)

Campfens, E., 'Nazi-looted art: a note in favour of clear standards and neutral procedures', *Art and Antiquity*, 22:4 (2017), pp. 315–45.

Cannadine, D., *Ornamentalism: How the British Saw Their Empire* (London: Penguin Books, 2001)

Carrieras, H., and C. Castro (eds), *Qualitative Methods in Military Studies: Research Experiences and Challenges* (London: Routledge, 2013)

Carrington, M., 'Officers, gentlemen and thieves: the looting of monasteries during the 1903/4 Younghusband Mission to Tibet', *Modern Asian Studies*, 37:1 (2003), 81–109

Castle, K., *Britannia's Children: Reading Colonialism through Children's Books* (Manchester, Manchester University Press, 1996)

Chakrabarti, D. K., *A History of Indian Archaeology from the Beginning to 1947* (Delhi: Munshiram Manoharlal Publishers Pvt Ltd., 1988)

Chakrabarty, R. R., *Duleep Singh: The Maharaja of Punjab and the Raj* (Birmingham: D. S. Samra, 1986)

Chandler, D. G., and I. Beckett (eds), *The Oxford History of the British Army* (Oxford: Oxford University Press, 2003)

Chapman, W. R., 'Arranging Ethnology: A. H. L. F Pitt Rivers and the Typological Tradition', in G. Stocking (ed.), *Objects and Others: Essays on Museums and Material Culture*, History of Anthropology Vol. 3 (Madison: University of Wisconsin Press, 1985), pp. 15–48

Chiu, C. B., *Yuanming Yuan: Le Jardin de la Clarté Parfaite* (Besançon, 2000)

Christie, Manson and Woods, *Catalogue of a Valuable and Interesting Collection of Indian Gold Jewellery, Richly Studded with Rubies, Emeralds and Diamonds, and Beautifully Enamelled in Translucent Colours; Indian Pure Gold Vases, Cups and Bowls; Silver Ornaments; and a Few French and English Gold and Silver Snuff-Boxes; The Property of H.H. The Prince Victor Duleep Singh, and Formerly the Property of the Late Maharajah Duleep Singh and the Maharajah Runjeet Singh, of Lahore*, Christie, Manson and Woods, 8 King Street, 19 June 1899 (London: William Clowes)

Churchill, W. S., *The River War: An Historical Account of the Reconquest of the Soudan*, Col. F. Rhodes (ed.), 2 vols (London: Longmans, Green and Co., 1899)

Claridge, W. W., *A History of the Gold Coast and Ashanti from the Earliest Times to the Commencement of the Twentieth Century*, 2 vols (London: Frank Cass, 2nd edn, 1964)

Clarke, J., and J. Horne (eds), *Militarized Cultural Encounters in the Long Nineteenth Century, Making War, Mapping Europe* (London: Palgrave MacMillan, 2018)

Classen, C. and Howes, D., 'The Museum as Sensescape: Western Sensibilities and Indigenous Artifacts', in E. Edwards, C. Gosden and R. Philips (eds), *Sensible Objects: Colonialism, Museums and Material Culture* (Oxford and New York: Berg, 2006), pp. 199–222

Clifford, J., 'Museums as Contact Zones', in J. Clifford, *Routes: Travel and Translation in the Late Twentieth Century* (Cambridge, Massachusetts and London: Harvard University Press, 1997), pp. 188–219

——, 'Ishi's Story' in J. Clifford, *Returns: Becoming Indigenous in the Twenty-First Century* (Cambridge, Massachusetts: Harvard University Press, 2013), pp. 90–191

Colchester, R. C. A. (ed.), *History of the Indian Administration of Lord Ellenborough, in His Correspondence with the Duke of Wellington* (London: Richard Bentley and Son, 1874)

Conder, C. R., and H. H. Kitchener, *Survey of Western Palestine: Memoirs of Topography, Orography, Hydrography and Archaeology*, 3 vols (London: Palestine Exploration Fund, 1881–85)

Cook, B. F., 'British Archaeologists in the Aegean', in V. Brand (ed.), *The Study of the Past in the Victorian Age* (Oxford: Oxbow Monograph 73, 1998), pp. 139–54

Coombes, A., *Reinventing Africa: Museums, Material Culture and Popular Imagination in Late Victorian and Edwardian England* (London and New Haven: Yale University Press, 1994)

Coote, J., and A. Shelton (eds), *Anthropology, Art and Aesthetics* (Oxford: Clarendon Press, 1992)

Cormack, Z., and C. Leonardi (eds), *Recovering Cultures: The Arts and Heritage of South Sudan in Museum Collections* (Leiden: Sidestone, forthcoming)

Crowley, T. and A. Mills (eds), *Weapons, Culture and the Anthropology Museum* (Newcastle upon Tyne: Cambridge Scholars, 2018)

Crownover, D., 'Discoveries at Cyrene', *Expedition*, Spring (1963), pp. 2831

Cunynghame, A. M. (ed.), *Post-Office Edinburgh & Leith Directory 1878–79* (Edinburgh: Murray and Gibb, n.d.)

Davey, A. (ed.), *Breaker Morant and The Bushveldt Carbineers* (Cape Town: Van Riebeeck Society, second series No. 18, 1987)

David, S., *The Indian Mutiny: 1857* (London: Viking, 2002)

Davis, P., *Museums and the Natural Environment: The Role of Natural History Museums in Biological Conservation* (London: Leicester University Press, 1996)

Davis, R., 'Three styles in looting India', *History and Anthropology*, 6:4 (1994), 293–317

Dawson, Captain L., *Sound of the Guns: Being an Account of the Wars and Service of Admiral Sir Walter Cowan* (Oxford: Pen-In-Hand, 1949)

Dennis, P., and J. Grey (eds), *The Boer War: Army, Nation and Empire, the 1999 Chief of Army/Australian War Memorial Military History Conference* (Canberra: Army History Unit, 2000)

Desmond, R., 'Photography in Victorian India', *Journal of the Royal Society of Arts*, 134:5353 (December 1985), 48–61

Deutscher Museumsbund/German Museums Association, *Leitfaden: Umgang mit Sammlungsgut aus kolonialen Kontexten, 2. Fassung 2019* (Berlin: Deutscher Museumsbund, 2019)

Deutscher Museumsbund/German Museums Association, *Guidelines on Dealing with Collections from Colonial Contexts* (Berlin: German Museums Association, 2018)

Diaz-Andreu, M., *A World History of Nineteenth-Century Archaeology: Nationalism, Colonialism and the Past* (Oxford: Oxford University Press, 2007)

Dickinson, G., and Wrigglesworth, L., *Imperial Wardrobe* (Toronto: Ten Speed Press, 2000)

Dickinson, R. J., *Officers' Mess: Life and Customs in the Regiments* (Tunbridge Wells: Midas Books, 1973; reprint 1977)

Diemberger, H., 'The Younghusband-Waddell collection and its people: the social life of Tibetan books gathered in a late-colonial enterprise', *Inner Asia*, 14: 1, Special Issue: The Younghusband 'Mission' to Tibet (2012), 131–71

Donnelly, Captain R. E., 'Photography, and its application to military purposes', *Journal of Royal United Services Institution*, 5 (1862), pp. 1–8

Douglas, J., *Nenia Britannica, or a Sepulchral History of Great Britain, from the Earliest Period to Its General Conversion to Christianity: Including a Complete Series of the British, Roman, and Saxon Sepulchral Rites and Ceremonies* (London: John Nichols, 1793)

Dowell's, *Catalogue of the Unique and Exceedingly Valuable Collection of Oriental Armour, Arms, and Objects of Eastern Art, of Supreme Historical Interest Which Came into the Possession of the Marquis of Dalhousie, K.T., When Governor-General of India, 1848–55; Also, Service of Old Silver Plate, War Medals, Oriental Shawls & Embroideries, etc., and the Casket of Personal Jewels and Lace of the late Right Hon. Lady Susan Georgiana Broun, Colstoun House, Haddingtonshire*, Dowell's Rooms, 18 George Street, 7th and 8th December 1898 (Edinburgh: A. & D. Padon)

——, *Dowell's List of Heritable and Moveable Property for Sale*, Dowell's Rooms, 18 George Street (Edinburgh: s.n., 1898)

Drayton, R., *Nature's Government: Science, Imperial Britain and the 'Improvement' of the World* (New Haven: Yale University Press, 2000)

Du Mont, J. S., *American Engraved Powder Horns: The Golden Age 1755 to 1783* (Canaan: Phoenix, 1978)

Dziennik, M. P., *The Fatal Land: War, Empire and the Highland Soldier in British America* (New Haven: Yale University Press, 2015)

Eastwood, S. A., *Lions of England: A Pictorial History of the King's Own Royal Regiment (Lancaster)*, 1680–1980 (Kettering: Silver Link, 1991)

Effros, B., *Incidental Archaeologists: French Officers and the Rediscovery of Roman North Africa* (London: Cornell University Press, 2018)

Emery, F., *The Red Soldier: Letters from the Zulu War* (London: Hodder and Stoughton, 1977)

Errington, E., *The Charles Masson Archive: British Library, British Museum and Other Documents Relating to the 1832–1838 Masson Collection from Afghanistan* (London: The British Museum, 2017)

Errington, S., 'What became authentic primitive art?', *Cultural Anthropology*, 9:2 (1994), 201–26

Evans, C., 'Megalithic follies: Soane's 'Druidic remains' and the display of monuments', *Journal of Material Culture*, 5 (2000), 347–66

——, 'Modelling Monuments and Excavations', in S. de Chadarevian and N. Hopwood (eds), *Models: The Third Dimension of Science* (Stanford, California: Stanford University Press, 2004), pp. 109–37

——, 'Engineering the past: Pitt Rivers, Nemo and the Needle', *Antiquity*, 80 (2006), 960–9

——, 'Soldiering archaeology: Pitt Rivers and militarism', *Bulletin of the History of Archaeology*, 24 (2014), Article 4

Eyo, E., 'The dialectics of definitions: "massacre" and "sack" in the history of the Benin Expedition', *African Arts*, 30:3 (1997), pp. 34–5

Fagg, W., 'Benin: The Sack That Never Was', in F. Kaplan (ed.), *Images of Power: Art of the Royal Court of Benin* (New York: New York University Press, 1981), pp. 20–21

Falconer, J., 'Photography and the Royal Engineers', *The Photographic Collector*, 2:1 (Autumn 1981), 33–64

Farrell, T., *Unwinnable: Britain's War in Afghanistan 2001–2014* (London: The Bodley Head, 2017)

Fergusson, J., *Rude Stone Monuments in All Countries; Their Age and Uses* (London: John Murray, 1872)

Finn, B. and B. C. Hacker (eds), *Materialising the Military* (London: NMSI, 2005)

Finn, M., and K. Smith (eds), *The East India Company at Home* (London: UCL Press, 2018)

Fraser, E., *Greenwich Hospital and Royal United Service Museum* (London: Wells, Gardner, Darton & Co., 1910)

Fraser, W., *History of the Carnegies, Earls of Southesk, and of their Kindred*, 2 vols (Edinburgh: T. Constable, 1867)

Frederickson, N. J., and S. Gibb, *The Covenant Chain: Indian Ceremonial and Trade Silver* (Ottawa: National Museums of Canada, 1980)

French, D., *Military Identities: The Regimental System, the British Army, and the British People c. 1870–2000* (Oxford: Oxford University Press, 2005)

——, *Army, Empire, and Cold War: The British Army and Military Policy, 1945–1971* (Oxford: Oxford University Press, 2012)

Fox, P., 'Kodaking a Just War: Photography, Architecture, and the Language of Damage in Egyptian Sudan, 1884–1898', in J. Clarke and J. Horne (eds), *Militarized Cultural Encounters in the Long Nineteenth Century, Making War, Mapping Europe* (London: Palgrave Macmillan, 2018), pp. 97–124

Gale, R., *A Soldier-like Way: The Material Culture of the British Infantry 1751–68* (Elk River: Track of the Wolf, 2007)

Gardyne, Lieutenant-Colonel C. G. et al., *The Life of a Regiment: The History of the Gordon Highlanders from its Formation in 1794 to 1816*, 7 vols (London: The Medici Society, 1901–74)

Gell, A., 'The Technology of Enchantment and the Enchantment of Technology', in J. Coote and A. Shelton (eds), *Anthropology, Art and Aesthetics* (Oxford: Clarendon Press, 1992), pp. 40–67

——, *Art and Agency: An Anthropological Theory* (Oxford: Clarendon Press, 1998)

Gere, C., and J. Rudoe, *Jewellery in the Age of Queen Victoria: A Mirror to the World* (London: British Museum Press, 2010)

Gilbert, M., *Servant of India: James Dunlop Smith Private Secretary to the Viceroy* (London: Longmans, 1966)

Glass, B. S., and J. MacKenzie (eds), *Scotland, Empire and Decolonisation in the Twentieth Century* (Manchester: Manchester University Press, 2015)

Gordon, S., *Shadows of War: Roger Fenton's Photographs of the Crimea*, 1855 (London: Royal Collection Trust, 2017)

Gosden, C. (2000) 'On His Todd: Material Culture and Colonialism', in M. O'Hanlon and R. L. Welsh (eds), *Hunting the Gatherers: Ethnographic Collectors, Agents and Agency in Melanesia, 1870s–1930s* (Oxford: Berghahn Books, 2000), pp. 227–50

Gosden, C., and C. Knowles, *Collecting Colonialism: Material Culture and Colonial Change* (Oxford: Berg, 2001)

The Graphic, 'Buddhist sculptures found near Jellalabad', *The Graphic*, 21 (1880/1), 293

Greenfield, J., *The Return of Cultural Treasures* (Cambridge: Cambridge University Press, 2007)

Griffiths, T., *Hunters and Collectors: The Antiquarian Imagination in Australia* (Cambridge: Cambridge University Press, 1996)

Grinslade, T., *Powder Horns: Documents of History* (Texarkana: Scurlock, 2007)

Gruber, J. W., 'Ethnographic salvage and the shaping of anthropology', *American Anthropologist*, 61 (1959), 379–89

Guillery, P. (ed.), *Survey of London: Woolwich* (London: Yale University Press, 2012)

Gunn, H., 'The Sportsman as an Empire Builder', in J. Ross and H. Gunn (eds), *The Book of the Red Deer and Empire Big Game* (London: Simpkin, Marshall & Co, 1925), pp. 137–8

Guthman, W. H., *Drums A'beating, Trumpets Sounding: Artistically Carved Powder Horns in the Provincial Manner, 1746–1781* (Hartford: Connecticut Historical Society, 1993)

Harries-Jenkins, G., *The Army in Victorian Society* (London: Routledge and Kegan Paul, 1977)

Harrington, P., and F. A. Sharf (eds), *Omdurman 1898: The Eye Witnesses Speak. The British Conquest of the Sudan as Described by Participants in Letters, Diaries, Photos and Drawings* (London: Greenhill Books, 1998)

Harris, C., *Photography and Tibet* (London: Reaktion Books, 2015)

——, *The Museum on the Roof of the World: Art, Politics and the Representation of Tibet* (Chicago: University of Chicago Press, 2012)

Harrison, F., *Duleep Singh's Statue: East Anglia's Lost Maharajah* (Oxford: Signal Books, 2018)

Harrison, R., S. Byrne and A. Clarke (eds), *Reassembling the Collection: Ethnographic Museums and Indigenous Agency* (Santa Fe: School of American Research Press, 2013)

Harrison, S. J., 'Skulls and scientific collecting in the Victorian Military: keeping the enemy dead in British frontier warfare', *Comparative Studies in Society and History*, 50:1 (2008), 285–303

——, *Dark Trophies: Hunting and the Enemy Body in Modern War* (Oxford: Berghahn, 2012)

Hart, H. G., *The New Annual Army List, Militia List, Yeomanry Cavalry List, and Indian Civil Service List, for 1881* (London: John Murray, 1881)

——, *The New Annual Army List, Militia List, Yeomanry Cavalry List, and Indian Civil Service List, for 1882* (London: John Murray, 1882)

Hartwell, N. M., 'A repository of virtue? the United Services Museum, collecting, and the professionalization of the British Armed Forces, 1829–1864', *JHC* (2018), 77–91, fhy006, https://doi.org/10.1093/jhc/fhy006

Hartwell, N., 'Artefacts of Mourning from the Indian Uprising', in A. Rihter, *War and Peace, Fear and Happiness 110 Years since the End of World War 1* (Ljubljana: ICO-MAM, 2020) pp. 92–105

Hawkins, Captain F., 'Management of regimental messes', *The United Service Journal and Naval and Military Magazine* (*USJ*), Part 3 (1831), pp. 544–5

Heffernan, M., 'Geography, cartography and military intelligence: the Royal Geographical Society and the First World War', *Transactions of the Institute of British Geographers*, 21 (1996), 504–33

Henare, A., *Museums, Anthropology and Imperial Exchange* (Cambridge: Cambridge University Press, 2005)

Hendley, T. H., *Indian Jewellery, Extracted from the Journal of Indian Art 1906–1909* (London: W. Griggs & Son, 1909)

Herbert, A., *Two Dianas in Somaliland: The Record of a Shooting Trip* (London: John Lane, 1908)

Hernon, I., *Britain's Forgotten Wars: Colonial Campaigns of the 19th Century* (Stroud, Gloucs.: Sutton, 2003)

Hevia, J., 'Loot's fate: the economy of plunder and the moral life of objects from the Summer Palace of the Emperor of China', *History and Anthropology*, 6:4 (1994), 319–45

——, 'Looting Beijing: 1860, 1900', in L. He Liu (ed), *Tokens of Exchange* (Durham and Hong Kong: Duke University Press, 1999), pp. 192–213

——, *English Lessons: The Pedagogy of Imperialism in Nineteenth-Century China* (Durham and Hong Kong: Duke University Press, 2003)

Hewitt, R., *Map of a Nation: A Biography of the Ordnance Survey* (London: Granta, 2010)

Hill, J., *The Prizes of War: The Naval Prize System in the Napoleonic Wars, 1793–1815* (Stroud: Sutton in association with the Royal Naval Museum, 1998)

Hill, K., *Culture and Class in English Public Museums, 1850–1914* (Aldershot: Ashgate, 2005)

——, 'Chinese ceramics in United Kingdom Military Museums', *The Oriental Ceramic Society Newsletter*, 20 May (2012), 11–14

——, 'Collecting on campaign: British soldiers in China during the Opium Wars', *JHC*, 25:2 (2012), 1–26

Hill, R. W. Sr, *War Clubs & Wampum Belts: Hodinöhsö:ni Experiences of the War of 1812* (Brantford: Woodland Cultural Centre, 2012)

Hingley, R., *Roman Officers and English Gentlemen: The Imperial Origins of Roman Archaeology* (London: Routledge, 2000)

Hodson, G. H. (ed.), *Hodson of Hodson's Horse: Or, Twelve Years of a Soldier's Life in India, Being Extracts from the Letters of the Late Major W. S. R. Hodson* (London: Kegan Paul, Trench, 1883)

Hofstra, W. R. (ed.), *Cultures in Conflict: The Seven Years' War in North America* (Lanham, Md.: Rowman and Littlefield, 2007)

Holland, T.J., and Hozier, H., *Record of the Expedition to Abyssinia by Order of the Secretary of State for War*, Volumes 1–3 (Her Majesty's Stationery Office: London, 1870)

Holmes, N. M. M., 'The Lindsay Carnegie Collection at the National Museums of Scotland', *The British Numismatic Journal*, 74 (2004), 145–59

Holmes, R., *Sahib: The British Soldier in India* (London: HarperCollins, 2005)

Holmes, R. (ed.), *The Oxford Companion to Military History* (Oxford: Oxford University Press, 2001)

——, *Soldiers: Army Lives and Loyalties from Redcoats to Dusty Warriors* (London: HarperPress, 2011)

Home, R., *City of Blood Revisited: A New Look at the Benin Expedition of 1897* (London: Collins, 1982)

Hoock, H., *Empires of the Imagination: Politics, War and the Arts in the British World, 1750–1850* (London: Profile Books, 2010)

Hooper, S., 'A cross-cultural theory of relics: on understanding religion, bodies, artefacts, images and art,' *World Art*, 4:2 (2014), 175–207

Hooper-Greenhill, E., *Museums and the Interpretation of Visual Culture* (London and New York: Routledge, 2000)

Hope, R., *The Zulu War and the 80th Regiment of Foot* (Lichfield: Churnet Valley Books, 1997)

Hoskins, J., 'Agency, Biography and Objects', in C. Tilley, W. Keane, S. Küchler, M. Rowlands and P. Spyer (eds), *Handbook of Material Culture* (London: SAGE, 2006), pp. 74–84

Hovens, P., and B. Berstein (eds), *North American Indian Art: Masterpieces and Museum Collections in the Netherlands* (Altenstadt: ZKF, 2015)

'How to get recruits. By "Colonel"', *USM*, 29 (1904), pp. 610–20

Howe, S. (ed.), *The New Imperial Histories Reader* (London: Routledge, 2009)

Hudson, K., *The Social History of Archaeology: The British Experience* (London: MacMillan Press, 1981)

Husemann, M., 'Golf in "the City of Blood": the translation of the Benin Bronzes in 19th Century Britain and Germany', *Polyvocia, The SOAS journal of Graduate Research*, 5 (2013), 1–24

Idiens, D., 'Early Collections from the North American Woodlands in Scotland', in J. C. H. King and C. F. Feest (eds), *Three Centuries of Woodlands Indian Art* (Altenstadt: ZKF, 2007), pp. 10–15

Iggulden, H. A., 'To Lhasa with the Tibet Expedition, 1903–4', *JRUSI*, 49:1 (1905), 659–79

Irwin, A., 'Reflections on the Scottish Military Experience', in E. M. Spiers, J. A. Crang and M. J. Strickland (eds), *A Military History of Scotland* (Edinburgh: Edinburgh University Press, 2014), pp. 795–812

Jackson, Lieutenant-Colonel P. R. S., *The Silver Room: The Royal Artillery Mess Woolwich* (London, Royal Regiment of Artillery, 1976)

Jacobs, K., and C. Wingfield, 'Introduction', in K. Jacobs, C. Knowles and C. Wingfield (eds), *Trophies, Relics and Curios: Missionary Heritage from African and the Pacific* (Leiden: Sidestone Press, 2015), pp. 9–23

——, C. Knowles and C. Wingfield (eds), *Trophies, Relics and Curios: Missionary Heritage from African and the Pacific* (Leiden: Sidestone Press, 2015)

Jackson, A., and D. Tomkins (eds), *Illustrating Empire: A Visual History of British Imperialism* (Oxford: Bodleian Library, 2011)

Jasanoff, M., 'Collectors of Empire: objects, conquests and imperial self-fashioning', *Past & Present*, 184 (August, 2004), 109–35

——, *Edge of Empire: Conquest and Collecting in the East, 1750–1850* (London: Fourth Estate, 2005)

Johnson, D., 'The death of Gordon: a Victorian myth', *The Journal of Imperial and Commonwealth History*, 10:3 (1982), 285–310

Jones, K., J. Macola and D. Welch (eds), *A Cultural History of Firearms in the Age of Empire* (Farnham: Ashgate, 2013)

Jones, S., 'Caldwell and DePeyster: Two Collectors from the King's Regiment on the Great Lakes in the 1770s and 1780s', in King and Feest (eds), *Three Centuries of Woodlands Indian Art* (Altenstadt: ZKF, 2007), pp. 32–43

Jones, S., 'Making Histories of Wars' in G. Kavanagh (ed), *Making Histories in Museums* (Leicester: Leicester University Press, 1996), pp. 152–63

Jordanova, L., 'Objects of Knowledge', in P. Vergo (ed), *The New Museology* (London: Reaktion Books, 1989), pp. 24–39

'Journal during the Chinese Expedition in 1841 and 1842', *Colburn's United Service Magazine, and Naval and Military Journal* (*USM*), Part 3 (1878), pp. 102–12

Kaplan, F. (ed.), *Images of Power: Art of the Royal Court of Benin* (New York: New York University Press, 1981)

Kasprycki, S. S. (ed.), *On the Trails of the Iroquois*, Kunst-und Ausstellungshalle der Bundesrepublik Deutschland, Bonn, 22 March to 4 August 2013; Martin-Gropius-Bau, Berlin, 18 October 2013 to 6 January 2014 (Berlin: Nicolai Verlag, 2013)

Kavanagh, G., *Museums and the First World War: A Social History* (Leicester: Leicester University Press, 1994)

Kehoe, V. J. R., 'The works of Captain Thomas Simes, 1767 to 1782', *JSAHR*, 78:315 (2000), 214–17

Kelly, I. S., *Echoes of Success: Identity and the Highland Regiments* (Leiden: Brill, 2015)

Kempe, J. 'An account of some recent discoveries at Holwood-hill in Kent', *Archaeologia*, 22 (1829) 336–49

——, 'Mr. Kempe's observations on the map of the Roman road', *Archaeologia*, 27 (1838), 414–16

Kennedy, C. 'Military Ways of Seeing: British Soldiers' Sketches from the Egyptian Campaign of 1801', in J. Clarke and J. Horne (eds), *Militarized Cultural Encounters in the Long Nineteenth Century: Making War, Mapping Europe.* (Cham, Switzerland: Palgrave Macmillan, 2018), pp. 197–221

King, A., 'The word of command: communication and cohesion in the military', *Armed Forces and Society*, 32:4 (2006), 493–512

King, J. C. H., *Thunderbird and Lightning: Indian Life in Northeastern North America, 1600–1900* (London: British Museum, 1982)

Kirke, C., 'Ball-headed Clubs in Nineteenth-Century Europe: Projecting Power among Woodlands Performers', in King and Feest (eds), *Three Centuries of Woodlands Indian Art* (Altenstadt: ZKF, 2007) pp. 75–84

——, *Red Coat Green Machine: Continuity in Change in the British Army 1700 to 2000* (London: Bloomsbury, 2009)

——, 'Orders is orders . . . aren't they? Rule bending and rule breaking in the British Army', *Ethnography*, 11:3 (2010), 359–80

——, 'Insider Anthropology: Theoretical and Empirical Issues for the Researcher', in H. Carrieras and C. Castro (eds), *Qualitative Methods in Military Studies: Research Experiences and Challenges* (London: Routledge, 2013), pp. 17–30

——, and C. F. Feest (eds), *Three Centuries of Woodlands Indian Art* (Altenstadt: ZKF, 2007)

Knox, R., *The Races of Men* (London: Henry Renshaw, 1850)

Koole, S., 'Photography as event: power, the Kodak camera, and territoriality in early twentieth-century Tibet', *Comparative Studies in Society and History*, 59:2 (2016), 310–45

Kopytoff, I., 'The Cultural Biography of Things: Commoditization as Process', in A. Appadurai (ed.), *The Social Life of Things: Commodities in Cultural Perspective* (Cambridge: Cambridge University Press, 1986), pp. 64–91

Kunz, F. G., *Rings for the Finger* (New York: Dover Publications, 1973; reprint Philadelphia: J.B. Lippincott Company, 1917)

Kutzer, M. D., *Empire's Children: Empire and Imperialism in Classic British Children's Books* (New York: Garland, 2000)

Kyle, D. G., *Spectacles of Death in Ancient Rome* (London: Routledge, 2000)

Lambert, D. and A. Lester, *Colonial Lives across the British Empire: Imperial Careering in the Long Nineteenth Century* (Cambridge: Cambridge University Press), pp. 21–4.

Lee, A., *History of the Thirty-Third Foot, Duke of Wellington's (West Riding) Regiment* (Norwich: Jarrold, 1922)

Leetham, Sir Lieutenant-Colonel A., *Official Catalogue of the Royal United Services Museum, Whitehall, S.W.* (London: The Royal United Services Institution, 1914)

Leetham, Sir Lieutenant-Colonel A., *Official Catalogue of the Royal United Service Museum* (London: Keliher & Co, 7th edn, 1924)

Lefroy, J. H., 'On a bronze object bearing a runic inscription found at Greenmount, Castle Bellingham, Ireland', *Archaeological Journal*, 27 (1870), 284–313

Levray, F., 'Etiquette in the mess-rooms of the British Army', *The Lotus Magazine*, 10:3 (1919), 106–9

Lidchi, H., 'The Poetics and Politics of Representing Other Cultures', in S. Hall, J. Evans and S. Nixon (eds), *Representation: Cultural Representations and Signifying Practices* (London: Sage/Open University Press, 2013), pp. 120–211

——, 'The World to Edinburgh,' in *Scotland to the World: Treasures from the National Museums of Scotland* (Edinburgh: National Museums Scotland, 2016), pp. ix–xv

Lindsay, T. S., 'John Lindsay, the Numismatist', in J. Lindsay (ed.), *Publications of the Clan Lindsay Society*, 6 vols (Edinburgh: Lindsay & Co., 1911), pp. 79–83

Livne, I., *Tibetan Collections in Scottish Museum 1890–1930: A Critical Historiography of Missionary and Military Intent* (unpublished PhD Thesis, University of Stirling, 2013)

Login, Lady [L.], *Sir John Login and Duleep Singh* (London: W.H. Allen & Co., 1890)

Longair, S., and J. McAleer (eds), *Curating Empire: Museums and the British Imperial Experience* (Manchester: Manchester University Press, 2012)

Lopez, D. S. Jr., *The Prisoners of Shangri-la: Tibetan Buddhism and the West* (London: University of Chicago Press, 1998)

Lysons, S., *An Account of Roman Antiquities Discovered at Woodchester* (London, 1797)

Macartney, J., 'China in worldwide treasure hunt for artefacts looted from Yuan Ming Yuan Palace', *The Times* (20 October 2009)

Mack, J., 'The 'Omdurman' Drum', in Z. Cormack and C. Leonardi (eds), *Recovering Cultures: The Arts and Heritage of South Sudan in Museum Collections* (Leiden: Sidestone, forthcoming)

MacKenzie, J. M., *Propaganda and Empire: The Manipulation of British Public Opinion 1880–1960* (Manchester: Manchester University Press, 1984)

——, 'Introduction' in J. M. Mackenzie (ed.), *Imperialism and Popular Culture* (Manchester: Manchester University Press, 1986), pp. 1–16

——, 'Chivalry, Social Darwinism and Ritualised Killing: The Hunting Ethos in Central Africa up to 1914', in D. Anderson and R. Grove (eds), *Conservation in Africa* (Cambridge: Cambridge University Press, 1987), pp. 41–61

——, 'The Imperial Pioneer and Hunter in the British Masculine Stereotype in Late Victorian and Edwardian Times', in J. A. Mangan and J. Walvin (eds), *Manliness and Morality: Middle-Class Masculinity in Britain and America, 1800–1940* (Manchester: Manchester University Press, 1987), pp. 176–98

——, 'Hunting in Eastern and Central Africa in the Late Nineteenth Century', in W. J. Baker and J. A. Mangan (eds), *Sport in Africa: Essays in Social History* (New York: Holmes and Meier, 1987), pp. 172–95

——, *The Empire of Nature: Hunting, Conservation and British Imperialism* (Manchester: Manchester University Press, 1988)

——, 'Hunting and the Natural World in Juvenile Literature', in J. Richards (ed.), *Imperialism and Juvenile Literature* (Manchester: Manchester University Press, 1989), pp. 144–72

——, *Popular Imperialism and the Military* (Manchester: Manchester University Press, 1992)

——, *Museums and Empire: Natural History, Human Cultures and Colonial Identities* (Manchester: Manchester University Press, 2009)

——, Editorial introduction, 'Imperial networks', *Britain and the World*, 11:2 (2018), p. 150

Macleod, D. P., *The Canadian Iroquois and the Seven Years' War* (Toronto: Dundurn/ Canadian War Museum, 1996)

Magubane, Z., 'Simians, Savages, Skulls and Sex: Science and Colonial Militarism in Nineteenth-century South Africa', in D. S. Moore, J. Kosek, and A. Pandian (eds), *Race, Nature and the Politics of Difference* (Durham: Duke University Press, 2003), pp. 99–121

Maharaja Duleep Singh (ed.), *A Reprint of Two Sale Catalogues of Jewels & Other Confiscated Property Belonging to His Highness The Maharajah Duleep Singh, Which Were Put Up to Auction and Sold at Lahore, in the Years 1850 and 1851, by the Government of India. With Introductory Remarks* (Privately Printed, 1885)

Mandala, V. R., *Shooting a Tiger: Big-Game Hunting and Conservation in Colonial India* (Oxford: Oxford University Press, 2019)

Mangan, J. A., and C. C. McKenzie, *Militarism, Hunting, Imperialism: 'Blooding' the Martial Male* (Abingdon: Routledge, 2010)

Marston, D. P., 'Swift and Bold: The 60th Regiment and Warfare in North America 1755–1765' (Master of Arts thesis, Montreal: McGill University, 1997)

Martin, T. C., *Report for the Year 1911–12 on the Royal Scottish Museum, Edinburgh* (London: His Majesty's Stationary Office, 1912)

Mason, P., *A Matter of Honour: An Account of the Indian Army, Its officers & Men* (London: Jonathan Cape, 1974)

Maud, W. T., 'Back to the Soudan: Khartoum and the coming campaign', *Daily Graphic*, July 20, 1898, reproduced in P. Harrington and F. A. Sharf (eds), *Omdurman 1898: The Eye-Witnesses Speak: The British Conquest of the Sudan as Described by Participants in Letters, Diaries, Photos and Drawings* (London: Greenhill Books, 1998), pp. 15–18

McAleer, J., and J. M. MacKenzie (eds), *Exhibiting the Empire* (Manchester: Manchester University Press, 2012)

McAleer, J., and N. Rigby, *Captain Cook and the Pacific: Art, Exploration and Empire* (Newhaven and London: Yale University Press, National Maritime Museum, 2017)

McCarthy, C., *Exhibiting Maori: A History of Colonial Cultures of Display* (Oxford and New York: Berg, 2007)

McIntyre, M., *The Wiltshire Regiment, 1756–1914* (Stroud: Tempus, 2007)

McKay, A., 'The British invasion of Tibet, 1903–04', *Inner Asia*, 14: 1, Special Issue: The Younghusband 'Mission' to Tibet (2012), 5–25

McNair, R. F., *The Colours of the British Army* (London, Day and Son, 1867)

Meadows Taylor, P., 'On prehistoric archaeology of India', *Journal of the Ethnological Society of London*, 1 (1869), 157–81

Miers, M., *Highland Retreats: The Architecture and Interiors of Scotland's Romantic North* (New York: Rizzoli, 2017)

Millais, J. G., *Life of Frederick Courtenay Selous* (London: Longmans, 1918)

Milne-Smith, A., 'A flight to domesticity? Making a home in the gentlemen's clubs of London, 1880–1914', *Journal of British Studies*, 45 (October 2006), 796–818

Morris, P. A., *Rowland Ward, Taxidermist to the World* (Ascot: MPM, 2003)

Moray Brown, J., *Shikar Sketches: With Notes on Indian Field–Sports* (London: Hurst and Blackett, 1887)

Murray, T., 'Excavating the Cultural Traditions of Nineteenth Century English Archaeology: The Case of Robert Knox', in A. Gustafsson and H. Karlsson (eds), *Glyfer och arkeologiske rum – en vänbok til Jarl Nordbladh* (Göteborg: University of Göteborg, 1999), pp. 501–15

Musgrave, T., and W. Musgrave, *An Empire of Plants: People and Plants That Changed the World* (London: Cassell, 2000)

Mutch, A., *Tiger Duff: India, Madeira and Empire in Eighteenth-Century Scotland* (Aberdeen: Aberdeen University Press, 2017)

Myatt, T., 'Trinkets, temples and treasures: Tibetan material culture and the 1904 British Mission to Tibet', *Revue d'Etudes Tibétaines*, 21 (2011), 123–53

——, 'Looting Tibet: conflicting narratives and representations of Tibetan material culture from the 1904 British Mission to Tibet', *Inner Asia*, 14: 1, Special Issue: The Younghusband 'Mission' to Tibet (2012), 61–70

Narrien, J., 'Observations on a Roman encampment near East Hempstead, in Berkshire', *Archaeologia*, 10 (1821), 96–8

Nationaal Museum van Wereldculturen, *Return of Cultural Objects: Principles and Process* (Leiden: NMVW, 2019)

Nestor, S. (ed.), *War-Booty: A Common European Heritage* (Stockholm: Royal Armoury Livrustkammern, 2009)

Newton, M., 'Celtic Cousins or White Settlers? Scottish Highlanders and First Nations', in K. Nilsen (ed.), *Rannsachadh na Gàidhlig 5* (Sydney: University of Cape Breton Press, 2011), pp. 221–37

Nilsen, K. (ed.), *Rannsachadh na Gàidhlig 5* (Sydney: University of Cape Breton Press, 2011)

Noltie, H. J., *Indian Forester, Scottish Laird* (Edinburgh: Royal Botanic Garden, 2016)

——, *The Cleghorn Collection: South Indian Botanical Drawings 1845–1860* (Edinburgh: Royal Botanic Gardens, 2016)

Norman, C. B., *Battle Honours of the British Army: From Tangier 1662, to the commencement of the reign of King Edward VII* (London: John Murray, 1911, reprinted 1971)

'Notes, questions and replies', *JSAHR*, 3:11 (1924), 156

'Officers' Mess', *JSAHR*, 3:11 (1924), 10–12

O'Hanlon, M., 'Introduction', in M. O'Hanlon and R. L. Welsh (eds), *Hunting the Gatherers: Ethnographic Collecting, Agents and Agency in Melanesia* (Oxford: Berghahn Books, 2000), pp. 1–34

——, *The Pitt Rivers Museum: A World Within* (London: Scala Arts & Heritage Publishers, 2014)

——, and R. L. Welsh (eds), *Hunting the Gatherers: Ethnographic Collectors, Agents and Agency in Melanesia, 1870s–1930s* (Oxford: Berghahn Books, 2000)

Ohrwalder, Father J., *Ten Years' Captivity in the Mahdi's Camp, 1882–1892*, redacted from original manuscripts by Major F. R. Wingate (London: Samson Low, Marston and Co., 1892)

Owen, J., 'Collecting artefacts, acquiring empire: exploring the relationship between Enlightenment and Darwinist collecting and late-nineteenth-century British imperialism', *JHC*, 189 (2006), 9–25

——, 'Collecting artefacts, acquiring empire: a maritime endeavour', *Journal of Museum Ethnography*, 18 (May 2006), 141–8

——, 'A Significant Friendship: Evans, Lubbock and a Darwinian World Order', in A. Macgregor (ed.), *Sir John Evans 1823–1908: Antiquity, Commerce and Natural Science in the Age of Darwin* (Oxford: Ashmolean Museum, 2008), pp. 206–29

——, *Darwin's Apprentice: An Archaeological Biography of John Lubbock* (Barnsley, S. Yorks.: Pen and Sword Archaeology, 2013)

Paddayya, K., *Essays in History of Archaeology: Themes, Institutions and Personalities* (Noida: Archaeological Survey of India, 2013)

Pakenham, T., *Boer War* (London: Weidenfeld & Nicolson, 1979)

Parkin, D., 'Mementoes as Transitional Objects in Human Displacement', *Journal of Material Culture*, 4:3 (1999), 303–20

Patterson, B., T. Brooking and J. McAloon, *Unpacking the Kists: The Scots in New Zealand* (Dunedin: University of Otago Press, 2013)

Pearce, S. M., *Museums, Objects and Collections: A Cultural Study* (Leicester: Leicester University Press, 1992)

Peers, L., and A. Brown (eds), *Museums and Source Communities: A Routledge Reader* (London and New York: Routledge, 2003)

Perkins, R., *Military and Naval Silver* (Devon: Roger Perkins, 1999)

Petch, A., 'Weapons and "the museum of museums"', *Journal of Museum Ethnography*, 8 (1996), 11–22

——, '"Man as he was and Man as he is": General Pitt Rivers' Collection', *JHC*, 10 (1998), 75–85

——, 'Chance and certitude: Pitt Rivers and his first collection', *JHC*, 18 (2006), 257–66

Phillips, R. B., *Museum Pieces: Exhibiting Native Art in Canadian Museums* (Montreal: McGill, 2011)

——, 'Reading and writing between the lines: soldiers, curiosities, and Indigenous art histories', *Winterthur Portfolio*, 45:2/3 (2011), 107–24

——, 'The Other Victoria and Albert Museum: Itineraries of Empire at the Swiss Cottage Museum, Osborne House', in M., Wellington Gathtan and E., Troelenberg (eds.), *Collecting and Empires: An Historical and Global Perspective* (London: Harvey Miller Publishers, 2018), pp. 239–57

——, and D. Idiens, 'A casket of savage curiosities: eighteenth-century objects from north-eastern North America in the Farquharson Collection', *JHC*, 6:1 (1994), 21–33

Piggott, S., *Ruins in a Landscape: Essays in Antiquarianism* (Edinburgh: Edinburgh University Press, 1976)

Pitt Rivers, Lieutenant-General. A. H. L. F., 'On the improvement of the rifle as a weapon for general use', *JRUSI*, 2 (1858), 453–88

——, 'On a model illustrating the parabolic theory of projection for ranges in vacuo', *JRUSI*, 5 (1861), 497–501

——, 'A description of certain piles found near London Wall and Southwark, possibly the remains of pile buildings', *Anthropological Review*, 5 (1867), lxxi–lxxxiii

——, 'Primitive Warfare: illustrated by specimens from the Museum of the Institution' (pts. I–III)', *JRUSI*, 11–13 (1867, 1868 and 1869), 612–45, 399–439, and 509–39

——, *Catalogue of the Anthropological Collection Lent by Colonel Lane Fox for Exhibition in the Bethnal Green Branch of the South Kensington Museum, June 1874* (London: South Kensington Museum, 1874)

——, 'Excavations of Cissbury Camp, Sussex', *Journal of the Anthropological Institute*, 5 (1875), 357–90

——, 'On the evolution of culture', *Proceedings of the Royal Institution*, 7 (1875), 496–520

——, 'On measurements taken of the officers and men of the 2nd Royal Surrey Militia according to the general instructions drawn up by the Anthropometric Committee of the British Association', *Journal of the Anthropological Institute* 6 (1877), 443–57

——, 'Excavations at Caesar's Camp, near Folkestone, conducted in 1878', *Archaeologia*, 47 (1883), 429–65

——, *Excavations in Cranborne Chase*, Vol. 1 (Privately Printed, 1887)

——, 'Typological Museums, as exemplified by the Pitt Rivers Museum in Oxford and his provincial museum in Farnham, Dorset', *Journal of the Society of Arts*, 40 (1891), 115–22

Pollock, J., *Kitchener: Architect of Victory, Artisan of Peace* (New York: Carrol & Graff, 2001)

Porter, W., *History of the Corps of Royal Engineers* (London: Longmans, Green & Co., 1889)

Pretorius, F., *The Anglo-Boer War 1899–1900* (Cape Town: Struik Publishers, 1985)

——, *Life on Commando during the Anglo-Boer War 1899–1902* (Cape Town Pretoria Johannesburg: Human & Rousseau, 1999)

Price, S., *Paris Primitive: Jacques Chirac's Museum on the Quai Branly* (Chicago: University of Chicago Press, 2007)

Price, S., *Primitive Art in Civilized Places* (Chicago: University of Chicago Press, 1991)

Prior, M., *Campaigns of a War Correspondent* (London: Edward Arnold, 1912)

Pritchard, J. C., 'On the Extinction of Human Races', *Edinburgh New Philosophical Journal*, 28 (1839), 166–70

——, 'Ethnology', in J. F. W. Herschel (ed.), *A Manual of Scientific Enquiry: Prepared for use of Her Majesty's Navy and Adapted for Travellers in General* (London: John Murray, 1849), pp. 423–44

The Queen's Regulations and Orders for the Army (London: Her Majesty's Stationery Office, 4th edn, 1868)

The Queen's Regulations and Orders for the Army (London: Parker, Furnivall, and Parker, 3rd edn, 1844)

Quintal, G. Jr., *Patriots of Color, 'A Peculiar Beauty and Merit', African Americans and Native Americans at Battle Road & Bunker Hill* (Boston, MA: Division of Cultural Resources, Boston National Historical Park, 2004)

Ramsey, N., 'Exhibiting Discipline: Military Science and the Naval and Military Library and Museum', in N. Ramsey and G. Russell (eds), *Tracing War in British Enlightenment and Romantic Culture* (Basingstoke: Palgrave Macmillan, 2015), pp. 113–31

Rawlinson, Lieutenant-Colonel H., 'Notes on some paper casts of cuneiform inscriptions upon the sculptured rock at Behistun', *Archaeologia*, 34 (1851), 73–6

Rawson, G., *Life of Admiral Sir Harry Rawson* (Oxford: Thornton Books, 1914)

Raychaudhuri, A., *Homemaking: Radical Nostalgia and the Construction of a South Asian Diaspora* (London: Rowman & Littlefield, 2018), pp. 21–46

Rayner, H. (ed, compiler) *Photographic Journeys in the Himalayas by Samuel Bourne* (Pagoda Tree Press: Bath, 2nd edn, 2004)

Rees, J. U., 'The use of tumplines or blanket slings by light troops,' *The Continental Soldier*, 8:2 (1995), 27–9

Reitz, D., *Commando: A Boer Journal of the Boer War* (London: Faber & Faber, 1929)

Rhys, O., *Contemporary Collecting: Theory and Practice* (Edinburgh: MuseumsEtc, 2014)

Richards, J. (ed.), *Imperialism and Juvenile Literature* (Manchester: Manchester University Press, 1989)

Richter, D., *The Ordeal of the Longhouse: The Peoples of the Iroquois League in the Era of European Colonization* (Chapel Hill, N.C: University of North Carolina Press, 1992)

Ringmar, E., *Liberal Barbarism: The European Destruction of the Palace of the Emperor of China* (New York: Palgrave Macmillan, 2013)

Robertson, D., *The Journal of Sergeant D. Robertson, Late 92d Foot: Comprising the Different Campaigns between the Years 1797 and 1818 in Egypt, Walcheren, Denmark, Sweden, Portugal, Spain, France, and Belgium* (Perth: J. Fisher, 1842)

Rose, E. P. F., 'British pioneers of the geology of Gibraltar, Part 2: Cave archaeology and geological survey of the Rock, 1863 to 1878', *Earth Sciences History*, 33 (2014), 26–58

Ross, J., and H. Gunn (eds), *The Book of the Red Deer and Empire Big Game* (London: Simpkin, Marshall & Co, 1925)

Rowlands, M., 'The good and bad death: ritual killing and historical transformation in a West African Kingdom', *Paideuma*, 39 (1993), 291–301

Royal Engineers (J. W. S.), 'Memoir: Colonel Arthur Moffatt Lang, C.B., R.E', *The Royal Engineers Journal*, 24:4 (October 1916), 165–8

Royal Engineers Institute, *The Pictures and Plate of the Royal Engineers Headquarters Mess Chatham* (Chatham: Institution of Royal Engineers, 1909)

Royal Regiment of Artillery, *Regimental Heritage* (London, 1984)

Royal Warrants, Circulars, General Orders, and Memoranda, Issued by the War Office and Horse Guards, August 1856–July 1864 (Glasgow: James Maclehose, 1864)

Royal Warrants, 'War Office Circular 600, 19 June 1860', in *Royal Warrants, Circulars, General Orders, and Memoranda, Issued by the War Office and Horse Guards, August 1856–July 1864* (Glasgow: James Maclehose, 1864), pp. 103–4

Russell, G., 'Romantic Militarisation: Sociability, Theatricality and Military Science in the Woolwich Rotunda, 1814–2013', in N. Ramsey and G. Russell (eds), *Tracing War in British Enlightenment and Romantic Culture* (Basingstoke: Palgrave Macmillan, 2015), pp. 96–112

Russell, W. H., *My Diary in India*, 2 vols. (London: Routledge, Warne and Routledge, 1860)

Ryan, J. R., *Picturing Empire: Photography and the Visualization of the British Empire* (London: Reaktion Books, 1997)

Sanderson, H., 'Transgression of the frontier: an analysis of documents relating to the British invasion of Tibet', *Inner Asia*, 14: 1, Special Issue: The Younghusband 'Mission' to Tibet (2012), 27–60

Sarna, N., *The Exile: A Novel Based on the Life of Maharaja Duleep Singh* (New Delhi: Penguin, 2008)

Sarr, F., and B. Savoy, *Restituer le Patrimoine Africain* (Paris: Philippe Rey/Seuil, 2018)

Saunders, N. (ed.), *Matters of Conflict* (New York and London: Routledge, 2004)

——, and P. Cornish (eds), *Contested Objects* (New York and London: Routledge, 2009)

Scheersoi, A., and S. D. Tunnicliffe (eds), *Natural History Dioramas – Traditional Exhibits for Current Educational Themes* (Cham, Switzerland: Springer, 2015)

Schikkerling, R., *Commando Courageous (A Boer's Diary)* (Johannesburg: Hugh Keartland, 1964)

Schofield, J., W. Gray Johnson and C. M. Beck (eds), *Matériel Culture* (London: Routledge, 2002)

Schaw, H., 'Notes on Photography', *Papers on the Subject of the Duties of the Royal Engineers*, New Series, 9 (1860), 108–28

Schwartz, J. M., and J. R. Ryan, 'Introduction: Photography and the Geographical Imagination', in J. M. Schwartz and J. R. Ryan (eds), *Picturing Place: Photography and the Geographical Imagination* (London: I. B. Tauris, 2003), pp. 1–19

—— and J. R. Ryan (eds), *Picturing Place: Photography and the Geographical Imagination* (London: I. B. Tauris, 2003)

Scientific American (G. E. W), 'Military photography', *Scientific American*, 16 August (1902), p. 102

Secord, J., 'King of Siluria: Roderick Murchison and the imperial theme in nineteenth-century British geology', *Victorian Studies*, 25 (1982), 413–42

Selous, F. C., *Travel and Adventure in South-East Africa: Being the Narrative of the Last Eleven Years Spent by the Author on the Zambesi* (London: Rowland Ward, 1893)

——, *Sunshine and Storm in Rhodesia* (London: Rowland Ward, 1896)

Shannon, T. J., 'Dressing for success on the Mohawk Frontier: Hendrick, William Johnson, and the Indian Fashion', *The William and Mary Quarterly*, 53:1, Material Culture in Early America (1996), pp. 13–42

——, 'War, Diplomacy and Culture: The Iroquois Experience in the Seven Years' War in North America', in W. R. Hofstra (ed.), *Cultures in Conflict: The Seven Years' War in North America* (Lanham, Md.: Rowman and Littlefield, 2007), pp. 79–103

Shaw, Major C., 'On the depot system', *USJ*, Part 2 (1861), pp. 33–9

Sheets-Pyenson, S., *Cathedrals of Science: The Development of Colonial Natural History Museums in the Late Nineteenth Century* (Kingston and Montreal: McGill-Queen's University Press, 1988)

Simes, T., *The Military Guide for Young Officers* (London: J. Millan, 2nd edn, 1776)

Simpson, M., *Making Representations: Museums in the Post-colonial Era* (London and New: Routledge, 1996)

Singh, G. (ed.), *Maharaja Duleep Singh, Correspondence*, History of the Freedom Movement in the Punjab, 3 (Patiala: Punjabi University, 1977)

'Six months with the Expeditionary Army', *USJ*, Part 2 (1855), pp. 26–34

Slatin Pasha, Colonel Sir R., *Fire and Sword in the Sudan: A Personal Narrative of Fighting and Serving the Dervishes, 1879–1895*, translated by Sir F. R. Wingate (London: Edward Arnold, 1905)

Smyth, W. H., 'Account of an ancient bath in the Island of Lipari', *Archaeologia*, 2 (1830), 98–102

——, 'On some Roman vestigia recently found at Kirby Thore, in Westmoreland', *Archaeologia*, 31 (1846), 279–88

Spiers, E. M., *The Army and Society, 1815–1914* (London: Longman Ltd, 1980)

——, *The Late Victorian Army, 1868–1902* (Manchester: Manchester University Press, 1992)

——, *The Victorian Soldier in Africa* (Manchester; Manchester University Press, 2004)

——, *The Scottish Soldier and Empire, 1854–1902* (Edinburgh: Edinburgh University Press, 2006)

——, J. A. Crang and M. J. Strickland (eds), *A Military History of Scotland* (Edinburgh: Edinburgh University Press, 2014)

Spies, S. E., *Methods of Barbarism? Roberts and Kitchener and Civilians in the Boer Republics: January 1900-May 1902* (Cape Town: Human & Rousseau, 1977)

Stanley, H. M., *Coomassie and Magdala: The Story of Two British Campaigns in Africa* (London: Sampson Low, Marston Low & Searle, 1874)

Stein, G., 'Archaeology and Monument Protection in War: The Collaboration between the German Army and the Researchers in the Ottoman Empire, 1914–1918', in J. Clarke and J. Horne (eds), *Militarized Cultural Encounters in the Long Nineteenth Century: Making War, Mapping Europe* (Cham, Switzerland: Palgrave Macmillan, 2018), pp. 297–317

Steiner, C., *African Art in Transit* (Cambridge: Cambridge University Press, 1994)

Stephenson, Sir F. C. A., *At Home and on the Battlefield* (London: John Murray, 1915)

——, 'Dressing for success on the Mohawk Frontier: Hendrick, William Johnson, and the Indian Fashion', *The William and Mary Quarterly*, 53:1, Material Culture in Early America (1996), pp. 13–42

Stocking, G. W. Jr, *Victorian Anthropology* (London: Collier Macmillan Pub., 1987)

Strachan, H., *Wellington's Legacy: The Reform of the British Army, 1830–54* (Manchester: Manchester University Press, 1984)

Streets, H., *Martial Races: The Military, Race and Masculinity in British Imperial Culture, 1857–1914* (Manchester: Manchester University Press, 2004)

Stronge, S., 'The Sikh Treasury: The Sikh Kingdom and the British Raj', in Brown, K. (ed.) *Sikh Art and Literature* (London and New York: Routledge, 1999, pp. 72–88)

Sweet, R., *Antiquaries: The Discovery of the Past in Eighteenth-Century Britain* (London: Hambledon & London, 2004)

Tabler, E. C. (ed.), *Trade and Travel in Early Barotseland: The Diaries of George Westbeech and Captain Norman MacLeod 1875–1876* (London: Chatto and Windus, 1963)

Talbot Rice, E., and M. Harding, *Butterflies and Bayonets: The Soldier as Collector* (London: NAM, 1989)

Taylor, J. W., *Guilty but Insane: J. C. Bowen-Colthurst – Villain or Victim?* (Cork: Mercier Press, 2016)

Ter Keurs, P. J. (ed.), *Colonial Collections Revisited* (Leiden: CNWS Publications, 2007)

Ter Keurs, P. J., 'Introduction: Theory and Practice of Colonial Collecting', in P. J. ter Keurs (ed.), *Colonial Collections Revisited*, pp. 1–16

Thomas, F. W. L., 'Account of some Celtic antiquities of Orkney', *Archaeologia*, 34 (1851), 88–136

Thomas, G., 'The looting of Yuanming and the translation of Chinese art in Europe', *Nineteenth-Century Art Worldwide: A Journal of Nineteenth-Century Visual Culture*, 7:2 (2008), 22–60, www.19thc-artworldwide.org/index.php/autumn08/93-the-looting-of-yuanming-and-the-translation-of-chinese-art-in-europe

Thomas, N., *Entangled Objects: Exchange, Material Culture and Colonialism in the Pacific* (Cambridge, Mass.: Harvard University Press, 1991)

——, *Possessions: Indigenous Art/Colonial Culture* (London: Thames and Hudson, 1999)

Thompsell, A., *Hunting Africa: British Sport, African Knowledge and the Nature of Empire* (London: Palgrave Macmillan, 2015)

Thompson, J., *Forgotten Voices of Burma: The Second World War's Forgotten Conflict* (London: Ebury, 2009)

Thompson, M. W., *General Pitt-Rivers: Evolution and Archaeology in the Nineteenth Century* (Bradford-on-Avon: Moonraker Press, 1977)

Thornborrow, T., and A. D. Brown, 'Being regimented: a case study of the regulation of identity in the British Parachute Regiment', *Organization Studies*, 1 (2008), 355–76

Thwaites, P., *Presenting Arms: Museum Representation of British Military History, 1660–1900* (Leicester: Leicester University Press, 1996)

Trimen, R., *An Historical Memoir of the 35th Regiment of Foot* (Southampton: Southampton Times, 1873)

Tylor, E. B., 'Presidential Address to the Anthropological Institute', *Journal of the Anthropological Institute of Great Britain and Ireland*, 10 (1881), 440–58

Tythacott, L., 'The Politics of Representation in Museums', in M. Bates (ed), *Encyclopedia of Library and Information Sciences* (London: CRC Press, Taylor & Francis Group, 3rd edn, 2010), pp. 4230–41

——, *The Lives of Chinese Objects* (Oxford: Berghahn Books, 2011)

—— (ed.), *Collecting and Displaying China's 'Summer Palace' in the West* (London: Routledge, 2018)

UK Parliament, *Papers Relating to the Punjab, 1847–1849. Presented to Both Houses of Parliament by Command of Her Majesty* (London: Harrison and Son, May 1849)

Ulbrich, A., and T. Kiely, 'Britain and the archaeology of Cyprus I: the long 19th century', *Cahiers du Centre d'Etudes Chypriotes*, 42 (2012), 305–56

Ultee, M. (ed.), *Adapting to Conditions: War and Society in the Eighteenth Century* (Tuscaloosa: University of Alabama Press, 1986)

UNESCO, *Protection of Cultural Property: Military Manual* (France: UNESCO Publishing, 2016)

Untracht, O., *Traditional Jewelry of India* (London: Thames & Hudson, 1997)

USJ, 'General orders, circulars, &c.', *USJ*, Part 1 (1829), p. 384

USJ, 'Advice from an old to a young officer', *USJ*, Part 2 (1839), pp. 84–6

USJ, 'General order – expenses of regimental messes, Horse Guards', *USJ*, Part 3 (1844), pp. 621–3

Van Beurden, J., *Treasures in Trusted Hands: Negotiating the Future of Colonial Cultural Objects* (Sidestone Press: Leiden, 2007)

Van Der Waag, I., 'South Africa and the Boer Military System' in P. Dennis and J. Grey (eds), *The Boer War: Army, Nation and Empire, the 1999 Chief of Army/Australian War Memorial Military History Conference* (Canberra: Army History Unit, 2000), pp. 45–69

Vetch, Colonel R. H., *Life, Letters and Diaries of Lieut.-General Sir Gerald Graham* (Edinburgh: William Blackwood and Sons, 1901)

Vincent, J. (ed.), *A Selection from the Diaries of Edward Henry Stanley, Fifteenth Earl of Derby (1826–93) between September 1869 and March 1878*, Camden Miscellany, 5th series, IV (London: Royal Historical Society, 1994)

Voigt, F., R. Nicolson and L. Bennison, 'Panjab connections: a Young Roots heritage project at National Museums Scotland', *Journal of Museum Ethnography*, 30 (2017), 24–48

Waddel, L. A., *Lhasa and Its Mysteries: With a Record of the British Tibetan Expedition of 1903–4* (New York: Dover Publications, 1988)

Wagstaff, M., 'Colonel Leake's collections: their formation and their acquisition by the University of Cambridge', *JHC*, 24 (2012), 327–36

Wallace, D. M., *The Web of Empire: A Diary of the Imperial Tour of the Their Royal Highnesses the Duke and Duchess of Cornwall and York in 1901* (London: Macmillan, 1902)

Wallace, Captain N. W., *A Regimental Chronicle and List of Officers: The 60th, or The King's Royal Rifle Corps Formerly the 62nd, or The Royal American Regiment of Foot* (London: Harrison, 1879)

Wallace, R. L., *The Australians at the Boer War* (Canberra: The Australian War Memorial and the Australian Government Publishing Service, 1976)

Wardrop, Lieutenant-General A. E., *Modern Pig-Sticking* (London: Macmillan, 1914)

Warren, C., C. W. Wilson and A. P. Stanley, *The Recovery of Jerusalem: A Narrative of Exploration and Discovery in the City and the Holy Land* (W. Morrison, ed.; New York: D. Appleton, 1871)

Webb-Carter, Brigadier B. W., 'A subaltern in Abyssinia', *JSAHR*, 38 (1960), 144–9

Welch, K. E., *The Roman Amphitheatre* (Cambridge: Cambridge University Press, 2007)

Werrett, S., 'The arsenal as spectacle', *Nineteenth Century Theatre & Film*, 37:1 (2010), 14–22

Wheeler, R. E. M., *Archaeology from the Earth* (Harmondsworth: Penguin, 1954)

White, R., *The Middle Ground: Indians, Empires and Republics in the Great Lakes Region, 1650–1815* (Cambridge: Cambridge University Press, 2012)

Wiener, J., 'Object lessons: Dutch colonialism and the looting of Bali', *History and Anthropology*, 6:4 (1994), 347–70

Wilkinson, S., and I. Hughes, 'Soldiering on', *Museums Journal*, 91:11 (1991), 23–8

Willcocks, Brigadier-General Sir J., *From Kabul to Kumassi: Twenty-Four Years of Soldiering and Sport* (London: John Murray, 1964)

Williamson, G., *Observations on the Human Crania Contained in the Museum of the Army Medical Department, Fort Pitt, Chatham* (London: McGlasham & Gill, 1857)

Wilson, Lieutenant-Colonel A., 'Old Army Customs', *JSAHR*, 6 (1927), 134–8

Wilson, B., *Soft Systems Methodology: Conceptual Model Building and Its Contribution* (Chichester: Wiley, 2001)

Wintle, C., 'Career Development: Domestic Display as Imperial, Anthropology and Social Trophy', *Victorian Studies*, 50:2 (Winter 2008), 282

Whitteridge, G., *Charles Masson of Afghanistan: Explorer, Archaeologist, Numismatist and Intelligence Agent* (Warminster: Aris & Phillips, 1986)

Wolseley, Lieutenant-Colonel G. J., *Narrative of the War with China in 1860* (London: Longman, Green, Longman, and Roberts, 1862)

——, General Viscount G. J., *The Soldier's Pocket Book for Field Service* (London: Macmillan & Co., 5th edn, 1886)

——, Field-Marshal Viscount G. J., *The Story of a Soldier's Life*, 2 vols (London: Constable & Co., 1903)

Wong, Y. T., *A Paradise Lost: The Imperial Garden Yuanming Yuan* (University of Hawai'i Press, 2001)

Wood, E., *From Midshipman to Field Marshal*, 2 vols (London, 1906)

Wood, P., 'Display, restitution and world art history: the case of the "Benin Bronzes"', *Visual Culture in Britain*, 13:1 (2012), 115–37

Wood, S., 'The British gorget in North America', *Waffen und Kostümkunde*, 26:1 (1984), pp. 3–16

——, 'Too serious a business to be left to military men: a personal view of the military museum's role today', *Museum International*, 38:1 (1986), 20–26

——, 'Wha's like us?: a personal view of the way ahead for Scotland's military museums!', *Museums Journal*, 86:1 (1986), 13–15

——, 'Military museums: the national perspective', *Museums Journal*, 87:2 (1987), 65–6

Woolley, C. L. and T. E. Lawrence, *The Wilderness of Zin* (Palestine Exploration Fund Archaeological Report; London: Harrison and Sons, 1914)

Younghusband, F., *India and Tibet* (London: John Murray, 1910)

Zaboly, G. S., 'The use of tumplines in the French and Indian War', *Military Collector and Historian*, 46 (Fall 1994), 109–13

Zea, P., 'Revealing the culture of conflict: engraved powder horns from the French & Indian War', *Historic Deerfield* (Summer 2008), pp. 20–7

Zulfo, 'I. H., *Karari: The Sudanese Account of the Battle of Omdurman*, trans. by P. Clark (London: Frederick Warne, 1980)

Internet sources

Allan, S., 'Individualism, exceptionalism and counter culture in Second World War special service training', paper presented to Waterloo to Desert Storm: new thinking on international conflict, 1815–1991, Scottish Centre for War Studies, Glasgow University, 24–25 June 2010 (National Museums Scotland Research Repository, 2011), http://repository.nms.ac.uk/id/eprint/276, accessed 2 June 2019

Asharq Al-Awsat, https://aawsat.com/english/home/article/1609991/uk-accuses-us-soldiers-stealing-remnants-historic-battle-afghanistan, accessed 31 March 2019

Bailey, M., 'London museum returns emperor's hair – taken by a British officer as a war trophy – to Ethiopia', *The Art Newspaper* (21 March 2019), available at www.theartnewspaper.com/news/maqdala, accessed 30 May 2019

Bailey, M. 'London's National Army Museum to return emperor's hair to Ethiopia', *The Art Newspaper* (4 March 2019), available at www.theartnewspaper.com/news/london-s-national-army-museum-to-return-emperor-s-hair-to-ethiopia, accessed 30 May 2019

Bailey, M. 'Ethiopia toughens position on Maqdala treasures calling for full restitution', *The Art Newspaper* (20 April 2018), available at www.theartnewspaper.com/news/ethiopia-toughens-position-on-maqdala-treasures-calling-for-full-restitution, accessed 30 May 2019

British Army website, *Values and Standards of the British Army*, available at www.army.mod.uk/media/5219/20180910-values_standards_2018_final.pdf, accessed 1 January 2019

British Broadcasting Corporation (BBC) Asian Network, Interview with Davindor Toor, available at www.kashihouse.com/whats-on/maharani-jind-kaurs-jewellery-goes-for-record-price, accessed 30 June 2019

BBC News, http://news.bbc.co.uk/1/hi/scotland/4106465.stm, accessed 30 October 2018

BBC News, S. Jacob, 'Indian MPs demand Kohinoor's return', 26 April 2000, http://news.bbc.co.uk/1/hi/world/south_asia/727231.stm, accessed 13 December 2013

Cordrea-Rado, A. 'UK Museum offers Ethiopia long term loan of looted treasures', *The New York Times* (4 April, 2018), www.nytimes.com/2018/04/04/arts/design/v-and-a-ethiopian-treasure.html?searchResultPosition=1, accessed 30 May 2019

The Dictionary of Victorian London, http://www.victorianlondon.org/entertainment/unitedservicemuseum.htm, accessed 1 August 2019

Embassy of the Federal Democratic Republic of Ethiopia, London, 'Culture Minister visits British Museums on debut visit to the UK', 29 March 2019, available at www.ethioembassy.org.uk/culture-minister-visits-british-museums-on-debut-visit-to-the-uk/, accessed 30 May 2019

First World War.com, Primary Documents, 'Lord Kitchener's guidance to British Troops, August 1914', www.firstworldwar.com/source/kitchener1914.htm, accessed 9 July 2015

Forces Net, www.forces.net/news/tri-service/former-sas-soldier-jailed-over-trophy-pistol, accessed 30 November 2018

The Gazette, Supplement to the London Gazette 1879, Issue 24685, available at www.thegazette.co.uk/London/issue/24685/, accessed 2 July 2019

Illustrated London News, www.gale.com/intl/c/illustrated-london-news-historical-archive, accessed 29 April 2019

International Committee of the Red Cross, https://www.icrc.org/en/doc/assets/files/publications/icrc-002–0173.pdf, accessed 1 June 2019

Flessas, T., 'The repatriation debate and the discourse of the Commons', *LSE Law, Society and Economy Working Papers*, 10 (2007), www.lse.ac.uk/law/working-paper-series, accessed 30 May 2019

Gignoux, S., 'Emmanuel Macron promet à l'Afrique des restitutions d'œuvres africaines « d'ici à 5 ans »', *La Croix* (28 November 2018), available at www.la-croix.com/Culture/Expositions/Emmanuel-Macron-promet-lAfrique-restitutions-doeuvres-africaines-dici-5-ans-2017–11–28–1200895496, accessed 30 May 2019

Häntzschel, J., 'Begründete Zweifel⊠, *Süddeutsches Zeitung* (12 March 2019), available at https://www.sueddeutsche.de/kultur/restitution-begruendete-zweifel-1.4364409, accessed 30 May 2019

Haughin, C., 'Why museum professionals need to talk about *Black Panther*', *The Hopkins Exhibitionist* (20 March 2018), available at https://jhuexhibitionist.com/2018/02/22/why-museum-professionals-need-to-talk-about-black-panther/, accessed 30 May 2019

Hickley, C., 'Culture ministers from sixteen German states agree to repatriate artefacts looted in colonial era', *The Art Newspaper* (14 March 2019), available at www.theartnewspaper.com/news/culture-ministers-from-16-german-states-agree-to-repatriate-artefacts-looted-in-colonial-era, accessed 30 May 2019

Kendal Museum, www.kendalmuseum.org.uk, accessed 25 August 2018

Kendal Museum, www.kendalmuseum.org.uk/about-us/the-collections/world-wild-life-gallery/, accessed 25 August 2018

Kultusministerkonferenz, 'Erste Eckpunkte 1 zum Umgang mit Sammlungsgut aus kolonialen Kontexten 2 der Staatsministerin des Bundes für Kultur und Medien, 3 der Staatsministerin im Auswärtigen Amt für internationale Kulturpolitik, 4 der Kulturministerinnen und Kulturminister der Länder 5 und der kommunalen Spitzenverbände', Anlage II, z. NS 1. Kultur-MK, 13 March 2019, Berlin, pp. 1–8, available at www.kmk.org/fileadmin/pdf/PresseUndAktuelles/2019/2019–03–25_Erste-Eckpunkte-Sammlungsgut-koloniale-Kontexte_final.pdf, accessed 30 May 2019

Marshall, A. 'Living things, with no bone or tissue, pose a quandary for museums', *The New York Times* (21 March 2019), available at www.nytimes.com/2019/03/21/arts/design/museums-human-remains.html, accessed 30 May 2019

Modern Ghana, K. Opoku, 'When will Britain return looted golden Ghanaian artefacts? A history of British looting of more than 100 objects', http://www.modernghana.com/news/310930/1/when-will-britain-return-looted-golden-ghanian-ar.html, accessed 13 December 2013

Museums Association, www.museumsassociation.org/museums-journal/news/11012016-regimental-museums-prepare-for-mod-cuts, accessed 5 December 2018

National Archives, https://webarchive.nationalarchives.gov.uk/20121018172935/http://www.mod.uk/NR/rdonlyres/051AF365–0A97–4550–99C0–4D87D7C95DED/0/cm6041I_whitepaper2003.pdf, accessed 24 August 2018

National Archives, http://filestore.nationalarchives.gov.uk/pdfs/small/cab-129–86-c-57–69–19.pdf, accessed 10 May 2019

National Army Museum, Annual Reviews and Published Accounts, 2010–17, www.nam.ac.uk/accounts-and-reviews, accessed 3 May 2019

National Army Museum, 'National Army Museum responds to repatriation request from Ethiopia', www.nam.ac.uk/press/national-army-museum-responds-repatriation-request-ethiopia, accessed 30 May 2019

National Army Museum, 'War and Sikhs: Indo-Persian weapons', volunteer session, www.youtube.com/watch?v=4neArxPAviE, accessed 3 May 2019

National Museum Liverpool, World Museum, Powder horn 56.26.414, available at www.liverpoolmuseums.org.uk/wml/collections/ethnology/americas/item-383330.aspx, accessed 14 June 2019

National Museums Scotland, 'Black Watch Museum and Castle, Perth: Individual Records', *Material Encounters Catalogue* (2016), available at https://www.nms.ac.uk/media/1150294/black-watch-ir.pdf, accessed 2 June 2019

National Museums Scotland, 'Casualty of war: A portrait of Maharaja Duleep Singh', *Explore our Collections: Stories*, available at www.nms.ac.uk/explore-our-collections/stories/world-cultures/india-in-our-collections/india/casualty-of-war/, accessed 30 June 2019

National Museums Scotland, 'The Fusiliers Museum, Tower of London: individual records', *Material Encounters Catalogue* (2016), available at https://www.nms.ac.uk/media/1150306/fusiliers-museum-ir.pdf, accessed 2 July 2019

National Museums Scotland, 'Redoubt Fortress Military Museum, Eastbourne: individual records', *Material Encounters Catalogue* (2016), available at https://www.nms.ac.uk/media/1150301/redoubt-ir.pdf, accessed 31 May 2019

National Museums Scotland, 'Royal Engineers Museum, Library and Archive, Gillingham, Kent: individual records', *Material Encounters Catalogue* (2016), available at https://www.nms.ac.uk/media/1150307/royal-engineers-ir.pdf, accessed 2 July 2019

National Museums Scotland, 'The Royal Green Jackets (Rifles) Museum, Winchester: individual records', *Material Encounters Catalogue* (2016), available at http://www.nms.ac.uk/media/1150310/royal-green-jackets-ir.pdf, accessed 31 May 2019

National Museums Scotland, 'Royal Norfolk Regiment Collection, Norwich Castle: individual records', *Material Encounters Catalogue* (2016), available at https://www.nms.ac.uk/media/1150304/norfolk-ir.pdf, accessed 2 July 2019

Nationaal Museum van Wereldculturen, 'The National Museum of World Cultures identifies the principles on the basis of which the museum will assess claims for the return of objects of which it is the custodian', press release, 7 March 2019, available at www.volkenkunde.nl/en/about-volkenkunde/press/dutch-national-museum-world-cultures-nmvw-announces-principles-claims, accessed 30 May 2019

National Portrait Gallery, London, available at www.npg.org.uk/collections/search/portrait/mw18875/Maharaja-Duleep-Singh, accessed 30 June 2019

Noce, V., 'French President Emmanuel Macron calls for international conference on the return of African Artifacts', *The Art Newspaper*, 26 November 2018, available at www.theartnewspaper.com/news/french-president-emmanuel-macron-calls-for-international-conference-on-the-return-of-african-artefacts, accessed 10 October 2019

——, 'France retreats from report recommending automatic restitutions of looted African Artefacts', *The Art Newspaper* (5 July 2019), available at www.theartnewspaper.com/news/france-buries-restitution-report, accessed 10 October 2019

Officer, L. H. and S. H. Williamson, 'Five ways to compute the relative value of a uk pound amount, 1270 to present', *Measuring Worth*, available at www.measuringworth.com/ukcompare/, accessed 2 July 2019

Powell-Cotton Museum, www.quexpark.co.uk/museum/, accessed 25 August 2018

Princess of Wales's Royal Regiment website, 'Officers' Mess Dining Room', available at www.armytigers.com/artefacts/1-pwrr-officers-mess-dining-room, accessed 1 January 2019

Queen Victoria's Journals, available at www.queenvictoriasjournals.org/, accessed 29 April 2019

Ragbir, L., 'What *Black Panther* gets right about the politics of museums', *Hyperallergic* (20 March 2018), available at https://hyperallergic.com/433650/black-panther-museum-politics/, accessed 30 May 2019

Royal Green Jackets Museum, available at, http://rgjmuseum.co.uk/our-story/history-of-the-museum/, accessed 1 June 2019

The Royal Sussex Regimental Collection, available at, http://mediafiles.thedms.co.uk/Publication/ES/cms/pdf/The%20Royal%20Sussex%20Regimental%20Collection.pdf, accessed 1 June 2019

Savage and Soldier Online, D. Johnson, 'A note on Mahdist flags', www.savageandsoldier.com/sudan/MahdistFlags.html, accessed 4 March 2014

Schuetze, C. F., 'Germany sets guidelines for repatriating colonial-era artifacts', *New York Times* (15 March 2019), available at www.nytimes.com/2019/03/15/arts/design/germany-museums-restitution.html, accessed 30 May 2019

Sharma, M., 'Two at a time: How the Singh Twins have crafted a seamless artistic identity', *Firstpost* (11 July 2016), available at www.firstpost.com/living/two-at-a-time-how-the-singh-twins-have-crafted-a-seamless-artistic-identity-2881174.html, accessed 30 June 2019

Society for the Study of the Sudans UK, F. Nicoll, 'Material related to the Mahdia', www.sssuk.org/main/Mahdiamaterials.pdf, accessed 8 April 2015

The Spectator, https://www.spectator.co.uk/2017/06/the-newly-refurbished-national-army-museum-is-full-of-inaccuracies-and-post-colonial-guilt, accessed 25 October 2019

Thomas, N., 'We need to confront uncomfortable truths about European colonial appropriation', *The Art Newspaper* (29 November 2017), available at www.theart-newspaper.com/comment/macron-repatriation, accessed 30 May 2019

The Times Digital Archive 1785–2013, www.gale.com/intl/c/the-times-digital-archive, accessed 29 April 2019

UK Government, www.gov.uk/government/news/supplying-troops-in-helmand-with-water, accessed 4 January 2019

UK Parliament, *Hansard*, 'Abyssinia—Prince Alamayon', 8 March 1872, available at https://hansard.parliament.uk/Commons/1872-03-08/debates/507237b7-cfa8-4b5b-bd46-bdad6aaeda0e/Abyssinia%E2%80%94PrinceAlamayon, accessed 2 June 2019

BIBLIOGRAPHY

UK Parliament, *Hansard*, 'Abyssinian War – prize – the Abana's Crown and Chalice', 30 June 1871, available at https://hansard.parliament.uk/Commons/1871–06–30/debates/0e763636–72ee–4a5c–bb3f–f6b19e10922f/AbyssinianWar%E2%80%94Prize%E2%80%94TheAbanaSCrownAndChalice, accessed 2 June 2019

UK Parliament, *Hansard*, 'Alleged looting by Tibet expeditionary force', available at https://hansard.parliament.uk/Commons/1904–08–10/debates/da7ded08–84ef–435e–9fb2–3337e9309a1a/AllegedLootingByTibetExpeditionaryForce, accessed 27 July 2019

UK Parliament, *Hansard*, 'The Mission to Tibet', available at https://hansard.parliament.uk/Commons/1904–07–28/debates/d698cb09–59af–44d7–b6a6–2b2f70d9ca83/TheMissionToTibet, accessed 27 July 2019

UK Parliament, *Hansard*, 'The Punjab Booty', HL Deb, 26 May 1851, vol. 116, cols. 11395–410, available at https://api.parliament.uk/historic-hansard/lords/1851/may/26/the-punjab-booty, accessed 2 July 2019

UK Parliament, *Hansard*, 'Punjabi community', HC Deb, 7 March 2000, vol. 345, cols 141–8WH, available at https://hansard.parliament.uk/Commons/2000–03–07/debates/07b16da0–17e9–4eed-add0–1982e3d038ec/PunjabiCommunity, accessed 2 July 2019

V&A, available at https://collections.vam.ac.uk/item/O18891/maharaja-ranjit-singhs-throne-throne-chair-hafiz-muhammad-multani/, accessed 30 August 2019

Warnock collection, available at http://www.splendidheritage.com/Cell/DataPages/WC8908007.html, accessed 31 May 2019

Wavell Room, https://wavellroom.com/2018/08/14/traditions-and-army-reputation/, accessed 25 October 2018

Wikiwand, available at www.wikiwand.com/en/Indian_rupee#/Historic_exchange_rates, accessed 30 June 2019

Yale Law School, https://avalon.law.yale.edu/19th_century/hague02.asp, accessed 10 May 2019

Yale Law School, https://avalon.law.yale.edu/20th_century/hague04.asp, accessed 10 May 2019

INDEX

Note: 'n.' after a page reference indicates the number of a note on that page.

9 781526 139207